Crowning Glory

Images of the Virgin
in the Arts of Portugal

MINISTÉRIO DA CULTURA gabinete das
Relações Internacionais

THE NEWARK MUSEUM

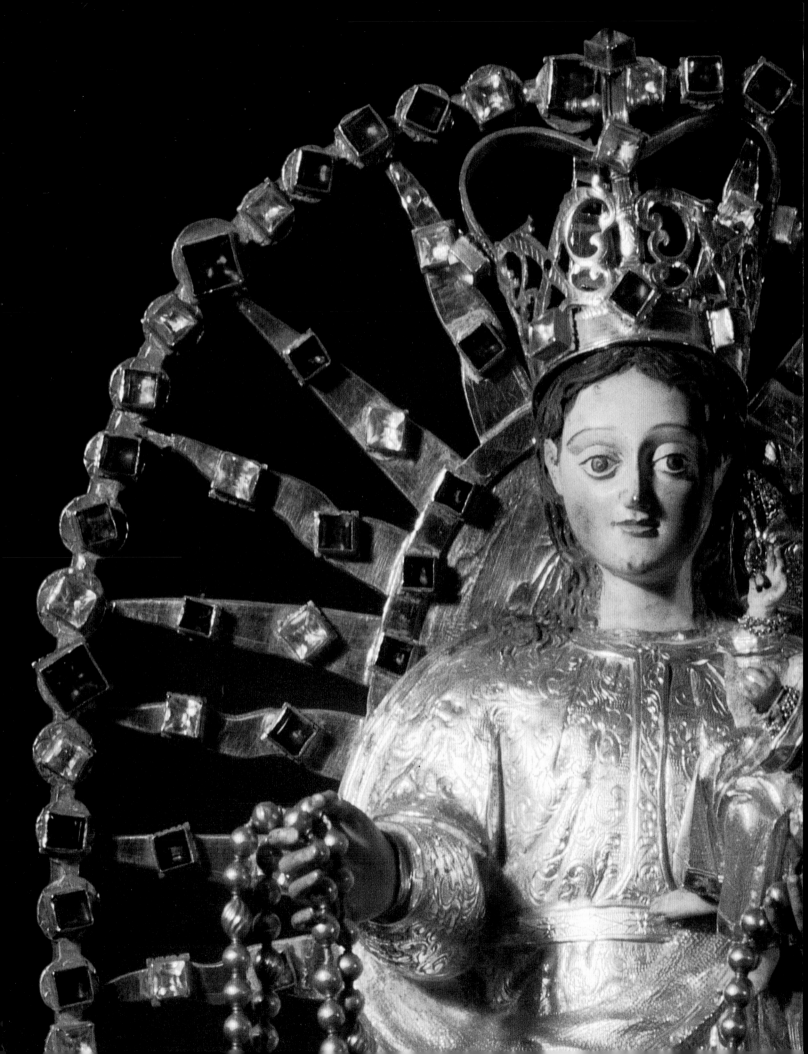

Crowning Glory

Images of the \mathcal{V}**irgin**
in the **Arts** of **Portugal**

Newark, New Jersey
1997

HONORARY COMMITTEE

His Excellency António Guterres
Prime Minister of Portugal

Dr. António de Almeida
The Honorable Augusto Amador
The Honorable Elizabeth Frawley Bagley
Ms. Susan V. Berresford
Professor Manuel Maria Carrilho
Dr. Luís de Melo Champalimaud
The Honorable Jack Collins
Prof. Dr. A. Ferrer Correia
Mr. Edward Cruz
Mr. Licinio Cruz
The Honorable Donald T. Di Francesco
The Honorable Armando Fontoura
Dr. Jaime Gama
Eng. António Sousa Gomes
Eng. Jorge Manuel Jardin Gonçalves
His Excellency Fernando Andressen Guimar‹es
The Honorable Lonna R. Hooks
The Honorable Sharpe James
Mr. Donald M. Karp
The Honorable Patrick J. Kennedy
The Honorable Frank R. Lautenberg
Ruy V. Lourenço, M.D.
Eng. José Lello
Dr. José Lemos
Mr. and Mrs. Sherman R. Lewis, Jr.
Eng. Manuel Ferreira Lima
The Honorable Wynona Lipman
Most Rev. Theodore E. McCarrick
Mr. Scott McVay
Dr. Rui Chancerell de Machete
Mr. and Mrs. António S. Matinho
The Honorable Robert Menendez
Prof. Doutor João Paulo Monteiro
The Honorable Donald S. Payne
Louis E. Preseav, Sr.
Dr. Catarina Vaz Pinto
Mrs. Reuben F. Richards
Linda M. A. Rodrigues, Ph.D.
Mr. Ricardo Espirito Silva Salgado
Dr. Joao Mauricio Fernandes Salgueiro
Dr. Natércia de Viana Teixeira
Mr. Anthony P. Terracciano
The Honorable Robert G. Torricelli
Mr. James Treffinger
The Honorable Christine Todd Whitman

ADVISORY COMMITTEE

Dr. Natércia de Viana Teixeira
Consul General of Portugal

Mr. Augusto Amador
Mon. João da Silva Antão
Ms. Luisa Araújo
Ms. Donzelina Barroso
Dr. Margarida C. Carrasco
Mr. Albert Coutinho
Mr. Nuno Crato
Mr. Licinio Cruz, Esq.
Mr. Frank Ferreira
Mr. Armando B. Fontoura
Mr. Antonio de Armrim Gomes
Mr. Carlos Goncalves
Mr. Donald Goncalves
Mr. Tarsíco Lopes
Ms. Natalie J. Matinho
Ms. Glória de Melo
Mr. Jorge Mendes
Mrs. Maria Fernandes Morais
Ms. Ana Rita Naia
Mr. José Reis
Dr. Linda M. A. Rodrigues
Mr. Fernando da Silva
Ms. Manuela Silva
Mr. Armando Spencer

*This exhibit presented at The Newark Museum has been made possible
thanks to the generous support of*

Major funding to The Newark Museum has been received from
The Rockefeller Foundation
Geraldine R. Dodge Foundation
Mr. and Mrs. Sherman R. Lewis Jr.
The Newark Museum Volunteer Organization
Mr. Scot Spencer
Dunphy Family Foundation

Generous funding for education programs has been contributed by
Banco Espírito Santo, Inc./North America
Rev. Monsignor William N. Field
The Most Reverend Theodore E. McCarrick
Vera G. List
Seton Hall University
Linda L. M. Rodrigues and Nancy Rodrigues in memory
of their parents, Daniel and Elvira Rodrigues
Anonymous donor in honor of The Honorable Armando B. Fontoura

The Newark Museum also acknowledges the in-kind support from
the Archdiocese of Newark and Continental Airlines.

The Newark Museum receives partial general operating support from
the City of Newark, State of New Jersey *and* New Jersey State Council on the
Arts/Department of State. *Additional support for operating and for other purposes
is annually contributed from* corporations, foundations *and* private individuals.

EXHIBITION

This exhibition was organized by the Gabinete das Relações Internacionais
Ministério da Cultura *and* The Newark Museum
in cooperation with the Portuguese Embassy, in Washington, D.C.,
Portuguese Consulate Genera in Newark *and* the Instituto Português de Museus

Patronage

H. E. António Guterres
Prime Minister of Portugal

H. E. Manuel Carrilho
Minister of Culture

Patrícia Salvação Barreto
Director of the Office of International Relations

Kevin Schanley
Chairman and President, The Newark Museum

Mary Sue Sweeney Price
The Newark Museum

Direction and coordination of the Project

Lourdes Simões de Carvalho

Jerrilynn Dodds
Guest Curator

Edward J. Sullivan
Co-Curator

Ward L. E. Mintz
Project Supervisor

Julia Robinson
Exhibition Coordinator

Natátia Correia Guedes
Adviser

David Palmer
Exhibition Designer

CATALOGUE

Coordinators

Maria de Lourdes Simões de Carvalho

Julia Robinson

Editors

Jerrilynn D. Dodds

Edward J. Sullivan

Entries

António José de Almeida

Teresa Leonor do Vale

José Lico

Photography

Nuno Fevereiro

Arquivo Nacional de Fotografia

CAMJAP | Fundação Calouste Gulbenkian (p. 61)

Designed in Portugal by

José Brandão | Mónica Mendes

[Atelier B2, Lisbon]

Copy editor

Jennifer Knox White

Additional Copy Editing

Elisa Urbanelli

Translators

Michael Reade

Mary Platt

Printed in Portughal by

Textype, Artes Gráficas, Lda.

Lisbon

ISBN 972-758-006-8

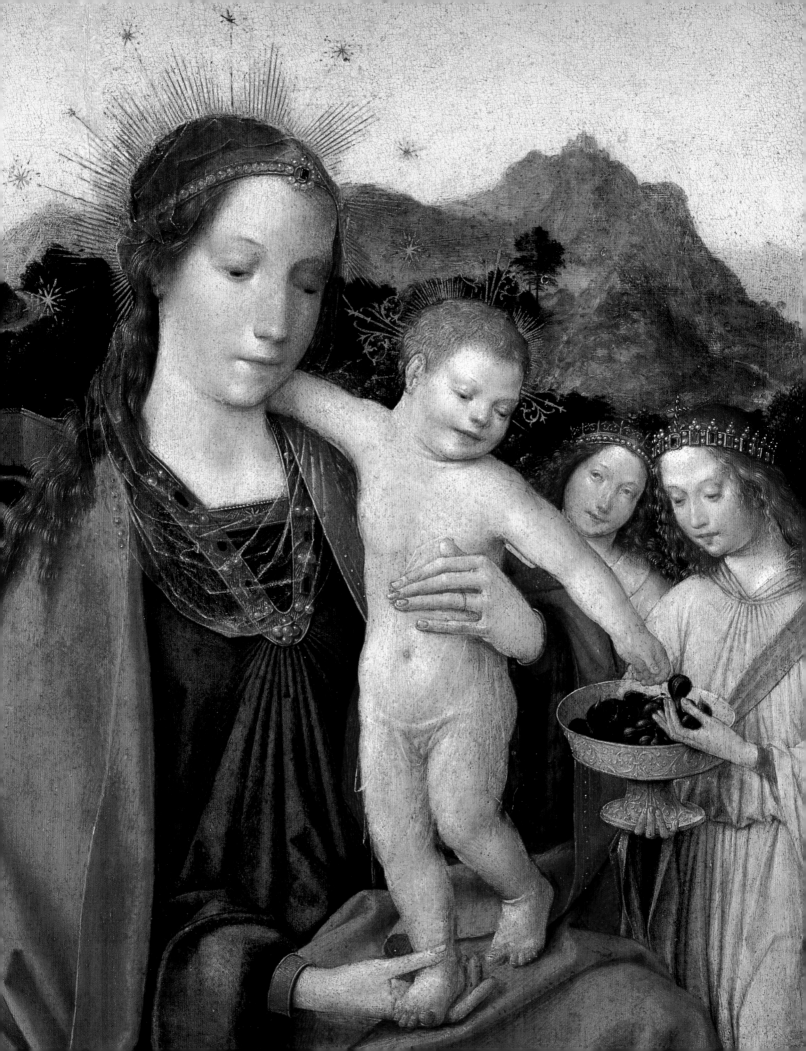

Contents

Newark is both home and workplace to a Portuguese speaking community that, over time, has established strong roots for itself. With it, this community brought an ancient spiritual tradition that it proudly maintains while simultaneously trying to absorb local culture.

> *"Whether we write or speak or do but look We are ever unapparent. What we are cannot be transfused into word or book."*
>
> FERNANDO PESSOA

On the horizon of this difficult and oftentimes trying process of acculturation, a very significant new tool – the New Jersey Performing Arts Center – has emerged. The New Jersey Performing Arts Center provides a voice for both American and Portuguese perspectives, and represents a decisive step toward the process of indetifying our differences, highlighting our similarities, and inspiring collaboration.

It was because of this significance that we enthusiastically accepted the invitation for Portugal to actively participate in the inaugural ceremonies of this great performance space in which the "Words and Ways" of Portugal will come to life.

Simultaneously with this World Festival, the Newark Museum will host an exhibition that expresses, as Fernando Pessoa has said, what neither word nor book can, that is, the deeper side of human nature, in which resides a nostalgia for things difficult to define, and in which echo the murmurs of dimensions lost to conscious memory but not totally inaccessible to human beings.

The most moving symbol of this ubiquitous desire to surpass one's limitations is the persistent cult of the Virgin, patron saint of Portugal, whose many facets pervade the imagination of Portuguese artists in an infinite fanning of the states of the soul. The Virgin inspires images as disparate as the Pietá and the Coronation in artists who have recovered their knowledge of the immortal essence of all things.

The "Crowning Glory: Images of the Virgin in the Arts of Portugal" exhibition attempts to show, through 76 works of art, the obsessive search for perfection for an ideal image and for eternity, in a path paved with smiles and tenderness, with doubts and with pain and compassion.

We wish to thank the Newark Museum for their collaboration, in particular for that of the director, Mrs. Mary Sue Sweeney Price, with whom we signed a protocol to make this exhibition come to fruition. Lastly, I wish to express my gratitude to the Portuguese Minister of Culture and to the Office of International Relations, for making this joint project possible.

António Guterres

Prime Minister of Portugal

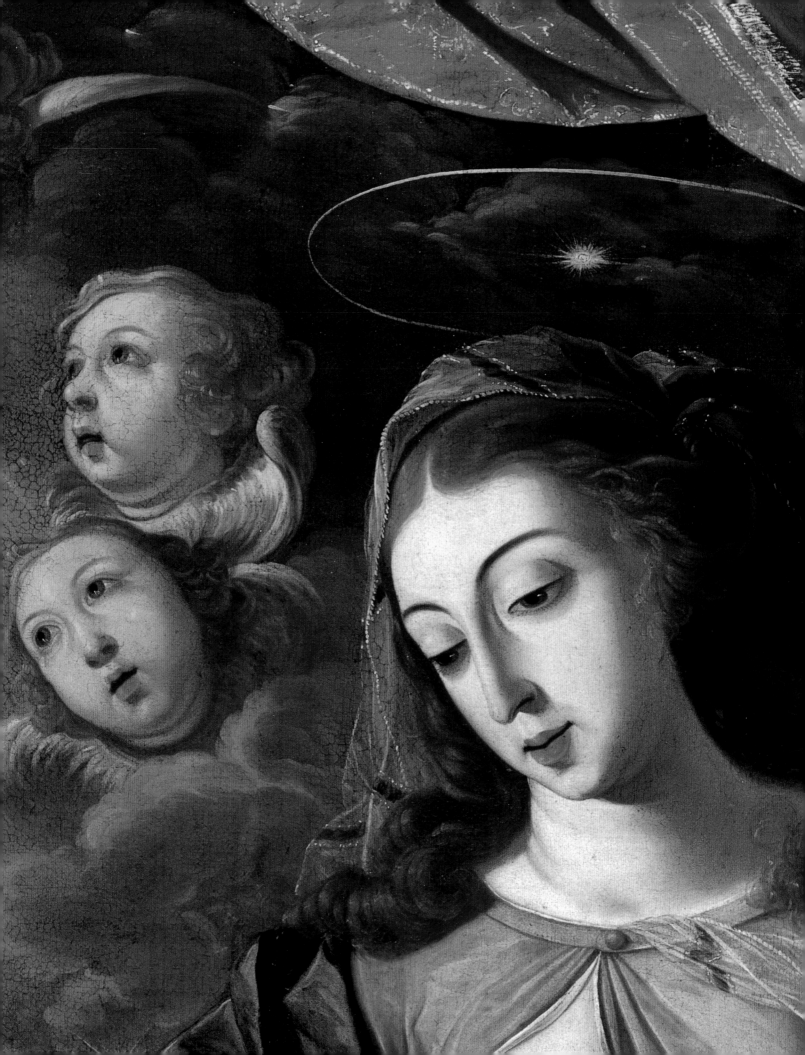

Acknowledgments

Planned to coincide with the opening of the New Jersey Performing Arts Center's inaugural World Festival showcasing the performing arts of Portugal, the exhibition *Crowning Glory* will offer a different angle to look at Portuguese culture. The medium, the subject matter and the chronological range all will contribute to the enlargement of the vision offered to the American public in general, and to Newark's Portuguese-American community in particular.

While at the NJPAC we are deating with arts representing the very dynamic creativity efforts of contemporary artists in Portugal and in Portuguese speaking countries, *Crowning Glory* constitutes a voyage in tradition and cultural heritage, traveling through many centuries and continents. The oldest piece is a marble Annunciation of the fourteenth century and the most recent a canvas on the same subject by Jorge Barradas, a contemporary painter. The images related to popular worship are included side by side with others showing the spread of religion in Asia and Africa. History, art and ethnography are constantly crossing their paths and this perspective defines the originality of the exhibition.

I have to thank Mary Sue Sweeney Price, Director of the Newark Museum, for her idea of this celebration of Virgin Mary as seen by artists ranging from Middle Ages to the 20th century. Her enthusiasm was crucial for the success of the project as was her discerned choice of professors Jerrylinn Dodds and Edward Sullivan, from New York, as scholarly consultants who developed the concept of the exhibition. We ave also gratefull for the valuable work of Dr. Linda Rodrigues, a leading personality of Newark's Portuguese community, and Ward Mintz, Deputy Director of Programs and Collections at the Museum. On the Portuguese side, the Ministry of Culture ensured the coordination of the project through its Office of International Relations and the Portuguese Museums Institute, with the support of our most important Museums.

I see this exhibition as a decisive step in a very fruitful collaboration with the Newark Museum and I very much hope the Portuguese-American community will become an ever-stronger supporter of the activities of the Museum.

Fernando Andresen Guimarães

Ambassador of Portugal

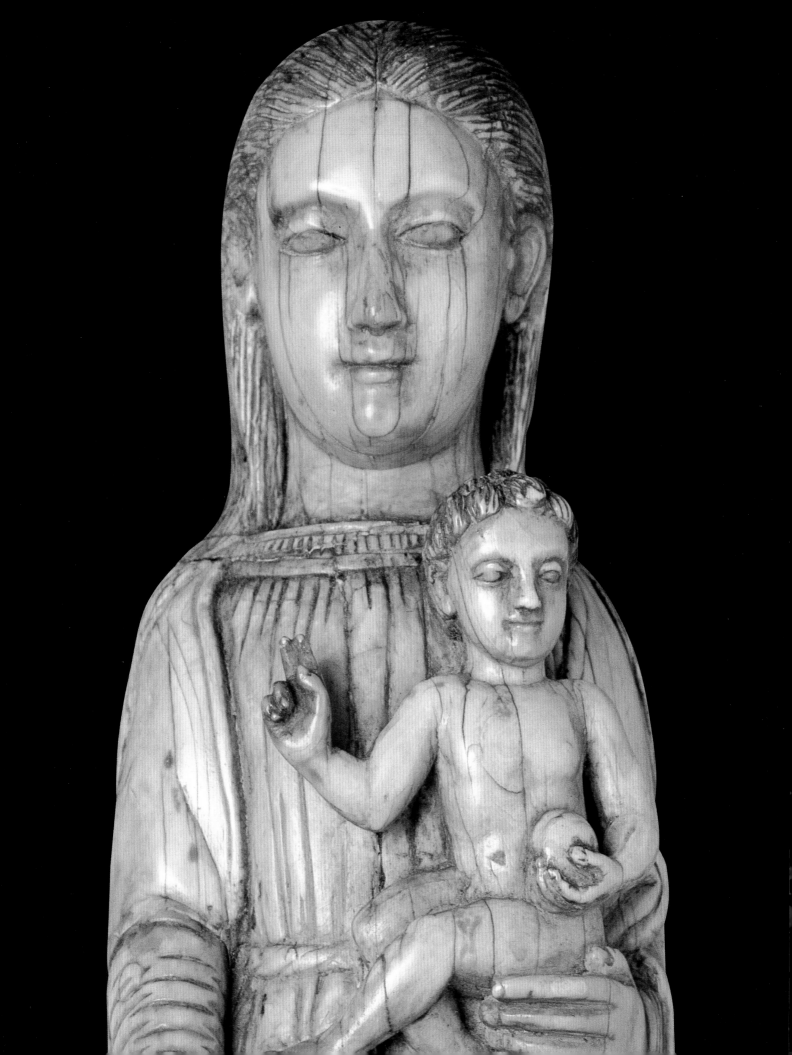

Foreword

The Newark Museum, through its presentation of *Crowning Glory: Images of the Virgin in the Arts of Portugal / Coroa de Glória: a Virgem na Arte Portuguesa,* carries on a legacy while fulfilling a long-standing dream. The legacy has to do with the Museum's pioneering efforts to interpret the artistic heritage of people and cultures throughout the world. The charter trustees and founding director, John Cotton Dana, collected broadly in order to interpret art to the tens of thousands of immigrants from many lands who settled in this city and enriched its life in the mid-nineteenth and early twentieth centuries. As early as 1912, Dana arranged an exhibition entitled *German Applied Arts,* alerting what was then a great manufacturing center to the latest developments in modernism and thus making the museum useful to its community. The significance attributed to these and other groundbreaking innovations in the presentation of visual culture is an important thread in the exhibition history of The Newark Museum.

The Museum has long dreamed of furthering this legacy by mounting a major exhibition of Portuguese art. Newark is the home of the largest Portuguese community in the United States and is located in relatively close proximity to other large communities in neighboring states. While some Portuguese-American families can trace their ancestry back to the mid-nineteenth century, many more have been part of a vital contingent that burgeoned in the mid-twentieth century. Some, indeed, have come to the United States from Portugal and many other Portuguese-speaking nations in the current generation. *Crowning Glory: Images of the Virgin in the Arts of Portugal* gives us the opportunity to embrace all groups into our New Jersey family in what we hope will be very meaningful ways.

Portugal has perhaps the richest tradition of devotional culture of any European country. *Crowning Glory: Images of the Virgin in the Arts of Portugal* recognizes this tradition and highlights it by focusing on its central image, that of the Virgin. A true national icon of Portugal, there is no doubt that the Virgin is also one of the most frequently painted images in the history of Western art. Indeed, it is the very nature of this extraordinarily rich subject that has given our guest curators the great scope of their undertaking. The Virgin image has allowed the curators to represent many layers of the rich tapestry of Portugal and the country's unique artistic traditions, while simultaneously interpreting some of the seminal impulses in European art over more than six centuries. This could not have come at a more opportune time: the subject of the Virgin has recently drawn considerable scholarly attention – from feminist studies to post-colonial debate to religious studies – as well as note in the popular press (in the past year, the Virgin has been depicted on the covers of *Life* and *Newsweek* magazines).

The Newark Museum owes a tremendous debt of gratitude to Professor Jerrilynn D. Dodds, our Guest Curator, for the enormous work, wisdom and passion she has invested in *Crowning Glory*. The exhibition's original and intellectually rigorous interpretation reveals, at every turn, her inspiration. I also thank Professor Edward J. Sullivan, Co-Curator, for his committed collaboration with Professor Dodds, and for bringing his great expertise, sensitivity and commitment to the exhibition and this accompanying publication. With so relatively little written in English on Portuguese art, we look forward to this catalogue becoming a standard text on the subject. We are further privileged to have the contributions of noted scholars Dr. Luís de Moura Sobral, Dr. Suzanne Stratton-Pruitt, and Dr. Manuel Clemente, all of whom provided excellent essays despite difficult deadlines. Thanks are due also to Michael Reade, translator, and Jennifer Knox White and Elisa Urbanelli, editors.

Crowning Glory is the result of tremendous efforts on both sides of the Atlantic. The government of Portugal truly has made this exhibition possible. We are particularly honored that His Excellency António Guterres, Prime Minister, personally endorsed this project and agreed to head the exhibition's Honorary Committee. To all the members of the committee, we offer our sincere gratitude.

The Portuguese Ministry of Culture has been the true partner of The Newark Museum in allowing this dream to become a reality, and for this I thank Manuel Maria Carrilho, Minister of Culture. The enthusiasm of Dr. Rui Nery, the former Secretary of State for Culture, for this project, and his appreciation of The Newark Museum were critical in cementing the Museum's relationship with the Ministry. The Ministry's Office of International Relations (GRI), under the inspired leadership of Dr. Patricia Salvação Barreto, generously made available countless resources. We particularly thank the Deputy Director of the GRI, Lourdes Simões de Carvalho, who took on the Herculean task of negotiating loans, arranging for the packing and trans-Atlantic transportation of art, and producing this memorable catalogue. Ms. Simões de Carvalho has been the anchor of our Portuguese partnership and the spirit and soul of the exhibition. Special thanks are also due to Concha Lemos, Assistant to Ms. Simões de Carvalho, and the other GRI staff members who worked on *Crowning Glory* in its various stages and in a variety of capacities. We are grateful to them all.

Many institutions and individuals were willing to part with their precious treasures for the length of this exhibition, thus sharing extraordinary examples of Portuguese creativity with thousands of Newark Museum visitors. We thank each and every lender for their generosity.

The curators and I also thank our scholarly partner, Dr. Maria Natália Brito Correia Guedes, for sharing her great knowledge of the material, for harnessing

resources – both human and logistical – and for her dedication to the excellence of the exhibition.

The Government of Portugal's representatives in this country have been enthusiastic supporters of our exhibition goals and have aided the project in innumerable ways from its very inception. Our greatest appreciation and gratitude must go to Ambassador Fernando Andresen Guimarães for all that he has accomplished on behalf of The Newark Museum. Our colleagues at the Embassy of Portugal in Washington, José Sasportes, Cultural Counselor, and Theresa Greenwald, Counselor, Social Affairs, have given much valuable advice and guidance.

The Portuguese Institute of Museums (IPM) was an early and enthusiastic supporter of our desire to create a major exhibition in Newark. The Institute's museums have graciously lent many of the most memorable objects. Our thanks go to Maria Raquel Henriques da Silva, Institute Director. At the individual museums, we have benefited greatly from the generous collegiality of the staffs. A substantial number of loans came from the Museu Nacional de Arte Antiga in Lisbon. For their hospitality and help, we thank Dr. José Luís Gordo Porfírio, Director, and staff. For making their facilities available for packing the exhibition and other gestures of collegiality, we are grateful to Joaquim Pais de Brito, Director, and Paulo Ferreira da Costa, Curator, of the Museu Nacional de Etnologia. We also thank João Castel-Branco Pereira, Director of the Museu Nacional do Azulejo, Maria José Paulo Sampaio, Director of the Museu Nacional de Machado de Castro in Coimbra, Mónica Baldaque, Director of the Museu Nacional de Soares dos Reis and all of the other museums and their curators who gave us vital advice and logistical support.

Here in Newark, I personally extend my great gratitude to Dr. Natércia de Viana Teixeira, Consul General of Portugal, for the gift of her intelligence, enthusiasm, and diplomacy concerning virtually every aspect of *Crowning Glory*.

The Museum is also most fortunate to have had the support of several enlightened foundations that have made *Crowning Glory* possible. I wish to thank, in particular, Scott McVay and Janet Rodriguez of the Geraldine R. Dodge Foundation, Mikki Sheppard and Tomás Ybarra-Frausto of the Rockefeller Foundation, and Dr. Bernardino Gomes, Administrator of the Fundação Luso-Americana para o Desenvolvimento. All have lent major financial support to this exhibition. We also thank Gabriella Morris Coleman, President of The Prudential Foundation, and Mary Y. Puryear, Program Officer, for their generous support of eduction-related activities for children. The Museum is most grateful for the financial and logistical support of Scot Spencer. We thank also The Newark Museum Volunteer Organization, the Dunphy Family Foundation, Vera G. List, Seton Hall University and Banco Espírito Santo

Inc./North America, which has provided additional funding, and the many others who have provided funding as well.

Crowning Glory: Images of the Virgin in the Arts of Portugal coincides with the opening of the New Jersey Performing Arts Center (NJPAC) in downtown Newark. The Newark Museum is a partner with NJPAC in the launch of its inaugural season, World Festival I: Portuguese Words and Ways. The World Festival Advisory Committee, chaired by Consul Teixeira and comprised of distinguished leaders of the Portuguese community in New Jersey, has been of invaluable assistance. We thank all of the Advisory Committee's members. We also acknowledge the involvement of many fine colleagues at NJPAC, including Lawrence Goldman, President and CEO, Stephanie Hughley, Vice President of Programming, John Richard, Senior Vice President of Development and Public Affairs, and Richard Bryant, Vice President, Marketing and Public Relations. We also recognize the contributions of Heidi Feldman, Amy Dickson, Baraka Sele, and Anthony Smith.

Museum staff have had the pleasure of working with a number of other residents of Newark's Portuguese community, all of whom have given unstintingly of their time and advice. In particular, I wish to thank the honorable Armando B. Fontoura, who championed this exhibition, and Ms. Dina Sousa, Dr. Margarida Carrasco, and Ms. Elaine Neves.

The Newark Museum received the invaluable assistance of New Jersey Network (NJN) in the preparation of a memorable video record of the procession for the Feast of Our Lady of Fátima in Newark's Ironbound. This important contribution to the *Crowning Glory* project was made possible through the good offices of Elizabeth Christopherson, Executive Director, and Janet Selinger, Senior Producer. Great appreciation is due to Producer Lisa Bair Morreale and her crew. Father Peter Uhde from the Church of the Epiphany in Newark and Father Mário Nunes and Associate Father James Manos from the Church of Our Lady of Fátima in Newark were indispensable to the tape's successful completion.

I am most grateful that the Trustees of The Newark Museum have lent their enthusiastic and essential support to this ambitious undertaking. I thank in particular Kevin Shanley, Chairman and President, my deepest appreciation is extended to Dorothy Lewis, Trustee, and her husband, Sherman R. Lewis, Jr., for their wonderful insight and early generosity, and to two very special Trustees, the Most Rev. Theodore E. McCarrick, Archbishop of Newark, and Monsignor William N. Field for their individual encouragement. Indeed, the Archdiocese of Newark has welcomed this exibition from its earliest stages and has contributed greatly to our outreach efforts in the community. Dr. Linda M. A. Rodrigues, a prominent member of Newark's Portuguese community and a newly appointed Museum Trustee, provided crucial

early support and enthusiasm for Dr. Dodds's idea of focusing on the Virgin as the symbol of Portuguese culture. Her continuing involvement has been a critical component of *Crowning Glory*'s success.

The staff of The Newark Museum is the source of so much intelligence, inspiration, and hard work, especially on a project of the magnitude of *Crowning Glory*. Two people have had special responsibility for seeing *Crowning Glory* to fruition. Ward L. E. Mintz, Deputy Director for Programs and Collections, was determined to help create an exhibition of scholarly depth and great meaning and I believe that he has succeeded admirably and with exceptional thoughtfulness. Project Coordinator Julia Robinson has shouldered virtually all of the day-to-day responsibility for the exhibition, and has done it with extraordinary dexterity, dedication, and warmth. We thank her for all her efforts. David Palmer, Director of Exhibitions, has created beautiful spaces with an appropriate Portuguese flavor for the objects, and Rebecca Buck, Registrar, has worked tirelessly to assure their safety.

Many thanks and congratulations are due to everyone involved, including Deputy Director for Finance and Administration Meme Omogbai, and Interim Coordinator of Marketing Toni Jones. Peggy Dougherty, Director of Development, and Tracy Elliott, Associate Director, have been critical to fund-raising efforts. Lucy Brotman, Eathon Hall, Linda Gates Nettleton, and staff members Kevin Heller, Stephen McKenzie, and Helene Konkus in the Museum's Education Department have planned a range of exciting interpretive programs and festivals, as has Public Programs Coordinator Jane Stein. Other museum staff, consultants, and volunteers who deserve thanks are Consultant Conservator Margaret Holben Ellis, Alejandro Ramirez, Lorelei Rowars, Ulysses Grant Dietz, Mary McGill, Patricia Faison, Bruce Freitag, Sharon Breland, William Peniston, Barbara Lowell, Isabel Santos, Festus Aleogena, Fernanda Gameiro, Luisa Kreisberg, Anne Edgar, Delores deNobrega Langone, and Erma Brown.

A number of colleagues from other museums, universities, and churches have been most helpful, in particular Claudia Nahson, Curator of Judaica at The Jewish Museum, New York; Monsignor John Antão of Our Lady of Fátima Church, Elizabeth; Dr. Asela Rodriguez de Laguna, Associate Professor, and Luisa Araujo, Lecturer, Rutgers, The State University, Newark College of Arts and Sciences; Christopher Noey of the Media Department at the Metropolitan Museum of Art, New York; and Donzelina Barroso of the Camões Center at Columbia University, New York. We also thank the Institute Cultural de Macau in Macau and the Centro de Arte Moderna of the Calouste Gulbenkian Foundation in Lisbon. Finally, to all those who have allowed us to have the privilege of sharing this extraordinary artistic, cultural, and devotional tradition, I thank you.

Mary Sue Sweeney Price

Director
The Newark Museum

A Message

"...Night
With starry sequins fleeting
In your robe fringed with the Infinite ..."
ÁLVARO DE CAMPOS [FERNANDO PESSOA]

This exhibition provides a glimpse into the fascinating story of that figure at once fragile, suffering and innocent, to whom the ruling powers of the universe announced that she would bear a divine being; but it can also give visitors an opportunity to reflect upon the human condition.

Around the globe, wherever their navigations took the Portuguese, anonymous craftsmen and established artists alike found inspiration and beauty in the story of the Annunciation, and in the many states of the soul associated with the Virgin.

The organizers have selected from this inexhaustible heritage of sacred art – from all over Portugal to the Far East, to Africa and to South America – paintings, sculptures, illuminated manuscripts and private devotionals from many eras, reflecting suffering, desperation, love and compassion, as well as the never-ending search for a paradise lost. At the heart of these works lies an undying hope – the desire to overcome our mortal condition.

Thus this exhibition is also an opportunity to reflect upon the significance of the story of the Virgin, who conceived and gave birth, without sin, to a divine Child. For believers, this is a matter of faith and not a question for argument. For agnostics, it is not to be discussed, for it seems absurd. The advances of science provide a trope for the mystery of this extraordinary biblical saga. Explorations into the core of the atom have proved that, beneath the fragile appearance of any form, there hides a universe pulsating with opposite forces interacting with devastating power. The discovery (or re-discovery) that there is no matter, but only imperishable energy and forces, can illuminate with a new and powerful meaning the story of the Virgin in whose womb was generated a Son who ascended to the Kingdom of Heaven.

For each of us, when the time is ripe, the consciousness suddenly opens up in a flickering glance into the radiant ocean of eternity that is always present, that always surrounds us although we are not aware of it. That quick rip in the consciousness is the annunciation of a new era. This awareness – direct, not intellectual – of the fire-born nature that resides within each of us, awakens the immense, dormant potential of each human being.

Our rational mind – up to that point, virgin of any contact with the forces that are responsible for all forms created – starts upon a new and painful, but rewarding, path of reconciliation with the abstract mind. The walls of skepticism

slowly begin to collapse. It is the nativity of a being with a regenerated consciousness which contemplates, for the first time, the endless dance between forces and energies, a newborn child who tries to understand the rules of this unveiled dimension.

This new observer, born to his illuminated mind, is without sin because he is liberated from the illusions of the old mind, and submits himself to the will of the abstract mind. His body of light radiates a splendid magnetic aura – the Virgin is now crowned with glory. He is heir to a kingdom that existed for him all the time, although he was never aware of it – an infinite ocean of light where entities of unimaginable power engage in fabulous disputes. In this immortal sea of immeasurable violence, he continues his adventure in search of the distant, unknown source from which everything sprang: planets, stars and quasars, galaxies and black holes and other inconceivable entities will be his playmates from then on.

Portugal expanded under the inspiration of this ageless wisdom which the Virgin and Child personify; a sacred science that lies more or less dormant in the heart of each human being. All these aspects of the spiritual quest pulsate in the Annunciations, the Nativities, the Dormitions and the Coronations on display.

The attentive visitor might also find, in the iconography of some of the works, a thread that enables him to find his way out of the labyrinth of ignorance about who we are, what we are doing here, and what our place is in the universe.

Lourdes Simões de Carvalho

Gabinete das Relações Internacionais

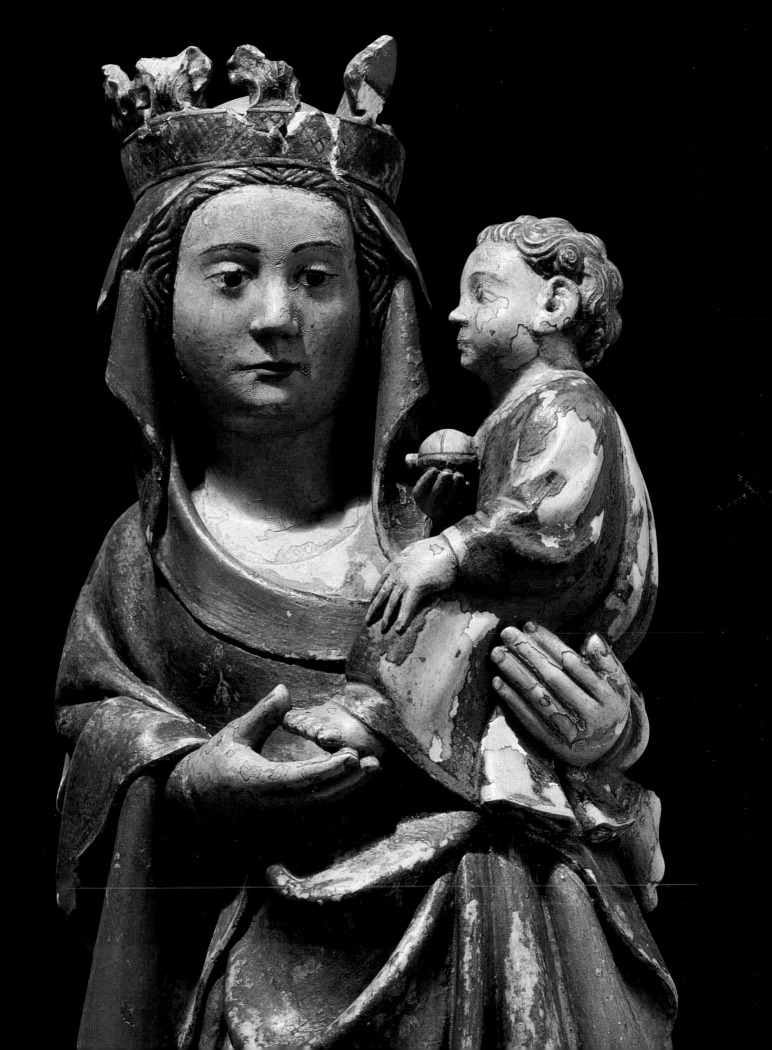

Introduction: Nossa Senhora Imagined

* For Jane Vern

Jerrilynn D. Dodds

I will come to ask for the consecration of Russia to my immaculate heart … If my requests are heard, Russia will be converted and there will be peace. If not, it will spread its errors throughout the entire world, provoking wars and the persecution of the church … But in the end, my immaculate heart will triumph.[1]

For those who believe the Virgin Mary to be a remote, mythic figure whose workings in history are counted only in whispered prayers over worn beads, these words, attributed to her at Fátima in central Portugal in 1917, seem jarring for their specificity, for their engagement in the fabric of a contemporary life, in the details of politics and morality on a scale both grandiose and mundane. She is benevolent and humane, intercessor and protector, but also one who wields a kind of staggering and sober power over the affairs of the world.

It is this Virgin – a powerful figure whose historical narrative far surpasses biblical witness, one deeply invested in the actual workings of a place and its people – who is celebrated in the works of this exhibition. She appears, in works of literature and in these works of art, not simply as the figure drawn by evangelical text and papal bull. She is also the grand maternal patron molded by her worshippers, by Portuguese history and society, by the political desire of a nation and the yearnings of personal spirituality.

Many European nations harbor deep connections with the figure of the Virgin Mary. The embrace in which images of the Virgin hold Portugal echoes in many ways the interaction of the figure of the Mother of Christ with the identities of other evolving European polities, as well as with the changing personal spirituality of individuals within their borders. Portuguese devotion to the Virgin, and many of the images that bear witness to it, have, however, their own character. In reading images of the Virgin Mary – both those shared throughout European tradition and those unique to Portugal – we hope to unravel a few fragments of the Portuguese collective consciousness. It is a consciousness softened by the image of the Virgin as a child, pierced through with the sword of her sorrows, a consciousness thrilled by the advocacy, the intervention, of the vision of an invincible queen in the conquests of a small, powerful nation.

Image and Text

Very little of the story of the Virgin Mary that appears in the works in this exhibition, or in the powerful and fecund cult they represent, is narrated in the Bible. The Bible yields no information concerning her childhood, birth or death, age, edu-

[1] William Thomas Walsh, *Our Lady of Fátima*, New York, 1947, pp. 75-77 (with alterations to the translation by the author).

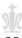

cation, or physical appearance.[2] Indeed, she appears only twice in each of the Gospels of Saint Mark and Saint John. She is not mentioned once in the entirety of the Pauline writings.[3]

It is in the Gospels of Saint Matthew and Saint Luke – which concern themselves with the events of the Nativity and the miraculous birth of Christ – that she is introduced as a pivotal character in the drama of the New Covenant. Matthew tells us how Mary "was found to be with Child of the Holy Spirit" (Matthew 1: 18). Yet, though the Nativity, the Adoration of the Magi, and the Flight into Egypt – some of the most familiar and beloved stories of the New Testament – are recounted in Matthew, the Virgin is silent and marginal in most of the account. "Matthew's main interest here," a group of Catholic and Protestant scholars maintain, "is centered on Jesus, not Mary."[4] It is only in Luke, as Marina Warner points out, that Mary "is at the heart of the drama in the Bible."[5] It is in Luke that the angel Gabriel greets Mary in Nazareth with the words, "Hail, O favored one, the Lord is with you!" (Luke 1: 28) – thus marking the Annunciation, the beginning of the odyssey of the Virgin Mary in the story of Christ.

Luke gracefully intertwines the stories of the miraculous pregnancies of Mary and her cousin Elizabeth, the mother of John the Baptist. The two accounts converge at the Visitation, with the greeting of the cousins and their mutual revelation of the favor shown them by God. The child in Saint Elizabeth's womb leaps in recognition of the presence of the Savior in Mary's womb, and Elizabeth sings a hymn of praise to Mary: "Blessed are you among women, and blessed is the fruit of your womb" (Luke 1: 42). Luke also provides the richest account of the Nativity, one that includes the manger, the adoration of the shepherds, and the circumcision of the infant Christ after eight days. Through Luke we hear that Mary and Joseph dedicate Christ at the Temple in Jerusalem, where they listen to the prophesies of Simeon, and that, when Jesus is twelve, they lose him, and later find him with the wise men in the Temple.[6]

After that, the Virgin Mary recedes from view. She appears in the Gospel of Saint Mark, but is not consistently portrayed in a positive light.[7] She hovers at the margins of a crowd as her son teaches in Matthew, Mark, and Luke. She is a lively presence at Cana in John, who recounts her following Christ to Capurnum, and finally mourning with apostles at the foot of his cross. Luke places her in a list of Jesus's "brethren" who were present at his Ascension. Finally, in Acts, she prays with the Apostles in Jerusalem.

"Of the four declared dogmas about the Virgin Mary," Warner observes in *Alone of All Her Sex*, her seminal work on the cult of the Virgin, only one can be "unequivocally traced to scripture," and that is the declaration of her divine motherhood.[8] The Evangelists are not clear on the question of her virginity, and neither her birth

[2] Raymond Brown, Karl Donfried, Joseph Fitzmyer, and John Reumann, eds., *Mary in the New Testament*, Philadelphia, 1978, pp. 8-22; Marina Warner, *Alone of All Her Sex: The Myth and the Cult of the Virgin Mary*, New York, 1983, p. 14; and Gertrud Schiller, *Ikonographie der christlichen Kunst, Band 4,2: Maria*, Kassel, 1982, pp. 9-19. In addition to the sources cited in the notes that follow, these publications are valuable: Hilda Graef, *Mary: A History of Doctrine and Devotion*, 2 vols., London, 1963, and Theodore Koehler, "Marie (sainte Vierge): Du moyen âge aux temps modernes," in *Dictionnaire de spiritualité, ascétique et mystique, doctrine et histoire*, vol. 10, Paris, 1977, cols. 409-63.

[3] Brown, Donfried, Fitzmyer, and Reumann, eds., *Mary in the New Testament*, p. 33.

[4] Ibid., p. 18.

[5] Warner, *Alone of All Her Sex*, p. 19.

[6] For the contribution of the Gospel of Saint Luke to the story of Mary, see Brown, Donfried, Fitzmyer, and Reumann, eds., *Mary in the New Testament*, pp. 18-20, and Warner, *Alone of All Her Sex*, pp. 3-24. The latter source is particularly valuable.

[7] See, for example, Mark 3: 31-33.

[8] Warner, *Alone of All Her Sex*, p. 19.

nor death are recounted, so the Scriptures cannot provide confirmation of the dogmas of her Immaculate Conception or her Assumption into Heaven. "The sum total of the Virgin's appearances in the New Testament," muses Warner, "is startlingly small plunder on which to build the great riches of Mariology."[9]

The power of the idea of the Virgin, and the deep needs that her cult fulfills, stimulated the quest for narratives beyond those provided by Scripture. The most important of these is surely the Book of James, an apocryphal account written around the end of the first century that was not considered seriously for inclusion in the canonical Gospels.[10] Here the story of Mary's parents, Joachim and Anne, is introduced; there is an annunciation of Mary's birth, which is accompanied by divine events: she walks at six months, is the beloved of priests and scribes, and is dedicated to the temple when she is only three.[11] The Book of James relates her betrothal and marriage to Joseph, which are accompanied by miraculous signs from Heaven, and the Annunciation of the birth of Christ is described fully, this time with precious anecdotal detail. Here we learn that a midwife is summoned at the Nativity, and that a doubting woman, Salome, is punished for her disbelief in Mary's virginity.[12]

The events described in the Apocrypha were given credibility by a number of the church fathers, who found in these accounts support for the dogma of Virgin birth.[13] But these stories of the Virgin were also locked in the popular consciousness through later recensions and informal versions of the tales – in particular Jacobus de Voragine's *The Golden Legend* – because they give her a life, a story.[14] The apocryphal accounts provide a cosmic, but also domestic and intimate narrative within which the Virgin might be imagined. The Book of James paints her life in both miraculous and humane colors, and she emerges from it a heroine in her own right.

The Virgin Imagined

The importance to Catholicism of such a figure, endowed now with a life, with her own accomplishments and miracles, cannot be overstated. As the Son of God, Christ presented a remote role model. Mary – who was human and not herself the issue of God – could serve, with few exceptions, as an example for those on Earth who aspired to live without sin. In time, history also made her a mediatrix, an intercessor, perhaps because her own earthly struggle suggests a forgiveness and indulgence for worldly sinners weighed down by concupiscence – the urge to sin that all humans inherited from the Fall. Like the faithful, she also suffers, also weeps for the human suffering of her child and out of love of him. In images, she presses her breast, into which swords have been thrust, as if her tears were not enough. These swords, and Mary's tears, rouse the devout with unspeakable memories of human yearning and mourning.

9 Ibid.

10 Edgar Hennecke, *New Testament Apocrypha, Vol. 1: Gospels and Related Writings*, Philadelphia, 1963, pp. 375-89.

11 "And he (Joachim) placed her on the third step of the altar, and the Lord God put grace upon the child, and she danced for joy with her feet, and the whole house of Israel loved her." See Hennecke, *New Testament Apocrypha*, p. 378.

12 Schiller, *Ikonographie der christlichen Kunst*, pp. 31-83.

13 Warner, *Alone of All Her Sex*, p. 33.

14 Jacobus de Voragine, *The Golden Legend*, trans. and adapted by Granger Ryan and Helmut Ripperger, New York, 1969.

[15] Caroline Walker Bynum, *Holy Feast and Holy Fast: The Religious Significance of Food to Medieval Women*, Berkeley, 1987, pp. 396-97, note 21, and David Herlihy, "Women in Medieval Society," in Herlihy, *The Social History of Italy and Western Europe, 700-1500*, London, 1978.

[16] Michael P. Carroll attributes the Virgin's appeal quite flatly to Oedipal draw: "Because the Mary cult does have some universal appeal (since devotion to Mary does gratify the Oedipal desires of both sexes), it will flourish whenever it is encouraged by those in power." Carroll, *The Cult of the Virgin Mary: Psychological Origins*, Princeton, 1986, p. 221. He further contends that the cult of the Virgin will flourish regardless of the presence or absence of official support in regions where the "father-ineffective family" is prevalent. In a disturbingly reductive gesture, he localizes this family profile in areas "like southern Italy and Spain" and "Latin America," where the cult of the Virgin is quite alive.

[17] David Herlihy states: "The cult [of the Virgin Mary as interceding mother] gained enormous popularity from the twelfth century on, even as western society was experiencing profound social changes that affected the family... [Young wives in the twelfth century were] ideally placed to serve as intermediary between conflicting male generations." "The Making of the Medieval Family: Symmetry, Structure and Sentiment," in Herlihy, *Women, Family and Society in Medieval Europe: Historical Essays 1978-91*, Providence, 1995, p. 149.

[18] This position can be argued from within a position of faith, or from a purely secular point of view. Michael P. Carroll outlines an argument for apparitions of the Virgin in times of civil strife: "Such illusions proliferated during Napoleon's invasion of Italy. It seems reasonable to suppose that when civilian populations are faced with danger and destruction, they would seek to reduce their anxiety by reassuring themselves that the forces of the supernatural world are on their side. They would be extremely receptive to the suggestion that … the Virgin Mary was giving them a sign that indeed, she was on their side." *The Cult of the Virgin Mary*, p. 195.

[19] Marina Warner maintains that "the Immaculate Conception remains the dogma by which the Virgin Mary is set apart from the human race because she is not stained by the Fall. And if on one plane the perfection of Mary is defined as the conquest of the natural laws of childbearing and death, then the prevailing idea of perfection denies the goodness of the created world, and of the human body, and postulates another perfect destiny where such conditions do not obtain." *Alone of All Her Sex*, p. 254.

[20] Caroline Walker Bynum, *Fragmentation and Redemption*, New York, 1992, p. 377, note 66.

[21] Bynum, *Holy Feast and Holy Fast*, Chapter 9.

Though no text recounts it, the Virgin is at times depicted in images at her coronation in Paradise, or as Queen of Heaven, elegant and powerful. Crowned, she sanctifies the earthly monarchies that evoke her, and yet, awesome and glamorous, she accepts personally the prayers of the disempowered. She is a deeply potent mother, her gaze fixed on the faithful who venerate her, ever forgiving, ever mindful of their particular cares: a mystic's desire in the twelfth century, a nobleman's hunt in the seventeenth century, or the destiny of Communism just eight decades past. There seems to be no doubt that devotion can be linked to the particular needs of the faithful, and that locked in the history of the Virgin is also a history of desire.

There are accounts of orphans who have found a mother in the Virgin,[15] and at different moments women and men have found nurturing, or power, or escape in the countless guises the Virgin assumes.[16] The Virgin developed her role of mediatrix, for instance, at a time in medieval history when young wives became intercessors within tightly wound family structures.[17] Personal piety, projected yearning, collective social tension, and anxiety have all contributed over time to the cult of the Virgin[18]; official acts, dogmas, and ecclesiastical visual symbols have grown more often from popular movements originating outside of the structure of the church than from any other source.

Yet scholars also emphasize the ways in which church doctrine has tended to contain and control the possibilities of women's spirituality in particular by qualifying the attributes and nature of the Virgin as unique and unattainable.[19] Caroline Bynum, however, cautions us from reductive reasoning, maintaining that "religious imagery cannot ever be read simply either as compensation or as projection."[20] The images of the Virgin, both textual and artistic, are multilayered; they contain the conscious and unconscious mark of wildly divergent actors in any social drama and, further, they can be read in different ways by diverse audiences. To venture just a little way into this issue, it is useful to review some of the basic arguments with which Catholic dogma frames the relationship between women and the Virgin.

In medieval theology, women carry, on one level, a conscious and symbolic association with flesh and matter, in opposition to the male gender, which symbolizes spirit and soul.[21] This opposition is linked to a notion of feminine weakness that finds its primal account in the Original Sin, in particular in Eve's role in the temptation and fall of humankind. Because of the expulsion from Paradise, humankind lives a life of toil, which ends in death and bodily corruption; women further bear the burden of menstruation, childbirth, and lactation. Mary, because she miraculously becomes the Mother of the Redeemer – bearing Christ as a virgin, she is thus outside the sins of the flesh – is the means by which the error of Eve is vanquished and humankind is delivered from death. The

Virgin Mary thus assumes a powerful role in the New Covenant.

It has been suggested, however, that when church dogma determined that the Virgin, unlike any other human, was from her birth miraculously free of original sin, and thus of the "incentive to sin" (the Immaculate Conception, 1854), or when it ordained her bodily assumption into Heaven (the Assumption of the Virgin, 1950), the possibility that any woman might effectively use her as a model was extinguished. The Virgin had been made incapable of sin, but all other humans were left mired in it, and women in particular were left irrevocably estranged by nature and dogma from the single powerful, dynamic female protagonist in the story of humanity's redemption and eternal life.[22]

This narrative certainly recognizes a deep struggle in which opposing images of male and female were drawn into an official discussion of the life and sanctity of the Virgin Mary, a discourse that was almost entirely mediated by male theologians and church hierarchy. Yet there is reason to see the Virgin's relationship to the women who worship her in a more complex way. "It is quite important as well to remember," Bynum reminds us, that in the Middle Ages, "devotion to Mary was by no means associated particularly with feminine piety."[23] Her cult was universal, and found its most ardent supporters among male clerics.[24]

Furthermore, the disempowered can be dynamic and creative. In a number of works, Bynum explores the nature of female spirituality in the Middle Ages, when many of the traditions and images of the Virgin discussed here were formed. She contends that certain medieval female devotional writers, especially those who found vocation in the church, tended to read the symbolic language of medieval Christianity differently from their male counterparts. Eschewing bipolar oppositions like weak and strong, and spirit and flesh, which might suggest the impossibility of a deep union with the divine for a woman, they found in the very attributes of fleshiness, servitude, and suffering assigned to them by medieval Christian social and doctrinal tradition enormous rooted power and deep identification with Christ.[25]

Even today, the power women draw from the Virgin is personal, and rarely translates into status within the catholic. While some attempt to establish her as "Mediatrix" with the Father and Son, more liberal Catholics see this movement as a way of diverting or pacifying Catholic women who agitate for the priesthood. Identification with the Virgin can provide a strong model, but her canonical triumphs are not always shared by mortal women. The strength and authority she imparts to women is personal and intimate, not institutional.

Carefully argued religious dogmas, apparitions, and miraculous stories – both those accepted by the church and those that reside in the fervent, liminal world of popular piety – form the balance of the

22 Warner, *Alone of All Her Sex*, pp. 236-54. See also Els Maeckelberghe, *Desperately Seeking Mary: A Feminist Appropriation of a Traditional Religious Symbol*, Kampen, 1991, and consider the conclusions of Ena Campbell: "In the West, the worship of the Virgin stands alongside the self-abnegation of women and the patriarchal, authoritarian attitudes of males." "The Virgin of Guadalupe and the Female Self-Image: A Mexican Case History," in James J. Preston, ed., *Mother Worship: Theme and Variations*, Chapel Hill, 1982, p. 21.

23 Caroline Walker Bynum, *Jesus as Mother: Studies in the Spirituality of the High Middle Ages*, Berkeley, 1982, p. 140. However, there is evidence that women have been at the center of Marian devotion in the nineteenth and twentieth centuries; see Sally Cunneen, *In Search of Mary: The Woman and the Symbol*, New York, 1996, p. 246.

24 Bynum, *Jesus as Mother*, p. 137.

25 Symbols of nurturing usually associated with women aided this identification: "Descriptions of God as a woman nursing the soul at its breast, drying its tears ... giving birth to it in agony and travail, are part of a growing tendency to speak of the divine in homey images and to emphasize its approachability." Bynum, *Jesus as Mother*, p. 129. See also Bynum, *Holy Feast and Holy Fast*, Chapter 10.

invocations and apparitions of the Virgin that appear in this exhibition. The images and the words of the Virgin recorded in these works responded strikingly to the needs of institutions and the faithful in the periods in which they were made. Like the societies that produced them, they are complex and multivalent: they harbor meaning for the empowered and disempowered, for children and bishops, for women and men.

Nossa Senhora

Alongside her extraordinary workings in the lives of humankind, the Virgin also became the patroness of fledgling nations. Her intervention was credited with battles won and hegemonies secured. The apparition of the Virgin at Fátima only eighty years ago is entirely consistent with her role in European society – and in Portuguese society in particular – since the formation of European national identities in the eleventh and twelfth centuries. Her name could sanctify a cause: the invocation of Nossa Senhora dos Mártires justified Portuguese claims in battles against Almohad forces, and transformed that political and geographical struggle into a cosmic one in which the Portuguese defended Christ's reign against an "infidel" foe.[26] Fallen soldiers became martyrs who died defending the Virgin's honor and her realm. And so the identity and fate of an earthly realm effortlessly became intertwined with the Kingdom in Heaven, a metaphor that empowered both the church and the cal-

low nation scant years after its formation in 1143.

The Virgin's authority, the mark of her direct intervention into the formation of the new state, required physical testimony of her presence and approbation.[27] In the years following the Gregorian reforms in Europe, when a newly independent church was led to appeal directly to its flock for authority, testimony of the intervention of the divine in daily life was provided by an extraordinary wave of vibrant humane images. The first monumental figural sculpture Europe had seen since the fall of Rome was created to narrate the authority and power of the church to its constituency in the Romanesque period, and it grew to define the alliance between the church and the monarchies of the Gothic period.

The Virgin emerged from medieval Portuguese workshops an elegant yet maternal queen (see [**fig. 1**]). Her courtly hauteur in this work recalls the praise of Gil Vicente, chanted in verse by clerics to just such an image of the Virgin: "When angels sing the glory of God, they neglect not your glory; for the glories of the Son are those of his mother, for you reign with him in the court of the Heavens."[28] Indeed, she holds her ground with a kind of regal solidity in image after image, a woman of real substance draped in layers of voluminous, gilded clothing. She holds a child too large, too dynamic, with perfect confidence, and her hands are enlarged so that we might feel their nurturing, protective power. Her pose – one hand holds the pre-

26 See Manuel Clemente's essay in this publication, "Devotion to the Virgin Mary in Portugal."

27 B. Xavier Coutinho, *Nossa Senhora na Arte: Algunas problemas iconográficos e uma exposição Marial*, Porto, 1959, is a substantial treatment of the iconography of the Virgin with special emphasis on Portuguese examples.

28 (1523). Maria Leonor Cavalhao Buescu (ed.), *Copilacan de todalas obras de Gil Vicente*, vol. 1, p. 143.

cious body while the other fondles the child's foot – evokes a deep memory of intimacy with which any maternal viewer might identify. But it is also a kind of offering of the feet, which will, in this child's life, be anointed for his final sacrifice. It is surely to this knowledge that we owe her sober gaze, which keeps us netted in a grave humor for all the intimacy and vitality that spills from this mother and child.

Clothed in the Sun;
Star of the Sea

Virgin, Star of the Sea
on this lake and on this night
a beacon which guides us to port
towards true and certain north[29]

The late-medieval and Renaissance periods saw Portugal buoyed by its *descobrimentos*, the establishment of the extensive network of colonies whose exploitation provided enormous wealth to the nascent monarchy for more than a century. Evangelization became part of colonization and economic exploitation, and the Virgin was deeply implicated in the spiritual arguments for the enterprise.[30]

As early as the fifteenth century, Prince Henrique "the Navigator" marked his explorations of the African coast with a chapel dedicated to Nossa Senhora de Belém. The Virgin's role as patroness of Christians in their struggle against a mythic Islam transformed quietly into one as benefactress of Portugal's heady expansion and its entitlement to seize any land east of the

Line of Demarcation that was not already in the hands of a Christian hegemony.[31] Vasco da Gama and many other explorers stopped to pray before the image of Nossa Senhora de Belém before embarking on their perilous conquests.

The Virgin's association with the sea and with exploration became linked, as well, with her attributes as the Virgin of the Immaculate Conception: in images (see [**fig. 2**]), she is pictured in the guise of the "woman clothed with the sun, with the moon under her feet, and on her head a crown of twelve stars" envisioned in the Book of Revelations (Rev. 12: 1). Because this woman's appearance in Revelations foreshadows the killing of a great dragon, images of the Virgin of the Immaculate Conception often include a dragon beneath her feet, his writhing a foil for the dynamic militancy of this flawless Virgin. It is symbolic of the part she takes in the battle against evil. But, as Warner observes, the vision of the Virgin in her astral crown also had potent and direct meaning in a world in which the skies had a clear and principal function as the central tool of navigation. In both Portugal and Spain, explorers prayed to Nossa Senhora dos Navigadores (Our Lady of the Navigators).[32] Countless navigators and explorers, among them Christopher Columbus, placed their ships under the aegis of the Virgin.

While the Virgin figured as a central part of the experience of exploration and appropriation in Portuguese colonization,

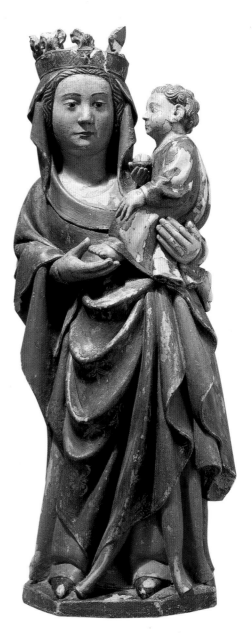

[fig. 1] Attributed to MASTER ALFONSO | **Virgin and Child** | 15th century. *Museu Nacional de Arte Antiga, Lisbon.*

[29] "Sa de Miranda, Song of Our Lady," in Ema Tarracha Ferreira, ed., *Textos Literarios: Séculos XVII & XVIII*, Lisbon, 1966, pp. 492-93 (trans. Linda Fernandes).

[30] On the iconography of the Virgin associated with a guiding star, see Coutinho, *Nossa Senhora na Arte*, pp. 170-72.

[31] See Clemente, "Devotion to the Virgin Mary in Portugal", and, also in this publication, Suzanne L. Stratton-Pruitt, "Nossa Senhora no Ultramar Português."

[32] Warner, *Alone of All Her Sex*, p. 267.

[fig. 2] Bento Coelho da Silveira | **Immaculate Conception** | late 17th century. *Museu de Aveiro.*

artists of European subjects and in European styles, which was fostered by Jesuit missionaries.[34] In a startling Momoyama oratory [**fig. 3**], she appears like the vision of a goddess, sheltered behind twin doors, which are worked in a contemporaneous Namban laquerwork and inlay to represent flowering and fruit-bearing trees, alive with birds and foliage.

Iconographically, the Virgin and Child painted within these doors finds its model in sixteenth-century Europe. The swarthy chiaroscuro of the Virgin's hands and the Christ Child's leg derive from Italian and Portuguese traditions as well. But other aesthetic choices in this work mark deep strains transforming the traditional sixteenth-century Virgin and Child. Sixteenth-century images of the Virgin in Portugal – like those by Frei Carlos in this exhibition – are so often hearty peasants pictured in a landscape with impish, smiling babies, revered for their celebration of the humble and humane. The Namban Virgin and Child is iconic in its stasis and sobriety. The color fields are deep, somber, and saturated. Though the combination of flat, abstract gilding and sporadic modeling are not unusual in sixteenth-century Portugal, the gravity and timelessness of this image, weighed by the dark, figureless ground into which the figures recede, suggests both a taste for more flat, elegant surface values and a remote, sanctified image. This combination of abstraction and sobriety, to which can be added the effect of the Virgin's

her accessibility and her symbolic mobility made her also a means of personal and indigenous expression among colonized groups and individuals. There was an enormous demand for images of the Virgin in Japan in the late sixteenth century, and the subject matter of paintings requisitioned from Europe by new Japanese Christians was concerned overwhelmingly with the Virgin and Child.[33] Indeed, countless images of the Virgin emerged from the Namban tradition – paintings by Japanese

[33] John E. McCall, "Early Jesuit Art in the Far East," *Artibus Asiae* 10 (1947), p. 124; quoted in Stratton-Pruitt, "Nossa Senhora no Ultramar Português," note 21.

[34] Stratton-Pruitt, "Nossa Senhora no Ultramar Português."

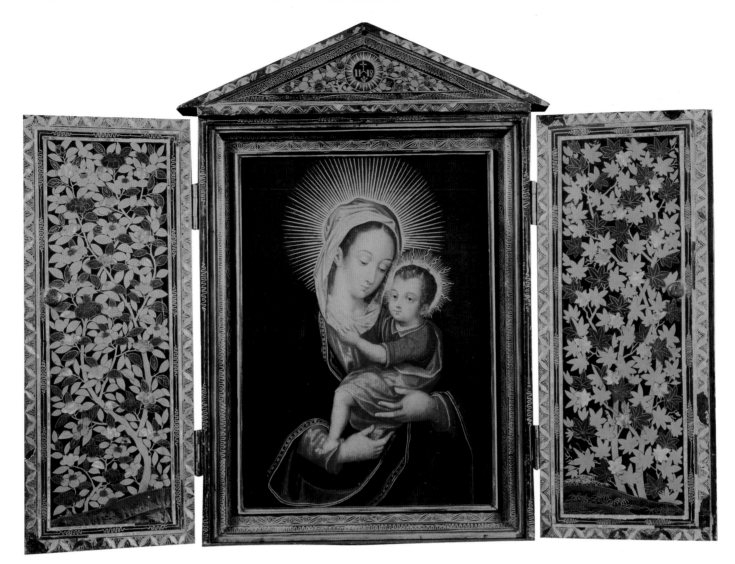

ivory face and neck, so different from her dark, molded hands, suggests the workings of aesthetic values and terms of reverence fed by a sixteenth-century Momoyama sensibility.[35]

Though the stylistic choices and iconography of Namban images of the Virgin are never anchored far from European tradition, this image of the Virgin emerges from her oratory exuding the suspended, timeless absorption one would expect of a goddess in a domestic shrine. That such images were subjected to physical violence by those who opposed Christianity in the early seventeenth century enables us to measure the potency of these artistic transformations within Japan.[36]

Perhaps no other image so straddles the line between Virgin and goddess as the Immaculate Conception, for here the Virgin appears alone, billowing with all that associates her with supernatural power: her feet on a sickle moon, her hair in a tangle of stars, she stands alone, unjustified by Christ, clothed in blinding sun (see [**figs. 2** and **4**]).[37] "Virgin dressed by the sun," sings Sa de Miranda, "wholly enveloped by your own bright light, crowned by the stars, the moon under your feet."[38]

[fig. 3] **Oratory** | late 16th century. *Santa Casa da Misericórdia do Sardoal.*

35 See Yoshitomo Okamoto, *The Namban Art of Japan*, New York, 1971, pp. 122-23, and Shin'ichi Tani and Tadashi Sugase, *Namban Art: A Loan Exhibition from Japanese Galleries*, exh. cat., Japan Society Gallery, New York; Saint Louis Art Museum, Saint Louis, Missouri; Honolulu Academy of Arts, Honolulu, 1973.

36 Tani and Sugase, *Namban Art*, p. 20; cited in Stratton-Pruitt, "Nossa Senhora no Ultramar Português," note 24.

37 Schiller, *Ikonographie der christlichen Kunst*, pp. 154-79, and Coutinho, *Nossa Senhora na Arte*, pp. 69-81, 233-46. For the iconography of the Immaculate Conception, see, in particular, Suzanne Stratton, *The Immaculate Conception in Spanish Art*, New York, 1994.

38 "Song of Our Lady," in Ferreira, ed., *Textos Literarios: Séculos XVII & XVIII*, pp. 326-27 (trans. Linda Fernandes).

[fig. 4] **Virgin of the Immaculate Conception** |
early 18th century. *Private collection, Porto.*

39 There were even dramatic representations of the Immaculate Conception during this time. See Nancy Mayberry, "Dramatic Representations of the Immaculate Conception in Tirso's Time," *Estudios* 43 (1987), pp. 79-86. It is important to note, however, that the Immaculate Conception had a Portuguese history long before the Counter-Reformation. A Portuguese nun, Beatrice da Silva, began the Order of the Immaculate Conception, under the patronage of Isabel the Catholic, in Spain in the late fifteenth century. A member of the house of Portalegre and descended from the Portuguese royal family, she had accompanied the Portuguese princess Isabel to Spain when Isabel married Juan II. Manuel de Castro, "Los monasterios de Conceptionistas Franciscanas en España," *Archivo Ibero-Americano* 51 (1991), pp. 411-77.

40 "Canticle of Praises of the Most Admirable Mother, Maria Most Holy of Saints, Our Lady," in Ferreira, ed., *Textos Literarios: Séculos XVII & XVIII*, pp. 492-93 (trans. Linda Fernandes).

41 Concerning the iconography of the young Virgin with Saint Anne, see Coutinho, *Nossa Senhora na Arte*, pp. 59-63, and Schiller, *Ikonographie der christlichen Kunst*, pp. 63-67.

The Counter-Reformation was the Catholic church's ardent reengagement with the visceral and emotional experience of faith, in response to the challenges posed to it by the Protestant Reformation. Though the Virgin of the Immaculate Conception would not be declared a dogma of the church for more than two hundred years, she was celebrated with unbridled exuberance in the seventeenth century. It was this image that consummated the Virgin's union with the Portuguese state.[39]

Between 1580 and 1640, Portugal was submitted to Castilian rule, a period initiated by the regency of Philip II of Spain. Emerging exuberantly from the revolution that expelled the Spanish, the Assembly of 1646 proclaimed the Virgin of the Immaculate Conception to be the patron saint of the vernal Portuguese state.

The new king, Dom João IV, came from the ducal villa at Viçosa (Vila Viçosa today), where a particular image of the Virgin of the Immaculate Conception was honored. Around this image, the Virgin's veneration and Portugal's national and regal identity were galvanized. From this time on, like a feudal sovereign, the Virgin of the Immaculate Conception of Vila Viçosa would receive in tribute the wedding clothes of new Portuguese queens (see [**figs. 5-6**]). Crowned and clothed in these regal garments, the Virgin of the Immaculate Conception would be processed and venerated, fusing fealty to her person with submission to a national identity and a royal hegemony.

The Virgin of the Immaculate Conception, for all of her distant, peerless power, her divine separation from the human condition, is venerated at Vila Viçosa by means of a physical image. The materiality of the image is so closely associated with the person of the Virgin herself that she can be worshipped through the adornment and clothing of the sculpture. These intimate physical acts have the effect of humanizing the most transcendent and remote of the apparitions of the Virgin, giving it an accessibility demanded since the Counter-Reformation. Thus any worshipper might feel the thrill of the tension between a figure miraculously divine and the mundane world in which she becomes physically manifest. "Give praise to the Lady," Padre Manuel Bernardes wrote in the seventeenth century, "rays of the sun, and flashes of lightning."[40]

This is perhaps the reason why there is no implicit contradiction between such celestial, transcendent images and the deeply intimate, homey depictions of the Virgin that emerged in the seventeenth and eighteenth centuries. In a very small, gilt-wood sculpture from the Museu de Aveiro [**fig. 7**], the Virgin, a diminutive five-year-old, walks beside her wimpled mother.[41] The image bustles with physical and domestic pleasure. Saint Anne gestures as if in speech, while the tiny Virgin

[fig. 5] **Virgin of the Immaculate Conception of Vila Viçosa** | TK date. *Church of Nossa Senhora da Conceição, Vila Viçosa.*

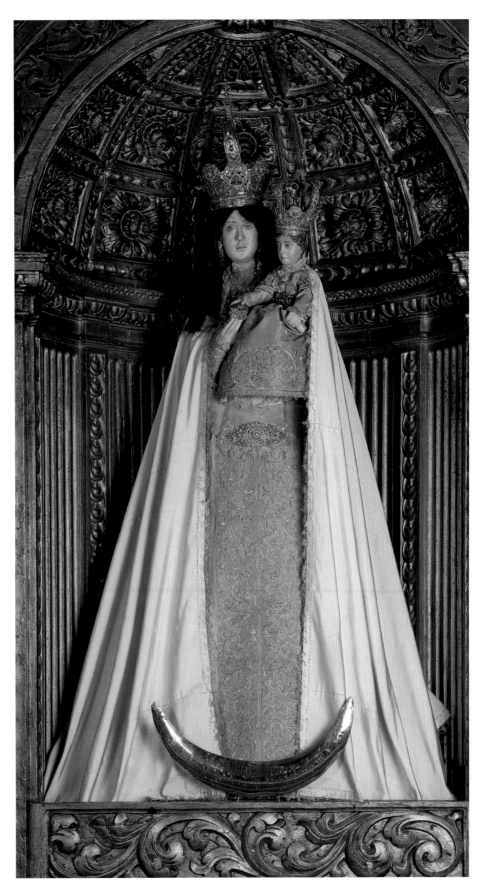

[fig. 6] **Offerings by the Duchesses of Portugal to the Statue of Nossa Senhora da Conceição** | TK date. *Church of Nossa Senhora da Conceição, Vila Viçosa.*

holds her robes, which are blowing in what seems to be a lively breeze. Their draperies and gestures are dynamic, and they hang in the air as if we have caught them unawares; it is an actual moment suspended in time. But for all this drama, it is an image of enormous familiarity, of humility and intimacy: a mother and child are walking together, into and through the lives of the faithful. Here, the drama of involvement is to be found in the thrill of recognition, of inclusion, and in the deep meaning that can be encased in the modest gestures and tiny acts of daily life.

Fátima

The nineteenth century saw the union between the Virgin and the Portuguese state dislodged, but not the popular association of the Virgin with the Portuguese identity.[42] The Napoleonic invasion, civil war, and socioeconomic crisis were accompanied by increasing secularization of society: in 1834, religious orders were abolished. A frail republic was established in 1910, but it fell, and from 1932 until 1968, António de Oliveira Salazar ruled Portugal as a virtual dictator.

In the midst of the growing pains of the tenuous Portuguese republic established in 1910, an apparition of the Virgin of the Rosary appeared to three children on a rural hillside in Cova de Iria, a small property in the township of Fátima. She was, according to one of them, Lucia dos Santos, "a Lady dressed all in white, more brilliant than the sun, shedding a light that was clearer and more intense than that of a crystal goblet … struck by the rays of the most brilliant sun." The Virgin admonished them to "Pray the Rosary every day to obtain peace for the world and the end of the war."[43]

The Virgin of Fátima appeared to a devout people deeply anguished by both the vicissitudes of war and the harsh social handiwork of political instability. Near the time of the apparitions, bread riots had broken out in Lisbon, and the republican government had instituted a strong campaign of secularization.[44] The suffering and instability must have seemed to the people of Fátima in part a consequence of the separation of their spiritual and national identities, which in some measure they associated with the country's fragile Socialist republic. At Fátima, the Virgin's appearance followed the repeated visits of an angel, who had admonished the children to pray and offered them miraculous communion. At one point, exhorting them to sacrifice, the angel had said: "Draw peace on your country by doing this. I am its guardian angel – the angel of Portugal."[45]

The need for a guardian angel, and for a luminous, serene queen was associated with the disruptions of the introduction of Socialism. The Virgin would later set out the restoration of religious and political order to Lucia dos Santos: "The Holy Father will consecrate Russia – which will convert to me, and a certain period of peace will be granted to the world. In Por-

[42] There is perhaps no better witness to this than the "Hymn to the Most Holy Mary for Having Rid Us of the Treacherous and Evil French," composed in 1808. See Clemente, "Devotion to the Virgin Mary in Portugal."

[43] Walsh, *Our Lady of Fátima*, pp. 52-53.

[44] Cunneen, *In Search of Mary*, p. 243.

[45] Walsh, *Our Lady of Fátima*, p. 42.

tugal, the dogma of the faith will always be kept."[46] Fátima was extraordinary above all because of the way the Virgin's message identified and answered a populist yearning for the marriage of Catholic spirituality and Portuguese national identity.[47]

Official images of the Virgin of Fátima are smooth and unfaceted; they are gently draped, milky compositions in white and ivory (see [**fig. 8**]). Though crowned, there is a delicacy of scale and proportion that denies these images the kind of temporal authority enjoyed by sculptures and paintings of the Virgin from the Renaissance and Baroque periods. Casual critics find the Fátima images provokingly bland and prosaic, and there has also been a sense that they reflect, in their apparent want of dynamism and character, the Catholic church's waning power in a secular world.

I do not believe these images to be as sweet and insipid, or as ineffectual, as they have been accused of being. The facial expression that lies at the emotive center of images of the Virgin of Fátima is one of sadness but also of decided serenity. It suggests the existence of an anguished but parented world. The Virgin of Fátima brings emotional and spiritual stability to a world perceived as rent and disrupted. Her gaze mirrors a kind of nostalgia and desire for a political structure that echoes the serene assurance of the heavenly one. This surely arises from a yearning for the protective mantle of the Virgin – for the foot that tramples the serpent, the star of the navigators, the sword, the breast, the crown, for the Marian song that is so deeply rooted in the history and images of Portugal.

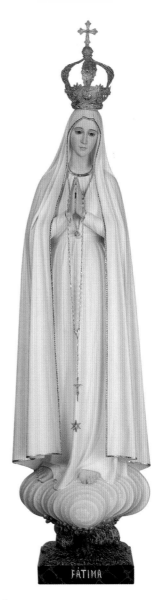

[fig. 7] **Saint Anne and the Virgin** | 18th century. *Museu de Aveiro.*

[fig. 8] **Our Lady of Fátima** | TK date. TK collection. 20th C.
(Photo: TK)

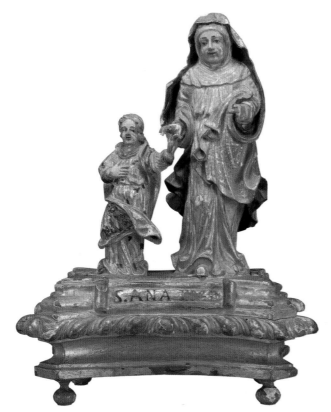

46 Ibid., pp. 75-77. Marina Warner reminds us of the militant associations that had been carried by the Virgin of the Rosary since the Battle of Lepanto. See *Alone of All Her Sex*, pp. 313-34.

47 In the community support at Fátima and at other recent apparitions, Cunneen sees "a form of passive political resistance." In regard to Fátima, she adds, "Such continuity of tradition in a rural community suggests an affirmation of its own experience in the face of insufficient response from the local church." *In Search of Mary*, pp. 242, 244-45. For more recent meanings to Marian pilgrimage, see Victor and Edith Turner, "Postindustrial Marian Pilgrimage," in Preston, ed., *Mother Worship*, pp. 145-73.

Six Centuries of Visual Art in Portugal: An (Improbable) Itinerary

The art of Portugal should be viewed as comprising a significant component of European visual expression. Despite its geographical position, remote from the centers of European culture, Portugal has produced art forms that have played important roles in the defining moments of European visual history, as well as that of Hispanic or Iberian civilization.[1]

Portuguese art has been produced under the most varied social and cultural historical conditions. Such diversity over an extended period of time has allowed neither for continuity nor for the recurrence of characteristics that, as some historians of this century infer, tend to establish or affirm a "national artistic spirit."

If we consider, for example, easel painting, we find that it is characterized, with more or less insistence, by the influences of various artistic centers. By the middle of the fourteenth century, and continuing for approximately one hundred years, Portuguese painting was dominated by the stimulus of Northern European art, especially that of Ghent, Bruges, and Antwerp. Italian Mannerism was the most influential model in the second half of the sixteenth century. During the seventeenth century, Portuguese art became more than merely "Hispanic," developing its own unique characteristics independent of the art of Spain. Later, during the eighteenth century, it found its sources in the grand tradition of Italian Baroque painting. In the nineteenth century, novelties, fashions, and aesthetics in Portuguese painting and sculpture came from Paris.

This essay attempts to present an overview of the evolution of Portuguese painting and sculpture, focusing on the works that have been considered by the majority of historians to be the most significant of each period.

From the beginning of the sixteenth to the end of the eighteenth centuries, there was tremendous activity in Portuguese painting. This period, which, from a historical perspective, is the most significant in relation to the works in this exhibition, corresponds to the three key centuries of Portugal's national history. Approximately half of this era, from the early sixteenth century on, was profoundly marked by the Counter-Reformation, which led to the renovation of the decoration of many churches and the creation of a considerable number of new convents and monasteries, whose decoration focused on specifically Catholic subjects (such as miracles, the lives of the Virgin Mary and the Saints, and the triumph of the Eucharist). Of overwhelming importance in the eighteenth century was the earthquake of 1755, which destroyed many of Lisbon's churches (and

Luís de Moura Sobral

[1] There is no current synthesis of the history of Portuguese art available in English. See the classic study by George Kubler and Martin Soria, *Art and Architecture in Spain and Portugal and their American Dominions*, Harmondsworth, 1959, and the shorter and more current synthesis by Robert C. Smith, *The Art of Portugal: 1500-1800*, London, 1968. For readers with access to university libraries, the entry entitled "Portugal" in *Dictionary of Art*, vol. 25, London, 1996, is of great use. Also of interest are the following recent works: *História da Arte em Portugal*, 14 vols., Lisbon, 1986, and Paulo Pereira, ed., *História da Arte Portuguesa*, 3 vols., Lisbon, 1995. In Spanish, there is José-Augusto França, José Luis Morales y Marín, and Wilfredo Rincón Garcia, *Arte português*, vol. 30 of *Summa Artis*, Madrid, 1986.

other architectural structures) and led to the construction and decoration of new buildings. Most of the art that can be seen in situ today is from the Baroque period, which without question is the richest period of Portuguese artistic history.

Portuguese painting was essentially religious until the end of the nineteenth century. Given the presence of the Catholic church in the life of the country, painting – and art in general – contributed deeply (and to a degree that to this day is hard to evaluate) to the formation of a national imagery. Because Portuguese painting had found its niche within the realm of religious institutions until this time, the process of cultural secularization, which culminated with the abolition of the religious orders in 1834, created in it a curious emptiness. Not being part of the aesthetic universe of secular society or of its elites, painting found itself an orphan without any obvious use. The immediate consequence of this state of affairs was the complete disappearance of regional schools of painting, which had flourished during the sixteenth and seventeenth centuries.

There no longer exist in Portugal any significant examples of mural or easel painting of the Romanesque period. The art of this time is known to us principally through works in the fields of miniature painting and manuscript illumination produced at the principal monasteries (Santa Cruz in Coimbra, Santa Maria in Lorvão, Santa Maria in Alcobaça, and São Vicente de Fora in Lisbon). An example of this type of art is the *Lorvão Apocalypse* (1189), which forms part of the tradition of book adornment that was derived from the late-eighth-century Spanish commentary on the Apocalypse illustrated by the Beatus of Liébana. Very recently, decorations and frescoes of the fifteenth century were discovered in Leiria, and are presently being conserved and studied. There are a few fragments of mural paintings from the mid-sixteenth century, such as those in Braga Cathedral.

Fifteenth and Sixteenth Centuries

Many of the paintings of the fifteenth and sixteenth centuries were diptychs, triptychs, or polyptychs made for retables, a great number of which have since been dismantled, their panels dispersed or lost. These paintings were conceived as part of narrative or symbolic programs for specific settings, which are impossible to re-create. The conditions in which these works are viewed today, so totally different from those in which they were originally conceived, affect our understanding of their original meanings. Then, painting was still completely dependent on the medieval system of rights, where, especially during the fifteenth to the first half of the sixteenth centuries, anonymous work was the norm.

The fifteenth century was dominated by the rather mysterious character of Nuno Gonçalves (active 1450-92), a court painter to Dom Afonso V (reigned 1438-81).[2] Based on a statement made by Francisco

de Holanda in 1548 and reported by José de Figueiredo in 1910,[3] it seems likely that Gonçalves is the artist of the panels of *Saint Vincent* (c. 1470-80, [**fig. 1**]), which were the object of unceasing polemic and interpretation from the time of their discovery at the end of the nineteenth century. The six paintings were part of the famous retable of the Church of São Vicente de Fora in Lisbon, a grand work dedicated to the glory of the patron saint of Lisbon. The retable also included other paintings, sculptures, a statue of the saint, and a tomb with his remains. It was dismantled at the end of the seventeenth century, and many of its elements, as well as the sense of its original organization, were lost. The six remaining panels, which are in the collection of the Museu Nacional de Arte Antiga, Lisbon (there are those who also attribute other works in the museum to the same painter), may be considered to be the most important Portuguese paintings of all time, due to the extraordinary and precocious mastery of the use of oil paint, the quality of the brush stroke, the aesthetic treatment, the unity of the composition of the whole series, and, above all, the extraordinary individualized portraits, which represent with exemplary dignity and acute perception the different types found in Portuguese society.

The artist of this grandiose and solemn work of art, unique in its rather crude humanism within the panorama of European painting of the 1500s, was an original painter with a strong personality that can only be explained by his having been an apprentice in Flanders. It is difficult to imagine that Portuguese painting might produce another work of this quality and depth, in perfect harmony with an aristocracy imbued with a strong mission and conscious of its historical perspective. Yet the quality of this work necessarily implies the existence in Lisbon of an artistic milieu with a solid tradition. Unfortunately, no other examples of this tradition have survived. Gonçalves seems therefore strangely isolated in his time.

Sculptural production in the fifteenth century was concentrated in Coimbra and Batalha. The works produced there are in malleable white polychromed limestone. The greatest masters of this period, Gil Eanes, João Afonso, and Diogo Pires-o-Velho (active until 1513), created many works on themes related to the Virgin Mary. Around 1500, wood sculpture in the form of altarpieces and choir stalls were being made in Flanders, and this had a considerable effect on Portuguese art. The most spectacular Portuguese example of this type of work is the late-Gothic retable of the Old Cathedral in Coimbra, made between 1498 and 1508 by two Flemish artists known as Olivier de Gand and João D'Ypres. The retable of Funchal Cathedral in Madeira, which combines sculpture and painting, is one of the few examples of its type to have survived. The most important sculptor of the early sixteenth century was Diogo Pires-o-Moço (active 1491-1530), who designed the tomb of Diogo

2 On this artist, see *Nuno Gonçalves. Novos Documentos*, Lisbon, Instituto Português dos Museus, 1994.

3 José de Figueiredo, *Quatro diálogos da pintura antiga*, ed. Joaquim de Vasconcellos, Porto, 1918, p. 91.

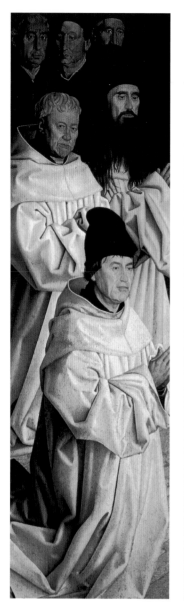
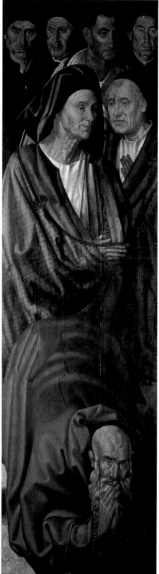
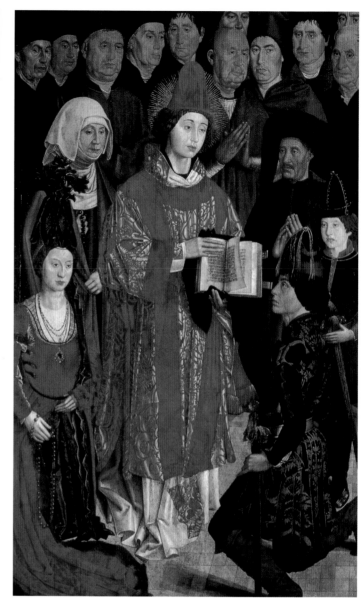

[fig. 1] NUNO GONÇALVES | **Panels of Saint Vincent** | c. 1470-80. *Museu Nacional de Arte Antiga, Lisbon.*

de Azambuja in the Church of Nossa Senhora dos Anjos, Montemor-o-Velho, in approximately 1518. Funerary art is an old tradition in Portugal, and probably constitutes the majority of the sculpture of this period.

From the beginning of the sixteenth century, the riches resulting from commerce with the Orient accounted for a massive influx into Portugal of Flemish paintings by Hans Memling, Quentin Metsys, and others. A number of Northern European masters, accompanied by their assistants, arrived in the country at the same time. It is very probable that Portuguese painters were trained in the workshops established by these artists. As a result, Portuguese painting in the first half of the sixteenth century must be referred to as Luso-Flemish. Aside from the workshops in the capital, which were the most important and cosmopolitan, major regional

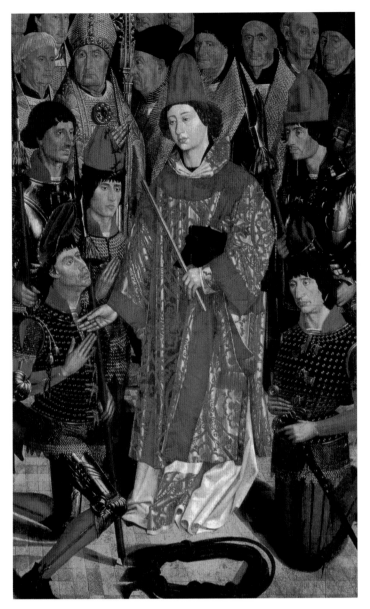

artistic centers were located in Viseu, Évora, and Coimbra. The studios were invariably organized as partnerships, an enterprise that does not allow us easily to identify individual artists of specific works.

The most important painter from Lisbon in the first half of the sixteenth century is known as the Master of 1515, who may be identified, presumably, as Jorge Afonso (c. 1470-1540), a court painter to Dom Manuel I and Dom João III. He was the artist of three important series of paintings: for the Convent of Cristo in Tomar (c. 1520-30), the Church of Jesus in Setúbal (c. 1520-30), and the Convent of Madre de Deus in Lisbon (c. 1515). *Adoration of the Magi* [**fig. 2**], the retable with Franciscan themes at the Convent of Jesus in Setúbal, is one of this artist's most distinguished works. In addition to its Northern or Germanic elements (such as the landscape and architectural ruins), one can identify some

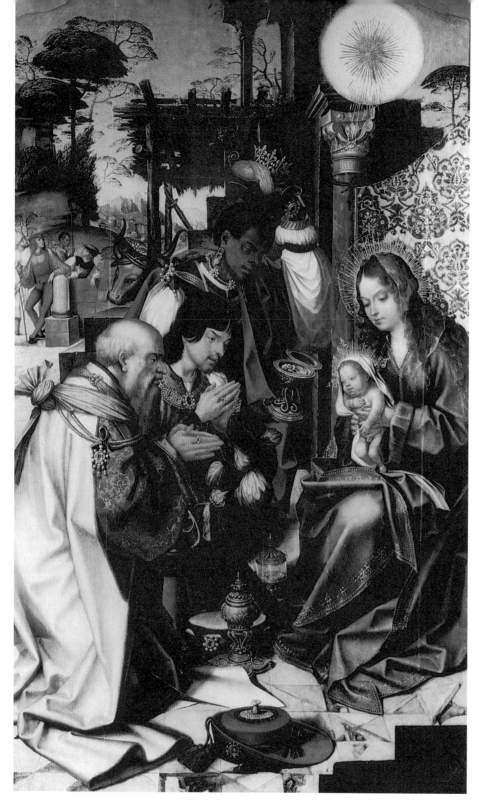

[fig. 2] Attributed to JORGE AFONSO | **Adoration of the Magi** | c. 1520-30. *Museu Municipal, Setúbal.*

4 See Dalila Rodrigues, ed., *Grão Vasco e a Pintura Européia do Renascimento*, Lisbon, National Commission for the Commemoration of Portuguese Discoveries, 1992.

Venetian characteristics (as in the group of young people on the right). The Magi are diagonally aligned in front of the Virgin and Jesus, and are presenting them with resplendent gilt offerings. It is impor-

tant to note the execution of the details of the clothing, jewels, and gold artifacts, as well as the group in the background, including a person with a turban who is positioned beside a column in a pose of natural elegance.

Francisco Henriques (died 1518), who headed an important workshop, which produced the paintings for the Church of São Francisco in Évora, was most likely of Flemish origin. The painter known as the Master of Lourinhã (active 1510-40), artist of the retable of Funchal Cathedral (c. 1515, still in situ) and the outstanding painter Frei Carlos (active 1517-40) were also probably from Flanders.

The most important figure in Portuguese painting of the first part of the sixteenth century is Vasco Fernandes, known as Grão Vasco (c. 1475-1543), who, for more than four decades, had an important and influential workshop in Viseu.[4] Until the 1530s, he remained faithful to the Flemish style, but developed a more Italianate style after a stay in Coimbra from 1530 to 1535, during which he absorbed the humanistic influences that surrounded Dom Miguel e Silva, Bishop of Viseu.

Grão Vasco worked on the now-dispersed retable of Viseu Cathedral (1501-06), a somewhat eclectic work that was the result of the collective efforts of several artists. He was also the sole painter of the Lamego Cathedral retable (1506-11). In the *Adoration of the Magi* of the Viseu retable, a Brazilian Indian represents

Balthazar, who was conventionally depicted as a black African; this is probably the first image of an individual indigenous to the New World in European painting. The Lamego retable (of which five panels survive from the original group of twenty) represents a major step forward in Grão Vasco's grasp of "modern" pictorial techniques. Each painting is carefully composed, the color, light, proportions, and volume of the human forms creating a harmonic whole. These characteristics are especially noticeable in one of the best works of the series, *Creation of the Animals* (which includes the mythic unicorn, a symbol of the Virgin Mary), a perfect composition in contrasting whites and reds. *Annunciation* [**fig. 3**], which shows a remarkable understanding of the spatial relationships between human figures and objects, is based on the traditional typology of the continuity between Old and New Testaments, a doctrine made popular in the time of Grão Vasco by, among other things, the etchings of the preachers' manual known as the *Biblia Pauperum*. This relationship is evident in the series of "paintings within paintings" above the background wall (including a small triptych, medallions, and the panel above the Virgin Mary) that contain stories from the Old Testament. The Virgin is depicted as representing the New Covenant, as proclaimed in the Old Testament. The painting emphasizes her purity (the fountain, the closed garden) and associates her with the symbols of the Trinity (represented by

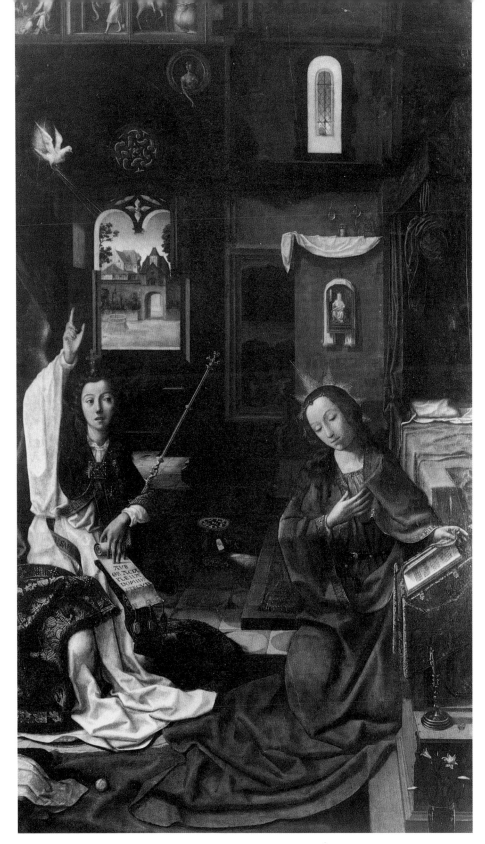

the three seals hanging from the parchment with the angelical salute). The unlit candle on the lower right indicates that

[fig. 3] Vasco Fernandes [Grão Vasco] | **Annunciation** | 1506-11. *Museu Lamego.*

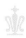

the Word of God has not yet been incarnated in Mary, and therefore refers to the Annunciation and not the event that immediately follows, the Incarnation.[5] Also noteworthy is the typically Portuguese clay oven that appears in the painting; representing an urge to nationalize or domesticate the Holy Mystery, the clay oven was depicted extensively over the following two centuries. Grão Vasco was a pioneer in signing his works (on one occasion using the Latin form of his name), a rare example of the modern consciousness of individual creation. The example of his art that bears the greatest Italian influence is the monumental *Saint Peter* (c. 1530-35), in Viseu Cathedral. Saint Peter, sitting in a pontifical chair under a canopy, occupies the geometric center of the composition, which is rigorously structured along the lines of a Roman style of architecture.

There were three prominent painters in Lisbon after the second decade of the sixteenth century: Cristóvão de Figueiredo (active 1515-43), Gregório Lopes (c. 1490-1550), and Garcia Fernandes (active 1514-c. 1565). Figueiredo painted *Exaltation of the Holy Cross* (1522-30) in the retable of the Monastery of Santa Cruz in Coimbra, which is characterized by a modern aesthetic concept of Italian inspiration. In his *Deposition* (c. 1530), two remarkable portraits (perhaps of the donors) indicate a naturalistic tradition of observation that might suggest the work of Gonçalves. Lopes, Jorge Afonso's son-in-law and also a court painter to Dom Manuel I and Dom

João III, was responsible for important paintings for the Convent of Cristo in Tomar (1536, in situ and in the collection of the Museu Nacional de Arte Antiga, Lisbon), in which the influence of the Antwerp Romanists can be seen. Fernandes, Francisco Henriques's son-in-law, executed the retable of *Saint Catherine* (c. 1539) for Goa Cathedral in India and the retable of the *Holy Trinity* (c. 1540, now in the collection of the Museu de Arte Antiga, Lisbon) for the Convent of the Trinidade in Lisbon.

Francisco de Holanda (1517-1574), architect, painter, illuminator, and, above all, theorist, marks the chronological break with the Netherlandish Gothic tradition in Portuguese art. He contributed greatly to consolidating the aesthetic and philosophical values of the Italian Renaissance in Portugal.[6] While in Rome between 1538 and 1540, Holanda associated with Vittoria Collona, Michelangelo, and Giulio Clovio. He is the author of an important theoretical and historical treatise filled with illustrations, in which he proclaims the theories of Italian Mannerism of the second half of the century. According to Sylvie Deswarte, Holanda is "the missing link in art theory between the Platonic illusions of Gauricus, Pacioli, and Castiglione of the first quarter of the sixteenth century and the metaphysics of late Mannerism." Holanda's work, however, did not have great impact in Portugal. (His treatise on Mannerism remained unpublished in his time.) The official adhesion to the Coun-

5 On the iconography of the Annunciation/Incarnation, see Luís de Moura Sobral, *Do Sentido das Imagens*, Lisbon, 1996, pp. 119-30.

6 See the collected essays of Sylvie Deswarte in *Ideias e Imagens de Portugal na Época dos Descobrimentos. Francisco de Holanda e a Teoria da Arte*, Lisbon, 1992.

ter-Reformation, which defended other values and other mental attitudes, radically distanced those who proposed or defended an art based upon Neoplatonic humanism.

Nonetheless, the concept of "progress," with painting viewed as an intellectual activity, began slowly to permeate Portuguese society, as an official document of 1577 by the painter Diogo Teixeira (c. 1540-1612) suggests. Proud of their practice of a "liberal" art, various painters expressed their disapproval, individually or collectively, of their categorization as "craftsmen" by the fiscal system. They considered this as unjust and a hinderance to their access to certain social dignities. As a result of this movement, the brotherhood called Irmandade de São Lucas was founded at the Church of the Anunciada in Lisbon in 1602. Consisting of painters and other "artists of drawing," its objective was to provide mutual assistance and support.[7]

After 1560, Portuguese painting incorporated some of the formal elements of Mannerism. This influence was conditioned by the spiritual and ideological restructuring promoted by the Counter-Reformation. In mid-century, various Portuguese painters went to study in Rome.[8] Other artists became acquainted with *maniera* through their study of works in the Escorial (the monastery and palace near Madrid) or through the art of the Romanists of Seville. The first ceiling paintings to use perspective (all of which have been lost) dated from the latter third of the century.

The painter who best portrays the transition in mid-century from a Flemish tradition to the new Italian manner is Diogo de Contreiras (active 1521-65), who has only recently been identified.[9] His best work, *Crucifixion* (c. 1545-50) at Sobral de Monte Agraço, is painted in shades of red, purple, and green, contrasting the sensuality of female forms with the emaciated and dramatic body of Christ on the cross. António Campelo (active 1560-80) worked in Rome in mid-century before returning to Portugal at the height of the Counter-Reformation. It appears that he benefited from the support of the princess Dona Maria, daughter of Dom Manuel I, painting a chapel-shrine, Santa Casa da Misericórdia in Torres Novas, for a family of her acquaintance. It is one of the best paintings in the Portuguese Mannerist style with an Italian influence. In its power and refined poses, the *Adoration of the Shepherds* (c. 1570, [**fig. 4**]) at Torres Novas is probably the most Michelangelesque of all works of the period, although the painter opted for a dramatic chiaroscuro. The scene is depicted in a building with a central opening and a dome, with the annunciation to the shepherds taking place in the background. The clearly visible stones upon which the Christ Child is resting anticipate the Stone of Unction, an iconographic reference that Campelo certainly absorbed in Italy.

7 See Vitor Serrão, *O Maneirismo e o Estatuto Social dos Pintores Portugueses*, Lisbon, 1983. A similar phenomenon in Spain has been studied by Julián Gállego, in *El pintor de artesano a artista*, Granada, 1976.

8 Vitor Serrão, ed., *A Pintura Maneirismo em Portugal. Arte no Tempo de Camões*, Lisbon, 1995.

9 Previously, his work had been grouped under the designation of "Master of São Quintino"; see Joaquim Oliveira Caetano, "A identificação de um pintor (Diogo de Contreiras)," *Oceanos* 13 (1993), pp. 112-18.

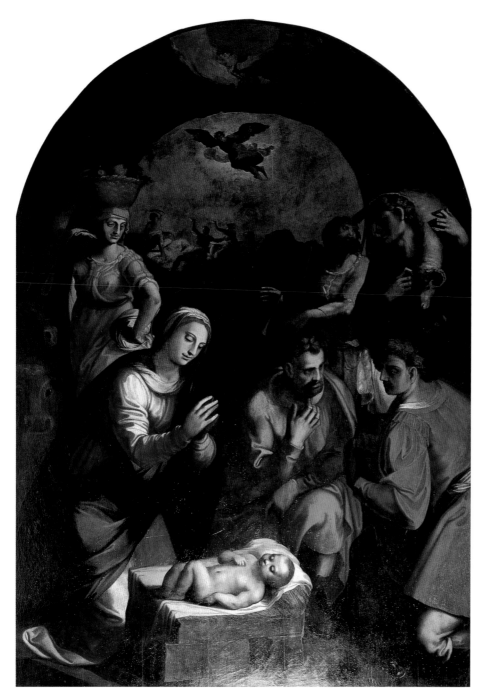

[fig. 4] ANTÓNIO CAMPELO | **Adoration of the Shepherds** | c. 1570. *Santa Casa da Misericórdia, Torres Novas.*

10 Regarding Moro in Portugal, see Annemarie Jordan-Gschwend, *Retrato de Corte em Portugal. O legado de António Moro*, Lisbon, 1994.

left. Cristóvão de Morais (active 1552-72) is most likely the artist of the portrait of the ill-fated king Dom Sebastião in the collection of the Museu Nacional de Arte Antiga, Lisbon. The king is shown in three-quarter profile, and the style of his breastplate and the general typology of the image place it in the tradition of portraiture of the Austrian Hapsburg court. It was probably part of a collection, in Madrid, Austria, or Hungary, for the glorification of the dynasty of the Spanish king Carlos V, alongside portraits of the other grandchildren. Cristóvão Lopes (c. 1516-c. 1570) is the presumed artist of the portraits of Dona Maria and Dom João III (based on prototypes by Antonio Moro[10]) at the Church of Madre de Deus in Lisbon.

Four of the oil paintings of the retable of the Church of Nossa Senhora da Luz de Carnide in Lisbon (c. 1590), three of which are signed, are by Francisco Venegas (active 1582-94), who also painted the ceiling of the Church of São Roque in Lisbon (c. 1574-90), one of the few examples from that period to have survived. The other four paintings of the Luz de Carnide retable, the most important Mannerist retable still in situ, were made by Teixeira. The main center panel, *Allegory of the Immaculate Conception*, shows a partially nude Eve. Venegas returned to this theme, a very unusual one in Portuguese painting, with the astonishing and recently discovered *Penitent Magdalene* (c. 1590) at the Church of Nossa Senhora de Graça in Lisbon. Fernão Gomes (1548-1612), originally from

Gaspar Dias (active 1560-91) also spent time in Italy, returning to Portugal around 1560. His *Angel Appearing to Saint Roch* (1584) is a splendid composition, characterized by precise drawing and acidic colors, with contrasting spaces, exaggerated postures and gestures, and an elegant touch provided by the image of the dog on the

the Spanish region of Estremadura, arrived in Portugal in 1570, the same year in which he painted a portrait of the poet Luís de Camões, a work now known only through copies. His *Annunciation* (c. 1594, [**fig. 5**]) in Lisbon's Monastery of Jerónimos depicts the Archangel in adoration of the unborn Christ, the Word of God incarnate in Mary's womb. This is indicated by the inscription on the rays of light that issue from the emblem of the Trinity (*verbum caro factum est*, John 1: 14), the flame of the oil lamp in the center of the composition, and the Archangel's respectful position. This is among the most representative Portuguese paintings of the Counter-Reformation relating to the cult of the Eucharist, which acquired great importance from that moment on.

In addition to the four wooden panels he painted for the Luz de Carnide retable, Teixeira also produced the retable of Arouca Monastery (1595-97). This work anticipates naturalism in its contrasting luminosity, so typical of the period, as well as in its echoes of the art of the Spanish painter Luis de Morales. Amaro do Vale (c. 1560-1619) worked at a time when painting on canvas was becoming more common. Appointed as a court painter in 1612, Vale also veered toward naturalism, the limits of which had been exhausted by the painters of the Escorial, where Vale worked around 1590. The most important work of Simão Rodrigues (1560-1629) dates from the beginning of the seventeenth century: the retable of the high altar of Leiria Cathedral (1605-06) and paintings for the Monastery of Santa Cruz in Coimbra (1611). He also painted the retable of the chapel of the University of Coimbra (1612-13) together with Domingos Vieira Serrão (1570-1632). This latter artist, who was

[fig. 5] Fernão Gomes | **Annunciation** | c. 1594. *Monastery of Jerónimos, Lisbon.*

responsible for the fresco paintings in the Charola dos Templários in Tomar, ended the cycle of the great Mannerist painters who employed a naturalistic mode of expression, anticipating the painting of the following century.

The influence of the Italian Renaissance on Portuguese sculpture can be seen in the shapes, proportions, and decorative vocabulary of the work of the early years of the sixteenth century. This influence became more pronounced with the arrival in Portugal of the French sculptor Nicolau de Chanterêne (active 1517-51), who was inspired by Italianate modes. Chanterêne produced the beautiful western portal of the Church of Santa Maria de Belém in Lisbon (1517), which features statues of the donors, Dom Manuel I and Dona Maria, beside those of Saints Jerome and John the Baptist. Chanterêne also worked in Évora and Coimbra, using local marble, and in Sintra, where he created one of the most important works of the Portuguese Renaissance, the retable of the Chapel of Nossa Senhora da Pena (1529-32). Other French sculptors also worked in Coimbra, the most important and mysterious of whom was Filipe Hodart, the creator of an extraordinary *Last Supper* in terracotta (1530-34), and João de Ruão (active 1526-80), the most famous and prolific, whose large-scale works are found in many parts of central Portugal. Sculpture in the sixteenth century was fundamentally associated with architecture, and frequently sculptors were also – or predominantly – known as architects.

Seventeenth and Eighteenth Centuries

The liturgical reforms of the Counter-Reformation had immediate consequences on the artistic organization of church interiors. High altars were invariably dedicated to the Eucharist, and the retable structure was progressively abandoned. This led to the creation, at the end of the seventeenth century, of a type of wooden altar that became known as the "national" altar. It featured Solomonic columns, rounded arches, and a large central niche to accommodate a monumental Eucharistic throne. The altar could, as a result, accommodate a painting (often immovable), and canvases could also occupy positions on the side walls of the main chapel, in the naves, and sometimes also on the ceiling. The narrative and symbolic functions of the painting cycles were modified; their reading became predominantly linear – as the unfolding of a narrative series – rather than ascending vertically, as was the case with retables.

At the same time, there was an increase in works of carved, polychromed, and gilt wood. By 1700, these sculptures often attained monumental proportions, sometimes covering the interior of churches, suggesting an obsessive urge to symbolically reconstruct the mythic temple of Jerusalem described in the Book of Kings.

Painting of the Baroque period, which still exists in great number and is often

found in situ, has received relatively little scholarly attention.[11] As a result of a centralizing movement typical of the time, the most important painters and workshops were found in Lisbon. During the initial Baroque period, which extended beyond the first half of the seventeenth century, Portuguese painting was influenced by artists from Madrid and Seville, resulting in a naturalistic and tenebrist art that is something of a synthesis of the work of the court painters of Madrid, the piety of Francisco de Zurbarán, and the pleasant aspects of the art of Bartolomé Esteban Murillo. However, toward the end of the century, Bento Coelho da Silveira (c. 1620-1708) began experimenting with an aesthetic that tended to diminish the importance of drawing and form, giving a privileged place to color.

The two most important painters of the first half of the seventeenth century were André Reinoso (active 1610-40) and José de Avelar Rebelo (active 1630-57). Reinoso was responsible for many works, among them a group of nineteen small canvases depicting scenes from the life of Saint Francis Xavier (1619).[12] These paintings are essential to the study of the iconography of the Jesuit saint. They contain numerous small figures defined by precise and confident brush strokes, and suggest a detailed and delicate art reminiscent of the contemporary paintings of those specialists in small formats from Antwerp. Rebelo, who executed a somewhat harsh portrait of Dom João IV, was also the painter of *Christ among the Doctors* (c. 1635, [**fig. 6**]), an architecturally structured composition, and probably also of *Martyrdom of Saint Bartholomew* in the Church of São Pedro in Palmela, a work inspired by the art of Jusepe de Ribera.

Marcos da Cruz (died 1683) was greatly praised by the writers of the eighteenth century, although only a dozen of his scenes of the life of the Virgin Mary painted for a religious institution in Vila Viçosa were known. He is considered the most important Portuguese naturalistic painter. The recent discovery of the Franciscan series of the Chapel of the Third Order of Jesus in Lisbon, documented in 1673-74,[13] allows us to attribute to him important paintings from various other religious institutions. Among them are the tenebrist canvases on the ceiling of the choir of the Church of Madre de Deus in Lisbon (see [**fig. 7**]), which had been tentatively attributed to Avelar Rebelo. These paintings show a firmness of stroke unparalleled at that time. Marcos da Cruz established a connection between the two halves of the seventeenth century, extending the tenebrist style (which he passed on to his followers) to the end of the 1600s.

Outside Lisbon, the most interesting artists were found in Óbidos, a small walled town near the coast, a few dozen kilometers from the capital. Baltazar Gomes Figueira (1597-1674) is a painter whose importance has only recently come to be understood. In the retable for the Church of Nossa Senhora de Graça in Coimbra

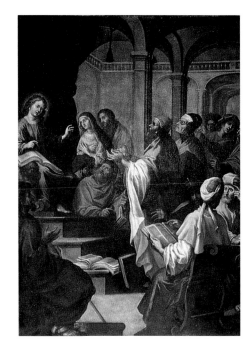

[fig. 6] JOSÉ DE AVELAR REBELO | **Christ among the Doctors** | c. 1635. *Church of São Roque, Lisbon.*

[11] See José Fernandes Pereira and Paulo Pereira, eds., *Dicionário de Arte Barroca em Portugal*, Lisbon, 1989, and Jay Levenson, ed., *The Age of the Baroque in Portugal*, exh. cat., The National Gallery of Art, Washington D.C., Yale University Press, New Haven and London, 1993.

[12] See Vitor Serrão, *A Lenda de S. Francisco Xavier pelo Pintor André Reinoso*, Lisbon, 1993.

[13] *Despesa Geral da Orgem desde o ano de 1675- te 1693*, Archives of the Chapel of the Ordem Terceira de Jesus, fol. 1.

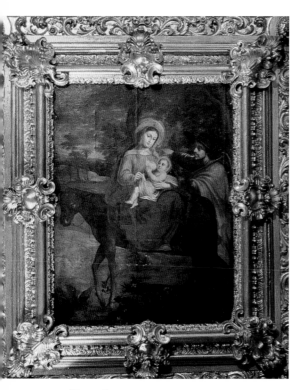

[fig. 7] MARCOS DA CRUZ | **Flight into Egypt** | c. 1650-60. *Church of Madre de Deus, Lisbon.*

14 See Vitor Serrão, ed., *Josefa de Óbidos e o Tempo Barroco*, exh. cat., Instituto Português do Patrimônio Arquitectónico, Lisbon, 1991; *The Sacred and the Profane: Josefa de Óbidos of Portugal*, exh. cat., National Museum of the Women in Arts, Washington, D.C., 1997; and Edward J. Sullivan, "Josefa de Óbidos and Portuguese Spirituality in the Age of the Baroque," in this publication.

15 See Luís de Moura Sobral, *Pintura e Poesia na Época Barroca. A Homenagem da Academia dos Singulares a Bento Coelho da Silveira*, Lisbon, 1994; Luís de Moura Sobral, *Do Sentido das Imagens*, Lisbon, 1996; and Luís de Moura Sobral, ed., *Bento Coelho da Silveira e a Cultura do seu Tempo*, exh. cat., IPPAR, Lisbon, 1998 (forthcoming).

16 See my comment on the debate in Luís de Moura Sobral and David Booth, eds., *Struggle for Synthesis*, Lisbon, 1997 (forthcoming).

17 See Luís de Moura Sobral, "Da mentira da pintura. A Restauração, Lisboa, Madrid e alguns santos," in Pedro Cardim, ed., *A História: entre Memória e Invenção*, Lisbon, 1997 (forthcoming).

18 Nuno Saldanha, ed., *Joanni V Magnífico. A Pintura em Portugal ao Tempo de D. João V. 1706-1750*, Lisbon, 1994.

(1644), Figueira reveals himself as a true follower of Sevillian naturalism of the first third of the seventeenth century, a style with which he had direct contact. His daughter Josefa de Óbidos (also known as Josefa de Ayala, 1630-1684), who was born in Seville, is the most renowned Portuguese artist of the seventeenth century.[14] An important painter, engraver, and, like her father, still-life painter, she worked for female convents whose spirituality and sensibility she was able to depict in her art.

The last third of the seventeenth century was entirely dominated by Bento Coelho, a prolific artist who was appointed a court painter in 1678. As a member of the Academia dos Singulares, a litereary academy, Coelho was unique among Portuguese painters of that time.[15] The Portuguese Baroque painter par excellence, he produced large decorative works with generous forms and expressive physical characteristics for churches and convents throughout the country. His figures, executed in quick and fluid color, occupy almost the entire canvas, a conception that was certainly inspired by Peter Paul Rubens. Coelho marks the conclusion, at the end of the century, of the Spanish tradition in Portuguese painting. During the last third of the century, he participated in the creation, in collaboration with architects, tile painters, wood carvers, and sculptors, of what can be called "total works of art" of the first phase of the Portuguese Baroque.[16] Examples of this are the Royal Chapel of Lisbon Palace (1666-70), some of the cha-

pels of the Church of São Roque in Lisbon (c. 1690), the antechoir of the Church of Flamengas, Lisbon (c. 1683), and the Church of Comendadeiras da Encarnação, Lisbon (c. 1697, [**fig. 8**]), where Coelho did all of the paintings.

The sixteenth and seventeenth centuries represent a period during which great decorative schemes proliferated. Before the end of the seventeenth century, lavish works were made combining canvas paintings, tile panels, altar statues, and, at times, polychrome marble overlay, all organized with great aesthetic coherence and iconographic unity. The now-lost Royal Chapel of Lisbon Palace was one of the most precocious examples of this all-encompassing vision, which is typical of the Baroque. Consisting of a series of paintings of Portuguese saints, it was the first example in which such hagiographic images were used by the ruling dynasty in Portugal to promote nationalism.[17] In the eighteenth century, representations of Portuguese saints became extremely popular in diverse forms of art, from canvas to tile paintings and in both secular and religious buildings.

At the beginning of the eighteenth century, the Spanish influence in art was replaced by the Italian model, which better suited the political program of Dom João V (reigned 1707-50).[18] There was also growing prestige in the types of compositions based on the work of Rubens and classical French painting, known, as always, through etchings. António de Oliveira Bernardes (c. 1655-1732), the founder of an

important family of specialists in tile painting, produced a significant body of work (only now becoming known) in both mural and canvas painting. His elegant and elongated figures are well drawn, and he established a new relationship with the surrounding space, giving it more importance than the previous generation had. These characteristics distance Oliveira Bernardes's work from the art of Coelho, linking it instead to the styles of painting with an Italian classical-Baroque imprint that followed. Oliveira Bernardes also painted ceilings with *quadri riportati* (which resemble easel pictures attached to the ceiling) framed by exuberant decoration in the Mannerist style, elements that he would later incorporate into his tile technique. His most spectacular work in this vein is the modified Chapel of the Immaculate Conception at the Church of Nossa Senhora das Mercês in Lisbon (1714, [**fig. 9**]), a great masterpiece of total tile decoration.[19] The series includes a group of paintings on Old Testament subjects, which allude to the central theme of the ceiling, and representations of symbols of the Immaculate Conception in the nave area. The altar (where an access door was placed) and the canvases that probably hung on the walls have been lost, but at the time it was created, this setting was a homogeneous artistic work of great aesthetic and doctrinal efficacy. The Virgin of the Immaculate Conception, associated with the return of Portugal's independence from Spain in 1640, took on special his-

torical and devotional meaning in Portugal, and was used by the Brigantine dynasty as a means to further national values. The Virgin of the Immaculate Conception was officially declared the protector of the nation in 1646, when her cult, though extremely popular in all the Peninsula, was still far from being proclaimed an article of faith (which happened only in the nineteenth century).

Other examples of complete tile decoration are found in the Church of São Lourenço in Almansil (the most famous sections were done by Policarpo de Oliveira Bernardes, son of António de Oliveira Bernardes) and in other chapels throughout the country. Tile painting is of great importance in the history of Portuguese art.[20] During the seventeenth and eighteenth centuries, tiles were applied not only to church and monastery walls, but also to the rooms of private palaces and on garden walls. With large production centers

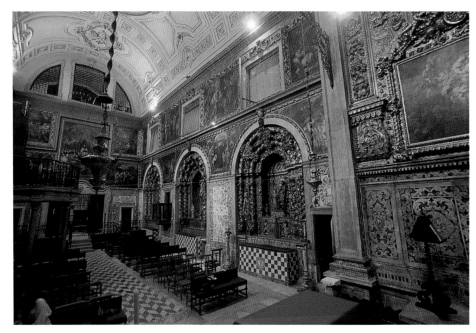

[fig. 8] Bento Coelho da Silveira | **Church of Comendadeiras da Encarnação** | Tk date.

[19] See Luís de Moura Sobral, "*Tota pulchra est amica mea. Simbolismo e narração num programa imaculista de António de Oliveira Bernardes,*" *Azulejo*, 1997 (forthcoming).

[20] See José Meco, *O Azulejo em Portugal*, Lisbon, 1989.

throughout the country, painted tiles were exported to Goa and Brazil, and contributed in creating an aesthetic imprint unique to the Portuguese Baroque.

The legitimate heir to Coelho in the eighteenth century was André Gonçalves (1685-1778).[21] A talented artist, as prolific as his predecessor, André Gonçalves preferred clearly defined shapes contained by firm lines, with figures situated in architectural spaces or exteriors. Painting large-scale works, André Gonçalves allowed his colors to become more open and the tenebrist tones of the 1600s disappeared. His *Last Supper* in the Castro Chapel in the Convent of São Domingos de Benfica in Lisbon, which has never before been associated with the painter, is, nonetheless, a typical work of his style. The composition is strongly influenced by the work of Jacques Nicolai (1605-1783) at Namur Cathedral in Belgium, though Gonçalves added a colonnade and candelabra to the uppermost area.

The best painter of the first half of the eighteenth century was Francisco Vieira de Matos, known as Vieira Lusitano (1699-1783). He studied with Benedetto Luti and Francesco Trevisani in Rome, a city where he enjoyed professional success. A talented painter and engraver, Vieira Lusitano painted the ceilings of various palaces and churches, and left behind numerous works in churches and private collections. Of all Portuguese painters of the eighteenth century, Vieira Lusitano had the most solid academic training. This is displayed in an

almost programmatic manner in the pleasant *Rest on the Flight into Egypt* (1770, [**fig. 10**]), with its symbolic and erudite references. Due to royal commissions for the Mafra Convent-Palace, a great many Italian paintings arrived in Portugal during the first part of the eighteenth century. These works strongly influenced the local aesthetic and the formation of many artists.

Pedro Alexandrino Carvalho (1730-1810), who worked with André Gonçalves and was equally productive, is the last master of the Baroque period of Portuguese painting. Alexandrino was the painter par excellence of the churches that were reconstructed or built in Lisbon following the earthquake of 1755, and created numerous decorative murals in palaces and churches. His figures are distinctive, with elegant heads, large eyes, and fluid lines that accentuate their expressive character. A typical example is his *Last Supper* [**fig. 11**] at the Church of Santa Maria do Castelo in Tavira, which was long considered to be an Italian painting.

The sculpture of the seventeenth and eighteenth centuries emphasized wood, due to a Spanish influence, and, after the second half of the seventeenth century, also terra-cotta. In the eighteenth century, however, there was a return to marble, following the example of the Italian masters who worked in Portugal. Given the importance of wood decoration during this period, distinctions are made between "imagery" (*imaginária* – sculpture of the human figure) and "carvings" (*talha* –

21 See José Alberto Gomes Machado, *André Gonçalves. Pintura do Barroco Português*, Lisbon, 1995.

coverings, decorative sculpture, liturgical furniture, and so on).[22]

The most important nucleus for sculpture in the seventeenth century was the Cistercian Alcobaça Monastery, the site of a prolific workshop. In the monastery's reliquary sanctuary (1669-72, fortunately preserved), the two traditional sculptural techniques can be found in work that covers the entire wall surface of the circular chapel: that of gilt wood in statues of the Virgin, Saint Bernard, Saint Benedict, and Saint Augustine, and that of terracotta in smaller reliquary bust sculptures. More important, however, are the large-scale terra-cotta sculptures at Alcobaça, which created for its artists an important position in the history of Portuguese art. In fact, the various works in the Chapel of the Redeemer and the spectacular retable of the *Death of Saint Bernard* (now in a state of advanced deterioration), which date from the latter third of the seventeenth century, are all in terra-cotta. Aside from Manuel Pereira (1588-1683), who worked in Spain, the most distinguished sculptor of the time was the Benedictine Frei Cipriano da Cruz (c. 1645-1716), who worked in terra-cotta, wood, and stone. His *Vision of Saint Lutgard* (1692-95, [**fig. 12**]) in Tibães Monastery was originally part of a large decorative work, a magnificent composition that symbolically evokes Eucharistic devotion.

At the end of the century, influences from outside the Peninsula once again provided the stimulus for renewal. A series of nine marble sculptures, influenced by the work of Gianlorenzo Bernini, were brought from Rome and placed in the Chapel of São Gonçalo de Amarante in the Convent of São Domingos de Benfica in Lisbon. The Frenchman Claude Laprade (1628-1738) worked in Coimbra and was responsible for the most Baroque of all Portuguese tombs, that of Bishop Dom Manuel de Moura Manuel in the Chapel of Nossa Senhora de Pena in Vista Alegre (1699). The tomb is a huge memento mori, depicting Death between Fortitude and Justice, little angels with a skull and an hourglass, and Time towering above the image of the bishop.

The Italian influence continued in Portuguese sculpture during the last two thirds of the century, when marble sculptures were imported for the Mafra Convent-Palace, the largest undertaking of Dom João V. The convent-palace in effect constituted a school that witnessed the formation of many sculptors. Among them was Joaquim Machado de Castro (1731-1822), who made the equestrian bronze statue of Dom José (1770-75) placed in the Terreiro do Paço in Lisbon. Machado de Castro was also responsible for a Nativity scene with terra-cotta figures for the Basilica of Estrela in Lisbon. This became a popular genre that later achieved great success.

Some astounding works were done in carved wood during this period, such as those in the Convent of Jesus in Aveiro, and also the Churches of Santa Clara in

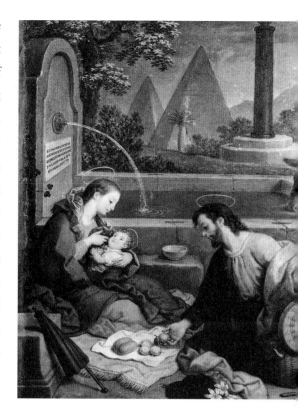

[fig. 10] Francisco Vieira de Matos [Vieira Lusitano] | **Rest on the Flight into Egypt** | 1770. *Museu Nacional de Arte Antiga, Lisbon.*

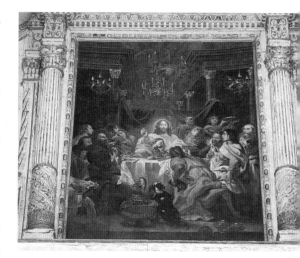

[fig. 11] Pedro Alexandrino Carvalho | **Last Supper** | TK date. *Church of Santa Maria do Castelo, Tavira.*

22 Aside from the classic study by Robert C. Smith, *A Talha em Portugal*, Lisbon, 1963, see Natália Marinho Ferreira Alves, *A Arte da Talha no Porto na época barroca*, Porto, 1989, and her *A Apoteose do Barroco nas igrejas dos conventos femininos portuenses*, Porto, 1992.

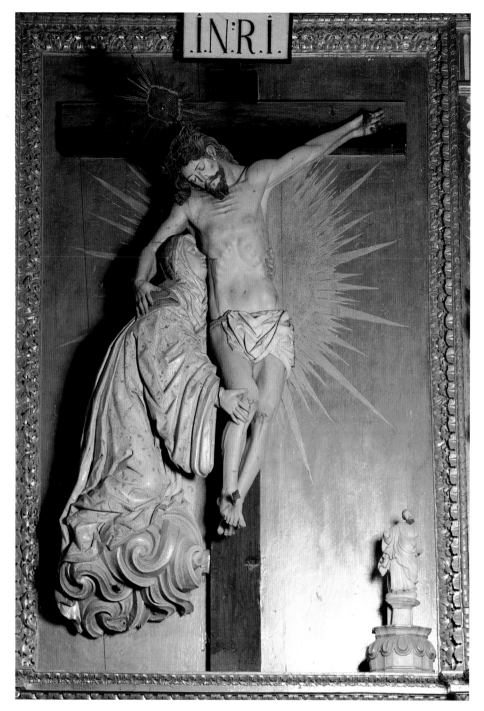

[fig. 12] FREI CIPRIANO DA CRUZ | **Vision of Saint Lutgard** | 1692-95. *Tibães Monastery, Tibães.*

city where the most spectacular open-air Baroque-style sanctuary in Europe is located, at the Church of Bom Jesus do Monte. The sanctuary includes an impressive group of isolated ornamental sculptures. Only the hard local granite from which they are carved prevents the sanctuary from being entirely Rococo.

From the nineteenth century on, sculpture, like painting, became secularized and followed the various international artistic movements. Increasingly, artists had academic training, often outside Portugal, and worked for the civil sector. Relatively few sculptural depictions of the Virgin Mary were produced in Portuguese art after this time.

Nineteenth Century

The dissolution of the religious orders in 1834 marked the end of the predominance of religious subject matter in Portuguese art.[23] Academies of fine arts were formed in Lisbon and Porto from the spoils of the convents (which also later supplied the core of the collections of Portugal's various national museums). The artistic life of the country was thus rapidly concentrated in its two main cities, and as a result, what remained of the old regional artistic centers disappeared almost immediately.

Francisco Vieira, known as Vieira Portuense (1765-1805), who was born in Porto, set the change from Neoclassicism to Romanticism. His most important work, *Filipa de Vilhena Presenting Arms to Her Sons* (1801), deals with a national theme, the Restoration of 1640. Named first

Porto and Santo António in Lagos, in which the Solomonic dream of a temple of gold seems actually to have been realized. It is also necessary to mention the work of André Soares and José de Santo Antonio Vilaça, both great masters of wood carving and both from the region of Braga, the

23 See the classic study on art in the nineteenth century by José-Augusto França, *A Arte em Portugal no século XIX*, 2 vols., Lisbon, 1967.

painter of the court, he worked at the Ajuda Palace, where he created other historical compositions.

Domingos António de Sequeira (1768-1837) became a renowned artist in Rome, where he lived between 1788 and 1795 and where he won many commissions and competitions.[24] Having enthusiastically supported the Liberal Revolution of 1820, Sequeira found ample opportunity in its wake to exert his talent and display his ideological inclinations, as in his studies for the unrealized painting *Allegory of the Constitution*. The Counter-Revolution of 1823, promoted by Dom Miguel de Bragança, forced Sequeira into exile in Paris. There, at the Salon of 1824, he showed his *Death of Camões* (now lost), for which he was awarded the gold medal. In Rome, where he lived after 1826, Sequeira made his last paintings on religious themes. They are vast compositions with a great lyricism and elements of Romanticism, reminiscent of the work of Rembrandt, Giambattista Tiepolo, and J. M. W. Turner. The trajectory of Sequeira's career, in both pictorial and ideological terms, has often been compared to that of his Spanish contemporary Francisco de Goya.

The most important Portuguese painting in the classical and erudite vein is *Aeneas Rescuing His Father and Anchises from the Fire at Troy* (1843) by António Manuel da Fonseca (1796-1890). A new period in painting was heralded by Tomás José da Anunciação (1818-1879), who inspired his friends to paint in direct contact with nature. He was portrayed as a plein-air painter by João Cristino da Silva (1829-1877) in *Five Artists at Sintra* (1855), a painting that is both a manifesto of artistic aims and a homage to Tomás José da Anunciação. In *Only God* (1856), Francisco Metrass (1825-1861) painted a sublime scene of a mother desperately clutching her child while they are both threatened by a flood.

Silva Porto (1850-1893) and João Marques de Oliveira (1853-1927) returned to Portugal from Paris in 1879, bringing with them the new naturalistic styles learned from the painters of the Barbizon School. Porto, a prolific landscape artist, settled in Lisbon, where, with José Duarte Ramalho Ortigão and other artists, he created the Grupo do Leão. The group's first exhibition took place in 1881. Porto continued to be influential until the beginning of this century. Marques de Oliveira, a professor at the Academia de Belas-Artes, Porto, was also a landscape painter. Some of his paintings (for example, *Beach at Póvoa de Varzim*, 1884) have a more modern aspect that transcends the lessons of the Barbizon artists. Henrique Pousão (1859-1884), who died at the age of twenty-five, left works that exhibit a rare aesthetic sensibility. Fascinated by the light of southern Italy, Pousão painted small and extremely modern canvases, always keenly aware of the interplay between visual values, color, and composition, and in a style with a strong Mediterranean spirit counter to that of the Impressionists.

24 *Domingos António de Sequeira*, exh. cat., Museu Nacional de Arte Antiga, Lisbon, 1996.

 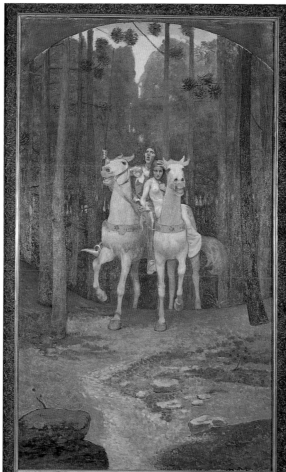

[fig. 13] ANTÓNIO TEIXEIRA CARNEIRO | **Life, Hope, Love, Longing** | 1899-1901. *Fundação Cupertino de Miranda, Famalição.*

José Veloso Salgado (1864-1945), who painted the well-known work *Cupid and Psyche* (1891), was one of the most significant exponents of academic painting, a movement that extended into the twentieth century. José de Brito (1855-1946) displayed a typical fin-de-siècle perversity and ambiguity in his *Martyr of the Inquisition* (1895). *Life, Hope, Love, Longing* (1899-1901, [**fig. 13**]), a triptych by António Teixeira Carneiro (1872-1930), echoes all the characteristics of international Symbolism (including those found in the art of Pierre Puvis de Chavannes and Edvard Munch and in the music of Richard Wagner), painted in the spirit of

the Renascença Portuguesa, a literary and philosophical movement that developed in Porto. Rafael Bordalo Pinheiro (1846-1905) was an illustrator and unrelentingly satirical cartoonist of the personalities and politicians of Portuguese society – especially those of Lisbon – in the second half of the century.

Although their work differs in many ways, José Malhoa (1855-1933) and Columbano Bordalo Pinheiro (1857-1929) are unique in the period that straddles the nineteenth and twentieth centuries, in that they were both unaffected by the artistic movements in Europe, drawing instead on their personal experiences of the Por-

tuguese people. Malhoa, who was of humble origin, studied painting in Lisbon. After 1881, he exhibited his works with the Grupo do Leão. Moving between a Post-Impressionist luminism and a naturalism that he never abandoned, Malhoa created a picturesque and sentimental image of the Portuguese countryside, which corresponded to a specific sensibility and popular experience. In his lifetime, Malhoa became a true figure of national myth. A painter of landscapes, history paintings, and portraits, he was at ease in all genres, yet without question his true vocation lay in realistic depictions of everyday life. *The Drunkards* (1907) and *Fado* (1910, [**fig. 14**]), which contain references to seventeenth-century Spanish painting, are typical of his work. In order to paint *Fado*, the artist searched the working-class neighborhoods of Lisbon for life models, whom he immortalized in his painting in the manner of nineteenth-century naturalism.

Columbano Bordalo Pinheiro, a member of an important family of artists, was the most inspired portrait painter of the last intellectual generation of the nineteenth century. The anguished expressions of his subjects mirror the social and political turmoil of the country at the time. A member of the Grupo do Leão, he was also the painter of the group's "official" portrait. Like all his works, *Grupo do Leão* (1885) exemplifies the artist's keen skills of observation. His *Portrait of Antero de Quental* (1889), a remarkably perceptive

[fig. 14] JOSÉ MALHOA | **Fado** | 1910. *Museu do Chiado/Cidade?, Lisbon.*

painting and a masterpiece of the genre, portends the subject's suicide two years later.

Twentieth Century

Modernist styles of art, which flourished on the international scene from the beginning of the century, developed in Portugal around 1911-13. Only Futurism, however, which was associated with the magazine *Orpheu* (published in two issues in 1915) and its influential contributor, poet Fernando Pessoa, acquired a wide audience.[25] The most active member of the Futurist movement was Santa Rita Pintor (1889-1918), whose only remaining works are

[25] For art in the twentieth century, see José-Augusto França, *A Arte em Portugal no século XX*, Lisbon, 1974.

59

Head (1912), a notable synthesis of Analytic Cubism and Futurist dynamics, and a few collage drawings that were reproduced in the second issue of *Orpheu*. Amadeo de Sousa-Cardoso (1887-1918) had the most compelling personality of the early Portuguese modernists. He discovered Cubism while living in Paris between 1906 and 1914, and his works were exhibited at the Armory Show in New York in 1913 and at Der Sturm gallery in Berlin. Influenced by the Orphist colors of Robert and Sonia Delaunay, Amadeo painted *Composition* (1913, [**fig. 15**]), a work structured in fragments of circles, straight lines, and areas of pure color.

Mário Eloy (1900-1951) and Júlio dos Reis Pereira (1902-1983) opened new horizons for Portuguese painting. Their work is marked by a German Expressionist influence as well as a lyric introspection. Marie Hélène Vieira da Silva (1908-1990) became an outstanding member of the School of Paris after moving to the French capital in 1928. She developed a unique form of abstraction, filled with references to Portugal (especially Lisbon) and to the country's unique tile work. Almada Negreiros (1893-1970) worked on *Orpheu* magazine and had an active literary and artistic life. In the late 1940s, the artist created two important decorative projects at the Gares Marítimas, the port of Lisbon. Embodying elements of the various modernist movements, these works contain a mythic vision of the coastal city, sort of a marine anti-saga portraying the departure of emigrants.

In 1938, Negreiros made ten stained-glass works for the Church of Nossa Senhora de Fátima (built 1934-38), which was designed by the architect Pardal Monteiro. In these works, which were very polemical for their time, Negreiros embraced popular Portuguese religiosity in an attempt to renew religious art in Portugal.

Much of the art of the mid-twentieth century was deeply marked by the Portuguese political environment. The country was controlled at this time by an ultra-conservative dictatorial government with Fascist tendencies. In pre-World War II literature, there were those who defended a realist aesthetic with a Marxist influence. In the visual arts, echoes of Mexican muralism and the work of Brazilian artist Cândido Portinari are evident in harsh neo-realist works from after the war. Júlio Pomar (born 1926) painted the most important and personal work of the movement, *Almoço do troalha* (The Lunch of the Mason) (1947), a departure from the Social Realist orthodoxy.

Surrealism also confronted the official political regime and its artistic taste, but investigated other aesthetic and poetic possibilities. Two veins ran parallel to Portuguese Surrealism: figurative and abstract painting. Cruzeiro Seixas (born 1920), the most important artist of the movement (and still active today), created an elegant, dreamlike figuration.

The Surrealists were responsible for an important break with tradition, after which Portuguese art displayed a taste for adven-

ture and individual experimentation. Ties to international movements were reestablished and a tradition of modernity was reinvented. Until the present day, in fact, Portuguese art has participated in international movements and trends – from lyrical and geometric abstraction and neo-figurative art, to Minimal and Conceptual art including installations, performances, and video.[26]

26 For more recent artists, see Alexandre Melo and João Pinharanda, *Arte Portuguesa Contemporânea*, Lisbon, 1986.

[fig. 15] AMADEO DE SOUSA-CARDOSO | **Composition** | 1913. *Centro de Arte Moderna, Lisbon.*

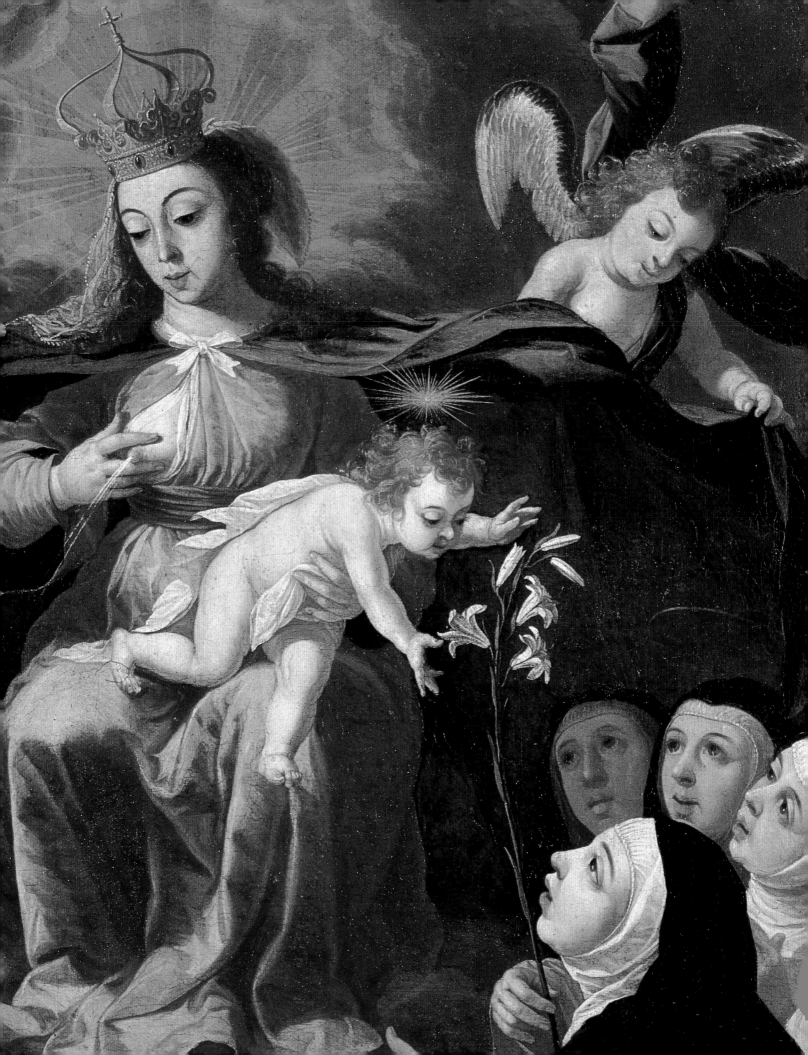

Josefa de Óbidos and Portuguese Spirituality in the Age of the Baroque

Edward J. Sullivan

There are many reasons for the indispensable presence of the work of Josefa de Óbidos (also known as Josefa de Ayala) in this exhibition dedicated to the image of the Virgin Mary in Portuguese art. Principal among them is her development, throughout her career, of Marian subject matter. Josefa (as she is most commonly called in the literature about her work) employed themes of the life of Mary in many of her paintings, depicting her as Mother of Jesus, Intercessor to Christ, Queen of Heaven, Sorrowful Mother, Immaculate Virgin, and, in some of the most intimate and appealing works, as an integral member of the Holy Family. If one of the objectives of *Crowning Glory* is to demonstrate that the Virgin Mary plays a crucial as well as a unique role in the iconography, the spiritual and emotional content, and the national identification of the art of Portugal, the paintings by Josefa in which Mary is the chief protagonist may be considered paradigmatic in the development of this visual and emotional project.

Unlike most Portuguese artists of the seventeenth century, whose careers developed mainly in the capital, Josefa lived and worked in the small provincial town of Óbidos, where, in relative isolation, she produced a substantial body of work in a variety of genres. Her art has often been discussed as a product of the margin rather than the center of pictorial production within the development of the European Baroque. Alfonso Pérez Sánchez, for instance, refers to Josefa's painting as representing "a mixture of insecurity and wisdom."[1] However, recent Portuguese scholarship (especially that of Vitor Serrão and Luís de Moura Sobral) has underscored Josefa's importance in the panorama of painting in that country,[2] while some feminist critics, including Germaine Greer,[3] have discussed her "professionalism."

There is relatively little of a conventional stylistic evolution in Josefa's art. She seems to have arrived at her highly individualized visual vocabulary and her thematic repertoire at a fairly early stage in her career. Much of her work can be characterized as intimate and reflects a particular engagement with female and especially maternal experience. In many of her paintings, she employs ornamental motifs and bright colors, which have led some writers to place her art in the category of the decorative. Yet, based on her capacity as a famous artist of her day and on her position as an unmarried woman not subject to the traditional mores of married life, I believe that Josefa was very much aware of the communicative potential of the elements that she employed in her painting as she implemented them in a highly personal visual idiom.

[1] Alfonso E. Pérez Sánchez, "La mujeres pintoras en España," in Pérez Sánchez, *Actas de las terceras jornadas de investigación interdisciplinaria*, Madrid, 1984; cited in Estrella De Diego, *La mujer y la pintura del XIX español*, Madrid, 1987, p. 204. (All translations are the author's.)

[2] For the most recent bibliography on Josefa, see Vitor Serrão, ed., *Josefa de Óbidos e o Tempo Barroco*, exh. cat., second ed., Instituto Português do Património, Lisbon, 1993. See also *The Sacred and the Profane: Josefa de Óbidos of Portugal*, exh. cat., National Museum of Women in the Arts, Washington, D.C., 1997.

[3] Germaine Greer, *The Obstacle Race*, New York, 1975, p. 235. Brief discussions of the art of Josefa have also appeared in other English-language studies of art by women. See, for example, Nancy G. Heller, *Women Artists*, New York, 1987, p. 48, and Karen Petersen and J. J. Wilson, *Women Artists: Recognition and Reappraisal*, New York, 1976, p. 31.

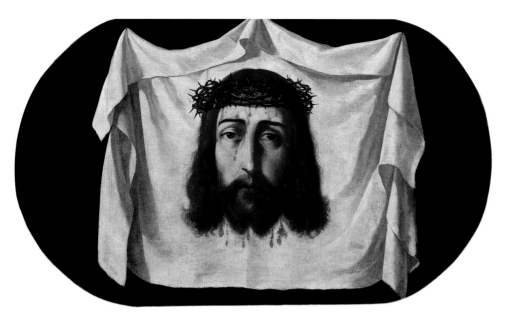

[fig. 1] JOSEFA DE ÓBIDOS | **Veronica's Veil** | 1679.
Santa Casa da Misericórdia, Peniche.

4 Luís Reis-Santos, *Josefa d'Óbidos*, Lisbon, c. 1955, p. 5.

5 Robert C. Smith, *The Art of Portugal: 1500-1800*, New York, 1968, p. 195.

6 It is interesting in this context to note that there has not been a general consensus of opinion as to what constitutes the Portuguese Baroque. Although the term usually refers to the art of the seventeenth century, the Portuguese frame of reference seems to be considerably wider. *The Age of the Baroque in Portugal*, a significant exhibition held at the National Gallery of Art, Washington, D.C., and the San Diego Museum of Art in 1993-94, dealt almost exclusively with art created in the eighteenth century, much of it secular and the majority of it made after the 1755 earthquake in Lisbon. (See the exhibition catalogue, edited by Jay A. Levenson.)

7 See Edward J. Sullivan, "Josefa de Ayala: A Woman Painter of the Portuguese Baroque," *Journal of the Walters Art Gallery* 37 (1978), pp. 22-35; "Obras de Josefa de Ayala, pintora ibérica," *Archivo Español de Arte*, no. 213 (1981), pp. 87-93; and "Herod and Salomé With the Head of John the Baptist," *Source: Notes in the History of Art* 2, no. 1 (1982), pp. 26-29.

8 See, for example, Josefa's paintings on this subject in the collection of the Walters Art Gallery, Baltimore, the Church of the Congregados, Braga, and the Museu Regional, Évora, which seem to have been suggested by similar works by Zurbarán, such as his painting on this theme in the San Diego Museum of Art.

Moura Sobral, in his essay in this publication, refers to Josefa as the most famous Portuguese artist of the seventeenth century. Portuguese Baroque art has received far less critical attention than that of the painting and sculpture of Spain (and of other western European countries) of the same period. In the past, both Portuguese and foreign historians have spoken of the Portuguese Baroque in less than favorable terms; it has been referred to as a period of "frank decadence"[4] and of "pleasant mediocrity."[5] While scholars have recognized the achievements of the well-known artists of the previous two centuries, such as Nuno Gonçalves and Gregório Lopes, the accomplishments of the seventeenth century in the area of the visual arts have been, until recently, considered as something of an afterthought in the development of the artistic panorama of Portugal.[6] In the field of painting, this was a century of intense interaction with Spain. Portugal had lost its independence to its neighboring country in 1580, when its crown was united through inheritance with that of Philip II of Spain, and this relationship lasted until 1640. Although the political circumstances were uneasy, the creative consequences of the increased cultural proximity were fruitful. The attributes of tenebrist painting, with its insistence not only on light and dark contrasts but on the depiction of realistic and even naturalistic figure types, became as characteristic of the Portuguese contribution to Counter-Reformation imagery as the Spanish. Moura Sobral indicates the significance of such artists as André Reinoso, José de Avelar Rebelo, and the previously little known Marcos da Cruz in the development of Baroque painting in Lisbon and elsewhere in Portugal. These artists, as well as Josefa, have a particularly close correlation to their contemporaries in Spain, especially those working in Seville.

Many authors, including myself in previously published articles, have insisted that the source of Josefa's art can be found in the work of the Sevillian master Francisco de Zurbarán.[7] While it is true that some of Josefa's paintings bear remarkable similarities to compositions by Zurbarán – her *Veronica's Veil* (1679, [**fig. 1**]) at Santa Casa da Misericórdia in Peniche, for example, or her paintings on the theme of *Agnus Dei* (Lamb of God)[8] – a more convincing source for the type of naturalistic tenebrist painting that Josefa developed in such a personal way is the work of older Spanish artists, especially

those working in Andalusia at the turn of the seventeenth century.[9] Among the Spanish artists who are likely to have nurtured her creative sensibility (whether directly or indirectly) are Francisco Pacheco, Juan de Roelas, and Juan del Castillo, the artists with whom Josefa's father, the painter Baltazar Gomes Figueira probably had the closest contact.[10]

Josefa was born in Seville in February 1630.[11] Her mother, Catarina Camacho Cabrera Romero, was Spanish and her father, who had come to Seville in 1626, was a native of Óbidos.[12] Her godfather was the Spanish painter Francisco de Herrera the Elder. This fact is an important indication of the closeness of the relationship between Josefa's family and one of the most significant painters of the early Sevillian Baroque. Herrera practiced a starkly realistic mode of painting, with sharp light-and-dark contrasts. He was highly influential among many younger artists, and is likely to have been the first teacher of Diego Velázquez.[13]

The family was forced to flee Seville in 1634, after a lawsuit was brought against Gomes Figueira.[14] Josefa apparently did not accompany them, remaining in Seville (perhaps in the household of her godfather) until the early 1640s.[15] By 1644, she was in Coimbra, living in the Augustinian Convent of Santa Ana. It was here that her artistic career began; her first known work is *Saint Catherine* [**fig. 2**], a print signed and dated "Coimbra, 1646." This work, redolent of the

visual qualities of Peter Paul Rubens, suggests a knowledge of international artistic styles beyond those that Josefa would have observed in the art of her father or of his Sevillian and Portuguese contemporaries. As with so many other artists of the Iberian Peninsula and the Americas in the seventeenth century and later, the extent of Josefa's reliance on prints (Northern European as well as Italian) as a source for compositions or motifs is a question that must be carefully examined, as Moura Sobral has noted.[16]

Recently discovered documents suggest that from the late 1640s on, Josefa's life developed almost exclusively in the small walled city of Óbidos. The relatively large number of commissions that she received for individual paintings as well as for altarpieces for churches in that city and in other parts of the country indicate that her reputation as an artist was solidly established by this time. One of the earliest references

[fig. 2] JOSEFA DE ÓBIDOS | **Saint Catherine** | 1646. *Private collection, Lisbon.*

[9] Vitor Serrão, "Josefa de Ayala, pintora, ou o elogio da inocência," in Serrão, ed., *Josefa de Óbidos*, p. 37.

[10] According to recent research on the art of Josefa, it is certainly her father and her father's connections to contemporary painting in Seville that played the greatest role in the development of her style. Gomes Figueira worked directly with Sevillian artists; for instance, in 1632, he collaborated with Juan del Castillo on an altarpiece for the Church of Santa Ana, Seville. See Serrão, "Josefa de Ayala, pintora, ou o elogio da inocência," in Serrão, ed., *Josefa de Óbidos*, p. 31.

A number of texts, including my "Josefa de Ayala: A Woman Painter of the Portuguese Baroque" (cited above), have erroneously stated the possible impact of a little-known artist, Bernabé de Ayala, in the development of Josefa's art. See Juan Antonio Gaya Nuño, "Zurbarán y los Ayala," *Goya*, January-April 1965, pp. 218-23.

[11] The archival reference to the exact date of the artist's birth was discovered by Antonia de la Torre and published by Serrão in "Josefa de Ayala, pintora, ou o elogio da inocência," in Serrão, ed., *Josefa de Óbidos*, p. 19. Until Serrão's publication, her date of birth was referred to as circa 1630.

[12] Gomes Figueira was married to his wife in 1629. See Serrão, "Josefa de Ayala, pintora, ou o elogio da inocência," in Serrão, ed., *Josefa de Óbidos*, p. 30.

[13] On Herrera the Elder, see Antonio Martínez Ripoll, *Francisco de Herrera "El Viejo,"* Seville, 1978.

[14] See Serrão, "Josefa de Ayala, pintora, ou o elogio da inocência," in Serrão, ed., *Josefa de Óbidos*, p. 31. The unspecified criminal charges, references to which are published by Serrão, contradict the traditional belief that Gomes Figueira and his family returned to Portugal to join the struggle for the liberation of the nation from Spain.

[15] See Serrão, "Josefa de Ayala, pintora, ou o elogio da inocência," in Serrão, ed., *Josefa de Óbidos*, p. 20.

[16] Luís de Moura Sobral, "Josefa d'Óbidos e as gravuras: Problemas de estilo e de iconografia," in Serrão, ed., *Josefa de Óbidos*, pp. 51-69. The impact of Flemish prints on Spanish Baroque art has been treated by, among others, Martin Soria, "Some Flemish Sources of Baroque Painting in Spain," *The Art Bulletin*, no. 30 (1948), pp. 249-59, and no. 31 (1949), pp. 74-75. For a discussion of prints as sources in colonial Baroque art, see Edward J. Sullivan, "European Painting and the Art of the New World Colonies," in Diana Fane, ed., *Converging Cultures: Art and Identity in Spanish America*, New York, 1996, pp. 28-41.

to Josefa in the literature of Portuguese art appears in a manuscript of 1693, in which she is referred to as "the notable painter Josefa."[17] Three years later, Felix da Costa, in *The Antiquity of the Art of Painting*, stated that she was "famous in the nearby regions" and that she "often portrays things in their natural state with much order and propriety."[18]

Perhaps the most revealing early intimation of Josefa's celebrity dates from an eighteenth-century Portuguese chronicle. The author, Damião Froes Perym, states:

Dona Josefa d'Ayala was famous inside and outside the kingdom for her paintings, which were unique in the age in which she flourished.… She practiced perfection in art to the applause of fame and praises for her honesty, living all her life in chaste celibacy. Josefa was visited by many women who frequented the hot springs known as Caldas da Rainha, near Óbidos, to speak with her, to see her paint, or to have their portraits done by her. She was a person of distinction and painted for curiosity's sake. She was favored and sought after for the devotion and respect that she demonstrated in her art.[19]

This description is an indication not only of Josefa's prominence and reputation, but also of the fact that she was considered an important woman, with a certain independence and freedom to contract both secular portrait and religious commissions. As she never married, she was not subject to the traditional dictates of the duties of wife and mother and, unlike many other women artists

of the premodern world, she was never obliged to curtail or terminate her career.

Josefa's fame and popularity certainly indicate an unusual situation for a female professional in the seventeenth century, especially in the context of the Iberian Peninsula. The roster of names associated with painting in Portugal in the Baroque period contains, insofar as I have determined, no other women artists. In Spain, figures such as Dorotea and Margarita Masip, daughters of the painter Vicente Macip, Juana Pacheco, daughter of Francisco Pacheco, and Blanca Ribera, daughter of Jusepe de Ribera, are cited in the histories of Spanish painting, but very few – if any – works by them have survived.[20] The painter Josefa Sánchez and the sculptor Luisa Roldán (daughter of Pedro Roldán) are somewhat better known. Roldán, who became famous for her ceramic group figures, is the female artist of the seventeenth century in Spain whose notoriety most closely approximates that of Josefa. Nonetheless, it is more revealing to consider Josefa in the light of much better known European Baroque painters, such as Artemisia Gentileschi, Elisabetta Sirani, and Livinia Fontana of Italy, Judith Leyster and Clara Peeters of the Netherlands, and Louise Moillon of France. Like Josefa, all of these artists were the daughter, sister, or wife of a well-known painter, and all were recognized for their expertise in their own time. In reviewing the careers of these European women artists in comparison to that of Josefa, it becomes clear

[17] Manuel Barreto da Silva, *Informação que tirei das igrejas de Santa Ma. e S. Pedro da Villa de Óbidos*, 1693, manuscript, Bibliothèque Nationale, Paris; cited in Serrão, ed., *Josefa de Óbidos*, p. 24.

[18] Felix da Costa, *The Antiquity of the Art of Painting*, ed. George Kubler, New Haven, 1967, p. 467.

[19] Damião Froes Perym, *Theatro heroino, abecedario histórico e catalogo das mulheres illustres en armas, letras, accôens heroicas, e artes liberais*, vol. 1, Lisbon, 1743, p. 493.

[20] See De Diego, *La mujer*, pp. 203-06.

that within the context of her time and country, Josefa developed a breadth of subject matter and a reputation that certainly equaled any of theirs. And, within the context of Portuguese art, Josefa's surpasses in prestige and, I believe, in inventiveness that of her male counterparts.

Although Josefa was cited for her portraits in the early literature, as we have seen, only one of these portrait paintings seems to have survived: *Portrait of Fray Faustino das Neves* (c. 1670), in the collection of the Museu Municipal de Óbidos.[21] A rather sober image of the cleric, it falls well within the category of realistic portraiture of the Iberian tradition, embodied by the work of Pacheco and, later, Velázquez. Much better known are Josefa's still-life paintings, of which many examples are extant. A 1676 example in

the Biblioteca Braancamp Freire, Santarém [**fig. 3**] is one of the most elaborate, and it typifies her approach to the painting of inert objects. Representing a plethora of elements, including flowers, candied fruits, biscuits, baskets, and ceramic and pewter vessels, this painting, along with many similar works, bears stylistic affinities to a number of seventeenth-century still-life paintings from Spain, especially those of Juan de Zurbarán (the son of Francisco de Zurbarán) and Pedro de Camprobín, both of Seville, and the Valencian painter Tomás Hiepes. Nonetheless, close comparison of works by Josefa with those by her Spanish contemporaries quickly reveals that the Portuguese artist evolved, within the traditional parameters of the still-life tradition, a distinct language that differentiates her paintings from

[fig. 3] JOSEFA DE ÓBIDOS | **Still Life** | 1676. *Biblioteca Municipal Anselmo Braancamp Freire, Santarém.*

21 See Serrão, ed., *Josefa de Óbidos*, p. 178, for a discussion of other portraits attributed to Josefa.

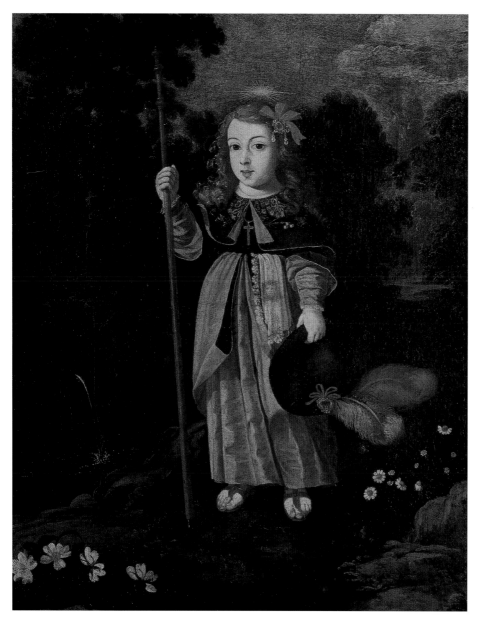

[fig. 4] JOSEFA DE ÓBIDOS | **Christ Child as a Pilgrim** | 1673. *Private collection, Lisbon.*

22 Charles Sterling, *La Nature Morte de l'Antiquité à nos Jours*, Paris, 1952, p. 123.

23 The most recent bibliography on this subject rarely treats the theme of Portuguese still life, focusing, rather, on works produced in Spain. Nonetheless, the discussions in the following volumes are useful, as they may also relate to the still-life compositions of Josefa and her colleagues in Portugal: *Pintura española de bodegones y floreros de 1600 a Goya*, exh. cat., Museo del Prado, Madrid, 1983-84; William B. Jordan, *Spanish Still Life in the Golden Age: 1600-1650*, exh. cat., Kimbell Art Museum, Fort Worth, 1985; and Jordan and Peter Cherry, *Spanish Still Life from Velázquez to Goya*, exh. cat., National Gallery, London, 1995.

rated vessels, small jeweled pins, and other diminutive elements) as a specific strategy to suggest an intimate homeyness is deliberately employed by the artist. It is useful in this context to cite the opinion of Charles Sterling, who associates these works with life in the Portuguese convents, where the confection of sweets and candied fruits was an invariable component of the nuns' activities.[22] Sterling thus suggests the specifically female quality intimated by these and other paintings by Josefa.

Several additional remarks might be made about Josefa's still-life compositions. There has long existed a controversy over the possible iconographic meaning of seventeenth-century Iberian still lifes; some critics have sought to attach complex iconographic connotations to the simplest of images, while others have argued for less symbolically charged readings.[23] In a number of cases, still lifes by Josefa display overt religious symbolism, as in her various versions of the *Lamb of God*. In other examples, however, the artist created her still lifes according to the purely visual, tactile, olfactory, and gustatory potential of the combination of foodstuffs and other elements. The still lifes in which specific religious or allegorical references are absent appear to have been created exclusively to express the sensual characteristics of their components. In at least one notable example, the artist stepped beyond the conventional allusions of still-life painting. *Still Life With Fruit, Meat and Fowl*, signed and dated 1676, displays an uncom-

the generally more sober images of the Spaniards. Some tentative links may also be made between Josefa's works and the Dutch tradition of still-life painting, in which an abundance of food stuffs and luxury table objects are often represented. Yet Josefa's still-life paintings suggest an aura of domesticity that is, in a subtle sense, distinct from that of virtually any of her contemporaries. The use of ornament (which includes the depiction of deco-

mon aspect of Josefa's art.[24] The heads of a pig and a ram as well as the bodies of fowl are shown in particularly prominent positions close to the picture plane. Amidst the flesh of the animals is a profusion of fruits and flowers. Somewhat more arresting is the appearance of a string of sausage as well as the heart, liver, lungs, and windpipe of one of the slaughtered animals whose head lies in the foreground of the composition. Further attention is called to this naturalistic element by the sprigs of flowers inserted into the flesh. Certainly, a work such as this calls into question the numerous references to the artist's "innocence," "sweetness," and homey intimacy. While these traits may indeed be present in some of her work, paintings such as this suggest that Josefa was an artist innately aware of the potential of visual irony, which she created within the confines of an outwardly benign domesticity. Indeed, in more that one instance, we may view Josefa not only as a pious creator of dulcet confections, but as a highly sophisticated crafter of images in which conventional notions of familial or conventual interior sites are subverted to suggest the harsher realities and struggles of earthly existence.

In Josefa's many depictions of Christ, we might also question received opinions regarding the serenity of the artist's world view. In *Flagellated Christ Wearing a Red Mantle* (1670),[25] the fissured and scarred body of Christ speaks more brutally of violence and suffering than most other paintings of the Iberian seventeenth century.[26]

Nonetheless, in the majority of her religious compositions, Josefa's development of a "language of decoration" as a specific expressive element is equally powerful. Christ is seen often as the Child Savior (enframed by a highly ornamental garland of flowers), or as in *Christ Child as a Pilgrim* (1673, [**fig. 4**]), exuding an aura of sweetness and juvenile compliance. There is a doll-like presence to these Christ figures. The ornamentation that characterizes their dress is not unlike that of the highly decorated clothing made for the statues of the Virgin and Child in Portuguese (and Spanish, as well as colonial Latin American) churches during this period.[27] Yet once again, if we delve even slightly beneath the surface of the aura of amiability, we may observe a darker side to Josefa's artistic personality. While in *Christ Child as a Pilgrim*, Christ appears to represent a quintessential innocence, there is, nonetheless, the imprint of his own face just slightly visible on the cloth that hangs from his waist (a Veronica's Veil image), a prefiguration of his Passion and Crucifixion. Death and suffering are equally present in the painting's charmed landscape: *et in arcadia ego.*

In Josefa's depictions of the saints, males rarely appear by themselves and female saints predominate. Certain saints, such as Saint Catherine, appear in more than one work. The subject of her first known engraving, Saint Catherine appears in several images of the Mystic Marriage, including a delicate work on copper of circa 1647

[24] This painting is reproduced in Serrão, ed., *Josefa de Óbidos*, p. 202.

[25] See *The Sacred and the Profane*, pp. 130-31.

[26] Indeed, the direct brutality shown here has more in common with the painfully violent images of Christ's suffering and death produced in the New World, especially in Mexico, in the seventeenth and eighteenth centuries.

[27] In this regard, it is significant to note that the various images depicting either the Savior or Saint John the Baptist standing on plinths and surrounded by garlands of flowers are, in effect, what could be termed "statue paintings," or depictions of the type of wood and ivory sculptures of the Christ Child and saints that were popular in the Iberian Peninsula as well as in the New World colonies during the Baroque period. Such depictions of devotional sculpture became well accepted in colonial art (especially in the Viceroyalty of Peru), to express a particularly potent brand of popular devotion. Josefa appears to have been approximating this tradition in her paintings, which, in their subject matter, are consciously aligned with what might be termed "provincial" rather than "mainstream" modes. It is my contention that Josefa was fully aware of her autonomy to depict the subjects that she wished to paint in her own distinct manner. This artistic "sovereignty" was gained, in part, by the fact that she was an independent – and successful – woman artist and therefore by definition at the margin of the conventional restrictions of representation.

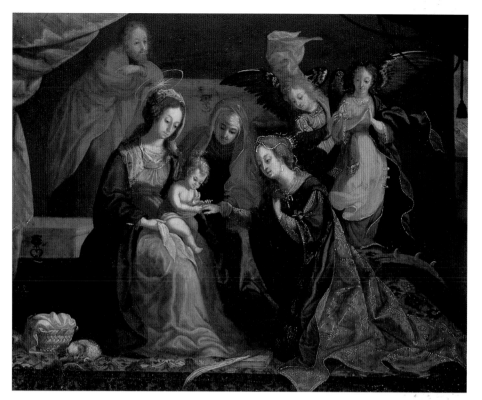

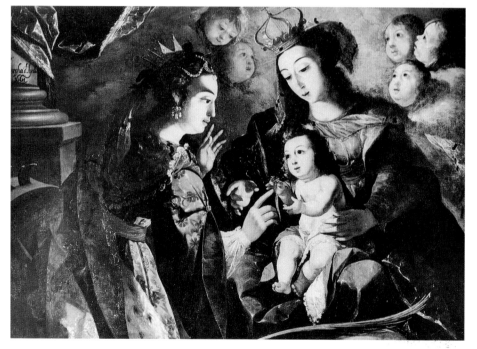

[fig. 5] JOSEFA DE ÓBIDOS | **Mystic Marriage of Saint Catherine** | c. 1647. *Museu Nacional de Soares dos Reis, Porto.*

[fig. 6] JOSEFA DE ÓBIDOS | **Mystic Marriage of Saint Catherine** | 1661. *Church of Santa Maria, Óbidos.*

28 This painting, like many others by Josefa, was done in several versions. Another example of the Mystic Marriage, dated 1647 and also on copper, is in the collection of the Museu Nacional de Arte Antiga, Lisbon.

29 For a photograph of the entire altarpiece, see Moura Sobral, "Josefa d'Óbidos e as gravuras," in Serrão, ed., *Josefa de Óbidos*, p. 53.

[**fig. 5**].[28] Saint Catherine also appears as the main protagonist in a series of paintings executed by Josefa in 1661 for a retable in the Church of Santa Maria in Óbidos. In this important altarpiece, the only commission of its type by the artist still in situ, we find the Mystic Marriage [**fig. 6**] dominating the upper story, flanked by bust-length images of Saint Mary Magdalene and Saint Theresa of Ávila. Below, on either side of a sculpted image of Saint Catherine, are large canvases depicting *Saint Catherine in Disputation with the Learned Men* and *The Torment of Saint Catherine.* This work is certainly one of the most important seventeenth-century representations of the life of a female saint.[29]

The Saint Catherine altarpiece is not the only such project executed by Josefa. In 1672, she was commissioned by the Carmelite Convent of Cascais to depict scenes from the life of Saint Theresa of Ávila. These paintings, now in the Igreja Matriz in Cascais, were also designed for a retable. Although one does not receive the same impression that the works originally suggested when they are seen in a free-standing state, these images are, nonetheless, very important not only within the context of the Portuguese painter's art but within the iconographic development of European Baroque painting. Saint Theresa, the sixteenth-century Spanish Carmelite reformer, was depicted by some of the greatest artists of the seventeenth century (the most well known among them is Gian-

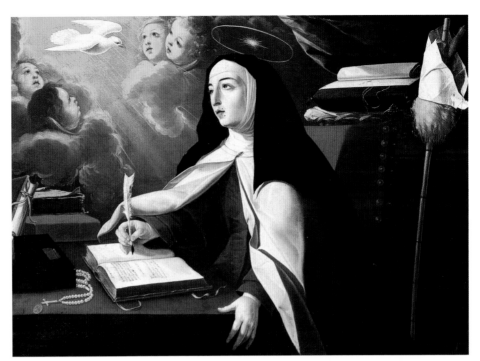

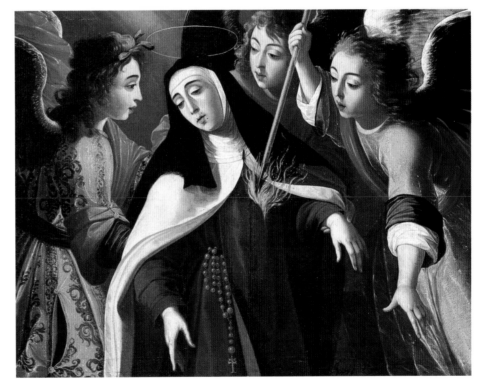

lorenzo Bernini, in his 1642-52 altarpiece for the Church of Santa Maria della Vittoria in Rome). Saint Theresa's writings were of great significance in articulating many aspects of the particularly Iberian character of the Counter-Reformation. Her autobiography, *Las Moradas* (1562-65), describes her life as a series of intimate rooms. This metaphor of domesticity, used to delineate a life of self-abnegation and compliance with the tenets of the Counter-Reformation church, may also be examined in regard to its impact on the visual imagery developed by many Portuguese and Spanish artists, including Josefa. Saint Theresa's famous phrase "God is found among the pots and pans" may be remembered when examining the Iberian Baroque still-life tradition, with its highly developed metaphorical language. It should also be remembered that Saint Theresa employed the grammar of the household in creating her allegorical signs of holiness. The ramifications of Saint Theresa's writings on Josefa's own symbolic vocabulary are clear.

In the Cascais series [see **figs. 7** and **8**], Josefa payed homage to both the intellect and spirituality of Saint Theresa. These paintings are marked by their use of otherworldly red and pink tones, and by the participation of the androgynous angels in the scene in which the saint is pierced

[fig. 7] Josefa de Óbidos | **Saint Theresa Inspired by the Holy Spirit** | 1672. *Igreja Matriz, Cascais.*

[fig. 8] Josefa de Óbidos | **Saint Theresa in Ecstacy** | 1672. *Igreja Matriz, Cascais.*

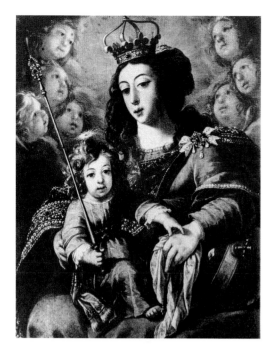

[fig. 10] JOSEFA DE ÓBIDOS | **Nativity** | 1669. *Museu Nacional de Arte Antiga, Lisbon.*

by the arrow of divine love. In their subtle way, these paintings define a highly sensual atmosphere of suppressed eroticism.

One of the center images of the Cascais retable is a scene of the Holy Family, among whom the Virgin appears as the principal figure. (This painting, like the rest of the series, is preserved in the parish church at Cascais.) Indeed, the Virgin was one of the artist's preferred subjects. In her paintings of Mary, Josefa articulated, as I indicated at the outset of this essay, many of the essential aspects of a particularly Portuguese approach to the Virgin and to Marian spirituality. A small-format work, *Virgin and Child* (1657, [**fig. 9**]) in the Museu Nacional de Arte Antiga, Lisbon, may serve as a paradigm image. Exemplifying the artist's intense interest in decoration, the Virgin's crown, cloak, and the broach at her shoulder are encrusted with jewels and pearls. Despite her queenly appearance, she remains, more than anything else, the sweet mother, protecting her son, delicately touching him as she speaks to him with her slightly open mouth. This attitude of motherly concern and tender intimacy is also evident in the various scenes of the Nativity depicted by Josefa (as in a 1669 version, [**fig. 10**]). When representing episodes of the life of Mary after the death and Resurrection of

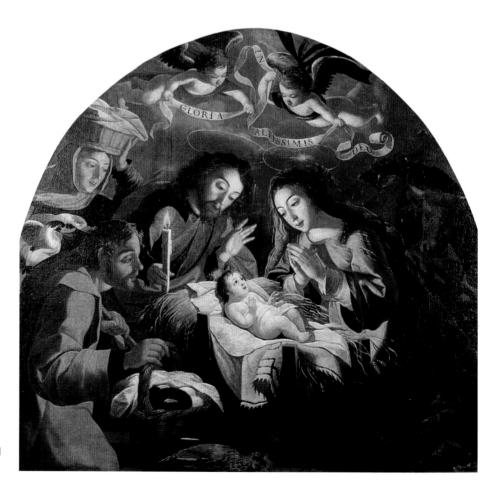

[fig. 9] JOSEFA DE ÓBIDOS | **Virgin and Child** | 1657. *Museu Nacional de Arte Antiga, Lisbon.*

Jesus (as in *Pentecost*, [**fig. 11**]), the artist evoked an attitude of private emotion, such as the state somewhere between exaltation and loneliness. In scenes in which the Virgin appears with the saints, Josefa defines Mary both as triumphant and as the epitome of the nurturing mother. In *Vision of Saint Bernard* (c. 1660-70, [**fig. 12**]), for example, Mary looks with tender love at the monks below her as she holds the infant Jesus to her breast.

For Josefa, the image of the Virgin was certainly one of the most powerful symbols of the spiritual values of the Portuguese Counter-Reformation church. In her hand, Mary takes on a multiplicity of attitudes and advocations, from protector to intercessor. In every case, Josefa imagined a divine mother able to enter the most intimate corners of our consciousness. Her roles as mother and heavenly companion, suggested by her gentle physical attitude, leave an indelible impression on the viewer. Josefa's representations of Mary evoke the artist's intense identification with her, both as a woman and as the creator of her own intimate world. In these paintings, Josefa devised a simulacrum of the spirituality of her time while, even more profoundly, creating a mirror image of the intimately fervent nature of Portuguese devotion to the Mother of God.

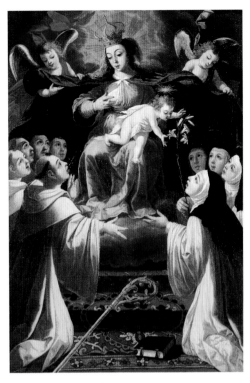

[fig. 12] JOSEFA DE ÓBIDOS | **Vision of Saint Bernard** | c. 1660-70. *Museu Nacional de Machado de Castro, Coimbra.*

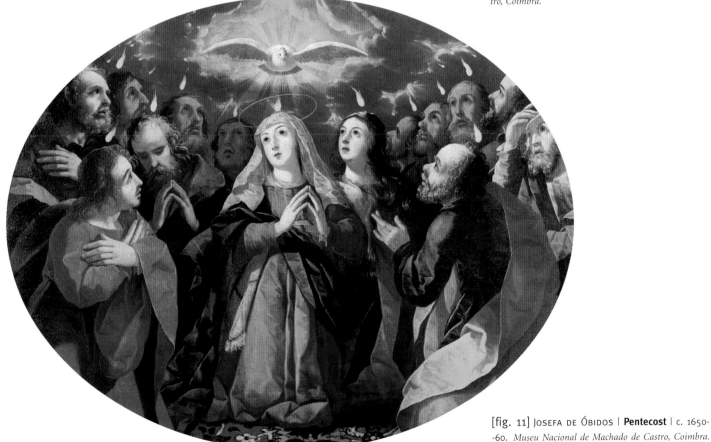

[fig. 11] JOSEFA DE ÓBIDOS | **Pentecost** | c. 1650--60. *Museu Nacional de Machado de Castro, Coimbra.*

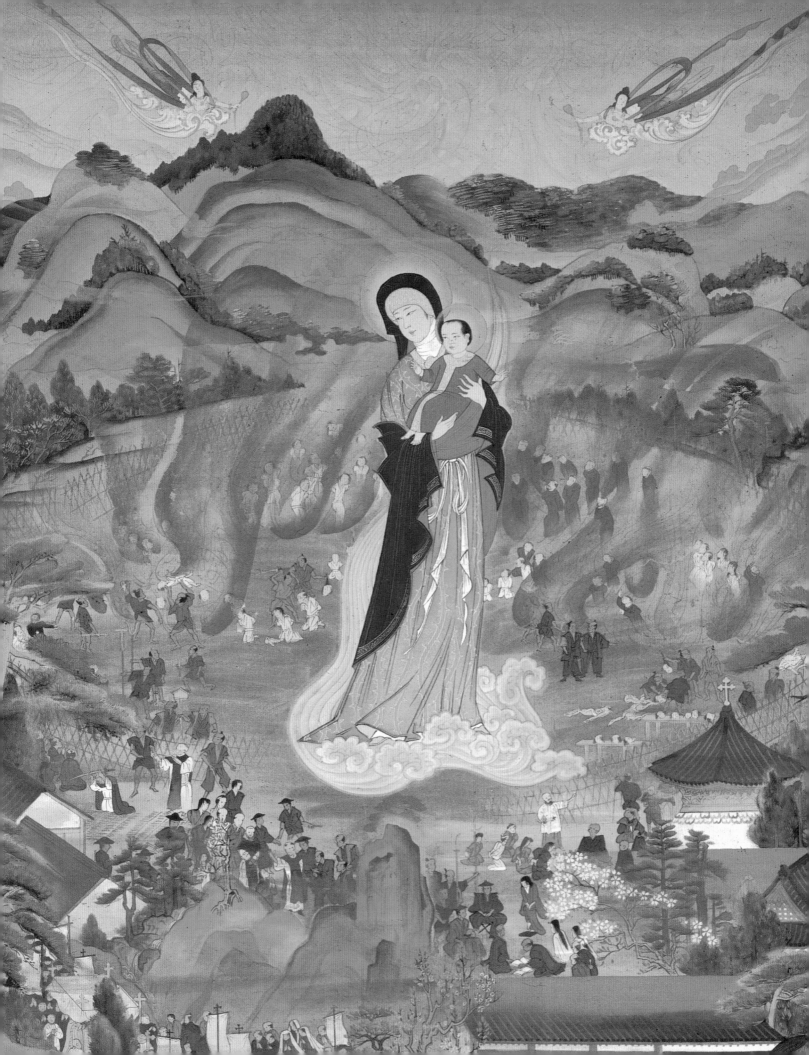

Nossa Senhora no Ultramar Português

Suzanne L. Stratton-Pruitt

During the reign of Dom Manuel I (1495-1521), the overseas expansion of Portugal reached its farthest limits. Portuguese navigators opened the sea route to India, discovered Brazil, and reached the Far East, touching the Chinese coast and the archipelagos of Molucca and Celebes. The Portuguese settled along the coast of India and elsewhere in the East, accompanied always by missionary priests who carried with them the Gospel and the visual images central to Catholic doctrine, especially those of the Crucified Christ and the Virgin Mary.

Even earlier, however, Portugal, a country of no great size and lacking rich natural resources, had shown its mettle in winning independence from the kingdom of Castile at the 1385 Battle of Aljubarrota. A century later, in 1494, the Treaty of Tordesillas settled an arrangement between the expansionist interests of Spain and Portugal; it gave Castile the sole right to explore the world west of a line 370 leagues from the Azores and granted Portugal unchallenged exploration of the African coast and an eastern sea route to the Indies.

Plans for Portuguese expansion beyond the Iberian Peninsula had been given royal impetus by the interests of prince Henrique "the Navigator," one of the five sons of Dom João I, first of the Aviz dynasty that ruled Portugal for two centuries. In the early fifteenth century, Henrique was appointed governor of the Moroccan city of Ceuta, which had been conquered by Portugal. The motives for Henrique's subsequent untiring exploration of the west African coast were summarized by Gomes Eannes de Azurara in his 1453 *Chronicle of the Discovery and Conquest of New Guinea*: to know the unknown, to establish trade, to know everything about the enemy ("the Moors"), to find a Christian king (probably the fabled Prester John) to help Henrique against "the Moors," and to extend the Christian faith.[1] Henrique had a chapel built in honor of Nossa Senhora de Belém in Lisbon, where the navigators Vasco da Gama, Pedro Álvares Cabral, and others prayed before her image before braving the perils of the seas.[2]

In effect, the Virgin Mary became patroness of Portuguese ventures in overseas trade. There can be little doubt that Henrique's dedication to exploration was fired by the lure of gold and spices, not the saving of heathen souls; however, the stated objective of Christianization leant a legitimizing gloss to the more fundamental goal of Portuguese ventures. Diogo de Couto, a Portuguese soldier-chronicler who spent many years in India, wrote in 1612: "The Kings of Portugal always aimed in their conquest of the East at so uniting

[1] Philip Wayland Porter, *Benin to Bahia: A Chronicle of Portuguese Empire in the South Atlantic in the Fifteenth and Sixteenth Centuries, with Comments on a Chart of Jorge Reinel*, n.p., 1959, p. 3.

[2] Clodovis Boff, *Maria na cultura brasileira: Aparecida, Iemanjá e Nossa Senhora da Libertaçao*, trans. Silva Debetto C. Reis, Petrópolis, Brazil, 1995, p. 10.

the two powers, spiritual and temporal, that the one should never be exercised without the other."[3]

The dual mission of evangelization and trade, "Christians and spices," was formalized by the Papacy. During the Renaissance, the Catholic church in Rome was concerned with European politics and with the rise of Protestantism on one flank and an Islamic threat to Italy on the other. The popes were thus relieved to invest Spain and Portugal with the task of Christianizing the new regions they might discover. These papal privileges (the Portuguese *padroado* and the Spanish *patronato real* in Spanish America and the Philippines) were in fact responsibilities: for sending missionaries, for building chapels and churches, and for the financial maintenance of these undertakings.[4]

The mendicant orders – Dominicans, Franciscans, Augustinians, and Carmelites – traveled to Portuguese settlements throughout the empire to convert the indigenous populations and to educate them. However, it was the Jesuits who were in the vanguard and were the most numerous and active of the Catholic orders in Portuguese realms, from the founding of the order in 1540 until its suppression in Portugal in 1760. In fact, although Portugal conquered and colonized overseas lands, the conversion of those native populations to the Catholic faith was a task handed over to the Jesuits, whose members were drawn from all over Europe. To maintain the missions, the Jesuits engaged

in trade on a large scale and eventually owned considerable agricultural property in Brazil, Angola, and India. This naturally drew criticism from their business competitors, as did the Jesuits' condemnation of the mistreatment of African slaves and their fight for the freedom of the native population of Brazil.

Brazil

Brazil was discovered when the fleet of Cabral, following da Gama's route down the west coast of Africa toward the Indies, sailed off course. Cabral sighted Brazil during Easter week of 1500; in honor of the religious calendar, he named his discovery Terra da Vera Cruz (Land of the True Cross). The scribe Pedro Vaz de Caminha wrote to Dom Manuel I:

The country is so well favored that if it were rightly cultivated it would yield everything, because of its waters. For all that, the best fruit that would be gathered hence would be, it seems to me, the salvation of these people. It would be reason enough, even if this was only a rest-house on the voyage to Calicut.[5]

In 1524, Dom João III divided Brazil into twelve captaincies to be settled and governed by twelve *donatarios*. During the following years, there was increasing enslavement of the native population to work on the sugar plantations and to collect brazilwood. In 1549, this *capitanias* system, found to have many defects, was centralized under a governor appointed by the king, and the Jesuits arrived to convert the

[3] Quoted in Charles Ralph Boxer, *Four Centuries of Portuguese Expansion, 1415-1825: A Succinct Survey*, Johannesburg, 1961, p. 64.

[4] Ibid.

[5] Quoted in Porter, *Benin to Bahia*, p. 5.

natives. (The latter remained intractable as a workforce, prompting the importation to Brazil of slaves from the Guinea coast of Africa.)

When the first governor of Brazil, Tomé de Sousa, embarked from Portugal, he was accompanied by Manuel da Nóbrega, the superior of a small group of Jesuits. Tomé de Sousa's mandate from Dom João III, outlined in the *regimentos* (royal ordinances), included the reminder to all Portuguese colonists in Brazil that the decision of the Portuguese crown to populate the new lands was prompted by a desire to convert the natives to Christianity. To this end, the natives were to be well treated by the Europeans, who would be punished for acts of oppression or mistreatment. "Since the King's will was to bring them to conversion, they were to be convinced and attracted and not alienated."[6] The royal ordinances further recommended that native Christians be separated from those not yet converted. They were to be encouraged to live near European settlements so that their children could be educated and their customs slowly Europeanized. Christianization was thus conflated with Europeanization, a process of socializing the native population that we may presume made them more amenable to work on the plantations.

From the moment of the discovery of Brazil, the image of the Virgin Mary was present in her role as the gentle mediatrix between humankind and God. Mary's comforting maternal presence was perhaps as appealing to an opressed native population, who could have understood little of theology, as it was for illiterate Europeans of the Middle Ages. Cabral brought with him on the voyage that landed in Brazil an image of Nossa Senhora da Esperança, said now to hang in the Franciscan Convent of Belmonte, Bahia.[7] And, of course, the missionaries who followed Cabral's discovery carried images of the Virgin with them.[8]

It was not until the early eighteenth century, however, that the Marian role in the unique *índio-afro-latino* culture of Brazil found a visual expression as potent as the Virgin of Guadalupe in Mexico. According to the Brazilian legend, a fisherman caught in his nets a small sculptured image of a black Virgin of the Immaculate Conception. It was for years venerated by the fisherman's family, who eventually built a small oratory to house the image, which was visited by many Marian devotees. When a proper chapel was constructed to house the image, more people (mostly of the working class) came, and miracles occurred.[9] The popular cult of this image of a black Virgin, called Nossa Senhora da Aparecida, was recognized by the church hierarchy in 1930, when Pope Pius XI named the Aparecida patroness of the nation. She remains today the popular symbol of Catholic Brazil (see [**fig. 1**]).

Africa

Had Cabral's fleet not deviated from its course in 1500, it would have contin-

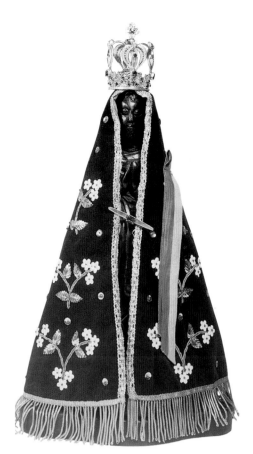

[fig. 1] **Our Lady of Aparecida** | 19th-20th century. *Congregação das Franciscanas Hospitaleiras Imaculada Conceição, Lisbon.*

6 Antonio da Silva Rego, *Portuguese Colonization in the Sixteenth Century: A Study of the Royal Ordinances (Regimentos)*, Johannesburg, 1965, p. 90.

7 Boff, *Maria na cultura brasileira*, pp. 12-13.

8 For a beautifully illustrated compendium of religious imagery created in Portugal and throughout the Portuguese dominions, see Maria Natália Correia Guedes, ed., *Encontro de culturas: oito séculos de missionação portuguesa*, exh. cat., Conferência Episcopal Portuguesa, Monastery of São Vicente de Fora, Lisbon, 1994.

9 Ibid., pp. 19-21. Other Marian miracles were recorded by the early missionaries. A miraculous spring was described by Simão de Vasconcelos in his chronicle of the early missionary efforts of the Jesuits in Brazil; see Simão de Vasconcelos, *Chronica de Companhia de Jesus do estado do brasil, e do que obraram seus filhos nesta parte do Novo Mundo ...*, second ed., Rio de Janeiro, 1864, pp. 137-38. The first church built in Brazil is said to have been dedicated to the Virgin as the result of her appearance in a dream to an indigenous princess, Paraguaçu, who was married to a Portuguese, Diogo Álvares. See Boff, *Maria na cultura brasileira*, p. 13.

ued around the coast of west Africa to the Far East (the "Indies" sought by Christopher Columbus). The political policies of Dom João I had promoted the expansion of Portugal into northern Africa, prompting the occupation of Ceuta.[10] What had been known to the Europe of the Middle Ages about Africa had depended on information provided by Arab geographers, whose knowledge was limited to the regions north of the western Nile. But the Arabs bought gold that had been transported across the Sahara, and Henrique the Navigator's encouragement of exploration was clearly in the service of finding a way to the gold market of fabled Timbuktu and a direct sea passage from Guinea to Portugal. By the time Henrique died, the Cape Verde islands and the coast of all Guinea as far as Sierra Leone had been reached by Portuguese navigators, and a brisk trade in gold, slaves, ostrich feathers, amber, gum, black pepper, and ivory enriched the coffers of Portugal. It was not until the sixteenth century that Portuguese enterprise penetrated more deeply into the African continent and a serious attempt was made to evangelize the Africans.

The earliest European contacts with the chief of Angola, the Ngola, occurred through the auspices of the converted Congo king Afonso I (reigned 1509-41). The first emissary sent to Angola by Dom Manuel I, Baltasar de Castro, was held prisoner there for six months. However, as the years passed, some Portuguese merchants traded with the Ngola and the harbor of Luanda became well known. Finally, the Ngola invited Portugal to send missionaries, as a way of officially establishing Portuguese trade in his kingdom. The Jesuits, whose work in India and Brazil was well known, were chosen for this mission, which arrived at the court of the Ngola Kiluangi in 1560. The experience of the Jesuits in the Congo, where Christianity did not outlast the life of Afonso I, suggested that their influence in Angola would be superficial and short-lived. In India and Japan, the Jesuits faced intellectual barriers to their mission; in Brazil, they had found satisfaction in shaping new generations through their faith. In Angola, they quickly realized that Christianity would have to be preached in a different way, and that, "if they wished to convert such people to Christianity, they must deal first with people submissive to a Christian king. Any lasting work needed a minimum of security. In short: Angola was to be subdued before any serious attempt at conversion was made."[11] The Donation Charter issued by the young king Dom Sebastião, which permitted Portuguese conquest and submission of the kingdom of Angola, expressly stated: "Let it be known that... it is becoming to God's service and mine that the Kingdom of Angola be subdued and conquered, so that divine cult and service may be therein duly performed, and our holy Catholic faith expanded and the Holy Gospel preached."[12]

Syncretism (a concept by which a variety of forms of belief and practices from

[10] For a broader treatment of the Portuguese expansion into Africa and subsequent years of trade, see John W. Blake, *West Africa: Quest for God and Gold, 1454-1578: A Survey of the First Century of White Enterprise in West Africa, with Particular Reference to the Achievement of the Portuguese and Their Rivalries with Other European Powers*, second ed., rev. and enl., London, 1977.

[11] Rego, *Portuguese Colonization in the Sixteenth Century*, p. 103.

[12] Quoted in ibid., p. 105.

different cultures blend together) permeated the earliest of Christian religious images in the Congo. The Crucifix (*nkangi kidutu*, or "attached Christ") was seen as a source of the power invested in the Portuguese (with their material goods and military strength) by the spirit of Jesus Christ. The Congo king Afonso I presented *nkangi* as gifts to clan chiefs and to judges.[13] The form of these images was derived from Spanish crucifixes brought to Africa by the Portuguese missionaries and copied by native craftsmen in wood or brass (using the lost-wax or open-mold method), or a combination of both. Naturally, the copies were formally quite different from their European models as the African artists had their own ways of depicting the human figure. The Virgin and Child in the present exhibition [**fig. 2**] exemplifies the adaptation of a western European iconographic type to a uniquely Angolan form of visual expression.

India

The Portuguese navigator Bartholomeu Dias rounded the Cape of Good Hope in 1488, opening up the sea route to India. That course was followed by da Gama, who reached Calicut on the southwestern coast of India in 1498. Two years later, a fleet of thirteen ships captained by Cabral sailed out of Lisbon to establish a Portuguese colony in India (discovering Brazil along the way). However, the most important Portuguese settlement was not on the mainland, but on the island of Goa, con-

quered by Afonso de Albuquerque in 1510. In 1542, the Jesuit order sent the Spaniard Francis Xavier to Goa to revitalize missionary work in India. He established stations at Chochin, Bassein, and Mylapore; baptized ten thousand low-caste Paravas, the people of the Fishery coast in the southeast; and established under Jesuit direction the seminary of the College of São Paulo for the education of native priests. By the end of the sixteenth century, missionary efforts had been made all along the coastal regions, and the Jesuit Gonsalvo Fernandez had penetrated the southern interior of India, with a mission established at Madurai. All of this effort, however, had resulted in a disappointingly small number of converts. Fernandez's dedication to his task cannot be faulted; he learned to speak Tamil and ran a clinic and school for children. However, in fourteen years at Madurai, Fernandez made not one convert. His efforts, like those of his fellow missionaries in India (most of whom did not learn the language), were hampered by his failure to understand the social structure of Indian society.

The situation changed after the arrival of Roberto de Nobili in 1605. Nobili's approach to evangelization differed markedly from that of his predecessors in India, who, Miguel A. Bernad writes,

> …insisted that Indian converts must give up their distinctive costume and insignia and must dress and act like the Portuguese. They even had to give up their names and adopt not only a

[fig. 2] **Virgin and Child** | *Museu Antropológico da Universidade de Coimbra.*

13 *Christian Imagery in African Art: The Britt Family Collection*, exh. cat., Snite Museum of Art, University of Notre Dame, Indiana, 1980, p. 5.

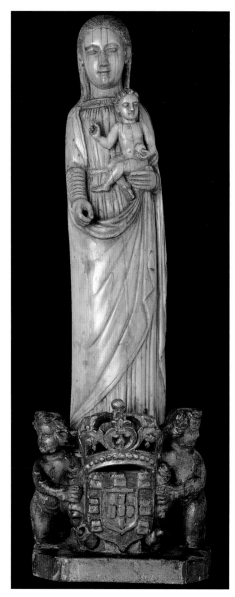

[fig. 3] **Virgin of the Rosary** | 17th century. *Museu de Arte Sacra da Sé, Évora.*

14 Miguel A. Bernad, *Five Great Missionary Experiments and Cultural Issues in Asia*, vol. 11 of *Cardinal Bea Studies*, Manila, 1991, p. 88.

15 Vincent Cronin, *A Pearl to India*, New York, 1959, pp. 224-25.

16 Bernad, *Five Great Missionary Experiments*, pp. 101-02.

European Christian name but also a Portuguese surname. In short, they had to give up their Indian culture and become, in effect, Portuguese.[14] Nobili quickly realized that the social caste system of India was more complex and rigorous in its divisions than was European society. In a treatise Nobili later wrote in defense of his missionary approach, he described the caste system, from Brahmin to Paria, in knowledgeable detail. Until Nobili's arrival, most of the converts to Christianity had been made among the lower classes, whose example would not be followed by members of higher castes. Nobili decided therefore that conversion of the masses must follow the conversion of the most noble ranks of Indian society. To that end, he adopted a lifestyle based on an Indian scale of values. With the permission of the archbishop of Cranganore, Nobili, whose family was of the highest Roman nobility, undertook the lifestyle of a *sanyasi*, a member of the Indian caste of rulers and warriors. His disciplined existence – he lived in a humble cabin, ate only rice, vegetables, and fruit, and spent all of his time in prayer and the instruction of his disciples – attracted the attention of a Brahmin, Sivadarma, who became Nobili's Sanskrit teacher and was eventually baptized by him.

Nobili had to defend his pastoral approach, which permitted new Christians to maintain Indian traditions in the way of hairstyles and frequent bathing, against mounting criticism within the Jesuit order.

His brief treatise written in 1610, "Response to the Objections Made Against the Method for Converting Pagans Employed at the New Madurai Mission," has been described as "a classic defense of the principle of adaptation, of the right of an alien civilization to receive the Word of God on fair terms."[15] In 1613, Nobili wrote a further essay on the customs of India. Based on the content of these two documents, his ideas have been summarized as follows:

First: It should be held as a general principle that every nation is entitled to keep its native customs and traditions unless they clearly contradict the Gospel.

Second: To judge whether a custom or usage is or is not contrary to the Gospel, its nature and its purpose should be studied in the context of a people's culture and psychology. No custom or usage should be condemned as "superstitious" unless its nature and purpose are first understood.

Third: A distinction should be made between those customs and usages which are primarily religious, and those which are primarily civil or social or cultural. The latter type of custom or usage should not be forbidden Christians, provided of course that it is purged of all taint of superstition.[16]

Conversion through adaptation and acculturation, which seems obvious to us today, enabled Nobili and his companions to convert Indians from all social levels, from a king (*nayak*) to a pariah (the latter was actually a *pandaram*, or holy man).

Their success was independent of the protection of the Portuguese military and governing authority, which remained centered at Goa and in fortified settlements such as Cochin along the western coast of India. Missionary work in the interior "received its crowning glory"[17] in 1693 with the martyrdom of Saint João de Brito, a Portuguese Jesuit who was beheaded by order of an Indian prince who resented the Christian prohibition of polygamy.

The rich materials and elegant effects of Christian images created in India during the seventeenth and eighteenth centuries (see [**figs. 3** and **4**]) are related to the success of the Jesuits in converting the Brahmins and high-caste Hindus. Precious works wrought in silver and ivory bespeak material wealth, in contrast to the simple forms of the wooden Virgin and Child carved by an anonymous craftsman in Angola.

Japan

In the year following the establishment of the viceroyalty at Goa, Portuguese ships took Malacca, on the west coast of the Malay Peninsula. Sailing from the south of China, the first Portuguese ship reached Japan in the 1540s. Saint Francis Xavier, heeding the mandate given to the Jesuits by the Portuguese government for the propagation of Christianity in the Far East, set out for India shortly after the founding of the order. After traveling through India, Malacca, and the Moluccas, he headed toward Japan, where he landed in Kyushu

in 1549. Francis Xavier spent two years in Japan, where he was soon joined by a number of Jesuit missionaries, whose work fostered a remarkable spread of Christianity. In one of his letters, Francis Xavier reported that when he arrived in Japan, he showed a painting of Christ and the Virgin to the local daimyo, Takahisa. Takahisa, according to Francis Xavier, was so struck by the image that he bowed in reverence to it. Takahisa's mother wanted an exact copy, but there was no one in Kagoshima trained to paint in three dimensions in the European style.[18]

By 1581, there were over two hundred churches in Japan. In the year 1596 alone, 8,012 new Christians were baptized.[19] The missionaries brought articles of religious art with them to Japan; in 1563, Luís de Almeida reported that he baptized converts under a beautiful painting of the Virgin Mary, and in the same year, Juan Fernandez reported that he saw a painting of the Virgin Mary in the Ikkaido Chapel on Ikutsuki Island.[20] However, the phenomenal success of their evangelization (as pictured in [**fig. 5**]) soon outstripped the supply. The Japanese were accustomed to placing images of Shinto gods and Bodhisattvas in household altars. After their conversion to Christianity, they avidly sought images of Christ, the Virgin Mary, or the saints for the same purpose. The missionaries requested quantities of religious art from the Jesuits in Rome (in 1584, they requested 50,000 works), but from dispatch of the order to receipt of the shipment the

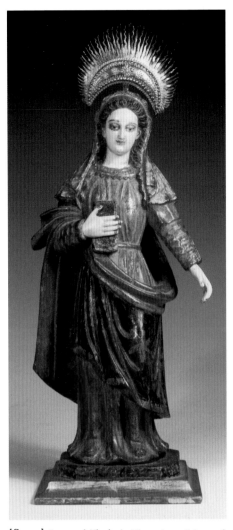

[fig. 4] **Crowned Virgin** | 18th century. *Private collection, Lisbon.*

[17] Ibid., p. 109.

[18] Shin'ichi Tani and Tadashi Sugase, *Namban Art: A Loan Exhibition from Japanese Galleries*, exh. cat., Japan Society Gallery, New York; Saint Louis Art Museum, Saint Louis, Missouri; Honolulu Academy of Arts, Honolulu, 1973, p. 21.

[19] Yoshitomo Okamoto, *The Namban Art of Japan*, New York, 1971, p. 16.

[20] Ibid.

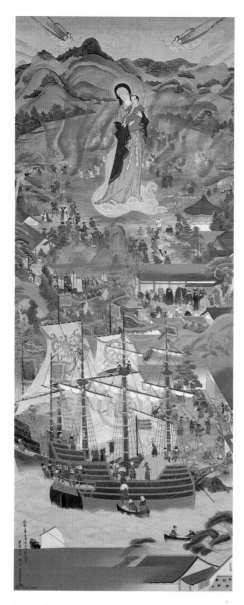

[fig. 5] LUCA HASAGAWA | **Introduction of Christianity to Japan** | 1925. *TK collection.*

21 "The subject matter of these imported European paintings is concerned almost entirely with the Virgin and Child, and the Virgin as Our Lady of Grace." John E. McCall, "Early Jesuit Art in the Far East," *Artibus Asiae* 10 (1947), p. 124.

22 "The Portuguese and Spanish who began to visit Japan in the middle of the 16th century, and the Dutch and British who followed in their wake, were collectively referred to as 'Namban-jin' by the Japanese. The European paintings they brought with them and the Japanese works modeled on these were called 'Namban-ga.' The terms mean literally 'southern barbarians' and 'paintings of southern barbarians' respectively ... with no malice intended." Tani and Sugase, *Namban Art*, p. 16.

requests took eight years to fulfill.[21] Furthermore, shipments were preempted in India, Malacca, and other points along the way, where religious images were also needed, so few actually found their way to Japan.

Alessandro Valignano, the visitor of the Jesuit order in the Far East, arrived in Japan in 1579. One of the policies he instituted for the enhancement of missionary efforts was the establishment of schools to prepare young Japanese for a religious vocation. The seminaries established in Arima (1580) and Azuchi (1581) soon began to offer instruction in European painting techniques. The report of the Jesuit priest Pedro Gomez for the period 1593-94 detailed the activities of the seminary in Hachirao on the Shimabara Peninsula. Among the art students there, eight were learning to paint in tempera, eight were mastering oil painting, and three were studying engraving. Later reports chronicling such studies in other seminaries included references to the young Italian painter and Jesuit Giovanni Niccolo, who arrived in Japan in 1583; he was noted for both his paintings and his teaching skills. By the end of the sixteenth century, the Japanese were creating paintings of both Christian and western European secular subjects in a thoroughly European style called Namban.[22]

Pedro Gomez's report waxed enthusiastic about the potential of this new generation of Japanese painters:

Some of the Portuguese, seeing the works, and not knowing them to be made in Japan, have said that they can only have been made in Rome. If we are thus blessed by Divine Providence, we shall have people who hereafter will fill our many churches with fine paintings, making glad the faithful lords and gentlemen…. The pious desire of the faithful to have pictures in their own houses, which was so long unattainable, is now in the process of being achieved.[23]

Most Namban art (for example, [**fig. 6**]) was created during the last decade of the sixteenth century and the first of the seventeenth century, during the Momoyama period of Japanese history. However, under Tokugawa Ieyasu, who became absolute ruler of Japan in 1600, this interesting artistic flowering ended with the ban on Christian activities imposed in 1612. In fact, most Namban art was systematically destroyed. Recognition of the power of religious art was reflected in an anti-Christian measure enacted in the 1620s. It required the residents of an area to trample on a picture of Christ or of the Virgin Mary, an act that would force Christians to reveal themselves.[24]

China and Macao

During the two years he spent in Japan, Saint Francis Xavier was repeatedly asked whether the Chinese had yet converted to Christianity. Such was the respect of the Japanese for China, Francis Xavier believed that if the Chinese were to embrace Christianity, the Japanese would follow in large numbers. In 1552, Francis Xavier died

[fig. 6] **Virgin and Child** | 17th century. *Museu--Escola de Artes Decorativas, Lisbon.*

on the island of Sancian, a few miles off the coast of China, from whence he had attempted in vain to enter China, the Forbidden Kingdom, to preach the Gospel.

In 1557, the imperial government of China leased the little port of Macao to the Portuguese as a base for trade with Canton, but even access to Canton up the river from Macao was closed after the rowdy behavior of some sailors abused that imperial privilege. Valignano had learned through his travels in India, Malay, and Japan that

China was a country with a sophisticated civilization even older than that of Europe. He therefore decided that the missionaries to China should be Jesuit priests whose learning in philosophy and the sciences would win the respect of the Chinese through their own language. In 1582, Valignano had the right men for the task.

The Jesuits Miguel Ruggieri and Matteo Ricci seem to have been the first two Europeans to learn the Chinese language, a prerequisite set by Valignano for their

23 Quoted in Okamoto, *The Namban Art of Japan*, pp. 112-13.

24 Tani and Sugase, *Namban Art*, p. 20.

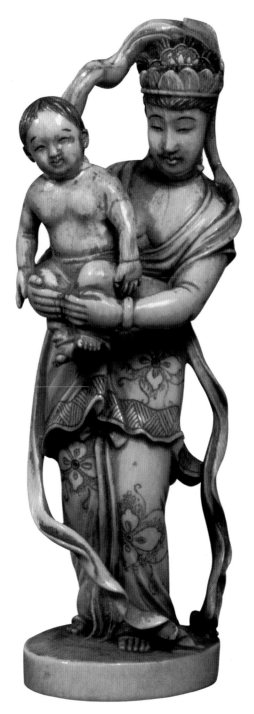

[fig. 7] **Virgin and Child** | 18th–19th century. *Private collection, Lisbon.*

25 Bernad, *Five Great Missionary Experiments*, p. 7.

26 Ibid., p. 9.

27 Ibid., p. 19.

entry to the mainland. Valignano learned to speak it, but Ricci, who was gifted with a prodigious memory, also quickly mastered the written language. During the twenty-seven years that Ricci spent in China, where he died 1606, "he wrote works that have been accepted by the Chinese themselves as part of their classics."[25] Having entered China through Ruggieri's contacts, the two Jesuits assumed Chinese names and costumes. They did not preach, nor would they have been allowed to. In ways similar to those undertaken by Nobili in India, "theirs was to be an indirect intellectual apostolate."[26] And, like Nobili, Ricci, who lived and studied among the Chinese as an intellectual among intellectuals, came to distinguish social customs from religious ones and therefore made converts to Christianity without the need to suppress ancient Chinese traditions. He made such distinctions through careful study, as Bernad notes:

> Ricci had studied the Confucian classics and had translated them. He became convinced that Confucianism, as Confucius himself had taught it, was not a theological but merely an ethical system, based on reason and common sense. It was therefore no more incompatible with Christianity than was the philosophy of Aristotle that Thomas Aquinas and others had adopted in medieval times.[27]

When the Jesuits entered China in 1583, there were no Christians at all. At the time of Ricci's death, there were 2,500 Christians, all of the educated class. Sixty years later, there were 300,000 Christians in China. A group of Spanish Franciscans reached Macao in 1578, bringing with them an engraving after a painting of the Virgin and Child said to have been created by Saint Luke, a painting of Saint Francis, and a "painting" of Mary Magdalene made in Mexico of bird feathers, the latter brought to the East via the Philippines.[28]

In 1598, Ricci received from Spain a copy of the Sevillian *Virgen de la Antigua*, which was reportedly greatly admired by the Chinese. Ricci showed several versions of the Virgin and Child to the Chinese emperor in 1601, as well as prints illustrating the dedication of popes, kings, and nobles to the Holy Name of Jesus, a view of the Escorial in Spain, and a scene of San Marco in Venice. However, some of the religious images that arrived from Europe proved more confusing than illuminating for the Chinese. Images of the Virgin and Child were likely to be interpreted as the goddess Kuan-yin in western guise (though later works by the Chinese themselves adapted oriental forms to orthodox subject matter without confusion, as in [**fig. 7**]). And the image of the Crucified Christ was, as late as 1600, thought to be an evil charm against the emperor. Thus, the iconographic needs of the missionaries, added to the difficulty of obtaining enough European objects of religious art, impelled the training of a native school of artists.

The first recorded Chinese artist to work for the Jesuits was Yu Wen-hui.

Born in Macao, Yu Wen-hui was sent to Japan to study painting under Niccolo sometime between 1593 and 1598, in which year he is recorded in the service of the Jesuits at Nanjing, under his baptized name, Manuel Pereira. Born in Japan of a Japanese mother and Chinese father, Ni Yi-ch'ang, baptized as Jacobo Niva, was reported to be one of Niccolo's most apt pupils. When Ricci requested that Valignano send him another artist, Niva was sent from Japan. On his way through Macao, Niva painted two pictures for the Church of São Paolo, to replace two lost in a fire. In 1602, he went to Beijing, where he worked under Ricci. Unfortunately, although the careers of Pereira and Niva are well documented, their works have not been preserved. In fact, Christian subject matter and European style were but brief moments in the artistic history of mainland China, as in Japan: "These Christian styles never really passed beyond the fad stage, dying out under the hostility of the governing classes in Japan, and just existing in China through the efforts of the missionaries."[29]

The great monument to Marian devotion in the far-flung lands governed by Portugal at the end of the European Renaissance is the façade of the Church of São Paolo in Macao, dedicated to the Mother of God.[30] There, carved in bas-relief, the Virgin of the Immaculate Conception appears surrounded by her symbols from the litanies. She is accom-

panied by statues of Saints Francis Borgia, Ignatius of Loyola, Francis Xavier, and Louis Gonzaga – all of them Jesuits, the Catholic order that most vigorously promoted a knowledge of Christ and his mother throughout the vast Portuguese *padroado* – Brazil, Africa, India, Japan, and China.

Throughout the world, the missionaries worked under different conditions, which stimulated different strategies. The notions of adaptation and acculturation which seem obvious to us today met with resistance from the church in Rome in the eighteenth century. Missionary adaptation was forbidden. The so-called Chinese Rites started by Ricci and the so-called Malabar Rites started in India by Nobili were condemned. It was not until the twentieth century that the flexible approaches taken by the missionaries of the Renaissance were once again formally approved by the Papacy and by an Ecumenical Council. The same more generous and flexible response to the spiritual needs of the faithful throughout the world has, in the present century, accommodated and allowed for more impulses from popular beliefs to enter religious practices than those affirmed during the Counter-Reformation. Of these manifestations, Nossa Senhora de Fátima in Portugal and Nossa Senhora da Aparecida in Brazil symbolize in their different ways the many roles that the Virgin Mary has played for the faithful over the centuries.

28 John E. McCall, "Early Jesuit Art in the Far East," *Artibus Asiae* 11 (1948), p. 47. Much of the information about Christian art in China in the present essay is based on McCall's very useful article.

29 Ibid., p. 69.

30 The body of the church was destroyed in a fire in 1835.

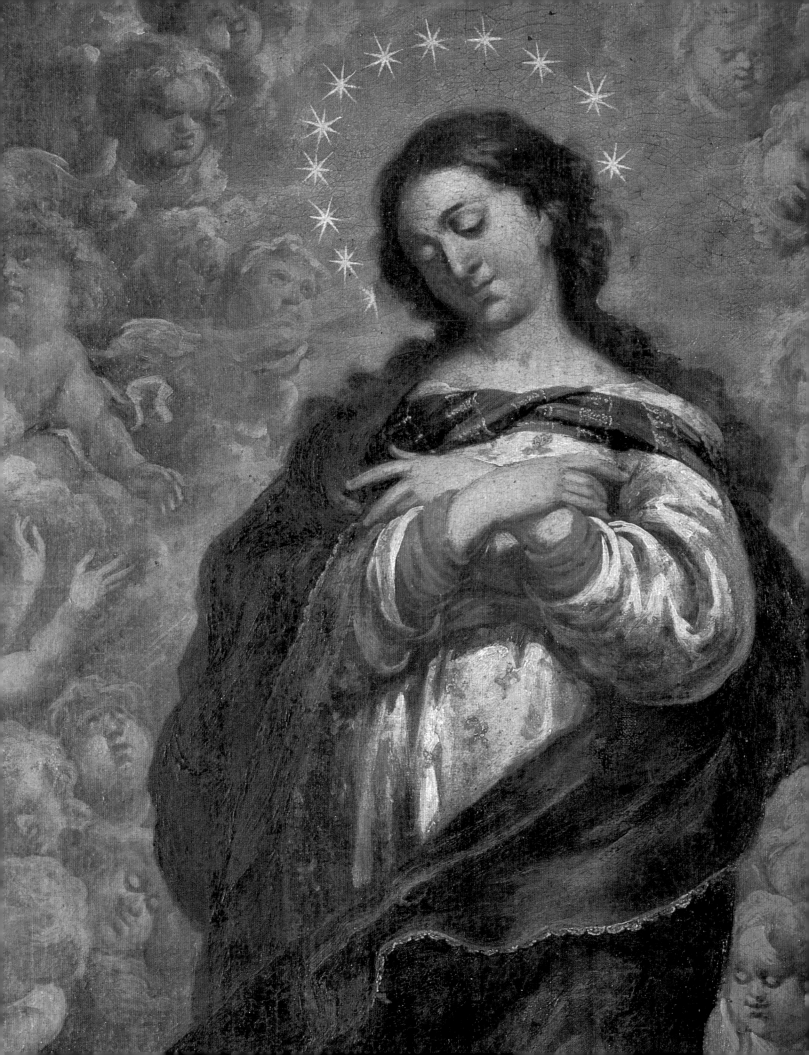

Devotion to the Virgin Mary in Portugal

Manuel Clemente

Great Portuguese moments are often Marian moments, which embrace events either directly related or dedicated to the Virgin Mary. If a nation is symbolized by the realities it asserts with great frequency and passion, then Portugal can be identified as a Marian nation.

Devotion to the Virgin Mary plays an important role in the personal piety of many Portuguese, but what I would like to emphasize here is the collective aspect of Marian devotion, which developed as part of the underpinning of Portuguese national identity.

The examples of this phenomenon are as old as the history of the nation itself. The Portuguese political reality was forged by the sword of Dom Afonso Henriques. It was he who created the Portuguese state, from Guimarães to Lisbon to the Alentejo, gathering diverse peoples together. The churches he built were dedicated to the Virgin Mary, as if she were the cohesive force in the country's unification.

In 1147, during the siege of Lisbon, Dom Afonso was forced to flee to Sacavém to defend the city in the struggles that followed the rise of Almohad rule in the province. Later, a temple dedicated to Nossa Senhora dos Mártires was built at the site, in honor of the Portuguese who died in battle. An evocation of the Virgin had made their battle a holy one.

The Papacy, in the meantime, had polarized Christians and Muslims, urging Christian rulers throughout Europe to purge the Iberian Peninsula of the so-called "infidel." After combined forces succeeded in conquering Lisbon, another church was built at a site where English crusaders had been buried. Once again, the Virgin was evoked: this church is also dedicated to Nossa Senhora dos Mártires, a feast that is celebrated every May 13.

The war continued in subsequent reigns, as did devotion to the Virgin Mary. In the South, churches were dedicated to Nossa Senhora dos Mártires in Silves and Castro Marim. Frei Agostinho de Santa Maria, in *Santuário Mariano*, writes about Nossa Senhora in Castro Marim: "Without doubt, the title 'Sanctuary of Mary' should be given to Nossa Senhora because, at the time of the Moors, many soldiers who had sacrificed their lives to defend the faith were buried under her altar."[1]

When Portugal was floundering due to Dom Fernando's rule, it regained its course in Aljubarrota on the eve of the Feast of the Assumption of the Virgin Mary (August 14, 1385). Fernão Lopes writes that the commander in chief, Nun Álvares, inspired the Portuguese troops by stating that the Mother of God, whose eve it was, would be his advocate. The new king added, "In the name of God and the Virgin Mary,

[1] Frei Agostinho de Santa Maria, *Santuário Mariano*, vol. VI, n. XXVI.

whose day is tomorrow, we will be strong and ready."[2]

The Portuguese victory was followed by the king's pilgrimage, on foot, to Nossa Senhora de Oliveira in the town of Guimarães. A dedication of gratitude was written in stone at Santa Maria da Vitória, and the people of Lisbon affirmed the promise they had made before the battle to undertake an annual procession to Nossa Senhora da Escada, venerated at Rossio.

After Portugal's kingdom was consolidated, a period of expansion ensued. The same Frei Agostinho writes that for this campaign the young prince Dom Henrique (known as the Holy Prince) chose the Virgin Mary as well as the Magi as his guiding lights, begging them to show him new stars, new men, and new worlds.[3] The Portuguese fleet came upon Ceuta in Morocco on August 14, 1415, again on the eve of the Feast of the Assumption of the Virgin. Also on August 14, in 1437, Dom Henrique went to Nossa Senhora da Escada before setting off for Tangier, where he would be imprisoned never to return to his country.

Victory followed defeat, wrote Frei Luís de Sousa in 1471. Dom Afonso V, Dom Henrique's nephew, set off in similar fashion but with greater success, when he took Arzila and Tangier from Islamic forces. Accompanied by the whole court, he went to visit Escada after this victory, on the morning of the Feast of the Assumption, August 15.[4]

The Virgin Mary was intertwined also with the great explorations, like those of Vasco da Gama and Pedro Álvares Cabral. Da Gama and his crew spent the night of July 7, 1497, at the chapel of Nossa Senhora de Belém before setting off to India. Cabral, before discovering Brazil, heard Mass at the same chapel on March 8, 1500.

There were moments of great glory for Portugal, and also moments of exile and defeat, but always protagonists associated their goals, their conquests, and their dreams with the patronage of the Virgin Mary. When a new empire was lost in Alcácer-Quibir, Morocco, before it was even born, the many who were taken prisoner turned to adoration of the Virgin. One of the prisoners, Diogo Bernardes, in his book of poems *Varias Rimas ao Bom Jesus e ao Virgem Gloriosa* (Assorted Rhymes to the Good Jesus and the Glorious Virgin), writes: "Oh, singular Virgin, pure and without sorrow, / … The Lusitanian people's hope, / For Your love may the Infinite Power / Help us in our afflictions."

After independence was lost to Spain in 1580, the Portuguese people continued to view the Virgin Mary as the Lusitanian people's hope, just as she was thought of by the defeated men in Alcácer. Under Spanish rule, the procession to Nossa Senhora da Escada was prohibited, an acknowledgment that the Virgin played a powerful political role in Portuguese nationalism. But such rulings only strengthened the people's resolve, and the patriots prayed for the Virgin to help them regain their independence. Her politicization and her

2 António José Saraiva, *As Crónicas de Fernão Lopes Seleccionadas e Trasportadas em Português Moderno*, Lisbon, n.d., pp. 385-86.

3 Frei Agostinho de Santa Maria, *Santuário Mariano*, I, XV.

4 Frei Luís de Sousa, *História de São Domingos*, vol. III, XIX.

alliance with the Portuguese identity were complete.

When the Spanish ruler ordered pine trees by the Church of Nossa Senhora da Assunção in Atalaia to be cut down, Frei Agostinho de Santa Maria reports that they miraculously bent, becoming useless.[5] Was that not a sign from Heaven of its discontent with the Spaniards? Whether truth or legend, one thing is clear: during these difficult years there was great demand for books about Marian devotion.[6]

The seventeenth century was a time of great exultation to the Virgin Mary throughout Catholic Europe, especially in regard to the dogma of the Immaculate Conception. The place and importance of the Virgin were emphatically affirmed in response to Protestant polemic, and even the kings of Spain defended this position. After Portugal's independence was restored in 1640, the Immaculate Mother, venerated at the ducal villa of Viçosa, home of the new king, Dom João IV, was immediately worshipped as the patron saint of the newly independent Portugal.

Later, the Assembly of 1646 officially announced the Virgin of the Immaculate Conception to be the patron saint of Portugal and of Portugal's still-frail independence, and, indeed, the chosen patron seemed to fulfill her role: on June 8, 1663, the Portuguese defeated the unrelenting Spanish at the Battle of Ameixial. One would have been hard put at the time to distinguish between a Portuguese victory and a victory for the Virgin, her interest

and intervention on behalf of the land seemed so sure. It was said that on May 26 and 27, just days before the battle, an image of Nossa Senhora da Piedade had miraculously appeared in Santarém. The apparition was authenticated by the church, through the Dean and Assembly of Friars of Lisbon in the Carta Pastoral, on January 15, 1664.

After regaining independence, Portugal experienced the golden years of the rule of Dom João V. As usually happens when a national identity is forged, history was rewritten. With this objective, the Royal Academy of History was founded by Dom João V on December 8, 1720.

The first historical research undertaken by the Academy, recorded in a work known as "Lusitana Sacra", concerned the churches of the kingdom.[7] Once again, it is difficult in this account to distinguish the history of Portugal from the history of Mary. According to Dom Manuel Caetano de Sousa, director of the Academy, they amounted to the same thing: while the aim of the "Lusitana Sacra" was to illustrate the churches and cathedrals of the kingdom, it resulted in the glory of the Virgin, to which they are all dedicated.

Also in the eighteenth century, with the blessing of Dom João V, it was determined that there would be a different liturgical festivity in honor of the Virgin each month of the year. In addition to those already in existence, the following festivities were added: Patrocínio de Maria in November; Nossa Senhora dos Prazeres on

5 Frei Agostinho de Santa Maria, *Santuário Mariano*, II, II, LV.

6 Alberto Pimentel, *História do Culto de Nossa Senhora em Portugal*, Lisbon, 1900, p. 224. This remains the most comprehensive work on the subject, and it is where I found the greater part of my references.

7 "Lusitania Sacra," *Colecção dos Documentos, Extatutos e Memórias da Academia Real da História Portuguesa*, Lisbon, 1721.

the Monday following Easter; Nossa Senhora do Desterro on the fourth Sunday of April; Nossa Senhora da Maternidade on the first Sunday of May; and Pureza de Nossa Senhora on the last Sunday of June. In 1815, the Coração de Maria was added.

The nineteenth century began with the threat of French invasion: the Napoleonic army finally arrived in 1807 and remained for one year, causing many deaths and much sorrow. Finally, the French left after having lost at Roliça e Vimeiro, a victory that was universally attributed to the intervention of the Queen of Heaven, patron saint of Portugal, who, it was felt, had come to Portugal's rescue. Singing of her praise returned, as in "Hymn to the Most Holy Mary for having rid us of the Treacherous and Evil French," created in Lisbon with more enthusiasm than inspiration in the year of victory, 1808: "Let us sing to the Virgin / Let us give her praise: / All sing with me: / God bless Thee."

The last century has seen great changes in the spiritual life of Portugal. The triumph of liberalism did not occur without a long-lasting conflict between political and religious life. Catholic institutions, which had become integrated with the Ancien Régime, were deeply shaken when it fell. In 1834, the religious orders were closed: immediately in the case of the male orders, the female orders over time. Furthermore, the new government exerted tight controls over the secular activities of the church. It looked with great suspicion at all things foreign, especially the Papacy in Rome, which was seen as a threat to Portuguese independence. The republican government's continuing mistrust of Portuguese liberalism in relation to Rome and the religious orders associated with Rome caused many Portuguese Catholics to distance themselves from politics, which may help to explain the precariousness and brevity of Portuguese political institutions.

Marian devotion, as a religious belief and as the source of national identity, was consequently intensified. Words by Padre Malhão written during this period (and still sung today) identify Portugal's national destiny with Mary's protection: "Your protected people, / Among all, chosen to be God's people, / Hail thee, noble Patron. / Glory to our land, / That You have saved a thousand times, / While there be Portuguese, / You shall be their love."

Devotion to the month of Mary has grown steadily. At the turn of the twentieth century, tensions between Marian devotion and Portuguese political institutions became accentuated, and were clearly revealed during events surrounding the apparition of the Virgin at Fátima.

By this time, the relationship between the church and state had been transformed. In 1854, when the dogma of the Immaculate Conception was affirmed by the church, Catholicism had been the state religion, but now the state no longer recognized any official form of worship. But the response of local authorities to the children who witnessed the apparition re-

vealed more than simple indifference. Rather, they exhibited a resistance to the apparition and its implications. Official resistance to the cult did not prevent the growth of Marian devotion; indeed, it provided a new stimulus. Soon the events at Fátima were interpreted as a guarantee of the Portuguese destiny, a reaffirmation of the intertwining of the Virgin and the identity and destiny of the Portuguese people.

The first official dedication (and "consecration") of Portugal to the Immaculate Heart of Mary on May 13, 1931, ended with these words: "Please remember, oh Patron Saint of our land, that Portugal taught so many nations to praise you, blessed among all women. In memory of what Portugal did for your glory, save it, Senhora de Fátima."

Devotion to the Virgin Mary continues to unite Mary and the national identity. The Portuguese seem never to tire of repeating: "Nossa Senhora do Rosário de Fátima, save us and save Portugal!"[8]

8 "Maria Nos Caminhos da Igreja," *Semana de Estudos Teológicos da Universidade Católica Portuguesa, Faculdade de Teologia*, February 8-12, 1988. Editorial Verbo, 1991.

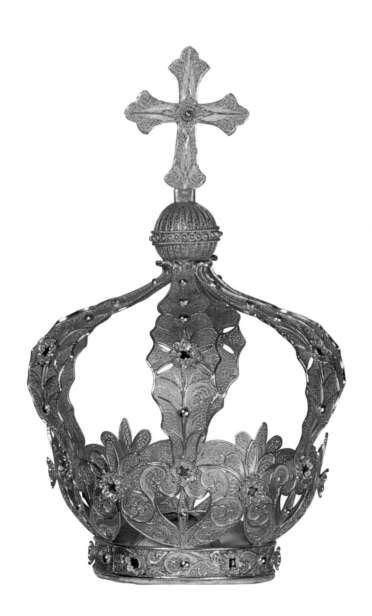

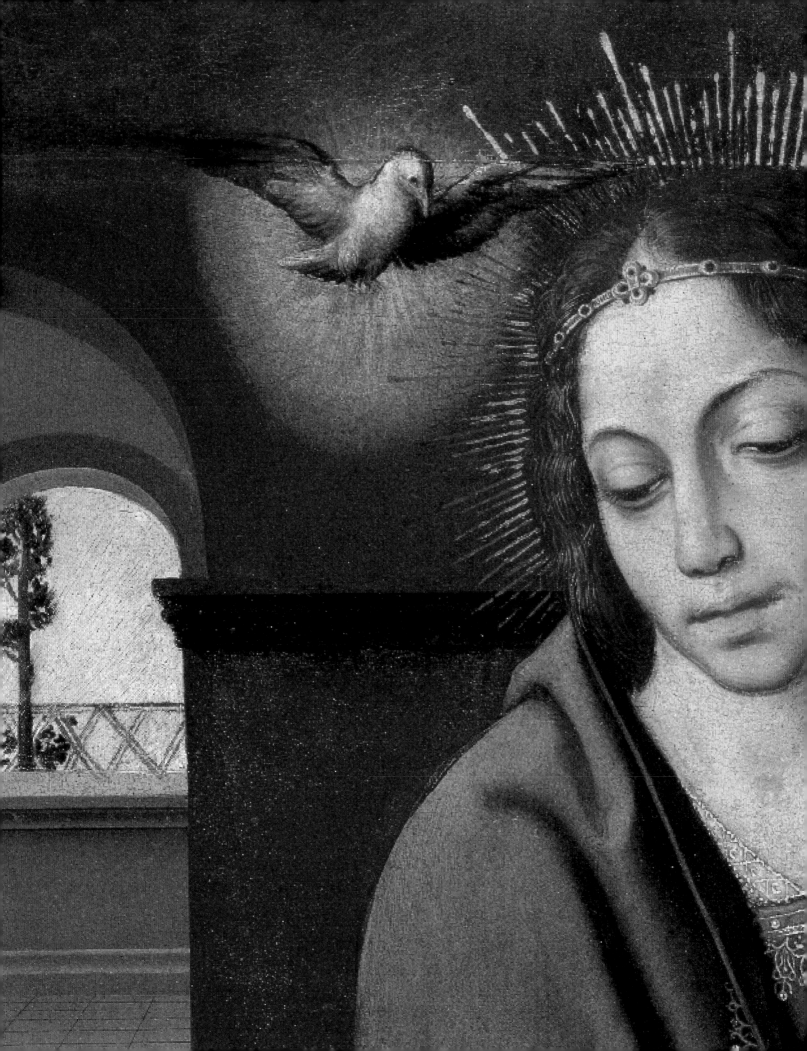

Catalogue

1 *Procession* [Procissão]

Augusto Roquemont (1804-1852)

Nineteenth century

Oil on canvas

520 × 625 mm

Museu Nacional de Soares dos Reis, Porto

The portrait and genre painter Augusto (Auguste) Roquemont was born in Geneva in 1804 and died in Porto in 1852. During his years in Portugal, where he arrived in 1829, he created many images, such as this painting, that characterize the rich folk traditions of the country.

In this canvas – entitled Procession *– the painter depicts, in great detail, the energy and pageantry of the procession of a local image of the Virgin from Minho. In the foreground, the zés-pereiras (bass drum) opens the procession. The bier carriers proceed with images of a holy bishop and the Virgin and Child. The faithful kneel at the appearance of the Virgin, their solemnity contrasted by the demeanor of the water seller. Behind the Virgin, the parish priest is followed by an ad hoc orchestra of violins and by women who protect themselves from the sun with parasols in gallant colors. At the top of the mount is the chapel from which the procession started.*

This genre painting, which evokes a sense of small-town life, is filled with picturesque and colorful scenes rendered in a serpentine composition. It documents a practice that has long been at the heart of Portuguese devotion to the Virgin, and that continues today.

A.J.A. and **E.J.S.**

BIBLIOGRAPHY

JÚLIO BRANDÃO. *O Pintor Roquemont. Subsídios para estudo do Artista: Vida, Época e obras.* Lisbon, 1929, fig. 5.

REGINA ANACLETO. *Neoclassicismo e romantismo.* Vol. 10 of *História da Arte em Portugal da Alfa.* 2nd edition. Lisbon, 1993, p. 145.

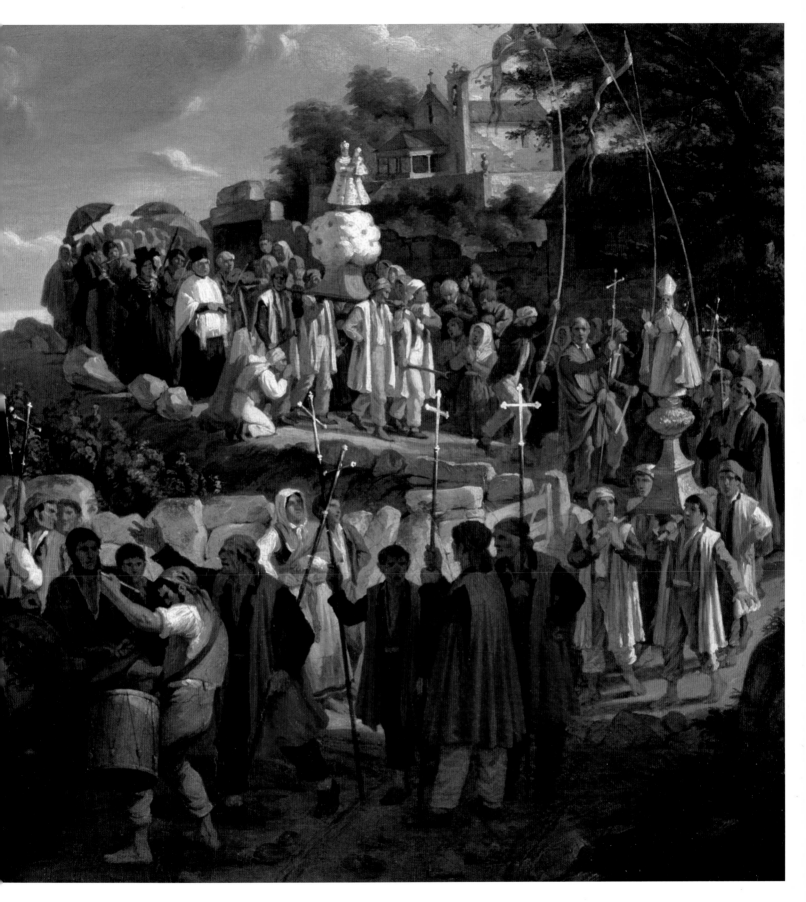

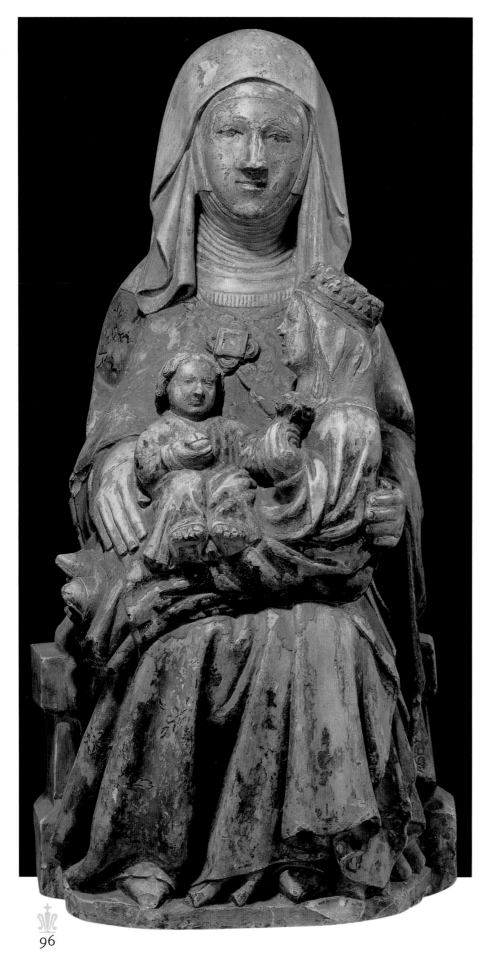

2 Saint Anne, the Virgin, and Christ

[Santa Ana Triplice]

Second half of the fifteenth century

Polychromed stone

730 × 370 × 280 mm

Museu Nacional de Arte Antiga, Lisbon

Medieval representations of the Virgin often eschew naturalism in order to explain the sacred or symbolic relationship between characters in redemptive history. This is the case in this sculpture depicting Saint Anne, the Virgin, and the infant Christ, called the Holy Mothers or Santa Ana Triplice (Mettertia in Latin).

Here the sculptor created a metaphor between the infant Christ in his mother's embrace, and the Virgin, who sits as a child as well on her own mother's lap. Saint Anne provides a powerful protective structure for the trio, for she takes the form of a throne, recalling images of Mary as the Throne of Wisdom (or Sedis Sapientiae). The triangle created by the figures echoes the notion of the Trinity and gives weight and authority to Christ's maternal lineage. Such representations were particularly popular in the fifteenth and sixteenth centuries, and were at times conceived to defend the notion of Mary's unsullied conception, and to suggest that Mary, like Christ, experienced an exceptional birth and childhood. As such, images of Saint Anne, the Virgin, and Christ can be seen as early expres-

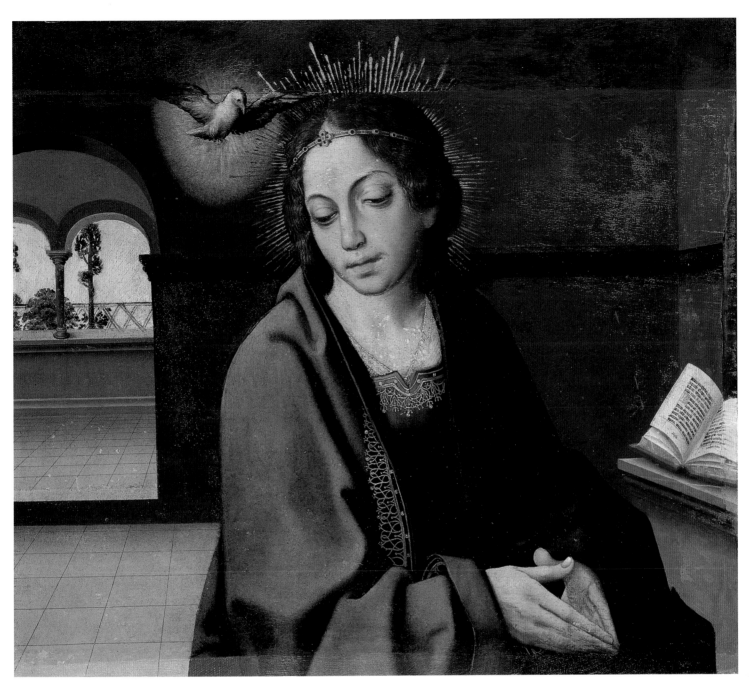

sions of support for the doctrine of the Immaculate Conception of Mary, enormously popular in the fifteenth and sixteenth centuries but not proclaimed dogma by the church until 1857. The relative scale of the figures, and the Virgin's ambivalent identity as both child and mother do not, then, stem from naïveté or misun-

derstanding. They are formal strategies intended to elucidate an ideology rather than to represent a moment in time. There is, nonetheless, a poignancy and tenderness in the compact forms of the Virgin and Christ, and the secure, thronelike structure in which they are held by Christ's maternal grandmother.　　**J.D.D.**

3 *Annunciation*

[Anunciação] (fragment)

Attributed to Gaspar Vaz (c. 1490-c. 1569)

c. 1530

Oil on chestnut wood

532 × 612 mm

Museu Nacional de Soares dos Reis,

Porto

In this fragment of a painting of the Annunciation, the Virgin is represented as a young woman at the moment when she is addressed by Gabriel with the news of her miraculous conception. She interrupts her prayer and turns to hear the angelical greeting.

The Virgin of the Annunciation can be interpreted either as passive or as an active participant who chooses to accept her vocation proclaimed by Gabriel. The Virgin's attitude here is one of accepting the Divine Will (Amen-Fiat). The Holy Spirit descends upon her "in the corporeal form of a dove" – an element taken from the narrative of the Baptism of Jesus (Luke 3: 22). The proximity of the dove to the Virgin, who is dressed as a princess, accentuates the tiara on her head.

The background opens through a gallery to the scene of a man in a garden (the "hortus conclusus" of the litanies [The Song of Solomon 4:12]), in the Italian manner. This enclosed garden is an emblem of Mary's virginity and purity, and part of an iconographical paradigm typical of contemporary Flemish painting. The drapery is achieved by black lines delineating the folds, also in the Flemish manner. The work of Gaspar Vaz is typical of many contemporary Portuguese masters whose art was highly inspired by northern European painting. **A.J.A.**

BIBLIOGRAPHY

L'Art au Portugal au temps des Grandes Découvertes (fin XIVe. siècle jusqu'à 1548), exh. cat. Antwerp, 1991.

No Tempo das Feitorias. A Arte Portuguesa na Época dos Descobrimentos, exh. cat. Lisbon, 1991, vol. II, p. 168.

Grão Vasco e a Pintura Europeia do Renascimento, exh. cat. Lisbon, 1992, p. 196.

Joaquim de Vascooncelos, *Arte Religiosa em Portugal*, fasc. 19, Porto, 1914, p. 6.

Luís Reis-Santos, *Os Processos Científicos no Estudo e na Conservação da Pintura Antiga*, Porto, 1939, p. 24.

Luís Reis-Santos, *Vases Fernandes e os Pintores de Viseu do Século XVI*, Lisbon, 1946, p. 71.

4 *Saint Anne Teaching the Virgin*

[Santa Ana ensinando a Virgem]

First half of the eighteenth century

Polychromed terra-cotta

380 × 140 × 120 mm

Museu Nacional de Arte Antiga, Lisbon

The young Virgin rests in the crook of her mother's arm while Saint Anne opens a book on the child's knees. The stylized treatment of the drapery, merely suggesting the body underneath, provides a dynamic feel, which is heightened by the work's polychromy and gold highlights.

The theme of the education of the Virgin by Saint Anne, although not present in the canonical Gospels, was a popular subject, which appeared more frequently after the sixteenth century when the cult of Saint Anne was intensified and disseminated. The intimacy of this scene and the movement and energy of the drapery gives the work an emotional intensity characteristic of the Baroque. **T.L.V.**

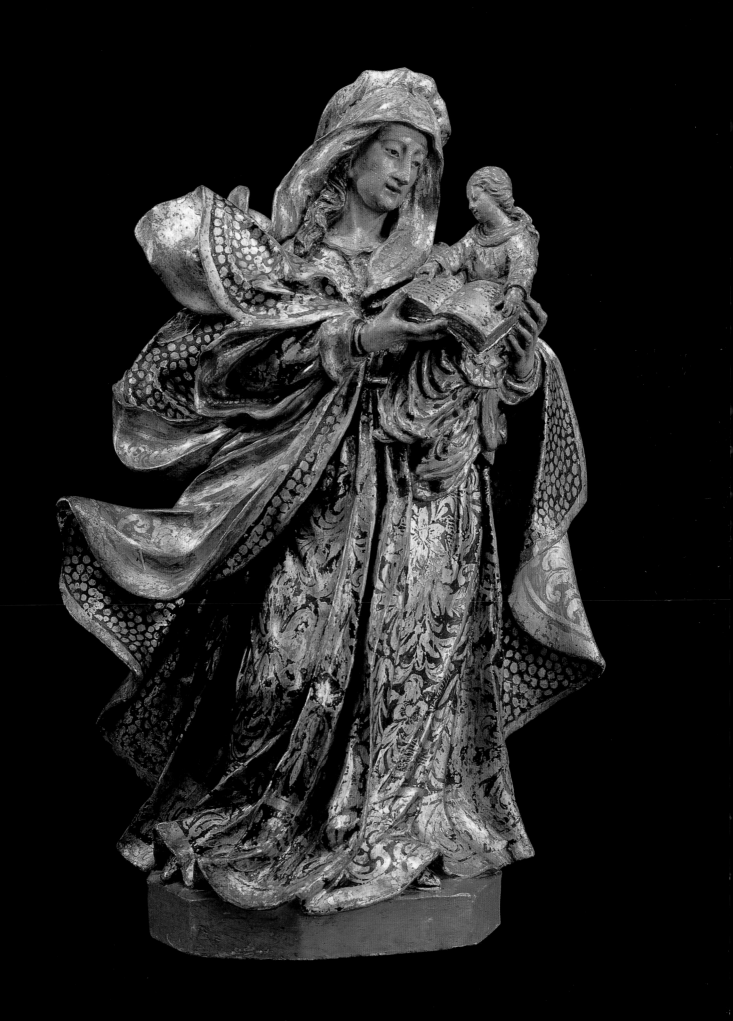

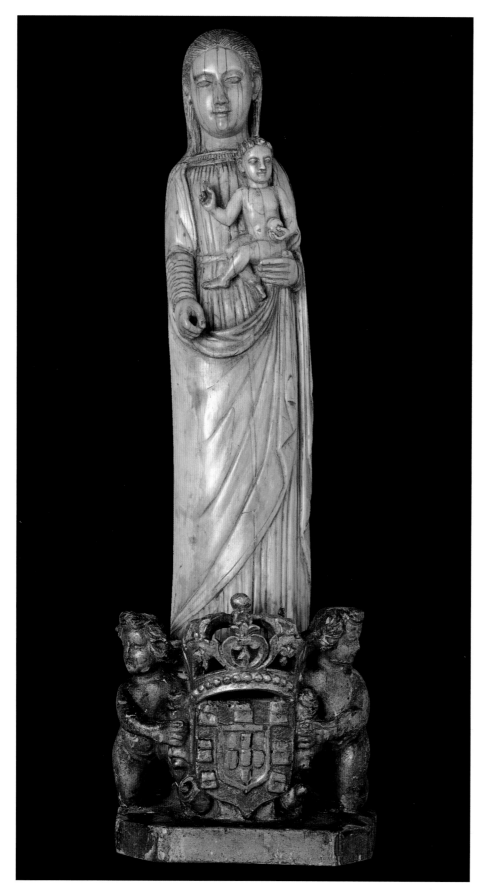

5 *Virgin of the Rosary*

[Nossa Senhora do Rosário]

Seventeenth century

Polychromed ivory

450 × 140 × 120 mm

Private collection, Lisbon

This ivory Virgin with Child from Goa originally held a rosary in her left hand. The sculpture is one of a series from Goa and India that conflates the iconography of the Virgin and Child with that of the Virgin of the Rosary, perhaps in response to the presence of Franciscans in Portuguese India. In their quest to keep the humility and humanity of Christ's origins ever before the people, the Franciscans favored representations that evoked Mary's maternal, nurturing role.

There is, however, an unusual authority and majesty in the commanding posture and elongated proportions of the Virgin, and the Christ Child, who holds a globe in his left hand, appears as a savior of the world. The particularly commanding, hierarchical nature of this piece is thought to be drawn from its connections to Indian tradition, while the iconography is drawn from Portuguese models. There are significant details that connect the piece to the Indian subcontinent as well: the Virgin wears a tunic and mantle, which draws inspiration from Indian models, and the use of ivory as a material – so rare and prohibitive in cost in Europe – links this Virgin and Child to a series of works produced in India in the seventeenth century.

The sculpture was almost certainly executed in one of the local workshops that developed near, or as adjuncts to, convents established as part of the Portuguese expansion into India and its colonization of Goa. This commanding Virgin of the Rosary arches in a delicate curve. Here, the artist has taken a medieval tradition of elegant, swaying Virgins and used it to exploit the curve of the elephant's tusk from which he carved the image. **José Lico**

6 Our Lady of the Four Corners of the World

[Nossa Senhora das Quatro Partes do Mundo]

Nineteenth century

Polychromed alabaster

500 mm (height)

Casa-Museu Fernando de Castro, Porto

This unusual image of the Virgin is an idealized representation of the Portuguese diaspora and the spread of Catholicism. The Virgin stands atop a column with allegorical figures of the faithful from Europe, Africa, Asia, and the Americas below. Portuguese hegemony in its many colonies throughout the world is expressed in this image of devotion to the Virgin.

This image derives from the Baroque sculptural tradition and is remarkable for its audacious and dynamic treatment of the drapery, which is freed from the central axis and projects the composition in multiple directions. **T.L.V.**

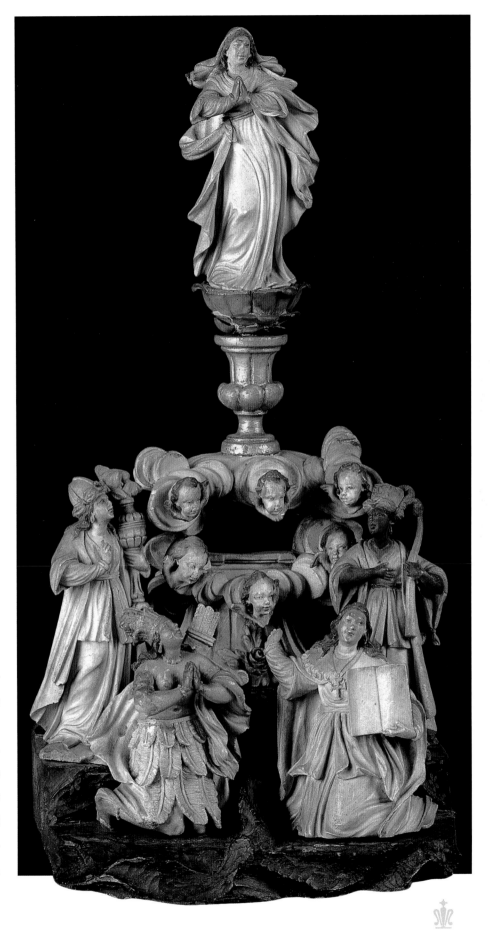

A SERIES OF THE LIFE OF THE VIRGIN

[eight panels; cat. nos. 7-14]

THESE SOBER AND TOUCHING PAINTINGS, AN INCOMPLETE SERIES OF EIGHT PANELS, FOCUS ON THE MAIN CHARACTERS IN THE STORY OF THE LIFE OF THE VIRGIN. THE PAINTINGS DRAW ON A NUMBER OF CANONICAL AS WELL AS APOCRYPHAL SOURCES TO PROVIDE THE VIRGIN WITH A CHILDHOOD AND ADULT LIFE. SHE IS OFTEN SHOWN IN SCENES THAT ACT AS PRECURSORS, OR PROPHESIES, OF THE LIFE OF CHRIST, AND IN HER OWN CONCEPTION AND CHILDHOOD MIRACLES, SHE IS SHOWN TO HAVE BEEN DISTINGUISHED FROM BEFORE HER OWN BIRTH.

THE STYLE OF THE PAINTINGS IS A GOOD EXAMPLE OF REFORMED MANNERISM, WHICH REMAINED VIABLE IN PORTUGAL LONGER THAN IN THE REST OF WESTERN EUROPE. A FOLLOWER OF PEDRO NUNES, THE PAINTER OF THESE PANELS USED VARIOUS MODELS OF MANNERIST FLEMISH ENGRAVINGS OF THE TIME, ESPECIALLY THOSE OF MARTIN DE VRIES AND, IN SOME PANELS (IN PARTICULAR, THE BIRTH OF THE VIRGIN), OF CORNELIS CORT.

7 *Meeting at the Golden Gate*

[Encontro de São Joaquim e Santa Ana]

Follower of Pedro Nunes (1586-1637)

First third of the seventeenth century

Oil on wood

665 × 520 mm

Museu de Évora

In the first of the series, the parents of the Virgin, Saint Joachim and Saint Anne, are represented embracing at the Golden Gate of Jerusalem, joyful with the news of Anne's pregnancy. Their names are symbolic: Anne means "Grace" in Hebrew. Saint Jerome said: "Anne means Grace of God… *the woman who begot* Maria, *the Grace-Full One." Joachim, a form of Eliachim (Eliacin), a diminutive of Elijah, means "Preparation of the Lord."*

The aged couple embrace affectionately, "happy at the sight of one another and their promised posterity," as described in Legenda Aurea *(The Golden Legend), written by the Dominican Jacobus de Voragine, Archbishop of Genoa.*

This scene was considered a prelude to the Birth of the Virgin. The Golden Gate, depicted in the pastoral landscape behind the two figures, symbolizes the Door of Paradise. It also creates a comforting sense of repetition within cosmic history, for it prefigures the Visitation, in which the Virgin and Saint Elizabeth embrace upon hearing of each other's miraculous pregnancy. The Meeting at the Golden Gate is a medieval iconographic form of the Immaculate Conception that has survived in this Marian cycle. **A.J.A.**

BIBLIOGRAPHY

ANDRÉS A. ROSENDE VALDÉS, *La Vida de la Virgem en la Sillería de la Catedral de Tui. Un testimonio de pervivencia medieval en el Barroco*, Tui, 1986.

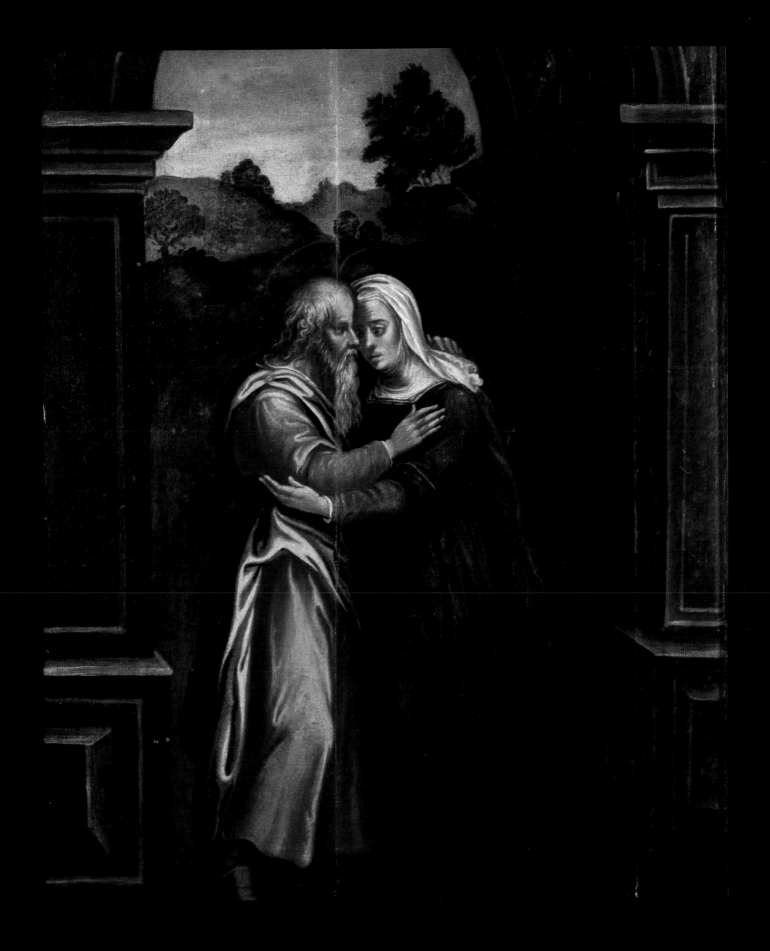

8 *Birth of the Virgin*

[Nascimento da Virgem]

Follower of Pedro Nunes

(1586-1637)

First third of the seventeenth century

Oil on wood

669 × 519 mm

Museu de Évora

This painting differs from the others in the series, as it depicts a dense and crowded scene. The figures in the foreground are midwives and friends who come to help Saint Anne, and they are bathing the recently born Virgin. This scene must have been familiar in seventeenth-century Portugal; it is one that would have enabled the faithful to identify with the lives depicted. Around the Virgin's infant head is a shining halo. In the foreground is a clay stove with burning coals, of a type still used today in Portugal. In the background are the progenitors: a servant presents a plate of food to Anne, who is leaning back in bed after labor, while Saint Joachim raises the door curtain to enter.

In this work, inspired by an engraving by the Flemish artist Cornelis Cort, one can observe a similarity to the same theme painted by Pedro Nunes for the old altarpiece of the church of the Remédios in Évora (1620).

A.J.A.

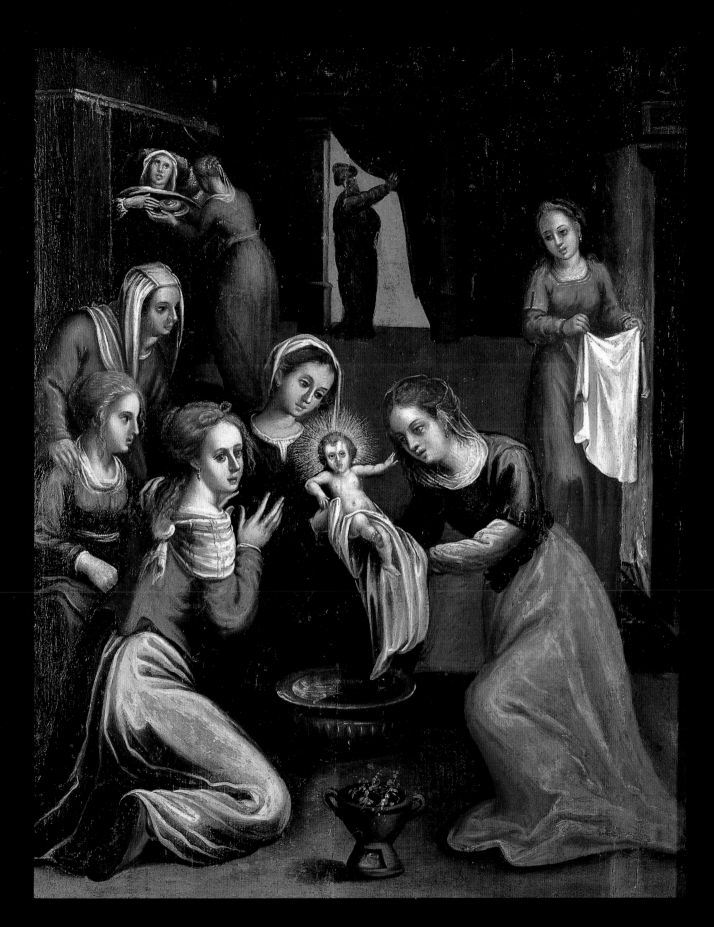

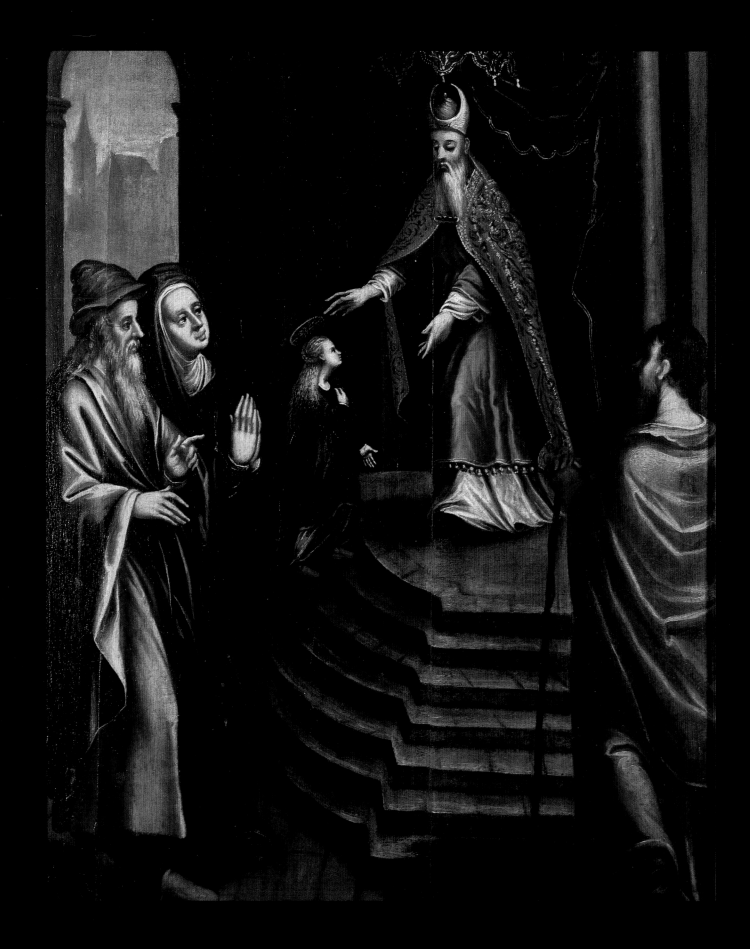

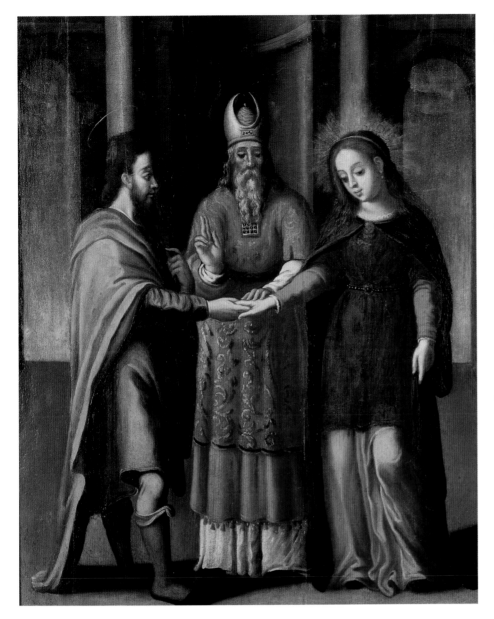

Saint Joachim and Saint Anne, in the left corner of the composition, observe their daughter's ascent; on the right, with his back to the viewer, the young Joseph also looks on, his presence linking this scene to the next panel in the series. **A.J.A.** and **J.D.D.**

10 *Marriage of the Virgin* [Esponsais da Virgem]

Follower of Pedro Nunes (1586-1637)

First third of the seventeenth century

Oil on wood

670 × 524 mm

Museu de Évora

This painting depicts the betrothal of Mary and Joseph, an event not included in the canonical Gospels, which state only that Mary was engaged to Joseph when the Annunciation took place (Luke 1: 27), and that she conceived Jesus before going to live with her husband (Matt. 1: 18). The scene as depicted here has been adapted to Western custom: the bride and groom hold each other's right hand in front of the high priest, who blesses them. In Roman Law, this is called Dextrarum junctio *or* Conjunctio manuum, *and is a sign of mutual consent.*

The composition, structured in a pyramidal shape, portrays only the three protagonists: the high priest, Joseph, and the Virgin Mary. As with other paintings in the series, the inspiration for this painting was an engraving by Flemish artist Cornelis Cort. **A.J.A.**

9 *Presentation of the Virgin at the Temple*

[Apresentação da Virgem no Templo]

Follower of Pedro Nunes (1586-1637)

First third of the seventeenth century

Oil on wood

672 × 523 mm

Museu de Évora

According to the apocryphal Book of James, when Mary was three years old, her parents took her to the temple of Jerusalem to consecrate her to God. In this representation of that scene, the child ascends the stairs alone, toward the high priest Zacharias who awaits her, his arms outstretched. This is another scene in the series that serves as a prophesy of the life of Christ, prefiguring Christ's presentation at the temple. The energy and joyous independence with which the little girl embraces her miraculous life is in keeping with the characterization of the Virgin as a child as described in the Book of James.

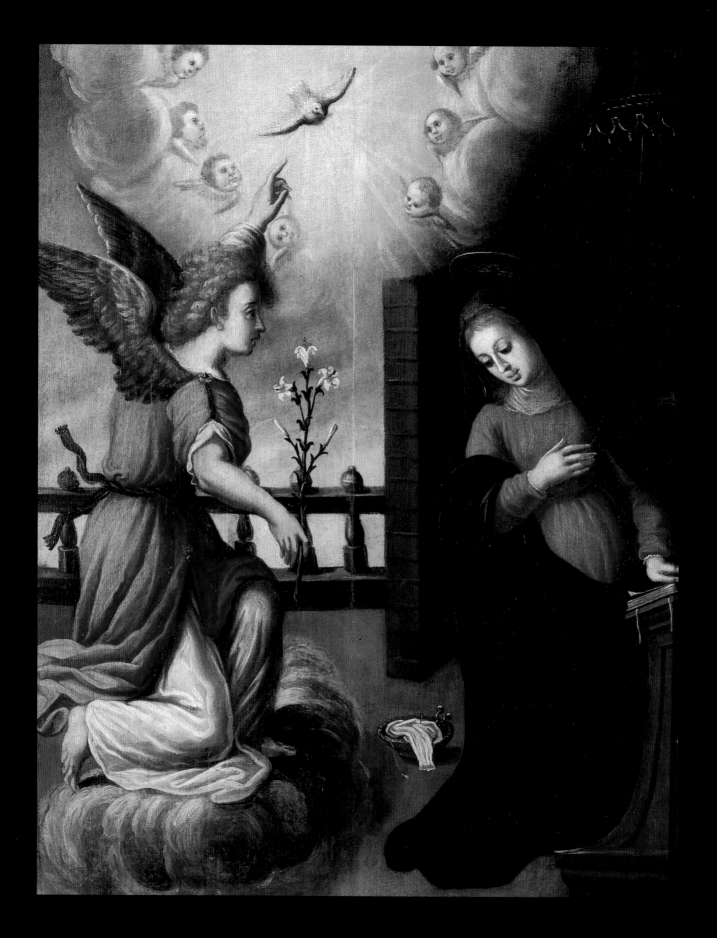

11 *Annunciation*

[Anunciação]

Follower of Pedro Nunes (1586-1637)

First third of the seventeenth century

Oil on wood

670 × 507 mm

Museu de Évora

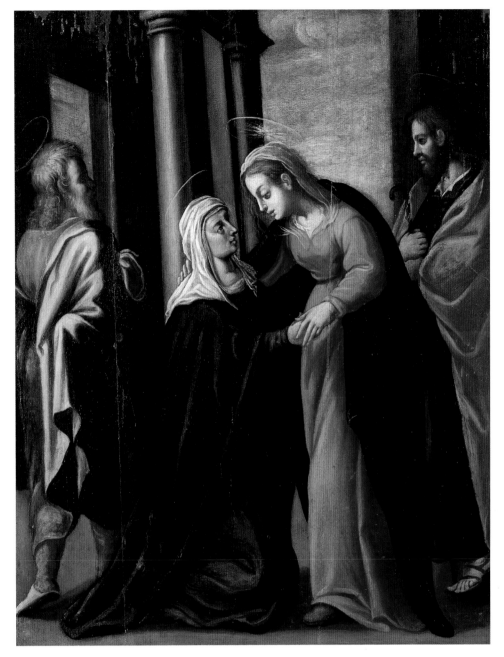

 In this panel, the archangel Gabriel descends from Heaven to announce to the Virgin the divine conception through the power of the Holy Spirit. The messenger appears on a cloud, with his right knee bent and a white lily branch in his right hand. With his left hand, he points to the dove, which represents the Holy Spirit.

The Virgin listens to the angelical message, her head tilted and her right hand on her chest in a sign of acceptance. Her face is reminiscent of those of the Virgin paint- ed by the Spanish artist Luis de Morales (called "El Divino"), such as one in the Museu Nacional de Arte Antiga in Lis- bon. It is known that Morales worked in Évora, and therefore probably influenced this painter. **A.J.A.**

12 *Visitation* [Visitação]

Follower of Pedro Nunes (1586-1637)

First third of the seventeenth century

Oil on wood

665 × 520 mm

Museu de Évora

As a sign to the Virgin Mary that "to God nothing is impossible," the archangel Gabriel cited the case of the pregnancy of her elderly cousin Elizabeth, "who was called barren" (Luke 1: 36). Upon hear- ing this news, the Virgin quickly left Naz- areth, in Galilee, and headed for the mountains of Judea in order to visit and assist her relative, who had miraculously conceived in extreme old age. In this scene, upon reaching the house of Zacharias and Elizabeth, Mary is greeted by her cousin, who kneels upon recognizing the Mother of God. Behind Mary is Joseph, and behind Elizabeth is Zacharias, her husband and a priest in Jerusalem. By turning the figure of Zacharias, the painter achieves a ser- pentine effect in the composition, which was very characteristic of the Mannerist aesthetic. **A.J.A.**

13 *Adoration of the Magi* [Adoração dos Magos]

Follower of Pedro Nunes (1586-1637)

First third of the seventeenth century

Oil on wood

675 × 525 mm

Museu de Évora

Here, the Christ Child, seated on his mother's lap, receives the homage of the Magi. The oldest of the kings leans over and kisses the feet of the Child, who places his tiny left hand on the old man's bald head, while with his right hand he makes the sign of the cross. This king represents Asia. Behind him is the middle-aged king who represents Europe, and behind him, the young black king who represents Africa. The most glorified figure, bearing a halo, is, of course, the Christ Child. The Adoration of the Magi always carries with it the theme of Christ's authority over all earthly kings. It would come to be used by the church as a reminder of its authority over kings in spiritual – and at times temporal – matters.

Behind the Virgin, we see Joseph depicted as an old man, as was common in medieval representations of the saint. This iconography was challenged during the Counter-Reformation, when the church favored a young, dynamic saint with a lively cult of his own. This prominent reappearance of Joseph as an old man is inconsistent with his image in the Marriage of the Virgin, *but consistent with the depiction of him in the* Presentation of the Virgin at the Temple. **A.J.A.**

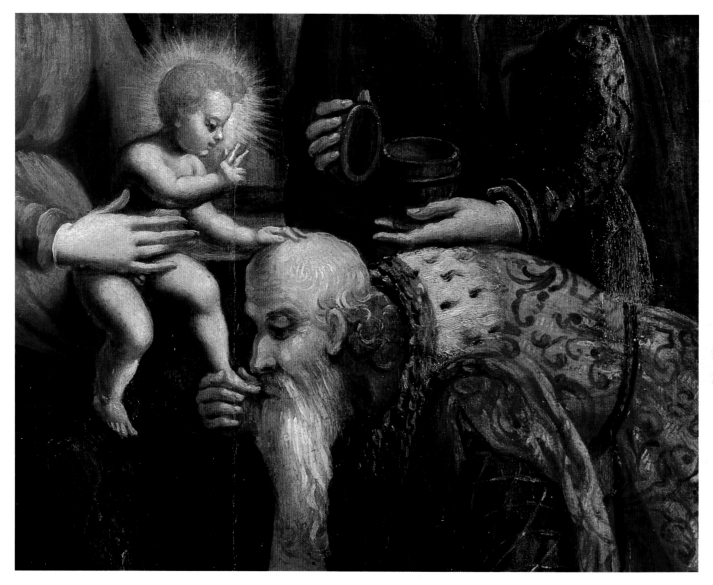

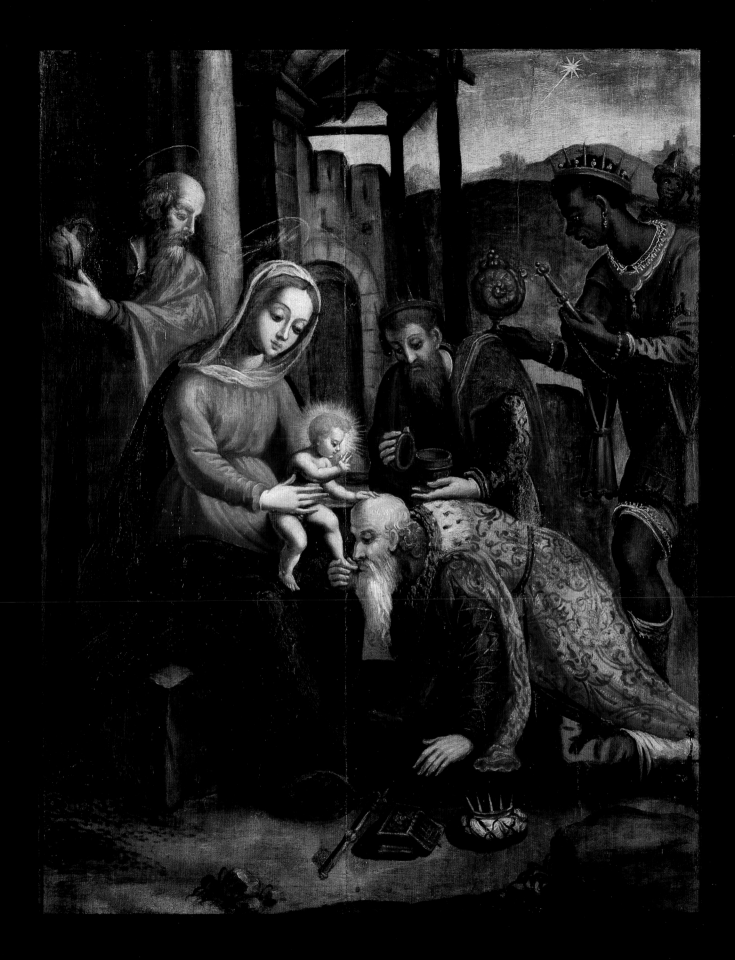

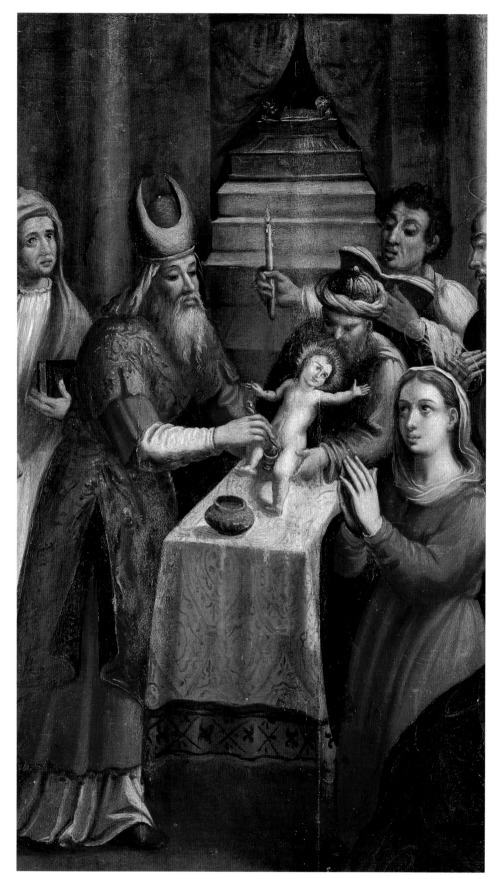

14 *Circumcision*

[Circumcisão]

Follower of Pedro Nunes (1586-1637)

First third of the seventeenth century

Oil on wood

673 × 425 mm

Museu de Évora

This scene portraying the circumcision of Christ takes place in the Temple of Jerusalem. In the background is the Arc of the Covenant, above which are cherubs. A veil opens to reveal the Arc. The Child is held by a priest above a table covered with a rich damask cloth, while the high priest cuts his foreskin with a knife. This first "sacrifice" of Christ anticipates the sacrifice of redemption – the Crucifixion. The scene is painted in a very realistic and, at the same time, symbolic manner. The blood is shown flowing into the cup held beneath the Child's genitals. This parallels the representation of the Crucifixion, in which the angels collect the precious blood that flows from the open wounds of the Savior, and suggests the Eucharist as well. Near the edge of the table is a gold pitcher with a narrow opening to collect the holy foreskin, much venerated since the Middle Ages as a relic. In the foreground, Mary kneels on a cushion, her hands in prayer, and looks with emotion at the Child, who returns the gaze and stretches his little right arm toward her. They share a knowledge of the sacrifice that is to come. Behind Mary is the elderly Joseph, who contemplates a book. **A.J.A**

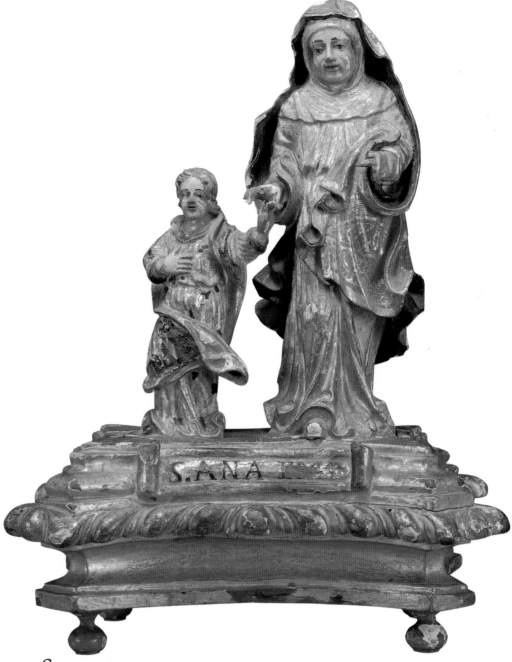

15 *Saint Anne and the Virgin* [Santa Ana e a Virgem]

Eighteenth century

Polychromed wood with gold leaf

340 × 230 × 140 mm

Museu de Aveiro

The Virgin is represented here as a small child walking with her mother. The scene is remarkably intimate in its diminutive scale and human gestures. There is also a great deal of vigor in the characteristically Baroque representation of movement, which is suggested by the positioning of the legs and is heightened by the animated treatment of the drapery.

This is one of a group of images in the exhibition that was intended to communicate with its audience through the evocation of emotional experience embedded in daily secular life and family relations. **T.L.V.** and **J.D.D.**

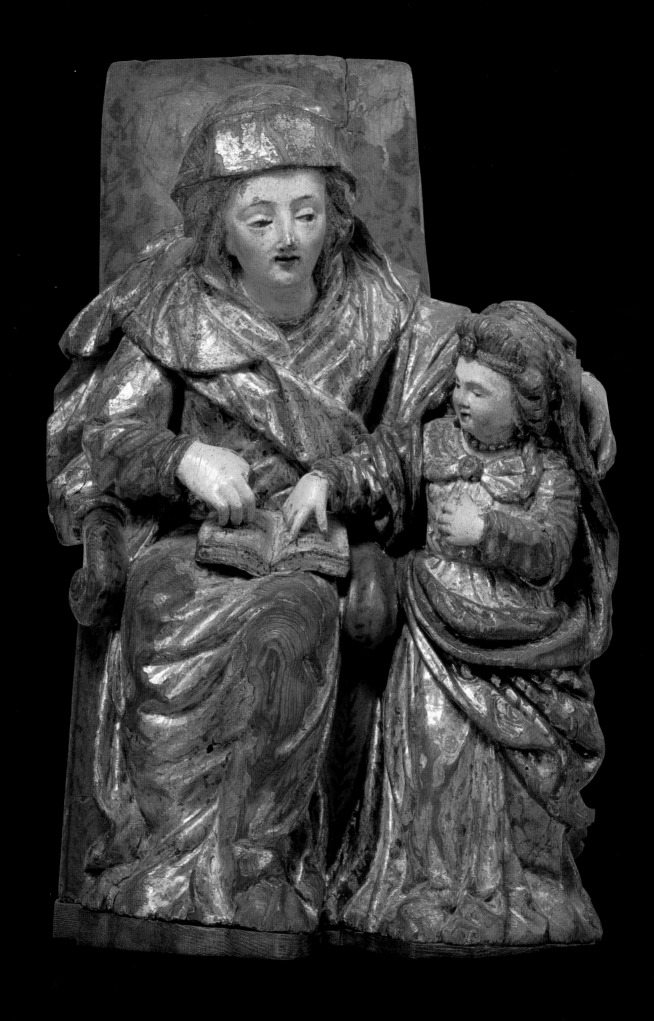

16 *Saint Anne Teaching the Virgin*

[Santa Ana ensinando a Virgem]

Seventeenth century

Polychromed wood

515 × 360 × 280 mm

Museu Nacional de Arte Antiga, Lisbon

In this representation of the education of the Virgin, the child stands by her mother, who is sitting with an open book on her lap. The scene suggests great serenity and intimacy, as indicated by the arm of Saint Anne, which gently embraces the young Mary.

The work evokes a kind of domestic empathy that allows the viewer to identify with the Virgin's life. This was an important part of the devotional emphasis in the art of the Counter-Reformation. **T.L.V.**

17 *Saint Anne Teaching the Virgin*

[Santa Ana ensinando a Virgem]

Nineteenth century

Polychromed wood

235 × 145 × 120 mm

Museu Nacional de Arte Antiga, Lisbon

Dating from the nineteenth century, when the theme of the education of the Virgin had waned in popularity, this sculpture presents a simple solution to the representation of this subject. Saint Anne is shown seated with her daughter standing next to her, and the attention of both women is turned to a book that rests on Saint Anne's lap.

The dignity of the figures, in their exact stance and emotional restraint, reveals the austere nobility of the neoclassical mode. **T.L.V.**

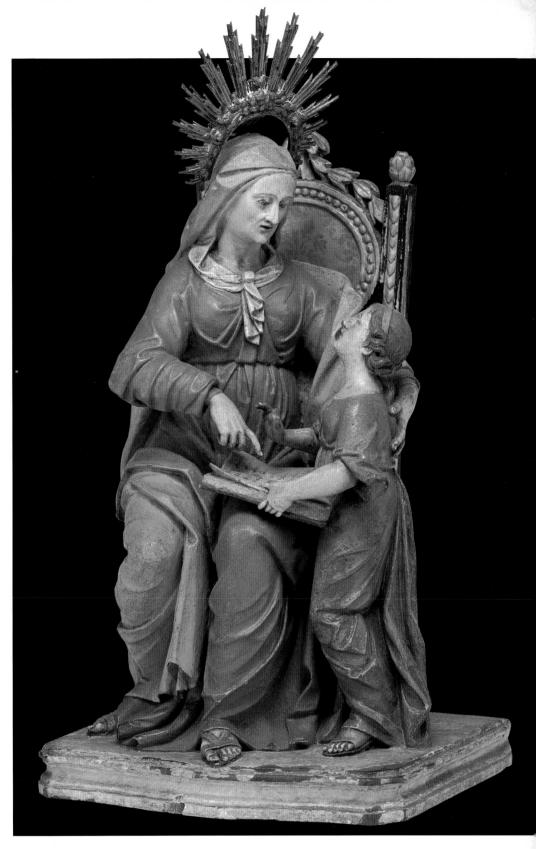

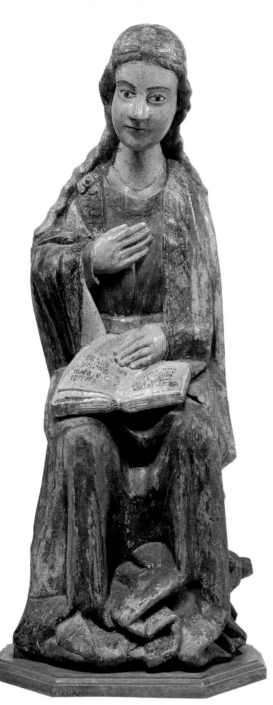

This work was probably originally part of an Annunciation group that included an image of the archangel Gabriel. As a work of the early sixteenth century, this sculpture of the Annunciation to the Virgin has medieval characteristics, such as her graceful, elongated proportions. The presence of the annunciate angel is suggested by her gesture of surprise as she lifts her hand to her chest. The Virgin's serenity and acceptance of the Divine Will is palpable in the gentle sweetness of her expression, the confident gaze of her prominent eyes, and her assured smile.　　**T.L.V.**

18 *Virgin of the Annunciation*

[Virgem da Anunciação]
First quarter of the sixteenth century
Polychromed wood
710 mm (height); 305 × 260 mm (base)
Museu Nacional de Arte Antiga, Lisbon

19 *Annunciation*

[Anunciação]
Fourteenth century
Marble
950 × 1,250 × 250 mm
Museu de Évora

Originally from the mausoleum of Rui Pires de Alfageme, this relief of the Annunciation portrays, on the left, the archangel Gabriel on his knees (a common representation at the time), holding a billowing scroll. On the right is the Virgin, greeting him with her left hand, while her right hand is on her abdomen, over the womb that will receive the Son of God. Between both figures is a vertical bookshelf holding a bible, which functions as the organizational axis of the composition.

The scene, arranged beneath three trefoiled arches with delicate botanical motifs as ornamentation, shows the figures of the archangel and the Virgin clearly separated from the background, which is carved in lower relief. The static and hieratic aspects of the composition give the scene a feeling of gravity, which is lightened only by the irreverent curve delineated by Gabriel's scroll.　**T.L.V.**

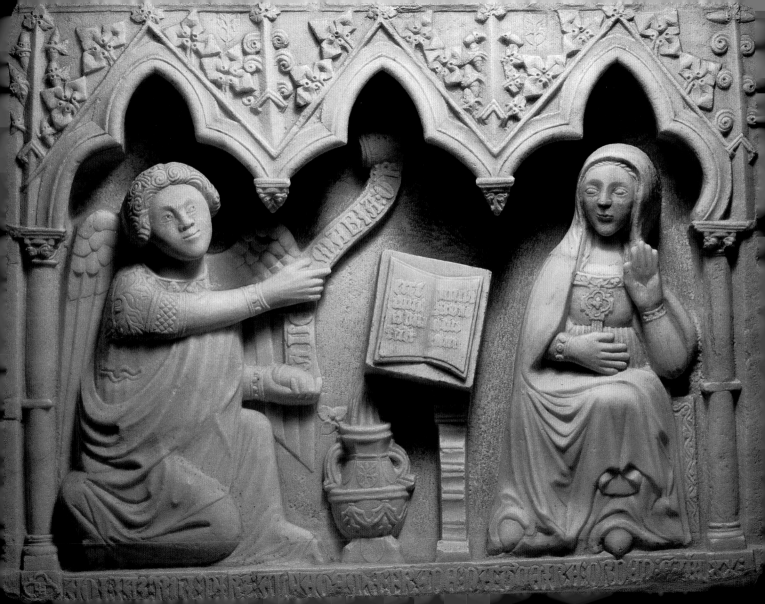

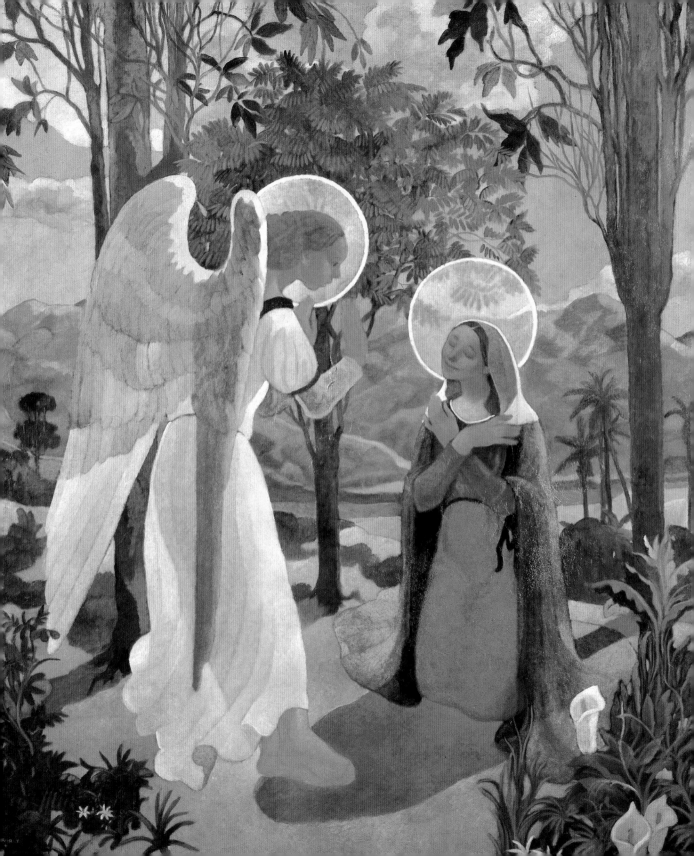

20 *A*nnunciation

[Anunciação]

Jorge Barradas (1894-1971)

1936

Oil on canvas

2,100 × 1,800 mm

Museu do Chiado, Lisbon

Jorge Barradas was known for his humorous illustrations as well as for his scenes of everyday life in Portugal. Painted in the spirit of Maurice Denis, this Annunciation, *in its soft ornamental tones and Art Nouveau articulation, has a tropical undertone. Barradas made a trip to the island of São Tomé in 1930, which resulted in various paintings on themes of the island. In 1933, thanks to a grant from the Instituto de Alta Cultura, he visited museums in England, France, Italy, and Spain, from which he absorbed the aesthetics of the Nabis and the pre-Raphaelites, which are evident in this painting. A highly decorative and sentimental image of the Annunciation, this early twentieth-century work lacks the drama and immediacy of medieval, Renaissance, or Counter-Reformation pieces, which were created in moments of unquestioned faith in Europe. Instead, this work is mediated by the artist's sense of decorative intimacy and nostalgia.*　　　　　**A.J.A.**

BIBLIOGRAPHY

Arte Moderna Portuguesa através dos Prémios Artísticos do S.N.I. (1935-1948), exh. cat. Lisbon, 1948.

José-Augusto França. *A Arte em Portugal no século XX (1911-1961).* 3rd edition. Venda Nova, 1991, pp. 162-63.

António Rodrigues. *Jorge Barradas.* Lisbon, 1995, p. 72.

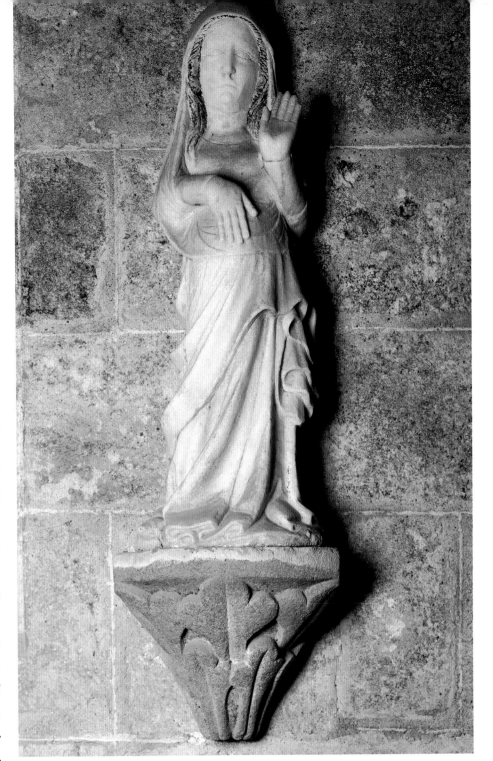

21 *O*ur Lady of O

[Nossa Senhora do Ó]

Fifteenth century

Limestone

840 mm (height); 295 × 215 mm (base)

Museu de Sé de Évora

In this representation of the Virgin during her pregnancy, Mary rests her left hand on her swelling womb while her right hand is raised in a salute to the faithful.

The origin of the cult of Our Lady of O appears to be associated with the recital of

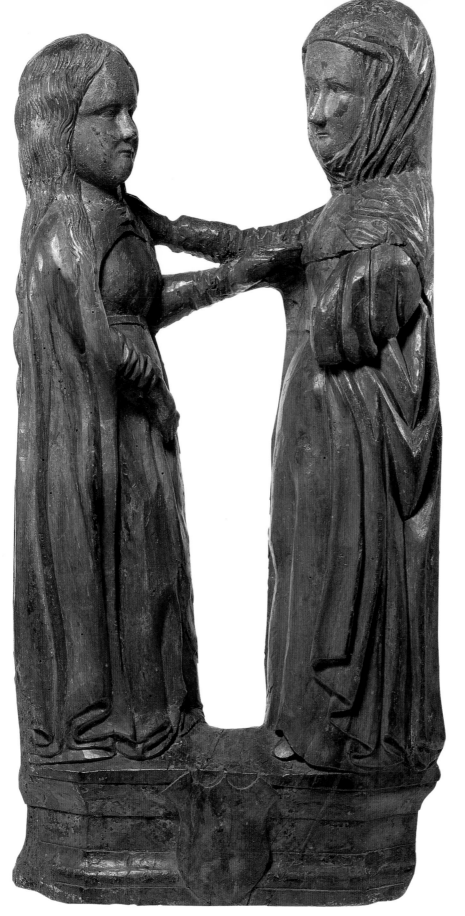

the seven antiphonies that start with "O" – O Sapientia, O Adonai, and so on – during the Vespers of the divine Rites that occur between December 17 and 23. The festivities date back to the Council of Toledo in the seventh century.

This representation of the Virgin was quite popular in Portugal during the Middle Ages and also appeared under the designation of Our Lady of Hope (Nossa Senhora da Esperança). These images, however, were progressively removed from altars during the Counter-Reformation, which considered it inappropriate to depict the mother of God during her pregnancy. The dynamic elements of the composition lie above all in the treatment of the surfaces and the drapery, which are organized along diagonal axes and presented with naturalistic folds. This was characteristic of the Gothic movement, along with Mary's elegant, swaying stance.

T.L.V.

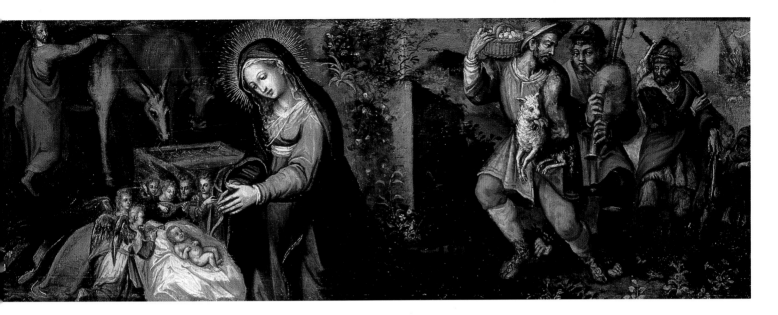

22 *Visitation* [Visitação]

**Late fifteenth century –
early sixteenth century
Polychromed wood
905 mm (height)
Museu Nacional de Arte Antiga,
Lisbon**

The theme of this sculpture is Mary's visit to her cousin Elizabeth, as narrated by the evangelist Saint Luke (1: 40-45). The work depicts the precise moment at which the two women meet in the house of Zacharias and Elizabeth, in a city of Judea. Their outstretched arms create tension and drama, which underscores their joyous recognition of each other's miraculous pregnancy.

Saint Luke's account of the occurrence tells us that when Elizabeth heard Mary's salutation, the infant she was carrying in her womb (who would be Saint John the Baptist) leapt for joy. This is interpreted as the future prophet recognizing the presence of Jesus Christ (whose coming he would later announce) in Mary's womb. The work reveals its medieval character in the self-contained geometry of the figures. The fragile arms, which stretch from one compact figure to the other, suggest the tenderness and intimacy of their emotional communication. **T.L.V., E.J.S.,** and **J.D.D.**

23 *Nativity, the Adoration of the Shepherds and Magi*

[Presépio, Adoração dos Pastores e dos Magos]
**Vasco Pereira Lusitano (1535-1609)
1575
Oil on panel
320 × 1,165 mm
Museu Nacional de Arte Antiga,
Lisbon**

This late-Mannerist painter worked in both Portugal and Spain. According to his Spanish biographer, Agustín Ceán Bermúdez, Vasco Pereira Lusitano spent his mature years in Seville (where he died). There, he became well-known for his fresco paintings. Ceán also mentions his excellence as a draftsman, while citing the dryness of his colors.

In the central panel of this triptych, the Virgin Mary is depicted adoring her newly born child. The Mother and Child are surrounded by angels playing music, which were copied from an engraving by Cornelis Cort. In fact, Vasco Pereira Lusitano had 2,407 engravings by Cort in his workshop at the time of his death. The panel on the right shows two shepherds approaching, and the one on the left shows the Magi. The signature and date are inscribed on the left panel. **A.J.A.** and **E.J.S.**

BIBLIOGRAPHY

Agustín Ceán Bermúdez. *Diccionário historico de los mas ilustres profesores de las Bellas-Artes de España*, vol. 5. Madrid, 1800.

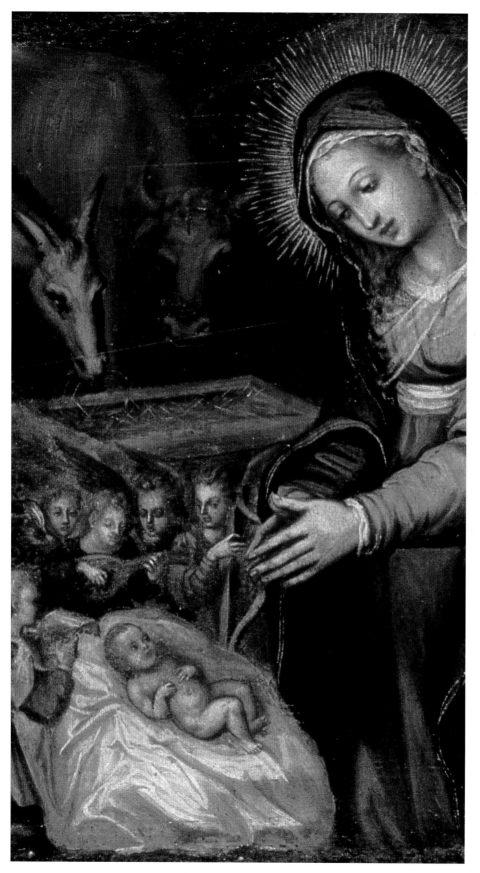

Atanasio Raczynski. *Dictionnaire Historico-Artistique du Portugal.* Paris, 1847, p. 228.

Fernando de Pamplona. *Dicionário de Pintores e Escutores Portugueses ou que trabalharam em Portugal.* 2nd edition. Lisbon, 1988, vol. 4, p. 309.

Juan Miguel Serrera. "O eixo pictórico Sevilha-Lisboa no século XVI: Francisco Venegas e Vasco Pereira" and "Vasco Pereira." In *A Pintura maneirista em Portugal. Arte no Tempo de Camões,* exh. cat. Lisbon, 1995, pp. 128-33, 498-99.

24 *Virgin Suckling the Infant Jesus*

[Virgem do Leite or Maria Lactans]

Third quarter of the fifteenth century

Polychromed stone

770 mm (height)

Museu Nacional de Arte Antiga, Lisbon

The image of Maria Lactans appeared as early as the second century A.D. in the catacombs of Priscilla in Rome. During the Middle Ages, representations of the Virgin (crowned as queen) breast-feeding her Divine Son became widespread. The inspiration for the image appears to be the Gospel of Saint Luke.

This sculpture, from the end of the Portuguese Gothic period, depicts the Virgin holding the Christ Child in her arms. This is an archaic Virgin for the fifteenth century; her blocky proportions and solid bearing suggest the enthroned Virgins of the Romanesque period, who brought structure and security to the image of the Christ Child as "Thrones of Wisdom." As such, they were also metaphors for the church. Crowned Queen of Heaven, this Virgin mother brings significant authority to this tender scene. **T.L.V.** and **J.D.D.**

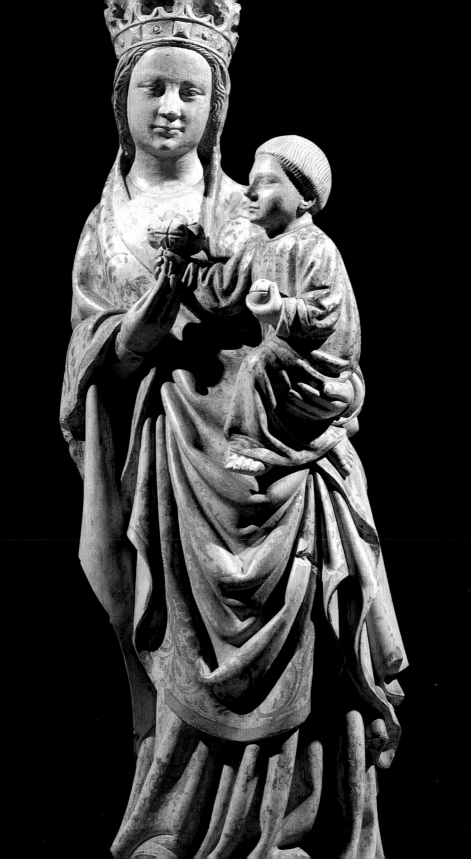

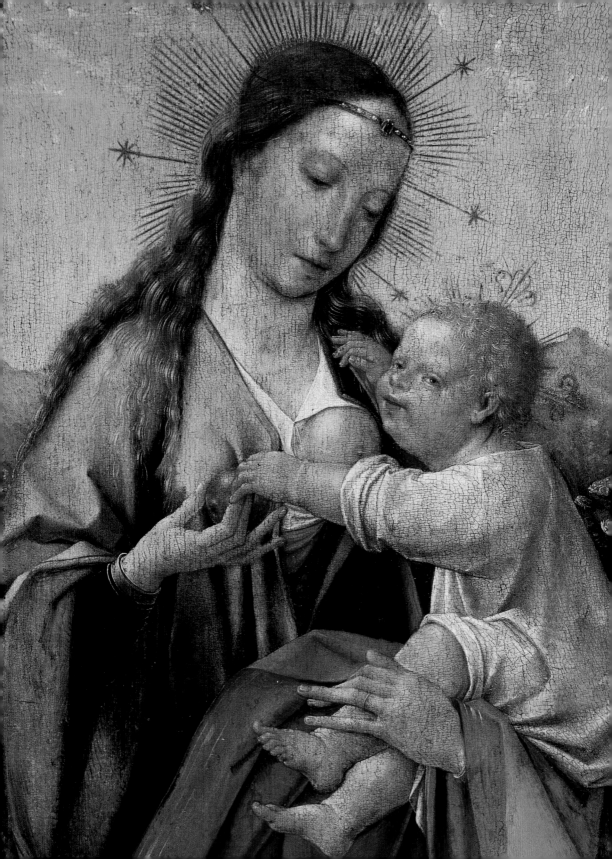

25 *Suckling Virgin*

[Virgem do Leite]

Attributed to Frei Carlos (active
1517-1540)

First third of the sixteenth century

Oil on oak

320 × 240 mm

Museu Nacional de Soares dos Reis, Porto

Frei Carlos, a Hieronymite monk of Flemish origin to whom this painting is attributed, maintained a workshop during the first half of the sixteenth century at the Monastery of Espinheiro, in Évora. He painted this Virgin with a sweet though inexpressive countenance, a wide face, a high forehead, and wide hands with thin and delicate fingers, her little finger isolated from the rest. She holds the Christ Child (chubby and round, with accentuated features), who appears to be more interested in the apple his mother holds in her left hand than in breast-feeding. This is one of a series of works that uses breast-feeding as a way of accentuating that which is accessible and human in the Virgin.

Although the origin of this panel is unknown, it shows the strong influence of fifteenth-century Flemish painting. The Flemish influence that is characteristic of the works attributed to Frei Carlos is most noticeable in smaller devotional easel pictures, especially in the overall sharpness, in the transparency and softness of the colors, and in the rendering of the clothing. The sober color palette is characteristic of the time. **A.J.A.**

BIBLIOGRAPHY

João Couto. *A pintura flamenga em Évora no século XVI, variedade de estilos e de técnicas na obra atribuida a Frei Carlos.* Lisbon, 1943.

João Couto. *A Oficina de Frei Carlos.* Lisbon, 1955.

José Alberto Seabra Carvalho. "Virgen de la Leche." In *El arte en la época del Tratado de Tordesillas,* exh. cat. Valladolid, 1994, pp. 217-18.

26 *Virgin and Child*

[Virgem com o Menino]

Second quarter of the fifteenth
century

Polychromed limestone

736 × 315 × 225 mm

Museu Nacional de Arte Antiga,
Lisbon

This representation of the Virgin and Child is part of the iconographic grouping generically known as the Virgin of Tenderness. It replaced the model of the Virgin as simply the throne of the Son of God, an image that was utilized in Western art until the twelfth century. Beginning in the following century, the representations emphasized more human attributes, in which the Virgin does not merely present her Divine Son for the adoration of the faithful but has an intimate relationship with him, as a normal mother would have with her child.

But this Virgin is also an elegant, regal lady. The curve of her body suggests that she is part of the fashionable, aristocratic tradition begun as early as the thirteenth century in Rayonnant France. Such gothic Virgins are also Queens of Heaven: crowned,

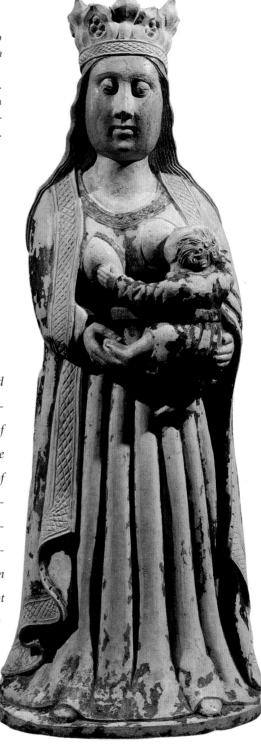

and elegantly attired in opulent garments, they provide favorable metaphors for contemporary queens, thus associating the monarchy with the power of the Queen of Heaven. **T.L.V.** and **J.D.D.**

27 *Virgin and Child*

[Virgem com o Menino]

Seventeenth – eighteenth century

Polychromed wood

730 mm (height)

Museu de Aveiro

This representation of the Virgin with her Divine Son as a child in her arms is a work that reveals much about the sculptural language of the Portuguese Baroque. The main concern of Baroque sculpture – to create a sense of emotional immediacy through drama and movement – is essentially achieved in this image through the treatment of the drapery, which is organized along various compositional axes and developed in multiple surfaces, and through the work's rich coloring, which was popular among Portuguese sculptors at the time.

In addition, there are elements of this sculpture that evoke a dramatic coalescence of the worldly and the divine; the gentle tenderness of the faces of the Virgin and Christ Child, for example, is echoed in those of the putti below them. These angels also function as a support for the fleshy and believable figures of the mother and child. These traits characterize this sculpture as a quintessential expression of Baroque sensibility. **T.L.V** and **E.J.S.**

28 *Virgin and Child*

[Virgem com o Menino]

Eighteenth – nineteenth century

Ivory

144 mm (height)

Private collection, Lisbon

This interpretation of the Virgin and Child image was common in the Christian imagery of China during this period. The Virgin is standing, holding the Child, who is balanced on her right hip. Her crown and adornments are indigenous: long, hanging earrings and a necklace; a double tiara in a petaloid shape; and her hair combed in rolls on the top of her head with the ends falling down her back. She wears a long, tight tunic with a noose bow, with the extremities falling in front of her, and a small cape with a wide fold over her shoulders. The Virgin and Child are both adorned with scattered floral motifs; the cape has an ornamented lower border, and its top border is marked by petaloid adornments. The Child is shown with folded legs, which are covered by a cloth that is wrapped around his waist. Both figures are surrounded by a sinuous sash, which goes over their hands and under the arm of the Virgin and falls loosely at her feet.

Reprinted, with alterations, from Encontro de culturas: oito séculos de missionação portuguesa, *exh. cat. (Lisbon, 1994).*

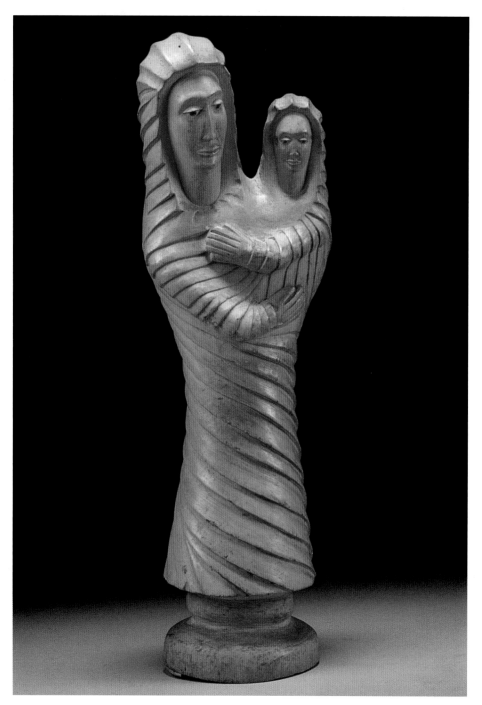

fabric privilege the dynamism of abstract form over naturalistic representation. It provides the sculptural form with an abstract structure that energizes it, as in much traditional Angolan carving. In this way, a particular mimetic or naturalistic image of the Virgin as might appear in contemporary European expression is rejected in favor of one whose surface creates its power and meaning. The Virgin's cloak, hooding her head and the Child, is a powerful device that emphasizes the mother's protective, nurturing values in a particularly effective way.

J.D.D. and **E.J.S.**

30 *Virgin and Child*

[Nossa Senhora do Pópulo]
Josefa de Óbidos (1630-1684)
c. 1670-80
Oil on canvas
1,284 × 940 mm
Casa Hospitalar das Caldas da Rainha

This half-length image of the Virgin and Child derives its ultimate inspiration from a twelfth-century Byzantine Madonna in the Cappella Paolina of the Church of Santa Maria Maggiore, Rome. According to legend, this is the painting that was executed by Saint Luke himself, patron of artists. Known as the Virgin of "Il Popolo," this image, venerated for its supposed miraculous powers, has engendered many replicas.

As Vitor Serrão reports, the Virgem do Pópulo (as it became known in Portugal)

29 *Virgin and Child*

[Virgem com o Menino]
Twentieth century (?)
Wood
320 × 108 × 84 mm
Museu Antropológico
da Universidade de Coimbra

This Virgin and Child, made in Angola, is depicted in a conventional format, the child balanced on his mother's hip. What is distinctive is the highly stylized mantle in which the pair of figures are draped, revealing only their faces and one hand of each. The broad, sweeping bands of

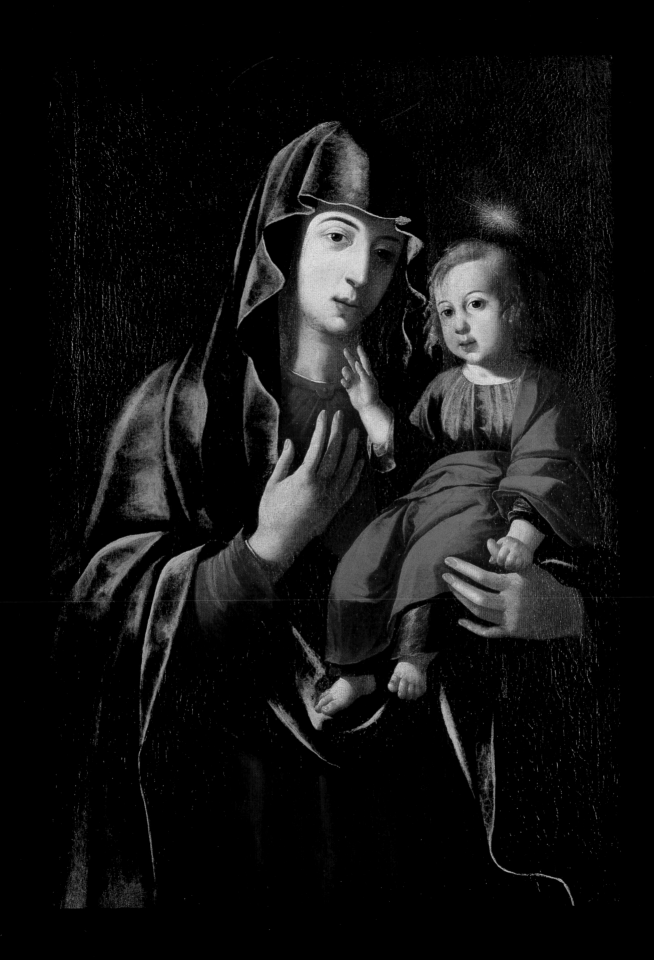

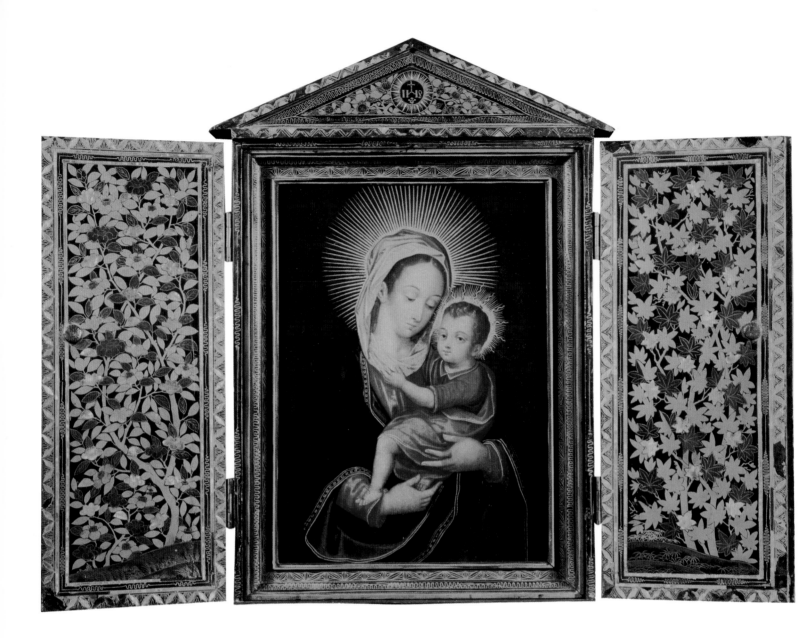

became a favorite likeness among the Jesuits beginning in the sixteenth century. They ordered many copies of this Madonna for their religious institutions. One of these, in the Santa Casa da Misericórdia in Lisbon, is by the Jesuit painter João de Maiorca (sixteenth century) and another, in the new Cathedral (Sé Nova) in Coimbra, was most likely the model for this work by Josefa.[1] It was commissioned for

the Church of the Hospital of Nossa Senhora do Pópulo in Caldas da Rainha, founded by Dona Leonor at the end of the fifteenth century. It was she who chose Nossa Senhora do Pópulo as the patron saint.[2]

E.J.S.

[1] See Vitor Serrão, ed., *Josefa de Óbidos e o Tempo Barroco*, exh. cat., second ed. (Lisbon, 1993), p. 216

[2] See Custódio Viera da Silva, *A Igreja de Nossa Senhora do Pópulo das Caldas da Rainha* (Caldas da Rainha, 1985), p. 26.

31 *Oratory* [Oratório]

Late sixteenth century

Oil on copper in oratory of lacquered wood inlaid with gold, silver, copper, and mother-of-pearl

472 × 350 × 510 mm

Santa Casa da Misericórdia do Sardoal

Painted in Japan in the late sixteenth century, during the Momoyama period, this

triptych of rectangular panels with a triangular frontispiece is an interpretation of a traditional oratory with a Virgin and Child. The main panel depicts the Virgin Mary with the Christ Child on her lap, in a representation that follows the European models of the period. The frame is adorned with straight lines and coiling tendrils. The movable side panels are decorated – both obverse and reverse – with Japanese floral themes (such as citrus trees, wild cherry trees, maples, and white camellias), contained by a border with zigzagging and coiling adornments. The frontispiece, which is decorated in similar fashion, has the Jesuit emblem, IHS, inside a circular halo.

Reprinted, with alterations, from Encontro de culturas: oito séculos de missionação portuguesa, *exh. cat. (Lisbon, 1994).*

32 *Virgin, Child, and Two Angels*

[A Virgem, o Menino e dois Anjos]
(front)

Christ in Majesty [Cristo em Magestade] (back)

Attributed to Frei Carlos (active 1517-1540)

Sixteenth century

Oil on wood

410 × 315 mm

Museu Nacional de Arte Antiga, Lisbon

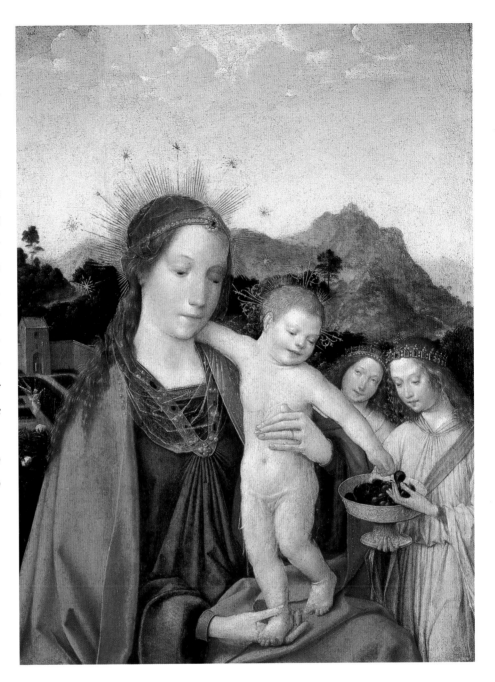

This painting was originally from the Monastery of Espinheiro, in Évora, where

Frei Carlos – to whom the work is attributed – had a workshop during the first half of the sixteenth century. At the end of the seventeenth century, the work was taken to the Monastery of Santa Maria de Belém, in Lisbon, which was also of the order of Saint Jerome.

In a landscape reminiscent of those found in Flemish paintings of the period, the

crowned Virgin holds a playful figure of the Christ Child. With his right hand around his mother's neck, he takes with his left hand a fig from a bowl held by an angel, while another angel observes the scene.

In this intimate representation, there is also a suggestion of the Eucharist and the redemptive cycle set in motion by Christ's

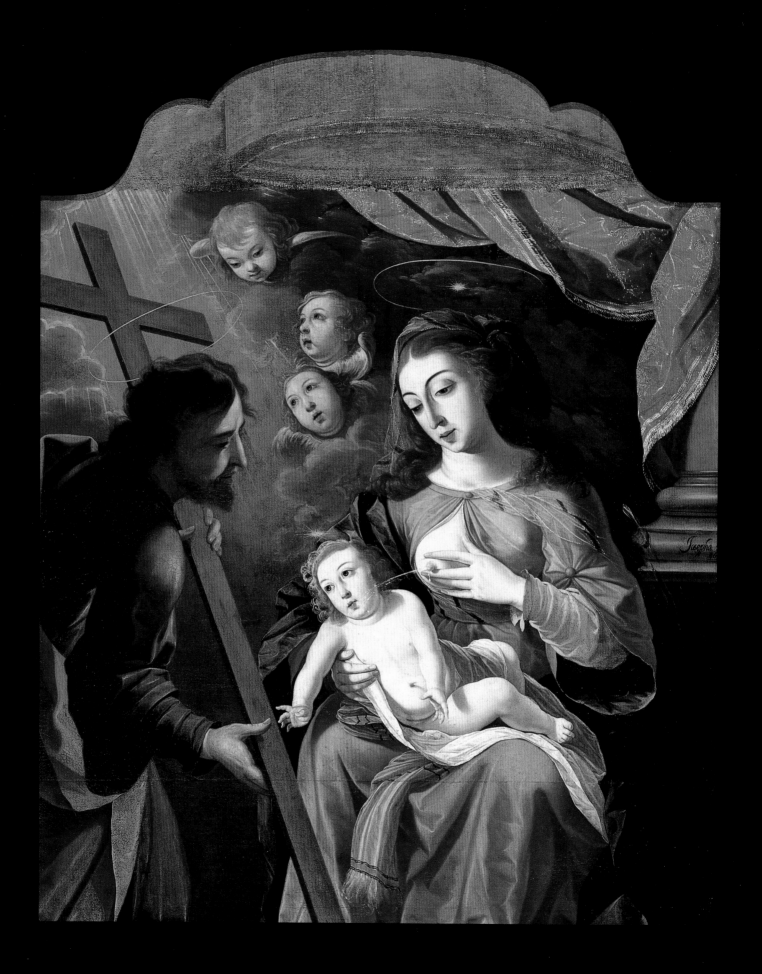

birth. The fig that the Christ Child grasps is symbolic of the Fall, since it is the fruit that Eve plucked from the tree of knowledge. Further, the Christ Child, nude and in a contraposto position, is, like his Italian Renaissance counterparts, a classical heroic type. The ensemble thus carries a veiled reference to Christ as a hero who will save mankind from the Fall.

A.J.A., E.J.S., and **J.D.D.**

BIBLIOGRAPHY

João Couto. *Frei Carlos e a Oficina do Espinheiro.* Lisbon, n.d., p. 8.

Jerónimos – 4 séculos de pintura, exh. cat. Lisbon, 1992.

33 *Holy Family*

[Sagrada Família]

Josefa de Óbidos

1672

Oil on canvas

1,660 × 1,435 mm

Igreja Matriz, Cascais

This well-known painting dates from one of the most productive periods in the career of the artist. By the 1670s, Josefa de Óbidos had reached the peak of her artistic maturity and was being commissioned to paint numerous individual works as well as series for religious institutions throughout Portugal. This painting was part of an altarpiece executed for the now-defunct Carmelite convent in Cascais, near Lisbon. The works are presently in the Igreja Matriz of the same town. There were six paintings done for this commission and all but the present work depict scenes of the visions of Saint Teresa de Ávila as narrated in her autobiography. The Holy Family was most likely the central image in the altar of the convent. Vitor Serrão has posited a reconstruction of the placement of the paintings. He, as well as Luís de Moura Sobral, also note that the compositions of the Cascais paintings of the life of Saint Teresa were suggested by Flemish prints by Adriaen Collaert and Cornelis Cort.[1] A Flemish source has also been cited for the Holy Family, which appears to be based upon a print by Raphael Sadeler after a painting by Martin de Vos.[2] While this painting represents a tender scene of familial warmth, it also embodies the complexity of the iconographic meanings that are often present in works by Josefa de Óbidos. The Virgin holds the Christ Child in her lap. She attempts to suckle him but he turns away from her to touch the wooden cross held by Saint Joseph.[3] Thus this image combines an episode from the earliest childhood of Jesus with a foreshadowing of his passion and death. In the upper portion of the composition, there are several cherubs who seem to descend from a miraculous opening in the sky, from which a gold light illuminates the scene. The Virgin and Child are seated next to a column on the base of which is inscribed the artist's name and the date. Rich swags of drapery and a suggestion of a red cloth canopy above the participants add a note of solemnity and richness to the scene.

Marina Warner has shown that the subject of the lactation of the Christ Child by Mary was a popular theme from the Middle Ages until the Renaissance (see the Maria Lactans image in this exhibition, cat. no. 24). She further states that by around 1600, it had waned in favor in most western European countries.[4] Art in the Iberian Peninsula provided an exception to this rule, however. Spanish artists such as Juan de Roelas, Alonso Cano, and Bartolomé Esteban Murillo executed well-known images of a variation of this theme in which the Virgin appears to Saint Bernard and offers her milk to him. In the art of Josefa de Óbidos, there are several instances of lactation imagery. These include a small Suckling Virgin painted on copper, of 1650-60 (private collection, Lisbon) as well as the better-known Apparition of the Virgin to Saint Bernard (1660-70, Museu Nacional de Machado de Castro, Coimbra), in which the enthroned Virgin is surrounded by Carmelite saints who observe her lactation of the holy man. Josefa painted a canvas dated 1664 depicting the Holy Family in which the Virgin attempts to suckle the Christ Child who rejects her milk, turning his attention instead to the cross held by his earthly father Saint Joseph. She repeated this composition eight years later for the Carmelite convent at Cascais. The earlier Holy Family (Direcção-Geral das Florestas, Lisbon) differs from the Cascais painting in only a few details. It includes five cherub heads

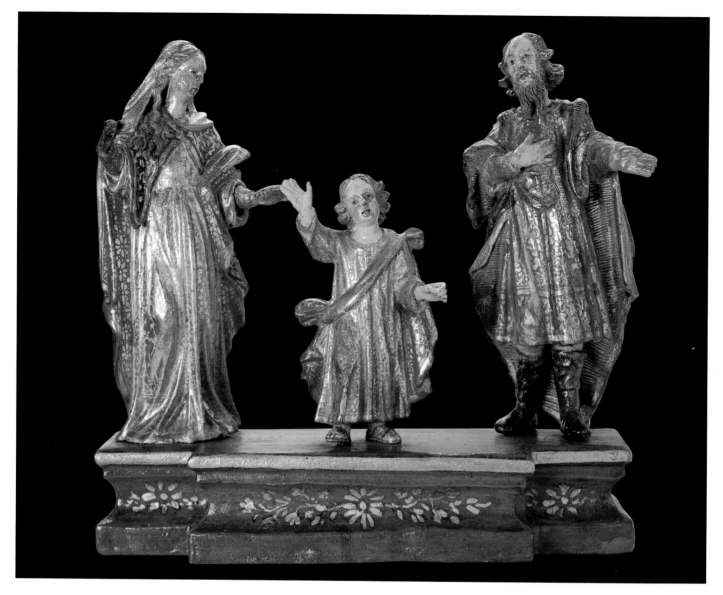

instead of three and lacks the column and cloth canopy that add weight and stability to the magisterial Holy Family *in the present exhibition.* **E.J.S.**

1 Vitor Serrão, ed., *Josefa de Óbidos e o Tempo Barroco,* exh. cat., second ed. (Lisbon, 1993), p. 183, and Luís de Moura Sobral, "Josefa d'Óbidos," in Serrão, *Josefa de Óbidos,* pp. 60-62.

2 See Barbara Van Barghahn, "A Quest for Paradise," in *The Sacred and the Profane: Josefa de Óbidos of Portugal,* exh. cat. (Washington, D.C., 1997), p, 79.

3 For a discussion of the iconography of Saint Joseph in this painting, see Von Barghahn, "A Quest for Paradise," pp. 78-80.

4 Marina Warner, *Alone of All Her Sex* (New York, 1983), pp. 192-205.

34 *Holy Family (with Christ)*

[Sagrada Família (com Cristo)]

Eighteenth century

Polychromed wood with gold leaf

250 mm (height); 270 × 85 mm (base)

Museu de Arte Sacra da Capela de São Miguel, Universidade de Coimbra

Eighteenth-century representations of the Holy Family, depicted as everyday individuals, are particularly interesting because they were created in order to bring the faithful closer to the objects of their devotion. Without ignoring the divinity of Christ and the holiness of Mary and Joseph, the Portuguese Baroque artists were able to show the Family's earthly existence, depicting the Son of God as any other child in the company of his parents. Though not an erudite work, this sculpture nonetheless reveals a clear Baroque influence in the dynamic composition of the drapery, the vivid polychromy, and the use of gold leaf. **T.L.V.**

35 *The Virgin, Saint Anne, and Saint Joachim*

[Nossa Senhora, Santa Ana
e São Joaquim]

Eighteenth century

Polychromed wood with gold leaf

260 mm (height);

260 × 100 mm (base)

Museu de Arte Sacra da Capela de

São Miguel, Universidade de Coimbra

Closely related to Holy Family (with
Christ) *(cat. no. 34) – they were certainly*
part of an ensemble (note the identical
decorative treatment of the bases) – this
group portrays Mary as a young girl accom-
panied by her parents, Saint Anne and
Saint Joachim, and, like its companion,
focuses on the human qualities of the Holy
Family. These family representations de-
rived from the broad interest in the gen-
ealogy of the Virgin, which is traced and
often depicted through the Tree of Jesse.
The source of these simple groupings is not
the canonical Gospels, but the Apocrypha,
where the names of Mary's parents and
other details are revealed. **T.L.V.**

36 *Holy Family with Saint Anne and Saint Joachim* [Sagrada Família
com Santa Ana e São Joaquim]

Eighteenth century

Polychromed wood with gold leaf

895 mm (height); 1,010 × 470 mm (base)

Museu da Igreja dos Clérigos, Porto

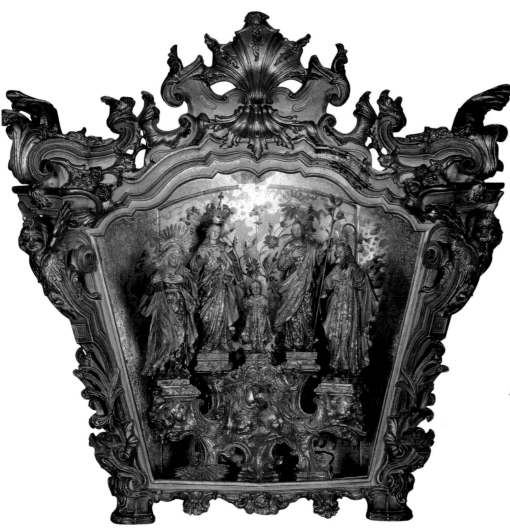

depicts the flight of Mary, Joseph, and the Christ Child into Egypt. Guided by an angel, they try to escape the massacre of the innocents ordered by Herod (Matt. 2: 13-23). Although the Gospel makes no mention of the fact, the donkey is normally led by Joseph, which is a more natural interpretation than the scene shown on these tiles. Here, the angel guides the donkey while Joseph follows behind. This is not an unusual depiction in Counter-Reformation versions of this theme, which often combine vernacular and miraculous details.

In the center of the composition is the figure of the Virgin carrying the Christ Child in her arms, forming a vertical axis that is contrary to the predominantly horizontal organization of the scene, the spatial openness of which is created by the landscape in the background.

The art of tile making is enormously important not only for understanding a vital facet of Portuguese visual expression, but also as an indicator of the multicultural nature of the country's artistic traditions. The earliest tiles found in Portugal date back to Roman times, and the medium flourished in the late Middle Ages and onward under the stimulus of Islamic tile making. Portugal soon became the leading European producer of tiles, which were often exported to its colonies in the Americas, Asia, and Africa. This spread of the art of tiles accounted for a great variety within the medium of both Asian and

Situated within the context of eighteenth-century representations of the Holy Family, this work depicts the young Jesus Christ surrounded by his parents Mary and Joseph, as well as his grandparents Anne and Joachim. Jesus occupies the center of the composition, portraying his central and determining position within the family structure.

The aesthetic of the eighteenth-century Portuguese Baroque is very apparent in this work, not only in the scenographic composition and in the forms of the figures, but also in the elaborate pedestals on which they are placed and, especially, in the ela-

borately carved and gilded wood shrine. The theatrical setting lends a regal air to an otherwise domestic scene. **T.L.V.**

37 *Flight into Egypt*

[Fuga para o Egipto]

Attributed to Policarpo de Oliveira Bernardes (1695-1778)

c. 1730

Blue and white ceramic tile

570 × 990 mm

Museu Nacional do Azulejo, Lisbon

Attributed to the tile painter Policarpo de Oliveira Bernardes, this panel of tiles

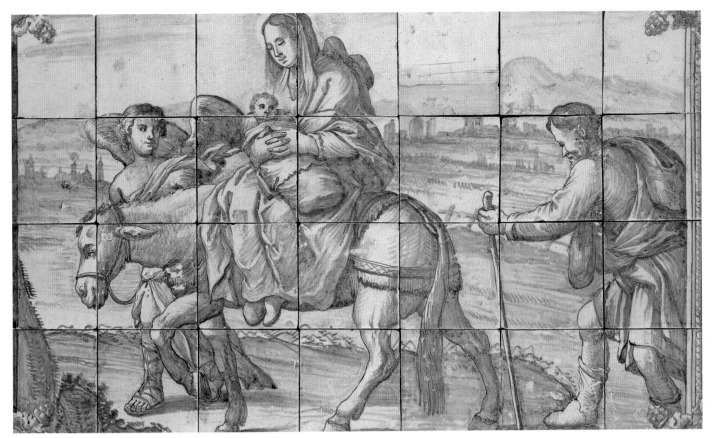

European inspiration. Tiles were (and continue to be) consistently used to adorn walls and even façades of houses, and they were also employed as substitutes for canvas paintings in churches and chapels.

T.L.V. and **E.J.S.**

38 *Rest on the Flight into Egypt*

[Repouso na fuga para o Egipto]

Josefa de Óbidos (1630-1684)

c. 1660-70

Oil on canvas

830 × 610 mm

Private collection, Lisbon

The scene in this painting represents an episode in the life of the Holy Family not found in the New Testament. In his Gospel, Saint Matthew (2: 13-23) describes the flight of the Holy Family into Egypt in order to avoid the massacre of all male children under the age of two years that had been ordered by King Herod. However, he provides us with few "details" of their journey. The apocryphal Gospel of Pseudo-Matthew contains many of the «details» of the Flight, including the story of the Rest by the Holy Family during their ordeal. According to these legends, the family was miraculously provided with water from a spring that arose from the roots of a palm tree and was fed by the branches of a date palm that lowered its branches so that Mary could pick the fruit.[1] This episode is depicted in this painting by Josefa de Óbidos, which

was recently published for the first time by Vitor Serrão.[2] In this version, however, Saint Joseph offers a branch of cherries to the Christ Child instead of proffering dates to the Virgin.

Serrão states that Josefa's painting is a virtual copy of a work known in two versions by her father, Baltazar Gomes Figueira (in the hermitage of São Brás de Dagorda and the Church of Graça, Coimbra), which itself was inspired by a print after a work by the Italian late-Renaissance painter Federico Barocci. Barocci's best-known of his three versions of Rest on the Flight *is* in the Pinacoteca Vaticana, Rome, and dates from the early 1570s. Another of these versions was engraved by the Flemish artist Cornelis Cort in 1575.[3] The

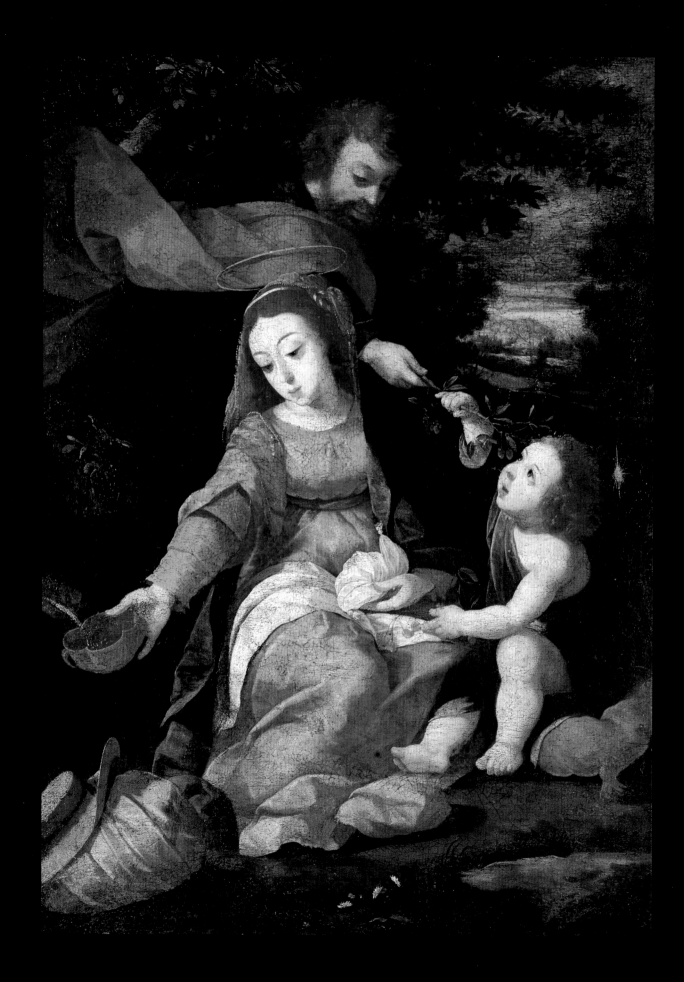

composition became an extremely popular one throughout Europe because of the widespread distribution of this print. It enjoyed particular favor in the Iberian Peninsula. Serrão lists a dozen variations by seventeenth-century Portuguese and Spanish artists.[4] Although Josefa's work closely follows that of her father's painting (itself done after Cort's engraving of Barocci's painting), she adds her own distinctive bright coloring to the scene and includes her characteristic facial features (small mouth, almond-shaped eyes) in the figures of the Christ Child and the Virgin. **E.J.S.**

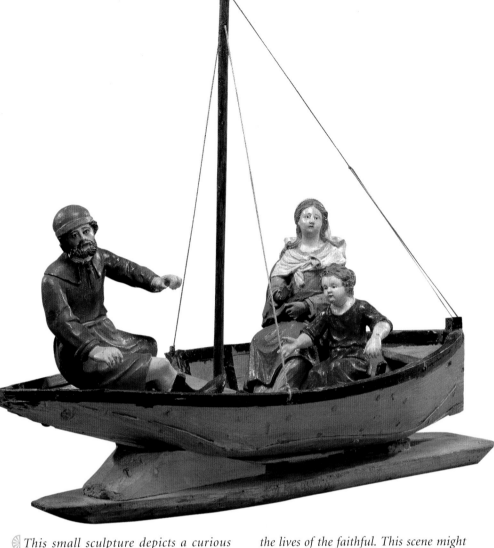

[1] For a discussion of the Flight into Egypt and its iconographical elements, see Marina Warner, *Alone of All Her Sex* (New York, 1983), pp. 28-29, and Louis Réau, *Iconographie de l'Art Chrétien* (Paris, 1959), vol. 2, pp. 278-79.

[2] Vitor Serrão, ed., *Josefa de Óbidos e o Tempo Barroco*, exh. cat., second ed. (Lisbon, 1993), pp. 161-62.

[3] For a further discussion of the work by Barocci and its versions, see Harald Olsen, *Federico Barocci* (Copenhagen, 1962), pp. 154-55, and Andrea Emiliani, ed., *Mostra di Federico Barocci*, exh. cat. (Bologna, 1975), pp. 85-86.

[4] Serrão, *Josefa de Óbidos*, p. 616. The subject of the Rest on the Flight into Egypt was painted prior to the sixteenth century by Portuguese and Spanish artists, including Vasco Fernandes and Fernando de los Llanos.

39 *Holy Family in a Boat*

[Sagrada Família num barco]

Late eighteenth century

Painted ceramic, glass, wax, and wood

345 × 420 × 155 mm

Museu Nacional de Machado de Castro, Coimbra

This small sculpture depicts a curious theme. The representation of the Holy Family in a boat can hardly be explained by the surviving narratives of the New Testament, whether canonical or apocryphal. One might therefore attribute the work's unusual subject and its nonerudite character to the sculptor's artistic freedom. The Holy Family is portrayed as any other family traveling in a boat, which is being guided by the father, Saint Joseph. The choice of an everyday scene places the work within the context of other eighteenth-century pieces that sought to compare the earthly existence of the Divine Family to the lives of the faithful. This scene might also be interpreted as a variation on the Flight into Egypt. It is plausible that the artist deemed it relevant to depict this well-known scene in a maritime situation rather than the conventional version on land. **T.L.V.**

40 *Pietà*

[Nossa Senhora da Piedade]

Fifteenth century

Polychromed limestone

905 × 530 × 365 mm

Museu Nacional de Arte Antiga, Lisbon

Medieval representations of the dead Christ in the Virgin Mary's arms, of which this is a noteworthy example, suggest an underlying parallel to representations of Christ as a child on his mother's lap. This association is present in the texts of Saint Bernard of Sienna and in the Meditations of Saint Bonaventure. It is in this context that the first Pietà statues appeared in Germany during the thirteenth century, and in France and Spain during the fourteenth and fifteenth centuries.

The anatomically exaggerated rendering of the body of Christ – aligned along a diagonal axis, as was characteristic in Pietà sculptures during the fifteenth century – with his feet touching the ground, graphically expresses the suffering inflicted upon the son of God. The rigid and hieratic composition confers upon the work a sense of solemnity, which is accentuated by the Virgin's countenance. **T.L.V.**

41 Pietà

[Nossa Senhora da Piedade]
Seventeenth century
Polychromed wood
1,020 × 620 × 380 mm
Museu de São Roque/Santa Casa da Misericórdia, Lisbon

This representation of the Pietà – originally from the church of São Roque da Companhia de Jesus – does not show

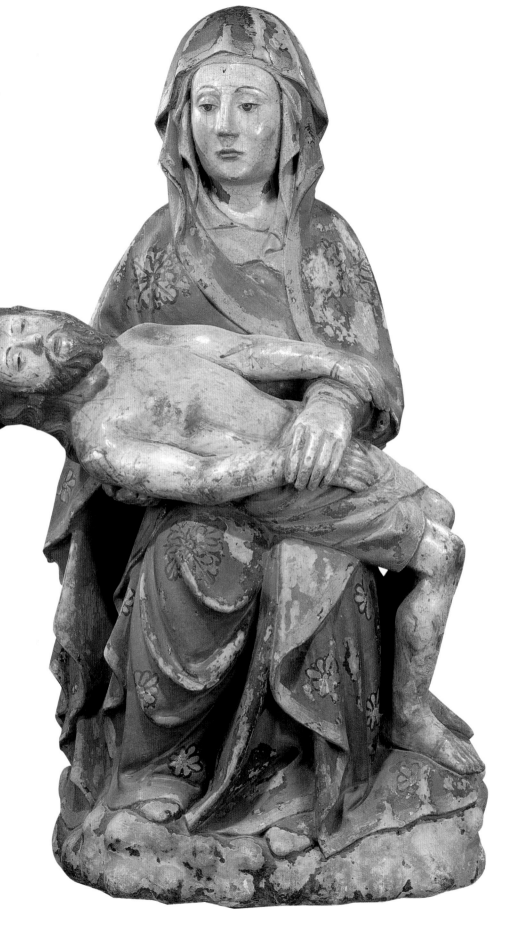

Christ dead on his mother's lap, as he is often depicted, but rather leaning on her. Christ is presented alongside the Virgin, who supports his body and guides it toward her lap. Their arms and hands are touching; especially moving are the delicate gestures of their left hands.

The Baroque theatricality, apparent in the mournful expression of the Virgin at the top of the composition, emphasizes not only the immense pain but also the transcendent aspect of the scene. This work is therefore characteristic of the post-Tridentine period, which valued the emotional engagement of the faithful with their religion.

T.L.V.

42 *Virgin of Sorrows*

[Nossa Senhora das Dores]

Eighteenth century

Polychromed wood

1,130 mm (height)

Museu de Aveiro

The iconography of the Virgin of Sorrows developed within the larger theme of the Pietà. The representation of the swords first appeared in the fifteenth century, and is an allusion to Simeon's prophecy: "Your soul will be crossed by swords" (Luke 2: 34-35). Initially five in number, a clear parallel to Christ's wounds, there were later seven swords, representing the seven sufferings of Mary that transformed her

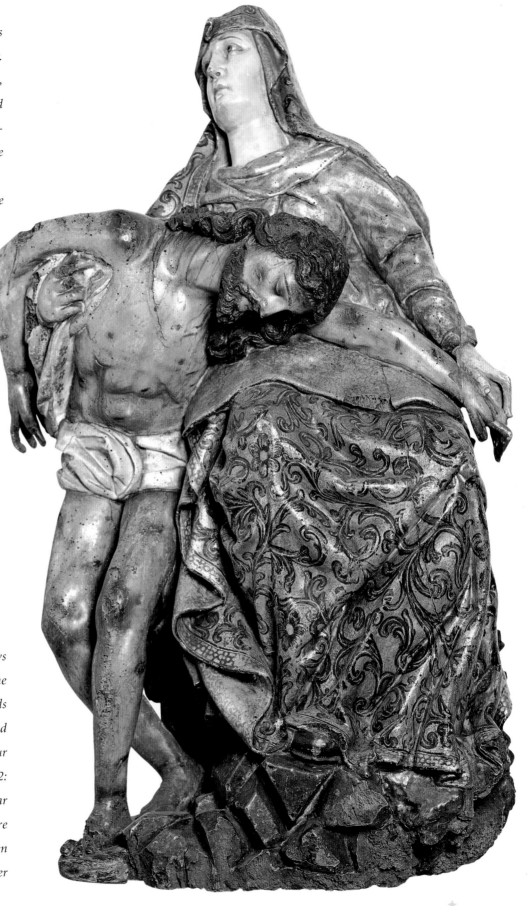

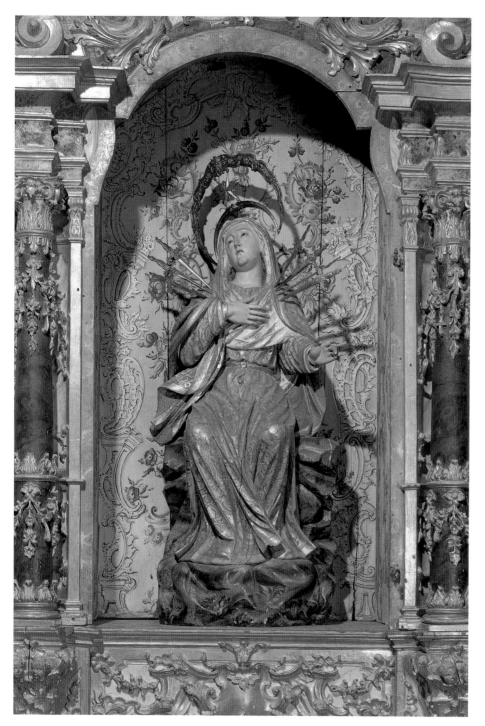

[Mater Dolorosa or Nossa Senhora das Dores]

Josefa de Óbidos (1630-1684)

c. 1680

Oil on canvas

955 × 690 mm

Private collection, Lisbon

In this painting, the Virgin stands alone with her arms crossed in an expression of anguish. The aureole surrounding her head bears the inscription "ECCE MATER" ("Behold the Mother"), suggesting that the iconography derives from the traditional imagery of the Virgin of Sorrows. In addition, a parallel is established with the Ecce Homo: the image of the suffering Christ. The Virgin of Sorrows type is a variation (or, rather, a distillation) of the Pietà; the Virgin expresses her affliction by herself, without the presence of the dead Christ. Josefa's painting is unusual because it lacks the element of the sword piercing the Virgin's heart, usually a standard component of the Virgin of Sorrows representation. Vitor Serrão, who published this work for the first time and who tentatively identified it as the painting referred to as a Senhora das Dores (Virgin of Sorrows) in a lateeighteenth-century account of the works in the novitiate chapel in the Convento de Varatojo, states that the image originally contained a sword, which disappeared in a nineteenth-century restoration.[1]

into a martyr. The devotion to the sufferings of the Virgin was further emphasized by the Order of the Servants of Mary, as a clear parallel to the seven pleasures advocated by the Franciscans.

The drapery shapes the body and defines predominantly diagonal folds, which lend rhythm to the composition. The Virgin is here depicted sitting with her eyes looking upward, her right hand on her breast and her left hand suspended, in a profoundly Baroque gesture and attitude. **T.L.V.**

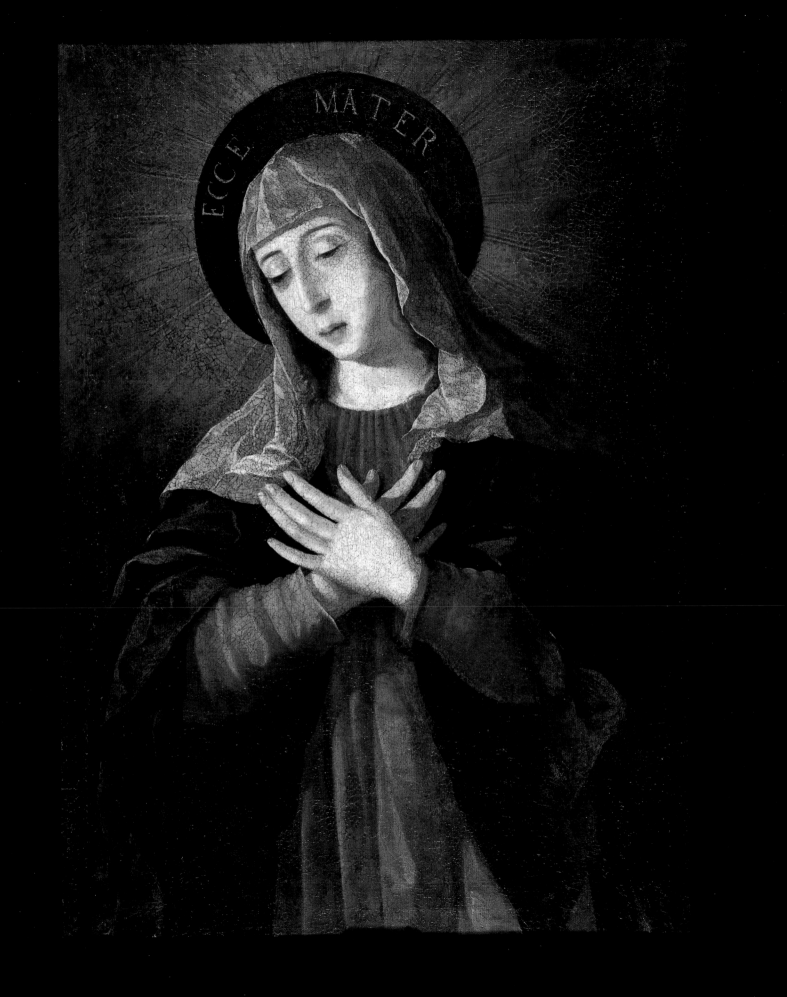

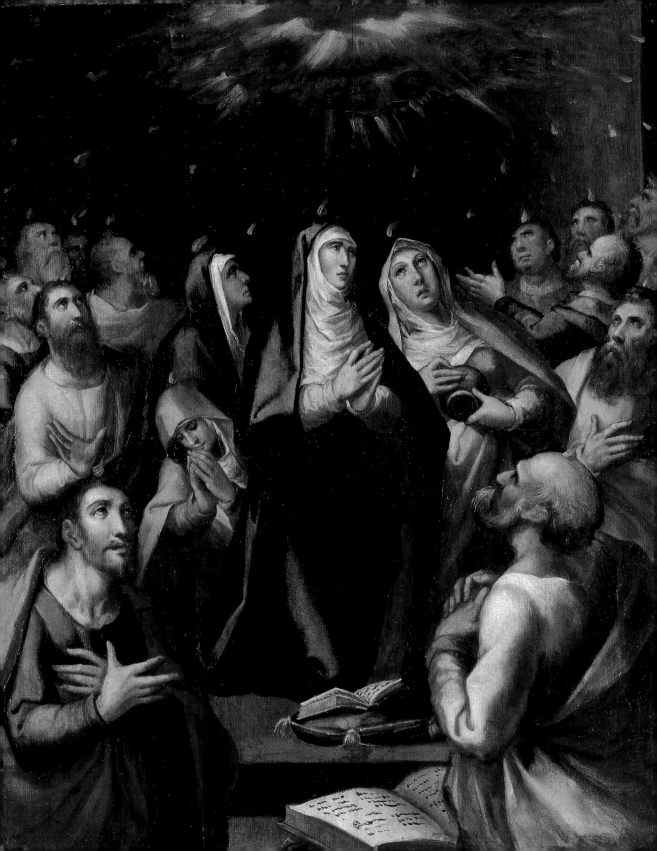

Devotion to the Virgin of Sorrows dates to the fifteenth century. In 1423, the Synod of Cologne added a feast day to the church calendar to celebrate the grieving Mother of God. The earliest images of the Mater Dolorosa in European art arose in the late fifteenth century in Flanders and became a popular iconography thereafter. Representations of the Virgin of Sorrows often included the presence of seven swords piercing the heart of Mary, referring to the seven sorrows that she suffered during her lifetime.[2] A sculpture of this type is included in the present exhibition (see cat. no. 42). The Virgin of Sorrows image was at times simplified by eliminating six of the seven swords. This image became very popular in the Iberian Peninsula and in colonial Latin America during the sixteenth and seventeenth centuries. **E.J.S.**

[1] Vitor Serrão, ed., *Josefa de Óbidos e o Tempo Barroco*, exh. cat., second ed. (Lisbon, 1993), p. 233.

[2] For a discussion of the development of this iconography, see Louis Réau, *Iconographie de l'Art Chrétien* (Paris, 1959), vol. 2, pp. 108-10.

44 *Pentecost* [Pentecostes]

Attributed to Simão Rodrigues (c. 1560-1629) and Domingos Vieira Serrão (1570-1632)

c. 1600

Oil on panel

780 × 625 mm

Museu Nacional de Machado de Castro, Coimbra

The style of this painting of the Pentecost, attributed to Lisbon painter Simão Rodrigues in collaboration with Domingos Vieira Serrão (from Tomar), represents a Portuguese variation of the central Italian manner of such painters as Correggio and Raphael, which became popular in numerous European artistic centers in the late sixteenth and early seventeenth centuries. Robert C. Smith has stated that this "is a style in which expressionless faces and inanimate gestures were considered a virtue."[1]

This work formed part of an altarpiece (of which four other panels, depicting scenes from the life of Saint Paul, are also in the collection of the Museu Nacional de Machado de Castro), which was executed for the former University College of San José dos Marianos, Coimbra. It has many similarities to the painting on a similar theme executed around 1580-90 by Diogo Teixeira for the Jesuit College of Santarém. Both works were probably inspired by the same engraving. This Pentecost, however, emphasizes the figures and lacks an architectural frame.

The painting depicts an event described in the Acts of the Apostles (2: 1-13). After Christ's Resurrection, he appeared to his disciples for a period of forty days before ascending into Heaven. Following his departure from earth, the Apostles, the Virgin Mary, and "some women" gathered together, "praying" (Acts 1: 13-14). On the day of the Hebrew Feast of Pentecost, the Holy Spirit descended upon them, enlightening them: "And when the day of Pentecost was fully come, they were all with one accord in one place. And suddenly there came a sound from Heaven as of a rushing mighty wind, and it filled all the house where they were sitting. And there appeared upon them cloven tongues like as of fire, and it sat upon each of them. And they were all filled with the Holy Ghost, and began to speak with other tongues, as the Holy Spirit gave them utterance" (Acts 2: 1-3).

The Pentecost was a relatively popular subject in Western European art of the sixteenth century. Among the most well-known examples is Titian's painting of around 1550 in the Church of Santa Maria della Salute in Venice.

The theme may be understood as a quintessential Counter-Reformation image, an allegory of the enlightenment of a Catholic population against the heterodox beliefs of Protestantism. The popularity of the Pentecost theme continued into the early years of the seventeenth century, finding particular favor in the Iberian Peninsula. **E.J.S.** and **A.J.A.**

[1] Robert C. Smith, *The Art of Portugal: 1500-1800* (New York, 1968), p. 202.

BIBLIOGRAPHY

PEDRO DIAS and J. J. CARVALHÃO SANTOS. *A Pintura Maneirista de Coimbra: Ensaio iconográfico*, Coimbra, 1988, pp. 37-39, photo 36.

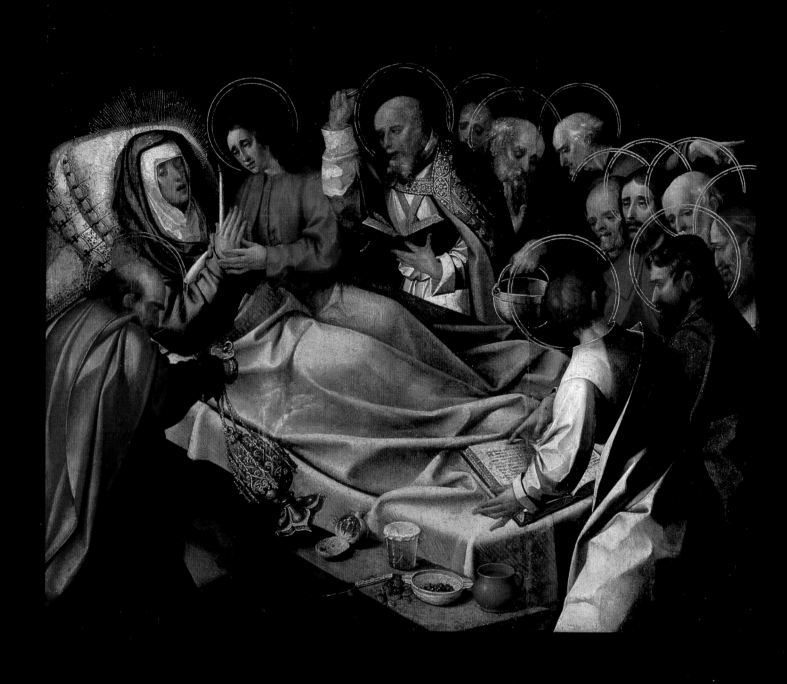

45 *Dormition of the Virgin*

[O Trânsito ou Passamento da Virgem]

Cristóvão de Figueiredo

(active c. 1515-1540)

Sixteenth century

Oil on panel

790 × 880 mm

Museu Nacional de Arte Antiga, Lisbon

According to the Legenda Aurea *(The Golden Legend), written by Jacobus de Voragine, the Virgin died when she was sixty years old, twelve years after the death of Christ. The Virgin is depicted in this panel holding a candle in her hands. She is attended by Saint John, "the beloved disciple," who was named Mary's son by Jesus at the foot of the cross (John 19: 26). Saint Peter officiates, holding a liturgical book in his left hand, while sprinkling holy water on the Virgin with his right. On the other side of the bed, placed diagonally so that the Virgin may be seen almost directly from the front, Saint Andrew balances a censer. On top of the shelf is an opened pomegranate, a covered glass, a knife, dried fruit, a shallow bowl with handles, and a small red clay pot – all of which form a discrete still life. The remaining twelve Apostles crowd around the bed of the dying Virgin. The halos of the characters depicted are treated in different ways – while the Virgin has a luminous halo around her head, the Apostles have a circular halo – thereby indicating the different levels of veneration accorded by the church (grea-*

ter worship in the case of the Virgin Mary, who is the Mother of God).

The coins placed on the shelf or footstool by the bed – including some with the shields of the Portuguese arms, others with the flowered cross of the Aviz dynasty, and still others with a castle – appear to be from the reign of Dom João III. The queen mother, Dona Leonor, widow of Dom João II, (well known as the founder of the brotherhood of Nossa Senhora da Misericórdia), commissioned a group of panels from the painter Cristóvão de Figueiredo, of which this might well be one. These panels were placed on the grave of the prince Dom Fernando, son of Dom João I, founder of the Monastery of Santa Maria da Vitória.

Frei Luís de Sousa, the chronicler of the Dominican Order in Portugal, to which this monastery was entrusted because of its great devotion to the Virgin, saw this retable in the seventeenth century. He described it as having the Assumption of the Virgin at the center, which must correspond to the painting illustrated here, since the Passage of the Virgin is one of the episodes pertaining to her Assumption.

The treatment of volume and surface in this painting is noteworthy, and very visible in the execution of the bed linen and the drapery of the first Apostle on the right, who reads a book that rests on the end of the bed, indicating the text to be read to the colleague on his right. **A.J.A.**

BIBLIOGRAPHY

PEDRO REDOL, "Passamento da Virgem." In *Frei Bartolomeu dos Mártires; mestre teólogo em Santa Maria da Vitória, Exposição Documental e Iconográfica,* exh. cat. Batalha, 1922, pp. 63-64 (n. 13).

46 *Our Lady of Good Death*

[Nossa Senhora da Boa Morte]

Eighteenth century

Polychromed wood with gold leaf

840 × 450 × 450 mm

Convento dos Cardais, Lisbon

Characteristic of the Portuguese Baroque of the eighteenth century, this dynamic representation of Our Lady of Good Death – originally from the Convent of the Barefoot Carmelites of Nossa Senhora da Conceição dos Cardaes – invokes a sense of spectacle and pomp and inspires the emotion of the faithful. This depiction of the Virgin on her Assumption into Heaven, in an ornate boat of carved and gilded wood, reflects the popular devotion in Portugal to Our Lady of Good Death, as do the many churches and chapels that evoke this scene and hold related festivities in her honor.

The Baroque character of the work is evident in the subtle coloring and gold leaf, in the sophisticated ornamental details, and especially in the theatrical rendition of the clouds, dotted by the Mother of God's angelic convoy, through which the boat navigates. **T.L.V.**

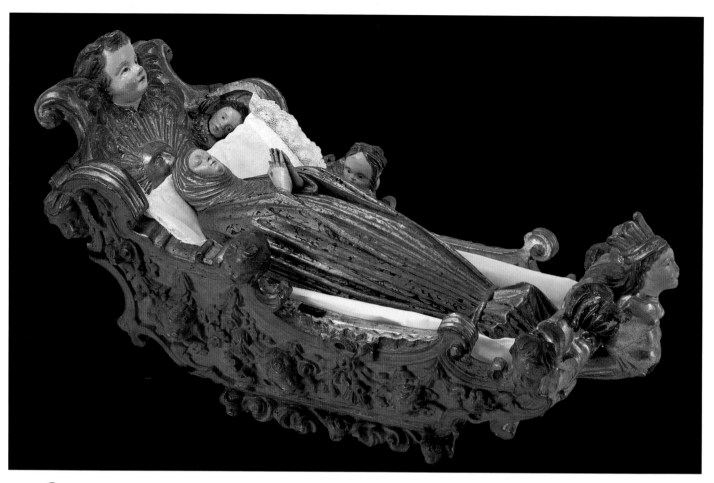

47 *Our Lady of Good Death*

[Nossa Senhora da Boa Morte]

Eighteenth century

Wood, ivory, silk, and silver

Sculpture: 390 mm (height);

bed: 630 × 460 × 300 mm

Diocese de Macau – Paço Episcopal,

Macao

*In this extraordinary and chilling sculpture from Macao, the Virgin is depicted in the moments following her death. Her head and feet, carved delicately from ivory in a tradition of long standing in Macao, are cool and drained of color. Her hands are crossed on her chest; her eyes are half-open-*ed. There is – despite the opulent elegance of the chiseled silver bed, her satin gown and ornaments, and her militant fiery halo – an insistence on the visceral experience of the Virgin's physical mortality.

In Catholicism, the decomposition of the human body after death is a burden carried by humankind. It is part of the divine punishment meted out to Adam and Eve at the time of the Fall. Only the Virgin, of all humans, escapes putrefaction; only the Virgin is pure enough to be bodily assumed into Heaven.

The more graphic and intimate the image of death, the more miraculous and present the miracle of the Virgin's Assumption becomes. The details of the bed and its covers suggest an actual domestic interior. The canopy bed, whose four legs each end in the shape of a claw; the mattress and decorated headrest, both covered with lace and embroidery; and the Virgin, immobile, laid out in opulent, worked cloths all invite the kind of personal identification that creates a high degree of emotional involvement with the image. The work is clearly indigenous, but its powerful, expressive language is reminiscent of the values of the Counter-Reformation as they formed Baroque religious arts in Portugal in the seventeenth and eighteenth centuries. **J.D.D.**

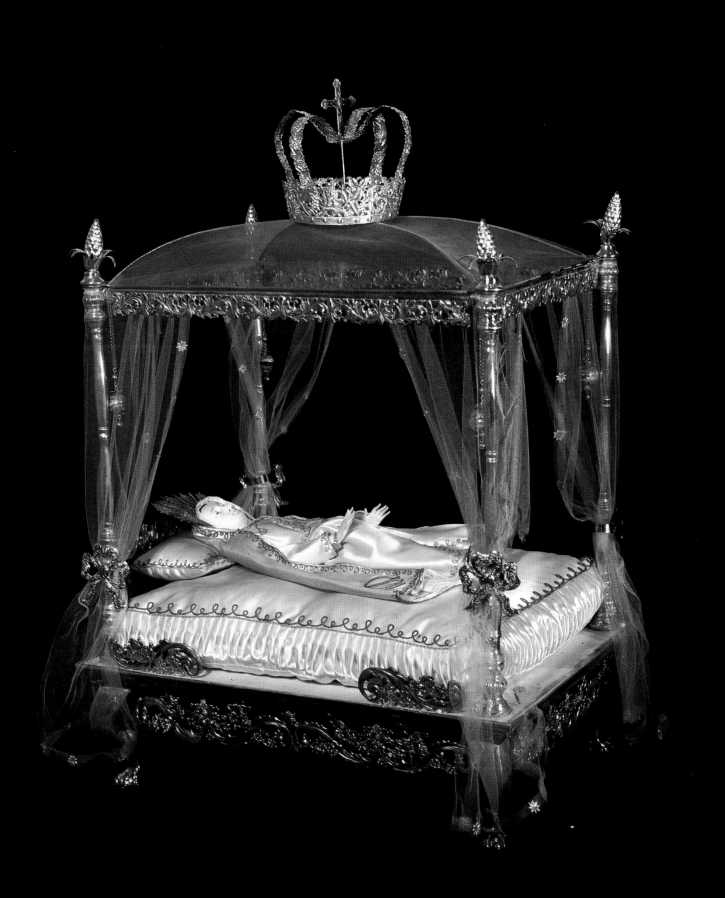

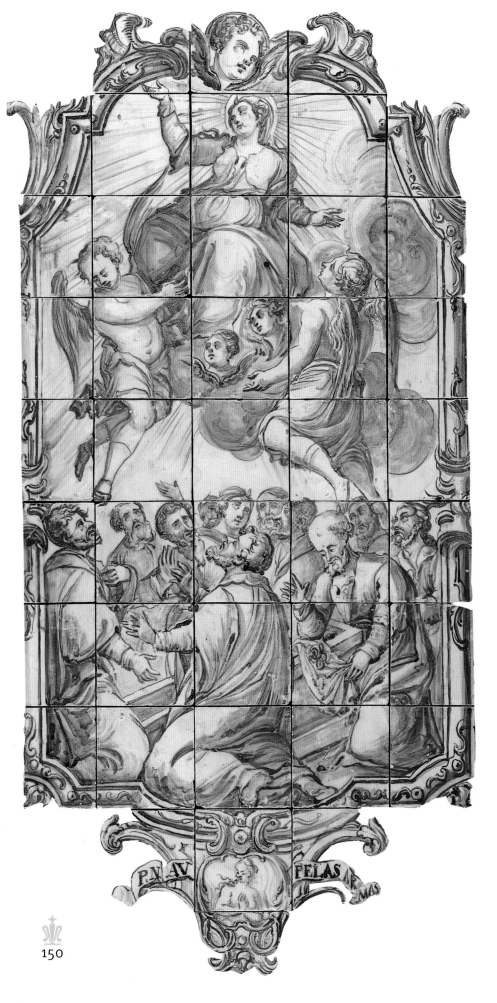

48 *Assumption*

[Assunção da Virgem]

c. 1750

Polychromed ceramic tile

1,400 × 710 mm

Museu Nacional do Azulejo,

Lisbon

The devotion to Our Lady of the Assumption was very popular in Portugal, especially after the end of the fourteenth century. It became an official liturgical festivity after the Portuguese victory at the Battle of Aljubarrota on August 14, 1385 (the eve of the Virgin's Assumption), which guaranteed national sovereignty. A political and religious symbol, Our Lady of the Assumption was considered the protector and patron of Portugal, as indicated in many sixteenth-century texts. She is sometimes depicted with the Portuguese coat of arms as her pedestal and surrounded by angels conducting her to Heaven.

This dynamic rendition of the Virgin's Assumption into Heaven, produced in Lisbon about 1750, is noteworthy because it presents a typical Baroque concern of representing movement, which is further amplified by the diverging position of the Virgin's arms – raised in mid-air by two angels. The composition is clearly divided into two planes: one earthly and one heavenly. **T.L.V.**

49 *Coronation of the Virgin* [Coroação da Virgem]

Simão Rodrigues (1560-1629)

Last quarter of the sixteenth century

Oil on canvas

1,425 × 1,718 mm

Museu Nacional de Machado de Castro, Coimbra

This painting portrays the coronation of the Virgin by the Holy Trinity, shown here iconographically in the conventional manner of the Counter-Reformation: the Father is depicted as the "Venerable Old Man of the Days" from the prophecy of Daniel (7: 9); the Son in the human form of Jesus Christ (Phil. 2: 6-7); and the Holy Spirit in the form of a dove, from the narrative of the Baptism of Christ on the Jordan River (Luke 3: 22). The figures of the Father and Christ hold the crown over the Virgin's head, above which is the figure of the Holy Spirit. The coronation is observed by cherubs on surrounding clouds. This iconographic theme was suggested, apparently, by an engraving by Albrecht Dürer, which shows the Assumption of the Virgin and which was quite popular in Portugal. In contrast to the print, the Portuguese representations of this theme do not include crowns or scepters on the

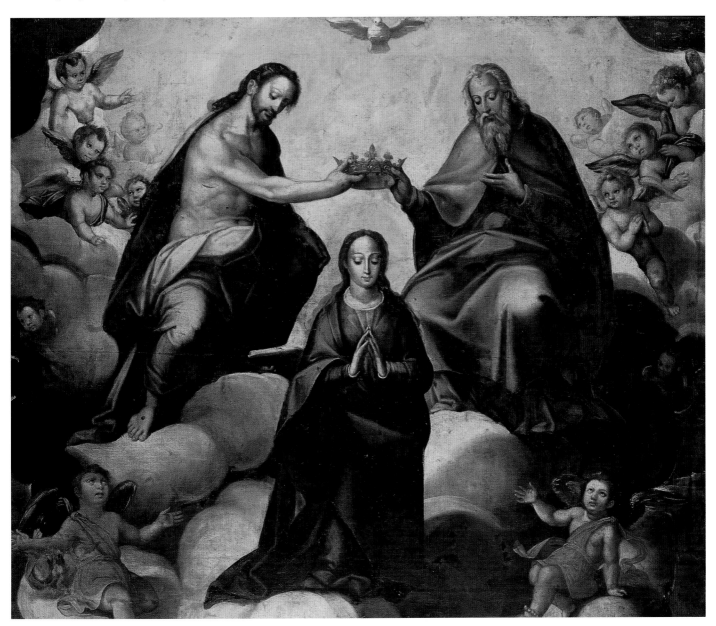

figures of the Father or the Son, and the Virgin appears with her hands together instead of crossing her arms over her chest. In this representation, the Virgin is shown in her glory, as the Queen of Heaven, without the stain of sin and triumphant not only over death but also over all her earthly detractors. This is, therefore, a most direct and clear attempt to authorize the cult of the Virgin, with which, because of its popular following, the church was eager to associate itself.

The composition is structured as two triangles, with a common base formed by the outstretched arms of the Father and the Son holding the crown. In this way, Simão Rodrigues portrayed the Assumption of the Virgin Mary in the bosom of the Holy Trinity, while maintaining a notional divide between the Heavenly trio and the Virgin. **A.J.A.**

BIBLIOGRAPHY
Museu Nacional de Machado de Castro. *Pintura Maneirista de Coimbra*. Coimbra, 1983, no. 26.
PEDRO DIAS and J. J. CARVALHÃO SANTOS. *A Pintura Maneirista de Coimbra: Ensaio iconográfico*. Coimbra, 1988, pp. 69, 157.

50 *Queen of Heaven*

[A Rainha do Céu]

Domingos António de Sequeira

(1768-1837)

c. 1826

Oil on canvas

895 x 1100 mm

Museu Nacional de Arte Antiga, Lisbon

Domingos António de Sequeira has often been described as Portugal's most famous painter after Nuno Gonçalves. His early years of artistic training in Rome (1788-94) gave his art an international flavor; he became conversant with older styles of the Roman Baroque as well as with nascent neoclassicism. His later years were also spent abroad, in France and again in Rome, where he may have painted the Queen of Heaven.

In this image of the Virgin as the Queen of Heaven, God appears in the middle of a rainbow as the Holy Trinity: the Father is shown as the "Venerable Old Man of the Days" (Daniel 7: 9); the Son, Jesus Christ, sits on his right; and the Holy Spirit, is shown between the two in the form of a dove. He is suspended in the air, as in the description in the Book of Genesis (1: 2).

The rainbow is a symbol of the bond between God and his creation, as it appears in the Book of Genesis (9: 12-13), where God makes an alliance with Noah. In Portugal, the rainbow is commonly called arco da velha, after this biblical event.

The separation between God and his creatures is marked, though Mary occupies a special place, as the Mother of the Word Incarnate. The painting depicts the theological idea that all creatures adore within a single cult of latria (worship of God only) the eternal Divine Trinity – one God in three hypostases (the "individual" beings of the Holy Trinity).

This painting bears many similarities to the 0series of biblical scenes dating from the artist's last years. Works such as the Adoration of the Magi and the Epiphany (both 1828), in the Museu de Arte Antiga, Lisbon, have been described by Robert C. Smith as "drenched in a warm and mystic glow that partakes of the grandeur of both Rembrandt and William Blake."[1] In these images, as in the Queen of Heaven, Sequeira employed intense illumination for surprisingly dramatic effects.

In this late masterpiece, the artist reached a balance between the intelligible orthodox iconographic reading of the scene he depicted and the luminous aura of the

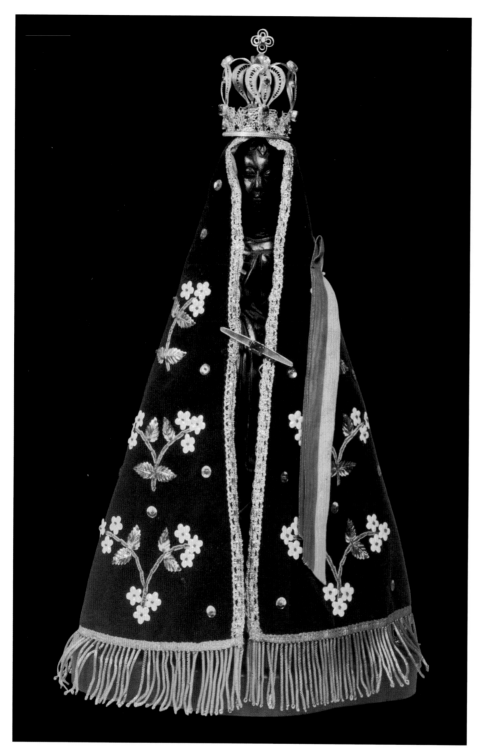

51 *Our Lady of Aparecida*

[Nossa Senhora da Aparecida]

Nineteenth – twentieth century

Wood, velvet, gold, and semiprecious stones

470 mm (height)

Congregação das Franciscanas Hospitaleiras Imaculada Conceição, Lisbon

According to legend, in 1737, in the state of Paraíba in Brazil, as a sailor cast his net in the water, he saw a small distorted figure appear at the surface. It proved to be a head of the Virgin of the Immaculate Conception with black skin. After it was placed in a shrine, which local people began to visit, miracles were believed to be performed whenever the Virgin of Aparecida was invoked. The cult of Our Lady of Aparecida that evolved was recognized by the church in 1930, when the Aparecida was named patroness of Brazil.

In this image of the Aparecida, the Virgin's oval face is framed by long hair that falls on her back and is adorned by five flowers. Over the head is a closed crown, adorned along its rim with pearls; its body has imperial and trilobed elements. The Virgin wears a long, pleated tunic with a white lace collar. On her shoulders is a robe, the ends of which are held in her arms.

The juxtaposition between the obscure, scarred face of the Virgin and the delicate, regal clothing from which it emerges creates a

splendor of eternal light. A characteristic of this painter's work is the absence of chromatic limits.　　**A.J.A.** and **E.J.S.**

BIBLIOGRAPHY

ARMANDO DE LUCENA, *Sequeira na Arte do seu Tempo.* Lisboa, 1969.

MARIA ALICE BEAUMONT. *Domingos António de Sequeira. Desenhos.* Lisbon, 1972-75.

Sequeira, um português na mudança dos tempos (1768-1837), exh. cat. Lisbon, 1997.

1 Robert C. Smith, *The Art of Portugal: 1500-1800* (New York, 1968), p. 208.

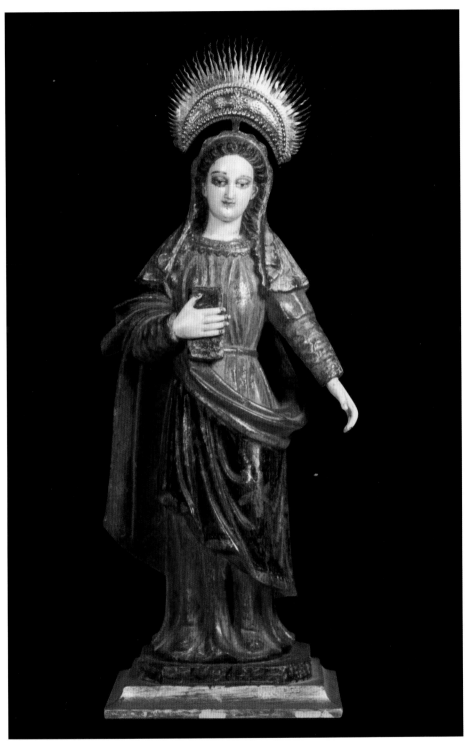

and Orléans in France, and at Loreto in Italy, among numerous other sites.[1] Attempts have been made to assign a single meaning or explanation to these dark Virgins. Positivists wonder if they might originally have been light images darkened by the smoke of votive candles. Marina Warner is correct, however, in pointing out that many are repainted black as time fades their countenances, and in suggesting the power garnered by an image that embraces darkness in a religion that traditionally associates dark colors with forces of evil.[2] Black Virgins can be seen, on one level, as absorbing and controlling that which is mysterious, uncontrollable, and unfathomable.

Reprinted, with additions, from Encontro de culturas: oito séculos de missionação portuguesa, exh. cat. (Lisbon, 1994).

[1] Marina Warner, *Alone of All Her Sex* (New York, 1983), pp. 268, 274-75.

[2] Ibid., p. 275.

52 Crowned Virgin

[Nossa Senhora Coroada]

Eighteenth century

Polychromed wood and ivory

640 mm (height)

Col. D. Marcus Noronha da Costa, Lisbon

The oval-shaped ivory face of this Virgin is framed by black hair, which falls in wavy strands on her shoulders. She wears a light veil, which covers her head and shoulders. The long and pleated red tunic,

sense of mystery and drama. That tension creates an atmosphere of heightened awareness consonant with the magical and powerful associations this Virgin carries in Brazil.

Our Lady of Aparecida might be figured with a group of Virgins called "Black Virgins," which receive particularly fervent devotion throughout the world: at Montserrat in Catalonia, at Chartres, Le Puy,

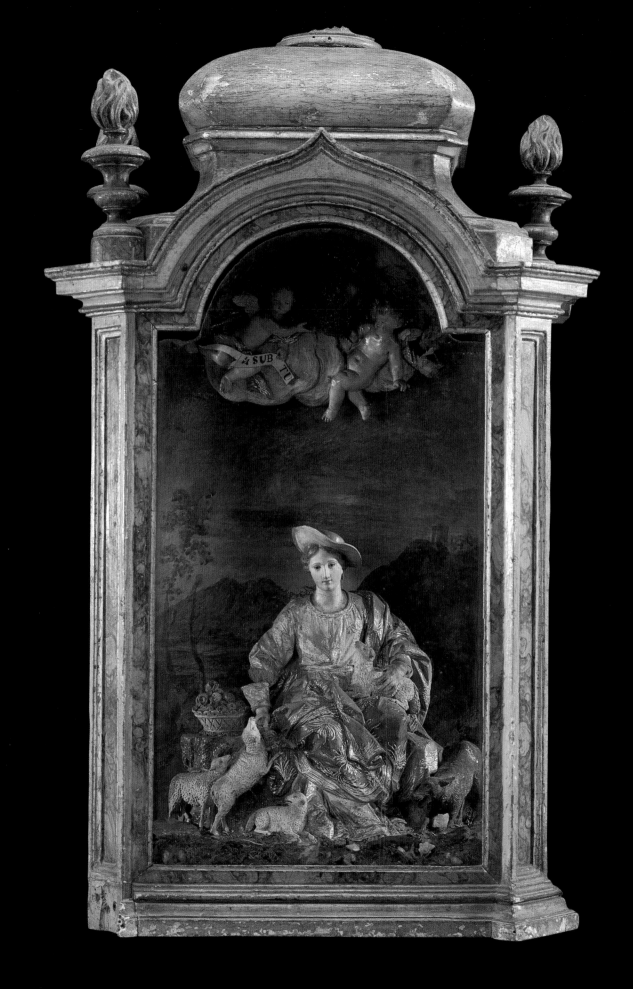

padded with a variety of flowers, is bordered by a fine golden thread adorned with pearls, a lacework collar, and a belt. Over her right arm, and attached to it, there is a green robe with golden borders. This eighteenth-century Virgin from India addresses the viewer with a lively gaze from joyful, heavy-lidded eyes. In India, half-closed eyes can signify spiritual enlightenment. Her animation, her loose, dark hair, her bold, confident countenance, and her flaming, halo-like crown suggest that in India, the Virgin could occasionally accrue a visual authority and autonomy from a tradition of depicting gods and goddesses.

Reprinted, with additions, from Encontro de culturas: oito séculos de missionação portuguesa, *exh. cat. (Lisbon, 1994).*

53 *Virgin as Good Shepherdess*

[Nossa Senhora como Boa Pastora]

Late eighteenth century

Sculpture: polychromed terra-cotta with gold leaf; shrine: wood

Sculpture: 370 mm (height); shrine: 550 × 300 × 190 mm

Museu Nacional de Arte Antiga, Lisbon

The iconographic representation of the Virgin as Good Shepherdess, a transposi-

tion of the theme of Christ in this role, has its origin in works created for Spanish convents during the seventeenth century. The Virgin appears dressed as a shepherdess, wearing a pastoral costume and a straw hat. She is surrounded by sheep, one of which lies on her lap while she caresses it. By placing the figure within a shrine, its precious and delicate character is accentuated.

This portrayal of an elegant and fashionable Virgin in a nonchalant pose parallels pastoral themes in both religious and secu-

lar art of many European countries during the eighteenth century. **T.L.V.**

54 *Virgin as Good Shepherdess*

[Nossa Senhora como Boa Pastora] (front)

A Saint [Santo] (back)

Eighteenth century

Gold with faceted glass and painted veneer

47 × 30 mm

Museu Nacional de Soares dos Reis, Porto

On the front of this small gold pendant with rocaille *ornaments, the Virgin is represented as Good Shepherdess. She is wearing pastoral attire and holds a small lamb, an allusion to her divine Son – "the Lamb of God, which taketh away the sin of the world," as Saint John the Baptist presented him to the people (John 1: 29). From an iconographic point of view, this image resembles the traditional representations of the Virgin that prefigure the life of Christ.*

The bucolic nature of this representation is in accord with the character of the Rococo aesthetic at the end of the Ancien Régime. *The conography of the piece is swathed in fashionable preoccupations of elite society.* **A.J.A.**

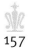

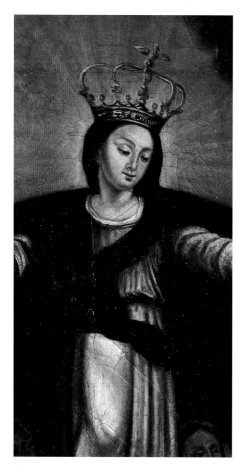

55 *Banner of Our Lady of Mercy*

[Bandeira da Misericórdia de Lisboa]

(front)

Pietà [Nossa Senhora da Piedade]

(back)

Seventeenth century

Oil on canvas

880 × 740 mm

Museu de São Roque/Santa Casa da Misericórdia, Lisbon

This bandeira or pendão is a two-sided image that was used as a processional banner. In addition to the Virgin of Mercy image on the front, there is a Pietà scene on the reverse. The iconography of the Virgin of Mercy (Nossa Senhora da Misericórdia) is derived from the Mater omnium or "all-embracing Virgin" type. The Virgin is represented here with a closed imperial crown on her head. Her open cape denotes her all-embracing protection and mediation for the faithful who huddle in its recesses. Among the many individuals beneath her blue mantle, which is held open by angels, are representatives of both civil and ecclesiastical society. At the lower right is a monarch wearing a purple cape with ermine trim. He has placed his crown on the ground before him and genuflects respectfully. We also observe several members of the clergy: the Pope with a crown on his head, a bishop with his miter, a cardinal with red and blue robes, and a member of the Trinitarian order who wears a white habit with a red and blue cross on the chest. This figure may be a reference to Frei Miguel de Contreiras, who, with the queen Dona Leonor, founded the confraternity. The Virgin is on an elevated platform; beneath her feet is a window with bars, behind which a prisoner is observed. The Trinitarian order was founded to redeem prisoners of the Moors and one of the principal functions of this banner of the Brethren of the Misericórdia was to accompany those prisoners condemned to death to their place of execution. The inscrip-

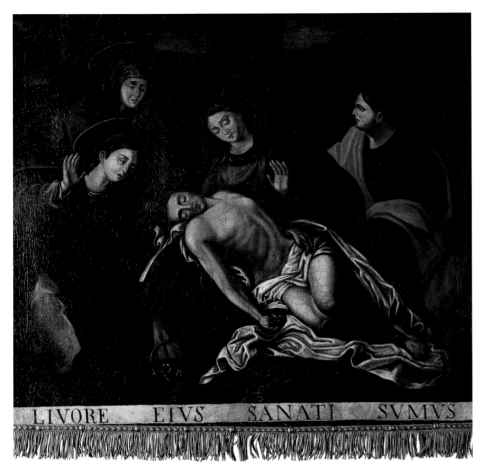

tion below reads "SUB TUUM PRAESIDUM CONFUGIMUS SANCTA DEI GENITRIX" ("In your protection we find shelter, Holy Mother of God"). The inscription below the Pietà group on the reverse reads: "LIVORE EIUS SANATI SUMUS" ("By your wounds were we cured," Isa. 53: 5).

The popularity of the iconography of Our Lady of Mercy was great in Portugal and throughout Europe until it was condemned at the Council of Trent in 1553. Since the iconography implies the independent working of the Virgin, it was held to be heterodox: at that time, the cult was thought to give special powers to the Virgin that ought to belong to Christ alone. The image continued, however, in Portugal.

In Portugal, images of Our Lady of Mercy are related to the importance of the Confrarias da Misericórdia, official public-assistance institutions created in almost every Portuguese city and town during the sixteenth and seventeenth centuries. In 1576, the board of the Lisbon Confraria decided to maintain the traditional iconography, and in 1627, Philip IV (Philip III in Portugal) ordered all the other Confrarias to follow the capital's model.

A.J.A., E.J.S., and **L.M.S.**

BIBLIOGRAPHY

Mater Misericordiae, exh. cat. Lisbon, 1995, p. 100.

56 *Our Lady of Mercy*

[Nossa Senhora da Misericórdia]

After 1539

Etching; frontispiece of the second edition of O Compromisso da Confraria da Misericórdia

295 × 210 mm

Biblioteca Nacional da Ajuda, Lisbon

The image reproduced on this frontispiece of the second edition of O Compromisso da Confraria da Misericórdia unites the theme of Mater omnium – the all-embracing Virgin – with that of the apocalyptic Virgin ("a woman clothed with the sun, with the moon under her feet, and on her head a crown of twelve stars," Rev. 12: 1).

The dissemination of the cult of Our Lady of Mercy in Portugal dates back to the fifteenth century, although it became widespread only at the end of the century, beginning its true expansion with the founding of the confraternity of Nossa Senhora da Misericórdia. **A.J.A.**

BIBLIOGRAPHY

Mater Misericordiae, exh. cat. Lisbon, 1995, pp. 57, 62-64.

57 *Our Lady of Nazaré*

[Nossa Senhora de Nazaré]

Early nineteenth century

Oil on glass

360 × 290 mm

Museu de Artes Decorativas Portuguesas da Fundação Ricardo Espírito Santo Silva, Lisbon

This painting on glass, copying an eighteenth-century engraving, reproduces in the conventional form the famous miracle that happened to Dom Fuas Roupinho, mayor of Porto de Mós, due to the intercession of Our Lady of Nazaré. In the background is the inscription (translated): "Portrait of Our Lady of Nazaré."

According to the legend, in 1182, Dom Fuas was hunting on horseback in the vicinity of Sítio, where in 1179 shepherds had discovered, amid the rocks, a statue of the Virgin Mary breast-feeding the Divine Child. Suddenly an exquisite stag with long antlers broke through the high grass.

The mayor immediately followed, and both disappeared in the dense fog that surrounded the promontory. When Dom Fuas thought he had caught up with the animal, it jumped straight into the sea. The horse halted, its front hoofs raised in the air, poised as though ready to jump. The

horseman invoked the name of the Virgin whose image had graced the area. The horse remained still in the air for a moment, then turned around and allowed the horseman to dismount on a nearby rock. Today people still point to the place where the horse rooted its back hoofs, leav-

ing marks on the rock. The legend further recounts that this image of the Suckling Virgin was carved by Saint Joseph in Nazareth – the origin of the Portuguese toponym – using the Virgin herself as a model. The Virgin of Nazaré is still venerated in the famous procession called the "círio da Prata Grande." The procession passes through seventeen parishes and the venerated replica is kept for one year in each parish. **A.J.A.**

58 *Immaculate Conception*

[Imaculada Conceição]

Bento Coelho da Silveira

(c. 1620-1708)

Late seventeenth century

Oil on canvas

415 × 305 mm

Museu de Aveiro

This work, in the style of Bento Coelho da Silveira, is a representation of the Immaculate Conception, the Virgin as the one human who was perpetually without sin. Although this characteristic of the Virgin was not confirmed by the church until the nineteenth century, the Virgin of the Immaculate Conception had a wide and passionate following in Portugal for hundreds of years beforehand.

The Virgin of the Immaculate Conception is most often represented as the "Woman Clothed with the Sun" from the Apocalypse, inspired by the Book of Revela-

tions (12: 1-4). The youthful Virgin, with a crescent moon at her feet, on a terrestrial globe, is crowned with twelve stars and surrounded by angels. The dragon in the background raises his head in her direction, a reminder of how she among all humans vanquished sin.

The Virgin was worshipped in this invocation at the court of Dom João, Duke of Bragança, at Vila Viçosa. When, following the revolt against the Spanish occupation on December 1, 1640, he became the king of Portugal with name of Dom João IV, starting the Bragança dynasty, this invocation naturally followed the monarch. In 1646, Nossa Senhora da Conceição was proclaimed in the cortes – an assembly or congregation of the representatives of the

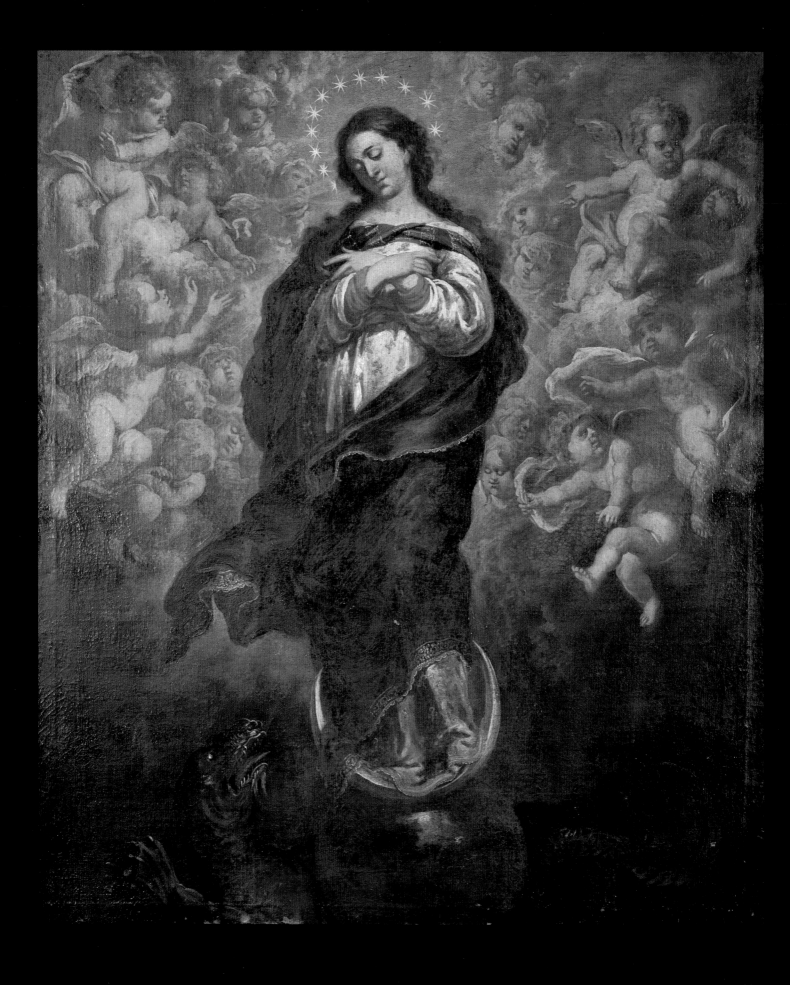

three estates of the realme: the Lords Spiritual, the Lords Temporal, and the Commons – as the patron saint and queen of Portugal, the country's true sovereign. The king crowned the statue at Vila Viçosa with his own royal crown, and from that moment on the kings of Portugal were no longer crowned; the royal crown was placed on a cushion next to the royal throne during the coronation of the new king.

It is worthwhile to note the sense of movement provided by the agitation of the drapery in this image, which is further amplified by the activity of the angels who surround the Virgin. The Virgin of the Immaculate Conception is quite often a dynamic figure to whom the faithful offer devotion. **A.J.A.**

59 *Processional Banner of the Virgin of the Immaculate Conception (Our Lady of Vila Viçosa)*

[Pendão Processional da Imaculada Conceição (Nossa Senhora de Vila Viçosa)]

Twentieth century

1,600 × 900 mm

Church of Santo Antão, Vila Viçosa

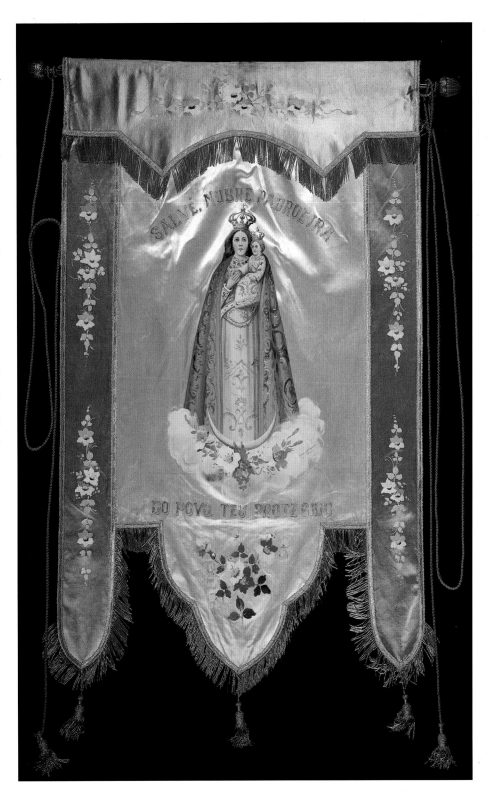

This processional banner depicts the Virgin of the Immaculate Conception as patroness and sovereign queen of Portugal, worshipped since the time of Dom João (later João IV), Duke of Bragança at Vila Viçosa. The Virgin and her Son are crowned with closed imperial crowns. Based on the apocalyptic image of the Virgin, with a crescent moon at her feet, this Virgin of the Immaculate Conception is depicted above clouds of flowers. Flowers adorn the entire banner.

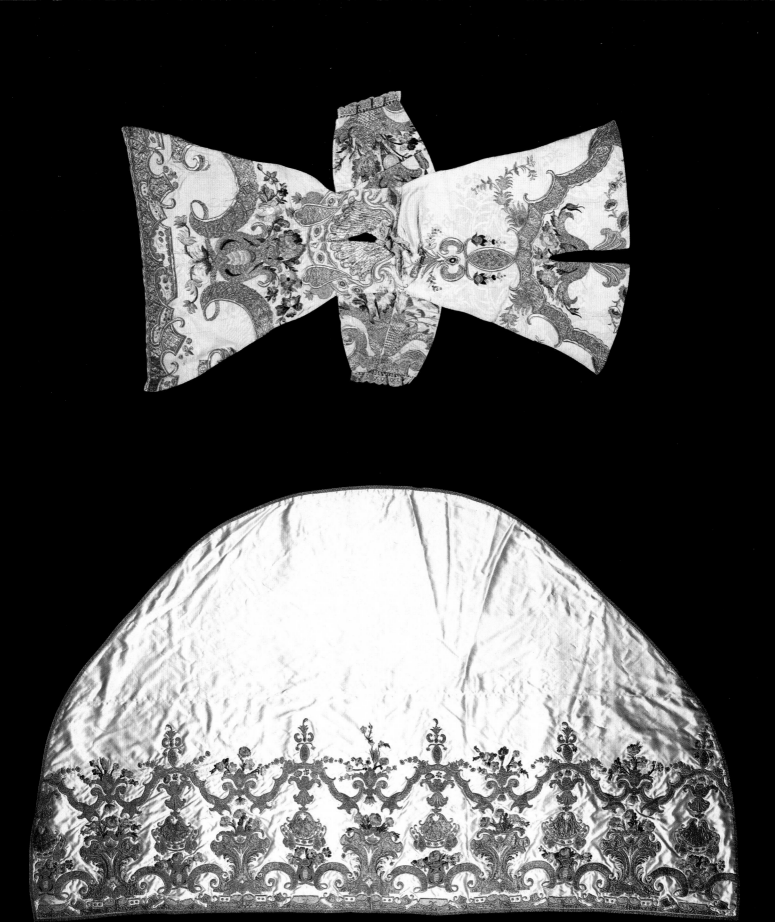

Above and below the image there is the beginning of a popular ode to Mary: "SALVE NOBRE PADROEIRA / DO POVO TEU PROTEGIDO" ("Hail thee, noble patron, / From your protected people"). It evokes the ode's continuation: "Among all, chosen to be God's people, / Glory to our land, / That You have saved a thousand times, / While there be Portuguese, / You shall be their love."

Images of the Immaculate Conception, like this one from Vila Viçosa, are sometimes barely distinguishable from other iconographic representations the Virgin and Child, showing the Child in his mother's arms. **A.J.A.**

60 *Offerings by the Duchesses of Portugal to the Statue of Nossa Senhora da Conceição*

Seventeenth and twentieth centuries
Silk, Velvet, brocade,
and embroidery
1,600 × 2,750 mm (Virgin's dress);
700 × 700 mm (Christ's mantle)
Santuário de Nossa Senhora
da Conceição, Vila Viçosa

In March 1645, Dom João IV crowned an image of the Virgin of the Immaculate Conception as queen of Portugal. Since the mid-fifteenth century, this sculpture (which dates from the fourteenth century) has been revered by the dukes and duchesses of Bragança at the chapel of Vila Viçosa. After the earthquake of 1755, it was moved first to the Church of Santo Antão, Vila Viçosa, and was later carried, in a procession, to its present sanctuary. At that time, it is believed, a duchess of Bragança placed a mantle on the statue for the first time. From that point on, the tradition of dressing the statue was established and entrusted to the duchesses of Bragança, who thus became the Aias da Image (Maids of the Statue). This duty was handed down from one generation to the next until the advent of the republic, at which time the responsibility was passed on to the ladies of the most respected families of Vila Viçosa, chosen by the archbishop of the diocese.

Many mantles and accessories were offered to the statue by the queens and duchesses of Portugal. The oldest ones, with gold embroidery, date from the reign of Dom João V; one is in a grenadine red brocade and the other in a natural blue silk, with a cream-colored dress. There are also four more very rich dresses and mantles, offered by Dona Maria Pia: a wedding dress in gold lamé with semiprecious stones; a dress and mantle in purple velvet, with applications of darker velvet; a gold brocade mantle with embroidery and tones of blue; and, finally, a mantle in natural white silk with embroidery in shades of white and gold. This wedding dress offered to the statue by Dona Amélia is made from grosgrain in natural white silk with lacework; a dress in natural cream-colored silk with blue patterns was also offered by this queen. The small gown made for the Christ child probably dates to the seventeenth century.

These offerings represent a powerful metaphorical link beween the heavenly court of the Virgin and the earthly court of Portugal.

Bárbara Elisa Pereira Silveira Menezes
Aia da Imagem de Nossa Senhora da Conceição de Vila Viçosa

61 *Suckling Virgin*

[Virgem do Leite]
Flemish School (Bruges)
Sixteenth century
Oil on panel
1,065 × 900 mm
Museu de Aveiro

Within the general theme of the Virgin Mary breast-feeding the Christ Child, there is this curious panel, in all certainty of Flemish origin and specifically of the Bruges School. It is well known that in the sixteenth century many works of art from Flanders were brought to Portugal – the result of close commercial, political, and cultural ties that existed between the two countries – and that these works greatly influenced Portuguese painters.

This painting employs three types of images of the Virgin: the apocalyptic Virgin, which would be employed often in representing the Immaculate Conception (as one can observe in another painting from the same

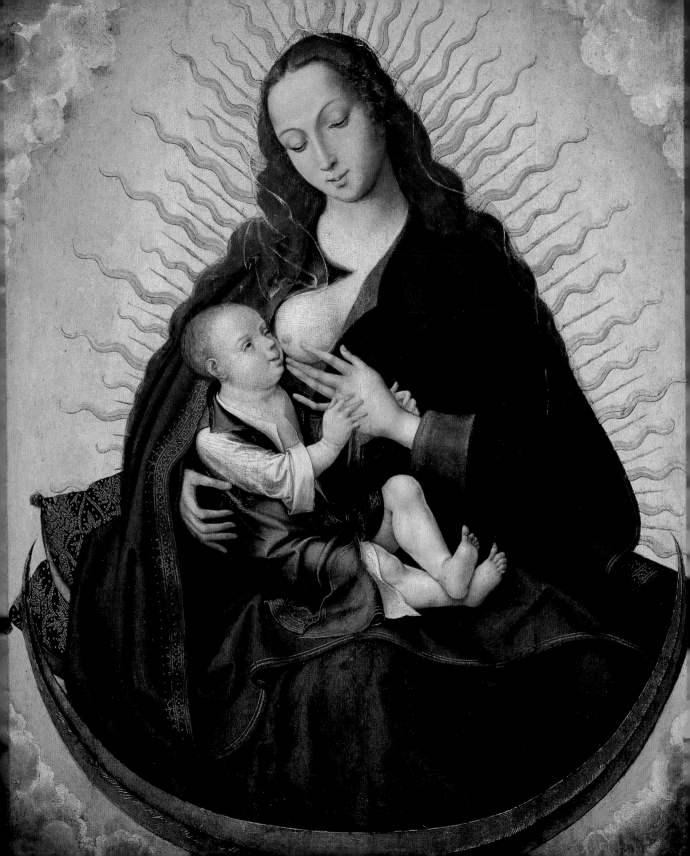

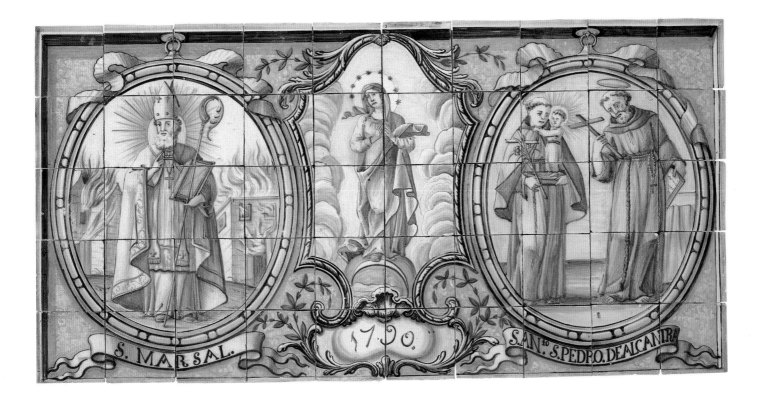

museum, cat. no. 58); the Throne of Wisdom, a theme that originated in the Byzantine and Romanesque worlds; and the Suckling Virgin.

Here, the Virgin is nestled in a crescent moon, sitting on cushions while breast-feeding the Christ Child. The cloudy sky opens to allow the "great signal." The "Woman Clothed with the Sun" radiates a golden blaze. The bush that Moses saw burn without being consumed (Exod. 3: 2) was a theme used in contemporary sermons to refer to the perpetual virginity of the Holiest Mother of God.

This image is both elegant and graphic, moving and joyous. Coming from a convent of Dominican nuns, this representation points to the maternal devotion that the nuns had toward the Christ Child,

identifying themselves with his mother Mary, the personification of the church.

A.J.A.

62 *Immaculate Conception (with Saint Martial, Saint Anthony, and Saint Peter of Alcântara)*

[Nossa Senhora da Conceição, São Marçal, Santo António e São Pedro de Alcântara]

c. 1790

Polychromed ceramic tile

700 × 1,410 mm

Museu Nacional do Azulejo, Lisbon

*Devotion to the Virgin of the Immaculate Conception has been popular in Portugal

since the Middle Ages. It was further disseminated during the restoration of national independence in 1640, when Dom João IV declared the Virgin of the Immaculate Conception the protector and patron saint of Portugal, consecrating her queen with the royal crown.

Noteworthy in this panel, which has neoclassical elements characteristic of the late eighteenth century, are the saints on two medallions on either side of the Virgin: Saint Martial on the left and Saint Anthony and Saint Peter of Alcântara on the right. These saints were certainly objects of devotion of the donor, though in general tile works featuring Saint Martial were quite common during the second half of the eighteenth century. This was essentially due to the earthquake that struck Lisbon on

167

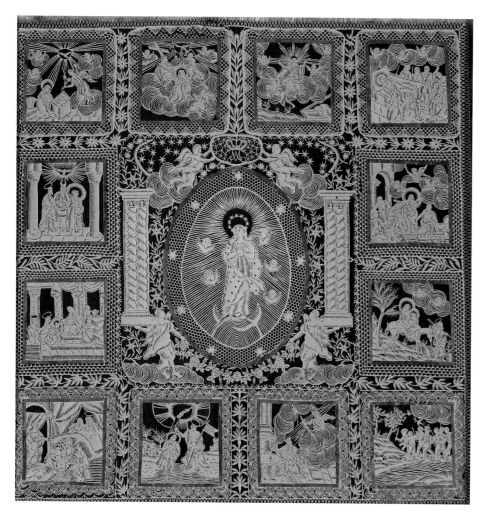

"columns of Hercules" (or the Straits of Gibraltar) in the coat of arms of the Spanish crown.

The small pictures that surround the central image are framed by a thin strip of golden paper, and depict the following scenes (from top to bottom and right to left): the Annunciation, the Coronation, the Assumption, the Dormition (or Death) of the Virgin, the Marriage, the Visitation, the Presentation of the Virgin, the Flight into Egypt, the Birth of the Virgin, the Baptism of Christ, the Angel appearing to King David, and a genre scene of a rabbit hunt.

The whole composition is framed by a thin strip of golden paper, lending a delicate regal quality to the whole. This detailed and painstakingly executed work was most certainly created in a female monastic setting. **A.J.A.**

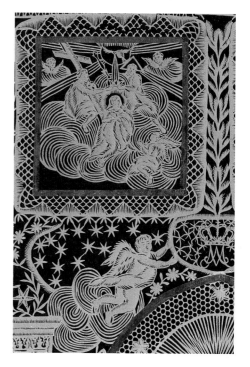

November 1, 1755, and the mass destruction that resulted from it. Saint Martial was considered the patron saint and protector against such calamities. **T.L.V.**

63 *Immaculate Conception*

[Imaculada Conceição]

Late nineteenth century

Cut paper

340 × 340 mm

Museu de Arte Popular, Lisbon

The central image in this delicate cut-paper design depicts the Virgin of the Immaculate Conception; according to traditional compositions of these works, the image is surrounded by twelve small pictures that show scenes related, for the most part, to the life of the Virgin.

The Virgin appears in a central medallion, surrounded by a thin strip of golden paper, as a traditional representation of the "Most Pure." Above this mandorlalike medallion are two angels holding a much smaller medallion with the interwoven monogram A(ve) M(aria), crowned with an imperial crown in a field replete with stars. On each side is a spiral column supported by two angels. The columns represent the

64 *Ex-Voto of the Immaculate Conception*

[Ex-Voto a Imaculada Conceição]

1819

Oil on wood

333 × 170 mm

Museu Nacional de Arqueologia, Lisbon

Caption: Miracle of the Virgin of the Immaculate Conception in Saving the Life of a Sick Person of this community already close to death. At the supplication of one Devoted Follower of Her, In 1819.

This votive panel is the oldest example of its type in this exhibition. The oldest known Portuguese "miracle" is one from 1550, from the Chapel of Nossa Senhora da Piedade at the Quinta de Argemil (Santo Tirso), which depicts a "gravely ill" Francisco Joaquim da Rocha Tabares Corte Rial in bed.[1]

At the left of this image is a wide bed with a large headrest. In it is a woman, whose body has no volume, and whose head appears from the fold of the sheets; her frailty underlies her vulnerability and the miraculous power of the Virgin. At the right is the Virgin of the Immaculate Conception, whose intercession before God is sought. She is bathed in light and surrounded by wisps of clouds. A man, the supplicant, kneels at the Virgin's feet and prays, imploring for the women to be cured. He wears a merchant's attire of the first quarter of the nineteenth century, and he is certainly the patron of this moving work. **A.J.A.**

[1] *Ex-Voto: painéis votivos do rio, do mar e do além-mar,* exh. cat. (Lisbon, 1983), p. 11.

BIBLIOGRAPHY

LUÍS CHAVES. "Ex-Votos do Museu Etnológico Português. Catálogo descritivo." *O Archeologo Português,* series 1, vol. 19 (1914), pp. 174-75, no. 25.
"A 'Imaculada Conceição' nas tradições e no folclore de Portugal." *Brotéria,* vol. 43 (1946), p. 583.

65 *Military Decorations of the Immaculate Conception*

[Grã-Cruz da Ordem de Nossa Senhora da Conceição]

Jean-Baptiste Debret (1768-1848)

First half of the nineteenth century

Gold with enamel inlay

77 mm (diameter)

Museu de Marinha, Lisbon

The Military Order of Our Lady of the Immaculate Conception of Vila Viçosa was founded on February 6, 1818, by Dom João VI, who was in Rio de Janeiro at the time, to commemorate his acclamation as king and as a solemn testimony of gratitude for the liberation of the kingdom from the Napoleonic invasion that year. The establishment of the order also commemorated the Portuguese liberation from the Spanish in 1640. In the words of Francisco Belard da Fonseca, it is "the Order of the Eternal Patron Saint of a United and Independent Portugal."

The insignia of the order was designed by Jean-Baptiste Debret. A Parisian artist and disciple of Jacques-Louis David, Debret was part of the artistic mission that arrived in Rio de Janeiro in 1815, where he remained until 1831.

The insignia is in the form of a star with nine points, in white enamel outlined and streaked with gold. Between the nine points are smaller five-pointed stars, also in white enamel. The center, in opaque gold, has the angelical salutation "A(ve) M(aria)," intertwined and in polished gold, around which is a light-blue enameled rim bearing the inscription: "PADROEIRA DO REINO" ("Patron saint of the kingdom"). It is further adorned, in the top section, by a royal crown. This insignia was used with a blue ribbon with a white border.

A.J.A.

BIBLIOGRAPHY

FRANCISCO BELARD DA FONSECA. *A Ordem Militar da Nossa Senhora da Conceição de Vila Viçosa*. Lisbon, 1955.

66 Ex-Voto of the Immaculate Conception (Fonte Santa)

[Ex-Voto a Nossa Senhora da Fonte Santa]

1823

Oil on panel

300 × 225 mm

Museu Nacional de Arqueologia, Lisbon

Caption: Miracle performed by Our Lady of Fonte Santa on José Joaquim do Monte das Pozoas, from Olivença, who had lost twelve cows that Our Lady permitted to reappear. Year of 1823.

Paintings of this type might be called gratitude panels, as they are made in gratitude for grace bestowed. They bear witness to the lives and prayers of people from all walks of life who have prayed to the

MILAGRE Q.ᵉ FES N.Sᴬ DA FONTE SANTA A IOZE IOAQ.ᵐ DOMONTE DAS POZOAS TERMO DE OLIVENCA Q.ᵉ TENDO DOZE VACAS PERDIDAS N.Sᴬ PERMETIO Q.ᵉ LHE APARCERAM. ANNO. DE 1823.

Virgin. The paintings were given by them to churches and sanctuaries in thanks for the Virgin's intercession before God on behalf of their lives at times of need.

The captions on such paintings habitually begin with the word miracle. This is most often identified with a wonder, grace, or gift offered by God through a saint (rendered in the concrete form of an image of that saint) or through an image of the Savior. In the case of the Virgin, she is identified by her invocation or sanctuary. These "miracles" (as the objects are popularly known) are placed on the walls of a sanctuary or chapel, or in an annex called the "room of the miracles."

At the top left of this votive panel is the figure of Our Lady of Fonte Santa, a representation of the Virgin of the Immaculate Conception, crowned and in a golden light that forms her halo, and surrounded by clouds. Below are the two grateful supplicants on their knees: on the left, a woman with her hands in prayer, looking at the Virgin; on the right, a man in the same position. They wear Spanish clothing; Olivença is a Portuguese land which had been under Spanish administration since the War of Laranjas (1801).

On the right, the twelve lost cows line up obediently, even cheerfully, in order of size. The representation of animals is not unusual in votive panels, given their importance in Portuguese rural life. They are traditionally represented in connection with human

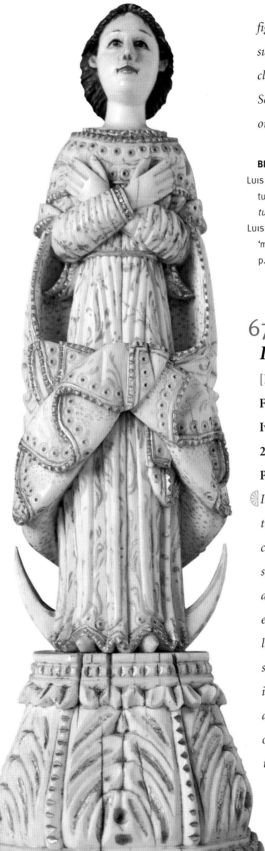

figures, as in this piece. The rather unusual representation of two bulls in a "miracle" at the chapel of Senhor da Aflição, Soutosa – Peva (Moimenta da Beira), is one notable example. **A.J.A.**

BIBLIOGRAPHY

Luis Chaves. "Ex-Votos do Museu Etnológico Português. Catálogo descritivo." In *O Archeologo Português*, series 1, vol. 19 (1914), pp. 162-63, no. 4.

Luis Chaves. "Na arte popular dos ex-votos – Os 'milagres.'" *Revista de Guimarães*, vol. 80 (1970), p. 16.

67 *Virgin of the Immaculate Conception*

[Imaculada Conceição]

First half of the eighteenth century

Ivory

210 mm (height)

Private collection, Porto

In this particularly ethereal representation of the Virgin of the Immaculate Conception, Mary is an especially delicate, slender figure whose deep-set eyes display a haunting and far-off gaze. This work embodies a variety of characteristics that link it to contemporaneous sculptures from several Indo-Portuguese workshops. They include the restrained parted hairstyle, the arms crossed at the chest (characteristic of those images of the Virgin carved for the Franciscan order), the small pallium enveloping the arms, the mantle interlaced at both ends, and the decorative richness of the borders and hems of the clothing, highlighted by polychromy

and gilt. The frontality and symmetry of the figure, coupled with curved surfaces and acanthus ornamentation, point to a date in the early eighteenth century.

In the history of artistic contact between continental Europe and India, the medium of ivory, so precious because of its prohibitive cost and rarity, was a highly significant link. Among the images executed in the Portuguese settlements in India, the figure of the Virgin appears more often than any other subject. A great many of these images represent the Immaculate Conception. The feast day of Our Lady of the Immaculate Conception, celebrated on December 8, became an official public holiday not only in Portugal but in overseas colonies as well. **T.L.V.** and **E.J.S.**

BIBLIOGRAPHY

Bernardo Ferrão Tavares e Távora. *Imaginária Luso-Oriental,* Lisbon, 1983.

Lucila Morais Santos. *Arte do marfim.* Rio de Janeiro, 1993.

68 *Ex-Voto of Virgin and Child with Ship (Our Lady of Atalaia)*

[Ex-Voto a Nossa Senhora da Atalaia]

1894

Oil on canvas

315 × 410 mm

Museu de Arte Popular, Lisbon

Caption: Miracle performed by Our Lady of Atalaya on (…) and crew on November 11, 1894

In this dramatic scene, the image of Our Lady of Atalaia appears at the top left cor-

ner surrounded by clouds. In the foreground is the boat to which the "miracle" refers, perilously engulfed in high waves. One can see the crew and the torn sails. Far off are other boats. The sky anticipates a tempest.

This votive – or gratitude painting – dating from the end of the last century, is the most recent of those included in this exhibition. Over the last century, photography has gradually replaced painting as the primary medium in this genre; there is, for instance, a more recent offering to Our Lady of Atalaia (Montijo), from May 8, 1946, executed in oil on cork, in which the only survivor of a shipwreck, José de Paiva, is shown in a photograph that is glued to the top right corner of the painting portraying the scene of the shipwreck.[1] These works are reminders of the associ-

ation of Our Lady of Atalaia with shipping and the sea, and the Virgin's long patronage, in a number of invocations, of those who sail.

Another votive painting dated 1952 was made for this Virgin; it bears the caption: *"Acção de Graças a N.ª Senhora da Atalaia por milagre que fez… Montijo 2-6-52"* ("In gratitude to Our Lady of Atalaia for a miracle performed… Montijo 2-6-52"). Three photographs were glued to the work, showing Deolinda das Dores Silva, who was saved from a "large dog" by the intervention of the Virgin, and two witnesses who "helped at the time."[2] **A.J.A.**

[1] *Ex-Voto: painéis votivos do rio, do mar e do além-mar. Primeira Exposição Nacional de Painéis Votivos do Rio, do Mar e de Além-Mar,* exh. cat. (Lisbon, 1983), p. 90 (n. 18).

[2] Albino Lapa, *Livro de Ex-Votos Portugueses* (Lisbon, 1967).

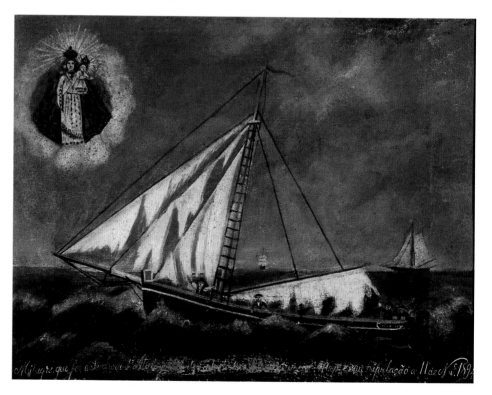

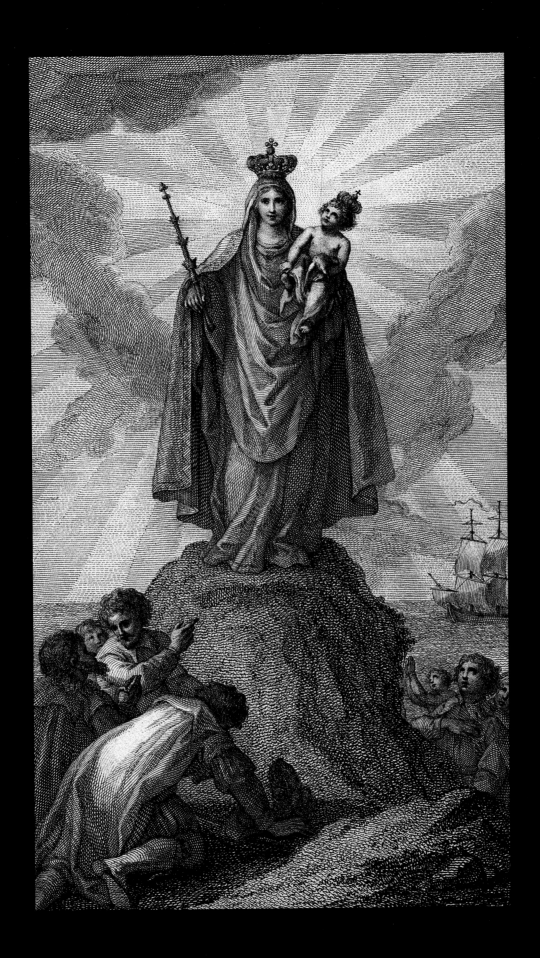

69 *Our Lady of Arrábida*

[Nossa Senhora da Arrábida]

Gregório Francisco de Queiroz

(1768-1845)

Eighteenth century

Engraving

319 × 249 mm

Museu Nacional de Arte Antiga,

Lisbon

Our Lady of Arrábida was the patron saint of the famous convent in the Arrábida mountain range in Setúbal. The convent belonged to the order of the Observant Franciscans of the reform of the "Capuchos" (as the Descalzos, or Barefoot Franciscans, were known in Portugal, not to be confused with the Capuchin Order, formerly called in Portugal the "Barbadinhos").

The praises of Our Lady of Arrábida were sung by the best mystic Portuguese poet of the late sixteenth and early seventeenth centuries, Frei Agostinho da Cruz. Every year, this Virgin is highly celebrated in a procession starting at the church of Anunciada, in Setúbal, and leading to Portinho de Arrábida.

This work portrays the Virgin and the Christ Child being venerated by the faithful, who are at the foot of a small mount that represents the Arrábida mountain range. Far off at sea is a sailboat. The Virgin holds a royal scepter in her right hand and is crowned with an imperial crown, as is her Divine Son. The clouds are parted and rays of sunlight cut through the haze, illuminating the head of the Virgin. **A.J.A.**

70 *Banner of the Guild of the Fishermen of Póvoa de Varzim*

[Bandeira da Casa dos Pescadores de Póvoa de Varzim]

Twentieth century

Silk embroidered

with colored thread

960 × 940 mm

Museu de Marinha, Lisbon

This blue silk flag places the Virgin at the center of the enterprise of fishing and the sea. A Virgin of the Immaculate Conception floats in the central medallion, as protector of those at sea.

Such flags recall the Virgin's powerful role as patroness of exploration and the sea. As the Virgin of the Immaculate Conception, she is pictured as the "woman clothed with the sun, with the moon under her feet, and on her head a crown of twelve stars" (Rev. 12: 1). The association with the stars and other heavenly bodies made the Virgin of the Immaculate Conception the patroness of navigators, and a long tradition in Portugal associates her with benevolent seas. **J.D.D.**

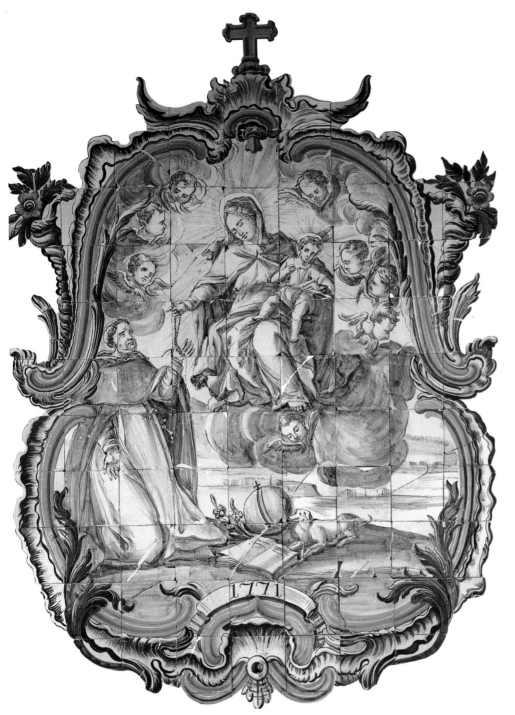

many fraternities dedicated to Our Lady of the Rosary, created on the initiative of the Dominican Order. The cult's popularity further increased after Pope Pius V attributed the merits of the victory at the Battle of Lepanto in 1571 to the Virgin of the Rosary.

This tile panel, which is framed by an elaborately colored rocaille ornament with shell and cornucopia patterns, makes an allusion to the traditional moment when the Virgin bestows the rosary on Saint Dominic. The essential components of the composition include the Virgin Mary on the right, seated on clouds with the Christ Child in her arms, and Saint Dominic kneeling on the left. These two figures are united by the rosary, which passes between their hands. Adjacent to Saint Dominic are his iconographic attributes: a book (signifying the Word of God), a dog (faithfulness), and a terrestrial globe (earthly life), upon which rest white lilies and a cross (death and destiny). **T.L.V.**

71 *The Virgin Appearing to Saint Dominic*

[Nossa Senhora entregando o rosário a São Domingos]

1771

Polychromed ceramic tile

1,770 × 1,270 mm

Museu Nacional do Azulejo, Lisbon

Dominican devotion to the rosary is a tradition that goes back to Saint Dominic of Guzmán (1170-1221), a Spanish priest and founder of the Dominican Order, though it was mostly disseminated by Friar Alain de la Roche, author of De Utilitate Psalterii Mariae, published in 1470. The rosary became very popular due to the

72 *Virgin of the Rosary*

[Nossa Senhora do Rosário]

Seventeenth century

Silver, gold, and semiprecious stones

700 × 300 mm

Museu de Arte Sacra da Sé, Évora

A figure of great opulence and power, this Virgin of the Rosary addresses the viewer with significant iconic authority. She stands frontally, the Christ Child perched

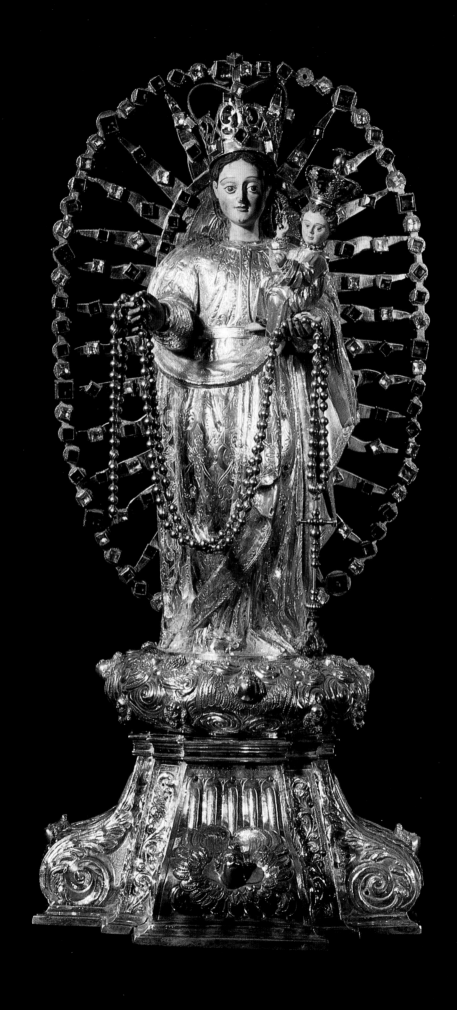

confidently on her left arm, her hands both outstretched, displaying an enormous rosary, which falls in a cascade from one palm to the other.

Her large eyes and otherworldly gaze, the authority drawn from her commanding frontal pose, and the enormous, ornamental halo that frames her entire body recall the treatment of standing Buddhas in Indian Buddhist tradition, as well as images of Brahma in Indian Hindu tradition. So distinct from the dramatic humanity of seventeenth-century Portuguese Virgins, this Virgin of the Rosary draws her power from the same remote formal vocabulary as Indian gods and Buddhas.

It is this autonomy and authority, as well as details of craft and decoration, that suggest that this Virgin was created by an indigenous workshop under Portuguese patronage in India.

The Virgin of the Rosary is an iconographic theme of great importance in sixteenth and seventeenth-century Europe. Its use might have penetrated Christian devotion at the time of the Crusades, when European Christians encountered Muslims using beads to count prayers, though there is fragmentary evidence of rosary use in Europe as early as the ninth century. The fifteenth century saw a number of fervent treatises on the value of the rosary, when its use was promoted by Dominicans in particular. Rosary devotion in the sixteenth and seventeenth centuries was

strongly supported by Pope Pius V, who endorsed its use as part of Counter-Reformation reforms. To legitimize his bull, he cited a vision, in which Saint Dominic was presented with a rosary by the Virgin herself.

This Virgin, then, follows an iconographic tradition of significant strength in Europe. However, the prominence of the rosary suggests a particular sympathy for its devotional use. In India, the use of the rosary might have found fertile ground among converts, because of its use, also, in Hindu and Buddhist devotion.

Commissioned by Diogo de Brito, who is thought to have returned from India to a parish near Évora in the seventeenth century, this sculpture seems to be one of a large number of works brought to Portugal from India. Voyagers returned to home parishes and shrines with offerings that carried with them a lustrous witness to the wealth to be found in the great enterprise of trade and the colonization of Asian lands. **J.D.D.** and **E.J.S.**

73 *Virgin of the Rosary*

[Nossa Senhora do Rosário]

Seventeenth century

Polychromed wood with gold leaf

500 mm (height)

Museu Nacional de Arte Antiga, Lisbon

The cult of the Virgin of the Rosary has its origin in the Dominican Order, and is

intimately related to Our Lady of Mercy (Nossa Senhora da Misericórdia). The rosary in representations of this Virgin consisted at first of white and red roses, but these were later replaced by different-sized beads, large ones and small ones, corresponding to the prayers of Our Father and the Hail Mary, respectively.

In this seventeenth-century depiction of the Virgin of the Rosary, the figure is encased in a single smooth volume (a truncated cone shape). This is a convention that was often present in Portuguese sculpture of this period. The reemergence of this archaic form of human representation, which recalls Romanesque sculpture, is often accompanied by an ornamental component that can reach remarkable levels of technical execution, as seen in the precise and detailed decorative work present in the Virgin's clothing. Another point worthy of attention is the characterization of the faces of the Virgin, the Christ Child, and the angels. The artist has individualized each angel and oriented their heads in different directions, providing the piece with its most dynamic element. **T.L.V.**

74 *Virgin of the Rosary*

[Nossa Senhora do Rosário]

1772

Polychromed ceramic tile

1,560 × 580 mm

Museu Nacional de Machado de Castro, Coimbra

177

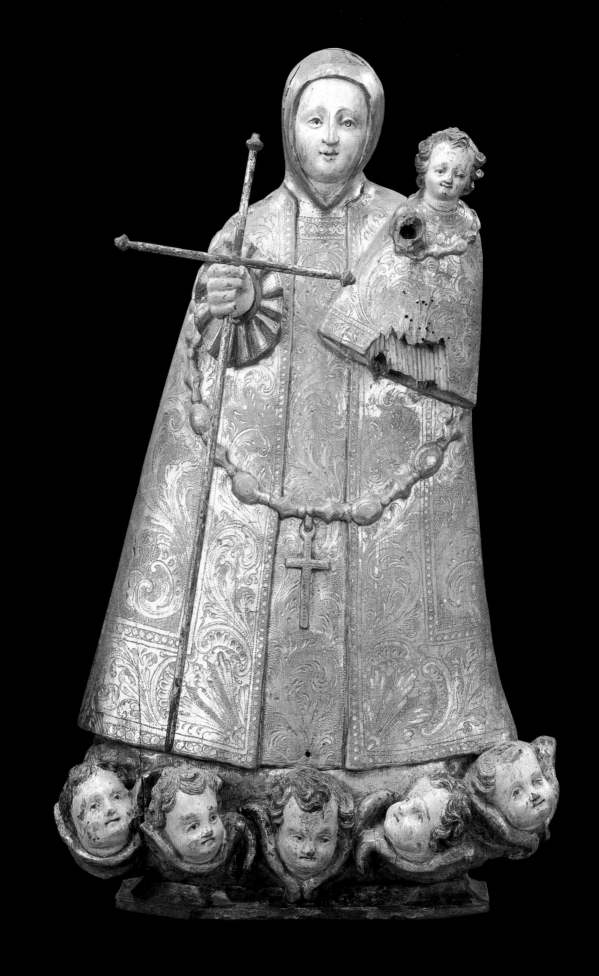

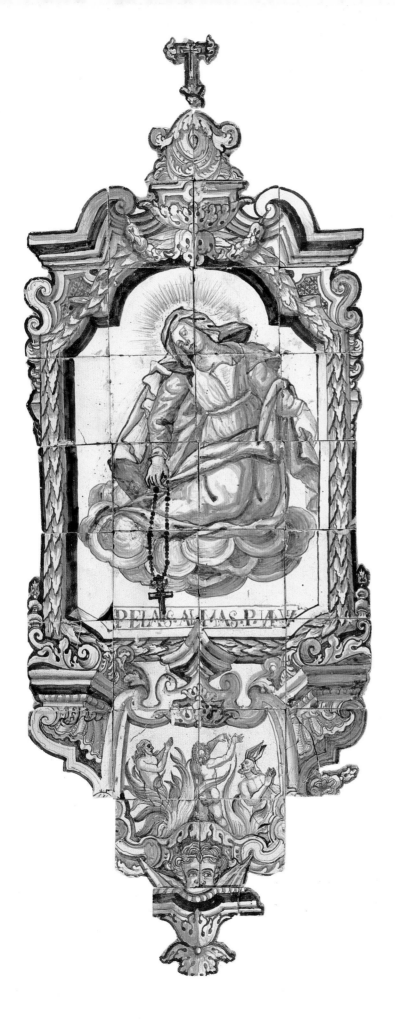

The Virgin of the Rosary became an official invocation in the late fifteenth century, and with the support of the Dominican order, it was spread throughout the world by its many confraternities both in Europe and Asia.

This elaborate tile panel connects the Virgin of the Rosary with another attribute of the Virgin: her capacity to save souls from purgatory, through the use of the rosary. The Virgin appears as she did to Saint Dominic, in a throne of clouds. She holds forth the rosary to save those souls who, having died in venial sin, yearn for the moment of their ascent into Heaven.

The iconography of this tile panel thus revolves around the Virgin's particular powers to intercede in favor of human souls. Her independent position before the souls in purgatory demonstrates to what extent she was considered a power in their redemption. **J.D.D.**

75 *Ex-Voto of Our Lady of the Rosary of Corval*

[Ex-Voto a Nossa Senhora do Rosário do Corval]

1875

Oil on wood

201 × 347 mm

Museu Nacional de Arqueologia, Lisbon

Caption: Miracle performed by Our Lady of the Rosary of Corval on Margarida

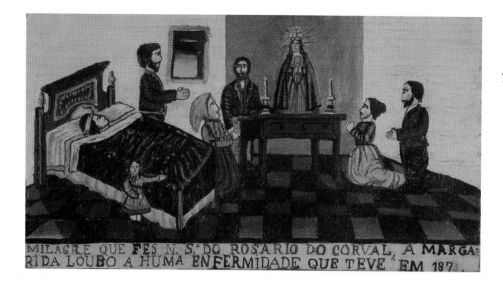

MILAGRE QUE FES N. S.ª DO ROSÁRIO DO CORVAL, A MARGA
RIDA LOUBO A HUMA ENFERMIDADE QUE TEVE EM 187.

Loubo, who suffered from an infirmity in 187(5)

The scene depicted in this painting takes place in a typical house of the Alentejo. The tiled floor in two colors and the diagonally placed bed end a sense of depth to the composition. Contrary to other examples of such panels in this exhibition, the image of the Virgin appears on a table, flanked by candles, and not in a cloud or mandorla in the sky. She is represented here instead as a sculpture of a particular version of the Virgin of the Rosary, through which, it is suggested, she was specifically invoked in this household. The painting is an offering of thanks for the recovery of Margarida Loubo, who was gravely ill. Three couples are depicted. Only one man is kneeling. The girl in front of the bed must be the daughter of the afflicted woman and the man behind the bed, her husband. It is a vivid and privileged look into the lives of a nineteenth-century family and their personal devotion to the Virgin. **A.J.A.**

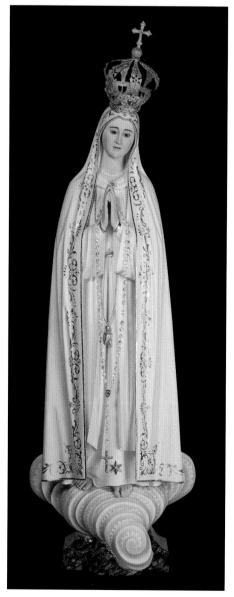
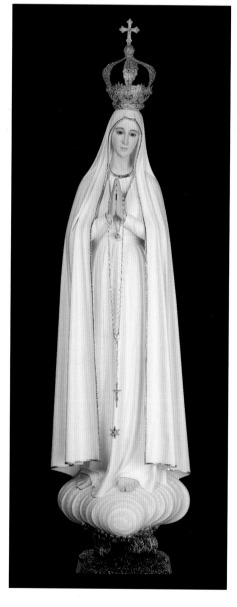

76 *Our Lady of Fátima*

[Nossa Senhora do Rosário de Fátima]

Twentieth century

Polychromed wood

1,250 mm (height); 250 × 155 mm (base)

Santuário de Nossa Senhora de Fátima

This is a copy of the first image of Our Lady of Fátima, which is kept at the Capelinha

das Aparições and was given to the sanctuary in 1920 by Gilverto Fernandes dos Santos, a young and devout merchant from Torres Novas. He had commissioned the work from the workshop of Fânzeres de Bragas. J. Thedim, considered the best maker of sacred images in the workshop, was put in charge of producing the work, having consulted with the prebendary Formigão, as well as with the three children who experienced the visions themselves. The artist, however, seems to have closely followed the iconography and composition of another work, known as Nossa Senhora de Lapa, published in 1914 in the catalogue of a competing workshop, Casa Estrela. Having been sculpted in wood by Thedim and painted by Alberto Barbosa, the first statue of Our Lady of Fátima was delivered to its donor in May 1920. It has suffered various subsequent alterations and has been repainted numerous times. This is one of innumerable copies that have represented the Virgin of Fátima throughout the world. **T.L.V.**

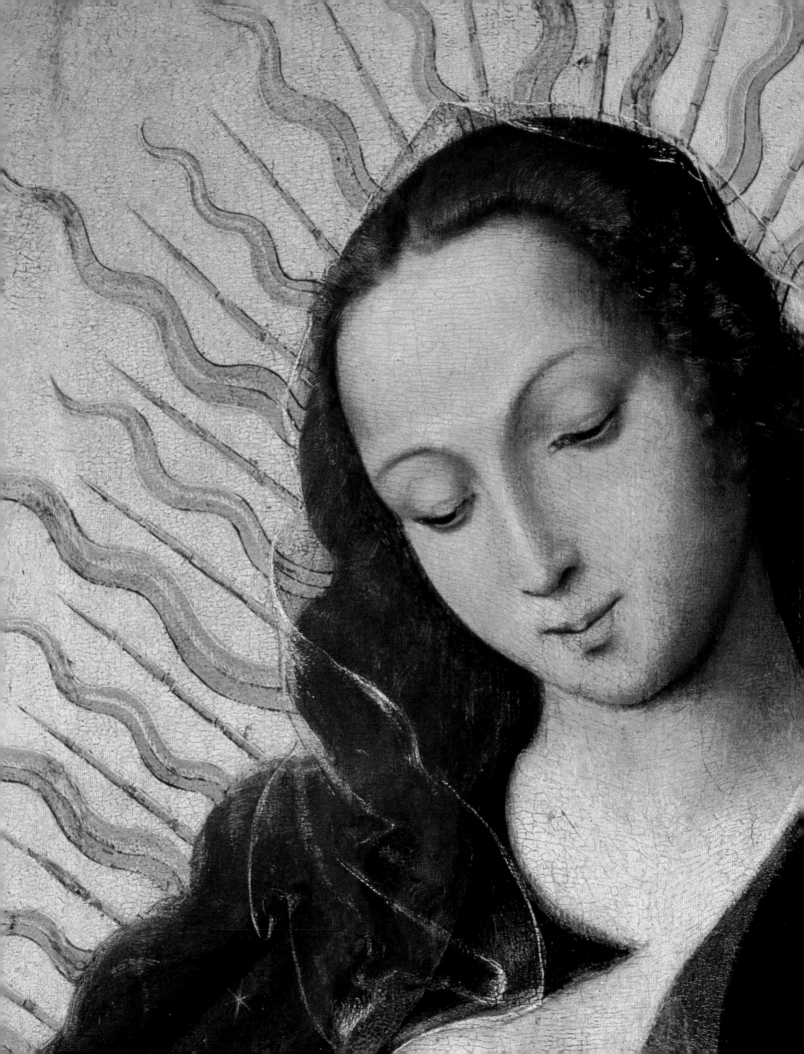

Exhibition Checklist

1 *Procession* [Procissão]
Augusto Roquemont (1804-1852)
Nineteenth century
Oil on canvas
520 × 625 mm
Museu Nacional de Soares dos Reis, Porto (inv. no. 994)

2 *Saint Anne, the Virgin, and Christ*
[Santa Ana Triplice]
Second half of the fifteenth century
Polychromed stone
730 mm (height); 370 × 280 mm (base)
Museu Nacional de Arte Antiga, Lisbon (inv. no. 1045)

3 *Annunciation* [Anunciação] (fragment)
Attributed to Gaspar Vaz (c. 1490-c. 1569)
c. 1530
Oil on chestnut wood
532 × 612 mm
Museu Nacional de Soares dos Reis, Porto (inv. no. CMP 54)

4 *Saint Anne Teaching the Virgin*
[Santa Ana ensinando a Virgem]
First half of the eighteenth century
Polychromed terra-cotta
380 mm (height); 140 × 120 mm (base)
Museu Nacional de Arte Antiga, Lisbon (inv. no. 810)

5 *Virgin of the Rosary* [Nossa Senhora do Rosário]
Seventeenth century
Polychromed ivory
450 mm (height); 140 × 120 mm (base)
Private collection, Lisbon

6 *Our Lady of the Four Corners of the World*
[Nossa Senhora das Quatro Partes do Mundo]
Nineteenth century
Polychromed alabaster
500 mm (height)
Casa-Museu Fernando de Castro, Porto (inv. no. 311)

7 *Meeting at the Golden Gate*
[Encontro de São Joaquim e Santa Ana]
Follower of Pedro Nunes (1586-1637)
First third of the seventeenth century
Oil on wood
665 × 520 mm
Museu de Évora (inv. no. 3339)

8 *Birth of the Virgin* [Nascimento da Virgem]
Follower of Pedro Nunes (1586-1637)
First third of the seventeenth century
Oil on wood
669 × 519 mm
Museu de Évora (inv. no. 3340)

9 *Presentation of the Virgin at the Temple*
[Apresentação da Virgem
no Templo]
Follower of Pedro Nunes (1586-1637)
First third of the seventeenth century
Oil on wood
672 × 523 mm
Museu de Évora (inv. no. 3341)

10 *Marriage of the Virgin*
[Esponsais da Virgem]
Follower of Pedro Nunes (1586-1637)
First third of the seventeenth century
Oil on wood
670 × 524 mm
Museu de Évora (inv. no. 3342)

11 *Annunciation* [Anunciação]
Follower of Pedro Nunes (1586-1637)
First third of the seventeenth century
Oil on wood
670 × 507 mm
Museu de Évora (inv. no. 3343)

12 *Visitation* [Visitação]
Follower of Pedro Nunes (1586-1637)
First third of the seventeenth century
Oil on wood
665 × 520 mm
Museu de Évora (inv. no. 3223)

13 *Adoration of the Magi*
[Adoração dos Magos]
Follower of Pedro Nunes (1586-1637)
First third of the seventeenth century
Oil on wood
675 × 525 mm
Museu de Évora (inv. no. 3222)

14 *Circumcision* [Circumcisão]
Follower of Pedro Nunes (1586-1637)
First third of the seventeenth century
Oil on wood
673 × 425 mm
Museu de Évora (inv. no. 3344)

15 *Saint Anne and the Virgin*
[Santa Ana e a Virgem]
Eighteenth century
Polychromed wood with gold leaf
340 × 230 × 140 mm
Museu de Aveiro (inv. no. 42/B)

16 *Saint Anne Teaching the Virgin*
[Santa Ana ensinando a Virgem]
Seventeenth century
Polychromed wood
515 × 360 × 280 mm
Museu Nacional de Arte Antiga, Lisbon (inv. no. 560)

17 *Saint Anne Teaching the Virgin*
[Santa Ana ensinando a Virgem]
Nineteenth century
Polychromed wood
235 × 145 × 120 mm
Museu Nacional de Arte Antiga, Lisbon (inv. no. 795)

18 *Virgin of the Annunciation*
[Virgem da Anunciação]
First quarter of the sixteenth century
Polychromed wood
710 mm (heigt); 305 × 260 mm (base)
Museu Nacional de Arte Antiga, Lisbon (inv. no. 1710)

19 *Annunciation* [Anunciação]
Fourteenth century
Marble
950 × 1,250 × 250 mm
Museu de Évora (inv. no. 1746)

20 *Annunciation* [Anunciação]
Jorge Barradas (1894-1971)
1936
Oil on canvas
2,100 × 1,800 mm
Museu do Chiado, Lisbon (inv. no. 850)

21 *Our Lady of O* [Nossa Senhora do Ó]
Fifteenth century
Limestone
840 mm (height); 295 × 215 mm (base)
Museu da Sé de Évora

22 *Visitation* [Visitação]
Late fifteenth century-early sixteenth century
Polychromed wood
905 mm (height); 415 × 150 mm (base)
Museu Nacional de Arte Antiga, Lisbon (inv. no. 1626)

23 *Nativity, the Adoration of the Shepherds
and Magi* [Presépio, Adoração dos Pastores e dos Magos]
Vasco Pereira Lusitano (1535-1609)
1575
Oil on panel
320 × 1,165 mm
Museu Nacional de Arte Antiga, Lisbon (inv. no. 1842)

24 *Virgin Suckling the Infant Jesus*
[Virgem do Leite or Maria Lactans]
Third quarter of the fifteenth century
Polychromed stone
770 mm (height); 305 × 260 mm (base)
Museu Nacional de Arte Antiga, Lisbon (inv. no. 1130)

25 *Suckling Virgin* [Virgem do Leite]
Attributed to Frei Carlos (active 1517-1540)
First third of the sixteenth century
Oil on oak
320 × 240 mm
Museu Nacional de Soares dos Reis, Porto (inv. no. CMP 56)

26 *Virgin and Child* [Virgem com o Menino]
Second quarter of the fifteenth century
Polychromed limestone
736 × 315 × 225 mm
Museu Nacional de Arte Antiga, Lisbon (inv. no. 1075)

27 *Virgin and Child* [Virgem com o Menino]
Seventeenth-eighteenth century
Polychromed wood
730 mm (height); 290 × 270 mm (base)
Museu de Aveiro (inv. no. 144/B)

28 *Virgin and Child*
[Virgem com o Menino]
Eighteenth-nineteenth century
Ivory
144 stet; 50 × 34 mm (base)
Private collection, Lisbon

29 *Virgin and Child*
[Virgem com o Menino]
Twentieth century
Wood
320 mm (height); 108 × 84 mm (base)
Museu Antropológico da Universidade de Coimbra
(inv. no. BR 82.4.114)

30 *Virgin and Child*
[Nossa Senhora do Pópulo]
Josefa de Óbidos (1630-1684)
c. 1670-80
Oil on canvas
1,284 × 940 mm
Casa Hospitalar das Caldas da Rainha
(inv. no. P5)

31 *Oratory* [Oratório]
Late sixteenth century
Oil on copper in oratory of lacquered wood inlaid
with gold, silver, copper, and mother-of-pearl
472 mm (height); 350 × 510 mm (base)
Santa Casa da Misericórdia do Sardoal

32 *Virgin, Child, and Two Angels*
[A Virgem, o Menino e dois Anjos] (front)
Christ in Majesty [Cristo em Magestade] (back)
Attributed to Frei Carlos (active 1517-1540)
Sixteenth century
Oil on wood
410 × 315 mm
Museu Nacional de Arte Antiga, Lisbon
(inv. no. 1179)

33 *Holy Family* [Sagrada Família]
Josefa de Óbidos (1630-1684)
1672
Oil on canvas
1,660 × 1,435 mm
Igreja Matriz, Cascais

34 *Holy Family (with Christ)*
[Sagrada Família (com Cristo)]
Eighteenth century
Polychromed wood with gold leaf
250 mm (height); 270 × 85 mm (base)
Museu de Arte Sacra da Capela de São Miguel,
Universidade de Coimbra

35 *The Virgin, Saint Anne,
and Saint Joachim*
[Nossa Senhora, Santa Ana
e São Joaquim]
Eighteenth century
Polychromed wood with gold leaf
260 mm (height); 260 × 100 mm (base)
Museu de Arte Sacra da Capela de São Miguel,
Universidade de Coimbra

36 *Holy Family with Saint Anne and Saint
Joachim* [Sagrada Família com Santa Ana e São Joaquim]
Eighteenth century
Polychromed wood with gold leaf
895 mm (height); 1,010 × 470 mm (base)
Museu da Igreja dos Clérigos, Porto

37 *Flight into Egypt* [Fuga para o Egipto]
Attributed to Policarpo de Oliveira Bernardes (1695-1778)
c. 1730
Blue and white ceramic tile
570 × 990 mm
Museu Nacional do Azulejo, Lisbon (inv. no. 1690)

38 *Rest on the Flight into Egypt*
[Repouso na fuga para o Egipto]
Josefa de Óbidos (1630-1684)
c. 1660-70
Oil on canvas
830 × 610 mm
Private collection, Lisbon

39 *Holy Family in a Boat* [Sagrada Família num barco]
Late eighteenth century
Painted ceramic, glass, wax, and wood
345 × 420 × 155 mm
Museu Nacional de Machado de Castro,
Coimbra (inv. no. 2148/E.928)

40 *Pietà* [Nossa Senhora da Piedade]
Fifteenth century
Polychromed limestone
905 × 530 × 365 mm
Museu Nacional de Arte Antiga, Lisbon (inv. no. 1046)

41 *Pietà* [Nossa Senhora da Piedade]
Seventeenth century
Polychromed wood
1,020 × 620 × 380 mm
Museu de São Roque/Santa Casa da Misericórdia,
Lisbon (inv. no. 78)

42 *Virgin of Sorrows* [Nossa Senhora das Dores]
Eighteenth century
Polychromed wood
1,130 mm (height); 520 × 460 mm (base)
Museu de Aveiro (inv. no. 27/B)

43 *Virgin of Sorrows*
[Mater Dolorosa or Nossa Senhora das Dores]
Josefa de Óbidos (1630-1684)
c. 1680
Oil on canvas
955 × 690 mm
Private collection, Lisbon

44 *Pentecost* [Pentecostes]
Attributed to Simão Rodrigues (c. 1560-1629)
and Domingos Vieira Serrão (1570-1632)
c. 1600
Oil on panel
780 × 625 mm
Museu Nacional de Machado de Castro, Coimbra
(inv. no. 2640/P.291)

45 *Dormition of the Virgin*
[O Trânsito ou Passamento da Virgem]
Cristóvão de Figueiredo (active c. 1515-1540)
Sixteenth century
Oil on panel
790 × 880 mm
Museu Nacional de Arte Antiga, Lisbon (inv. no. 63)

46 *Our Lady of Good Death*
[Nossa Senhora da Boa Morte]
Eighteenth century
Polychromed wood with gold leaf
840 × 450 × 450 mm
Convento dos Cardais, Lisbon

47 *Our Lady of Good Death*
[Nossa Senhora da Boa Morte]
Eighteenth century
Wood, ivory, silk, and silver
Sculpture: 390 mm (height);
bed: 630 × 460 × 300 mm
Diocese de Macau-Paço Episcopal, Macao

48 *Assumption* [Assunção da Virgem]
c. 1750
Polychromed ceramic tile
1,400 × 710 mm
Museu Nacional do Azulejo, Lisbon (inv. no. 6113)

49 *Coronation of the Virgin* [Coroação da Virgem]
Simão Rodrigues (1560-1629)
Last quarter of the sixteenth century
Oil on canvas
1,425 × 1,718 mm
Museu Nacional de Machado de Castro, Coimbra
(inv. no. 2503/P.69)

50 *Queen of Heaven* [A Rainha do Céu]
Domingos António de Sequeira (1768-1837)
c. 1826
Oil on canvas
895 × 1100 mm
Museu Nacional de Arte Antiga, Lisbon (inv. no. 544)

51 *Our Lady of Aparecida*
[Nossa Senhora da Aparecida]
Nineteenth-twentieth century
Wood, velvet, gold, and semiprecious stones
470 mm (height); 255 × 140 mm (base)
Congregação das Franciscanas Hospitaleiras Imaculada
Conceição, Lisbon (inv. no. 829)

52 *Crowned Virgin* [Nossa Senhora Coroada]
Eighteenth century
Polychromed wood and ivory
640 mm (height), 170 × 80 mm (base)
Private collection, Lisbon

53 *Virgin as Good Shepherdess*
[Nossa Senhora como Boa Pastora]
Late eighteenth century
Sculpture: polychromed terra-cotta with gold leaf; shrine: wood
Sculpture: 370 mm (height); shrine: 550 × 300 × 190 mm
Museu Nacional de Arte Antiga, Lisbon (inv. no. 356)

54 *Virgin as Good Shepherdess*
[Nossa Senhora como Boa Pastora] (front)
A Saint [Santo] (back)
Eighteenth century
Gold with faceted glass and painted veneer
47 × 30 mm
Museu Nacional de Soares dos Reis,
Porto (inv. no. 202 MNSR)

55 *Banner of Our Lady of Mercy*
[Bandeira da Misericórdia de Lisboa] (front)
Pietà [Nossa Senhora da Piedade] (back)
Seventeenth century
Oil on canvas
880 × 740 mm
Museu de São Roque/Santa Casa da Misericórdia, Lisbon
(inv. nos. 72, 73)

56 *Our Lady of Mercy*
[Nossa Senhora da Misericórdia]
After 1539
Etching; frontispiece of the second edition of
O Compromisso da Confraria da Misericórdia
295 × 210 mm
Biblioteca da Ajuda, Lisbon
(inv. no. 50-XII-4)

57 *Our Lady of Nazaré*
[Nossa Senhora de Nazaré]
Early nineteenth century
Oil on glass
360 × 290 mm
Museu-Escola de Artes Decorativas Portuguesas, Lisbon
(inv. no. 711)

58 *Immaculate Conception*
[Imaculada Conceição]
Bento Coelho da Silveira (c. 1620–1708)
Late seventeenth century
Oil on canvas
1,265 × 1,107 mm
Museu de Aveiro (inv. no. 55/A)

59 *Processional Banner of the Virgin
of the Immaculate Conception
(Our Lady of Vila Viçosa)*
[Pendão Processional da Imaculada Conceição
(Nossa Senhora de Vila Viçosa)]
Twentieth century
1,600 × 900 mm
Church of Vila Viçosa

60 *Offerings by the Duchesses
of Portugal to the Statue of Nossa Senhora
da Conceição*
Seventeenth and twentieth centuries
Silk, velvet, brocade, and embroidery
1,600 × 2,750 mm (Virgin's dress);
700 × 700 mm (Christ's mantle)
Santuário de Nossa Senhora da Conceição, Vila Viçosa

61 *Suckling Virgin* [Virgem do Leite]
Flemish School (Bruges)
Sixteenth century
Oil on panel
1,065 × 900 mm
Museu de Aveiro (inv. no. 97/A)

62 *Immaculate Conception (with Saint
Martial, Saint Anthony, and Saint Peter
of Alcântara)* [Nossa Senhora da Conceição,
São Marçal, Santo Antonio e São Pedro de Alcântara]
c. 1790
Polychromed ceramic tile
1260 × 980 mm
Museu Nacional do Azulejo, Lisbon (inv. no. 6105)

63 *Immaculate Conception* [Imaculada Conceição]
Late nineteenth century
Cut paper
340 × 340 mm
Museu de Arte Popular, Lisbon (inv. no. TR.PAP.20/90)

64 *Ex-Voto of the Immaculate Conception*
[Ex-Voto a Imaculada Conceição]
1819
Oil on wood
333 × 170 mm
Museu Nacional de Arqueologia, Lisbon (inv. no. 2078)

65 *Military Decorations of the Immaculate
Conception*
[Grã-Cruz da Ordem de Nossa Senhora da Conceição]
Jean-Baptiste Debret (1768-1848)
First half of the nineteenth century
Gold with enamel inlay
77 mm (diameter)
Museu de Marinha, Lisbon (inv. no. CO209)

66 *Ex-Voto of the Immaculate Conception
(Fonte Santa)* [Ex-Voto a Nossa Senhora da Fonte Santa]
1823
Oil on panel
300 × 225 mm
Museu Nacional de Arqueologia, Lisbon (inv. no. 2232)

67 *Virgin of the Immaculate Conception*
[Imaculada Conceição]
First half of the eighteenth century
Ivory
210 mm (height); 70 × 50 mm (base)
Private collection, Porto

68 *Ex-Voto of Virgin and Child with Ship
(Our Lady of Atalaia)*
[Ex-voto a Nossa Senhora da Atalaia]
1894
Oil on canvas
315 × 410 mm
Museu de Arte Popular, Lisbon (inv. no. PIN 30/90)

69 *Our Lady of Arrábida*
[Nossa Senhora da Arrábida]
Gregório Francisco de Queiroz (1768-1845)
Eighteenth century
Engraving
319 × 249 mm
Museu Nacional de Arte Antiga, Lisbon (inv. no. 731.GRAV)

70 *Banner of the Guild of the Fishermen
of Póvoa deVarzim*
[Bandeira da Casa dos Pescadores de Póvoa de Varzim]
Twentieth century
Silk embroidered with colored thread
960 × 940 mm
Museu de Marinha, Lisbon

71 *The Virgin Appearing to Saint Dominic*
[Nossa Senhora entregando o rosário a São
Domingos]
1771
Polychromed ceramic tile
1,770 × 1,270 mm
Museu Nacional do Azulejo, Lisbon (inv. no. 1643)

72 *Virgin of the Rosary*
[Nossa Senhora do Rosário]
Seventeenth century
Silver, gold, and semiprecious stones
700 × 300 mm
Museu de Arte Sacra da Sé, Évora

73 *Virgin of the Rosary*
[Nossa Senhora do Rosário]
Seventeenth century
Polychromed wood with gold leaf
500 mm (height); 235 × 120 mm (base)
Museu Nacional de Arte Antiga, Lisbon (inv. no. 602)

74 *Virgin of the Rosary*
[Nossa Senhora do Rosário]
1772
Polychromed ceramic tile
1,560 × 580 mm
Museu Nacional de Machado de Castro,
Coimbra (inv. no. 1174/C.1566)

75 *Ex-Voto of Our Lady of the Rosary of Corval*
[Ex-Voto a Nossa Senhora do Rosário do Corval]
1875
Oil on wood
201 × 347 mm
Museu Nacional de Arqueologia, Lisbon (inv. no. 7039)

76 *Our Lady of Fátima*
[Nossa Senhora do Rosário de Fátima]
Twentieth century
Polychromed wood
1,250 mm (height); 250 × 155 mm (base)
Santuário de Nossa Senhora de Fátima

Excerpts from an Ode

Come, age-old never changing Night,
Night born a queen without a throne,
Night inwardly the same as silence, Night
With starry sequins fleeting
In your robe fringed with the infinite.

Come, dimly seen,
Come lightly felt,
Come in lone majesty, holding your hands

...

Our Lady
Of the impossible things we seek in vain,

...

Come in sorrow,
Mater Dolorosa to the Anguish of the Timid

...

Come silent and ecstatic Night,
Come wrap my heart in the pale folds
Of night's cloak...
Serenely like a breeze in the gentleness of the evening
With the stars shining in your hands
And the moon's mystery masking your features.

ÁLVARO DE CAMPOS
[FERNANDO PESSOA's heteronymous]
Translated by Peter Rickard

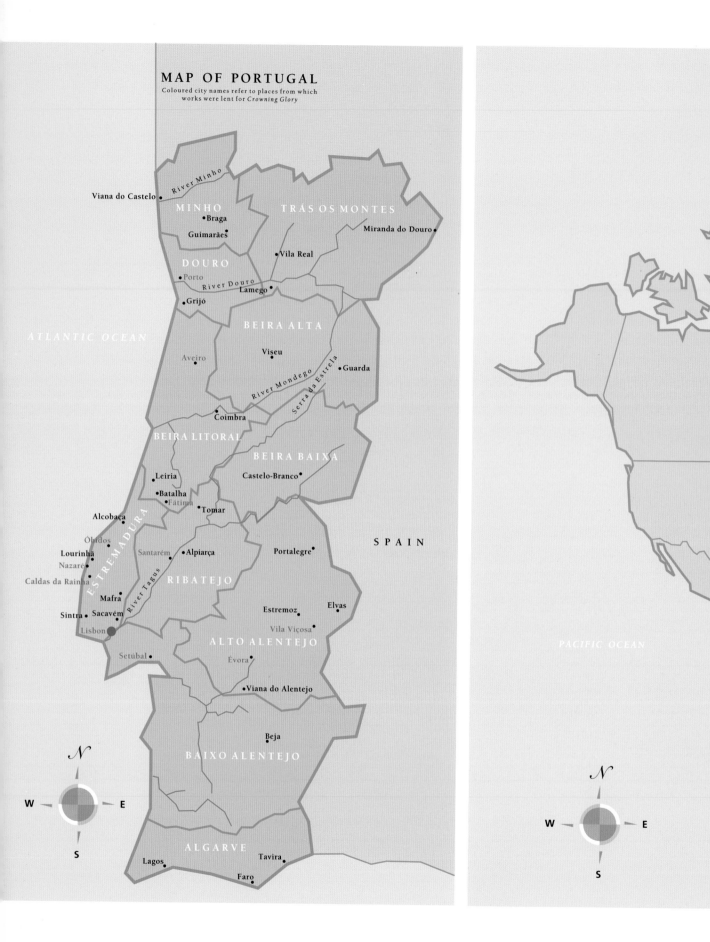

MAP OF PORTUGAL

Coloured city names refer to places from which
works were lent for *Crowning Glory*

MINHO

Viana do Castelo

River Minho

•Braga

•Guimarães

TRÁS OS MONTES

Miranda do Douro•

•Vila Real

DOURO

•Porto

River Douro

Lamego•

•Grijó

BEIRA ALTA

Aveiro

•Viseu

•Guarda

River Mondego

Serra da Estrela

•Coimbra

BEIRA LITORAL

BEIRA BAIXA

•Leiria

Castelo-Branco•

•Batalha

•Fátima

•Tomar

•Alcobaça

Óbidos

ESTREMADURA

Santarém•

•Alpiarça

Portalegre•

SPAIN

Lourinhã•

Nazaré•

Caldas da Rainha•

RIBATEJO

River Tagus

•Mafra

Estremoz•

•Elvas

Sintra•

•Sacavém

Lisbon•

Vila Viçosa

•Setúbal

ALTO ALENTEJO

Évora•

•Viana do Alentejo

ATLANTIC OCEAN

PACIFIC OCEAN

•Beja

BAIXO ALENTEJO

ALGARVE

Lagos•

•Tavira

•Faro

SITES OF PORTUGUESE
CULTURAL AND LINGUISTIC HERITAGE

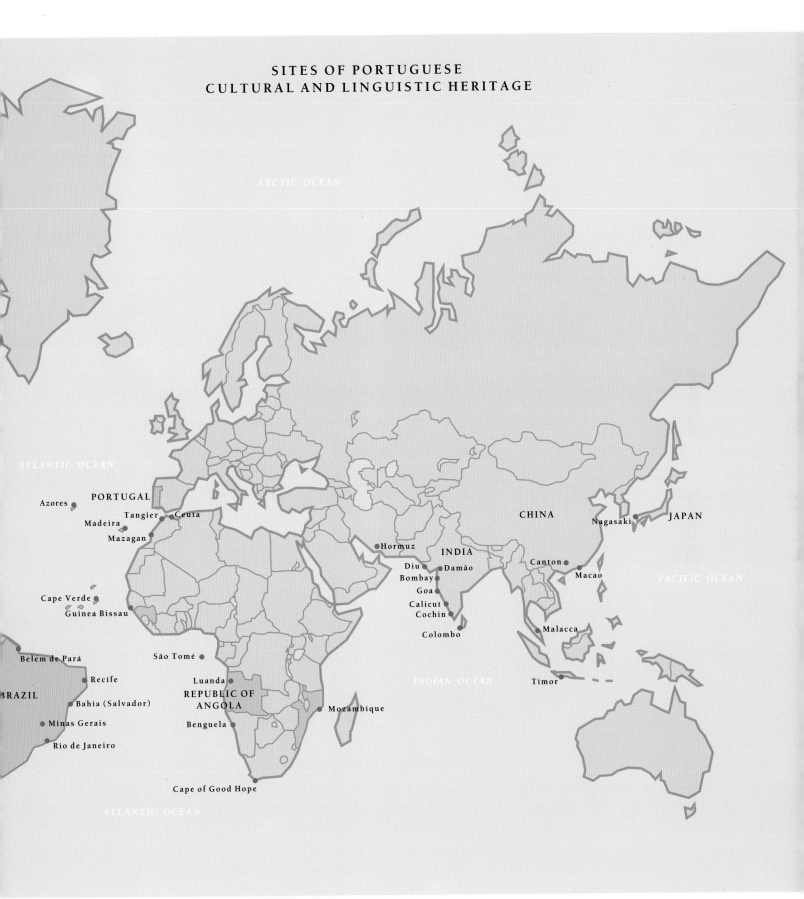

ARCTIC OCEAN

ATLANTIC OCEAN

PORTUGAL

Azores

Tangier Ceuta

Madeira

Mazagan

CHINA

JAPAN

Nagasaki

Hormuz INDIA

Diu Damão

Bombay

Goa

Calicut

Cochin

Canton

Macao

PACIFIC OCEAN

Cape Verde

Guinea Bissau

Colombo

Malacca

Belém de Pará

São Tomé

Recife

Luanda

BRAZIL

Bahia (Salvador)

Minas Gerais

REPUBLIC OF
ANGOLA

Benguela

INDIAN OCEAN

Timor

Mozambique

Rio de Janeiro

Cape of Good Hope

ATLANTIC OCEAN

Bibliography

Imagens de Nossa Senhora, exh. cat. Lisbon: Instituto Português do Património Cultural, Centro Universitário Católico de Lisboa, 1988.

AGOSTINHO DE SANTA MARIA, Frei. *Santuario Mariano*. vol. I, XXVI.

ALMEIDA, Fortunato de. *História da Igreja em Portugal*. Porto, 1967.

ALVES, Natália Marinho Ferreira. *A Arte da Talha no Porto na época barroca*. Porto, 1989.

A Apoteose do Barroco nas igrejas dos conventos femininos portuenses, exh. cat. Porto, 1992.

L'Art au Portugal au temps des Grandes Découvertes (fin XIVe siècle jusqu'à 1548), exh. cat. Antwerp, 1991.

Arte Moderna Portuguesa através dos Prémios artísticos do S.N.I. (1935-1948), exh. cat. Lisbon, [1948].

BEAUMONT, Maria Alice. *Domingos António de Sequeira, Desenhos*. Lisbon, 1972–75.

BLAKE, John W. *West Africa: Quest for God and Gold, 1454–1578: A Survey of the First Century of White Enterprise in West Africa, with Particular Reference to the Achievement of the Portuguese and Their Rivalries with Other European Powers*. Second ed., rev. and enl. London, 1977.

BOFF, Clodovis. *Maria na cultura brasileira: Aparecida, Iemanjá e Nossa Senhora da Libertaçao*, trans. Silva Debetto C. Reis. Petrópolis, 1995.

BOXER, Charles Ralph. *Four Centuries of Portuguese Expansion, 1415–1825: A Succinct Survey*. Johannesburg, 1961.

BRANDÃO, Júlio. *O Pintor Roquemont. Subsídios para o estudo do Artista: Vida, Época e Obras*. Lisbon, 1929.

BROWN, Raymond, Karl Donfried, Joseph Fitzmyer, and John Reumann, eds. *Mary in the New Testament*. Philadelphia, 1978.

CARROLL, Michael P. *The Cult of the Virgin Mary: Psychological Origins*. Princeton, 1986.

CASTEL-BRANCO PEREIRA, João. *As Colecções do Museu Nacional do Azulejo, Lisboa*. London and Lisbon, 1995.

CHAVES, Luis. "Ex-Votos do Museu Etnológico Português. Catálogo descritivo." *O Archeologo Português*, series 1, vol. 19 (1914).
—. *Ex-votos do Museu Etnológico Português. Catálogo descritivo*. Lisbon, 1915.
—. "A 'Imaculada Conceição' nas tradições a no folclore de Portugal." *Brotéria*, vol. 43 (1946).
—. "Na arte popular dos ex-votos – Os 'milagres.'" *Revista de Guimarães*, vol. 80 (1970).

CORREIA GUEDES, Maria Natália, ed. *Encontro de culturas: oito séculos de missionação portuguesa*, exh. cat. Lisbon, 1994.

COSTA, Felix da. *The Antiquity of the Art of Painting*, ed. George Kubler. New Haven, 1967.

COUTINHO, B. Xavier. *Nossa Senhora na Arte: Alguns problemas iconográficos e uma exposição Marial*. Porto, 1959.

COUTO, João. *A Pintura Flamenga em Évora no século XVI, variedade de estilos e de técnicas na obra atribuída a Frei Carlos*. Lisbon, 1943.
—. *A Oficina de Frei Carlos*. Lisbon, 1955.
—. *Frei Carlos e a Oficina do Espinheiro*. Lisbon, n.d.

CRONIN, Vincent. *A Pearl to India*. New York, 1959.

CUNNEEN, Sally. *In Search of Mary: The Woman and the Symbol*. New York, 1996.

DESWARTE, Sylvie. *Ideias e Imagens de Portugal na Época dos Descobrimentos. Francisco de Holanda e a Teoria da Arte*. Lisbon, 1992.

DIAS, Pedro, and J[oaquim] J[osé] Carvalhão [Teixeira] Santos. *A Pintura Maneirista de Coimbra: Ensaio iconográfico*. Coimbra, 1988.

Domingos António de Sequeira, exh. cat. Lisbon: Museu Nacional de Arte Antiga, 1996.

FIGUEIREDO, José de. *Quatro diálogos da pintura antiga*, ed. Joaquim de Vasconcellos. Porto, 1918.

FONSECA, Francisco Belard da. *A Ordem Militar de Nossa Senhora da Conceição de Vila Viçosa*. Lisbon, 1955.

FRANÇA, José-Augusto. *A Arte em Portugal no século XIX*. 2 vols. Lisbon, 1967.
—. *A Arte em Portugal no século XX (1911-1961)*. Lisbon, 1974.

GRAEF, Hilda. *Mary: A History of Doctrine and Devotion*. 2 vols. London, 1963.

Grão Vasco e a Pintura Europeia do Renascimento, exh. cat. Lisbon, 1992.

Jerónimos: 4 séculos de Pintura, exh. cat. Lisbon, 1992.

JORDAN-GSCHWEND, Annemarie. *Retrato de Corte em Portugal. O legado de António Moro*. Lisbon, 1994.

Josefa de Óbidos e o Tempo Barroco, exh. cat. Lisbon, 1993.

KOEHLER, Theodore. "Marie (sainte Vierge): Du moyen âge aux temps modernes." In *Dictionnaire de spiritualité, ascetique et mystique, doctrine et histoire*, vol. 10. Paris, 1977.

KUBLER, George, and Martin Soria. *Art and Architecture in Spain and Portugal and Their American Dominions*. Harmondsworth, 1959.

LAPA, Albino. *Livro de Ex-votos Portugueses*. Lisbon, 1967.

LEVENSON, Jay, ed. *The Age of the Baroque in Portugal*, exh. cat. New Haven: Yale University Press, 1993.

MACEDO, Diogo de. *A Escultura Portuguesa nos Séculos XVII e XVIII*. Lisbon, 1945.

MACHADO, José Alberto Gomes. *André Gonçalves. Pintura do Barroco Português*. Lisbon, 1995.

MAECKELBERGHE, Els. *Desperately Seeking Mary: A Feminist Appropriation of a Traditional Religious Symbol*. Kampen, 1991.

Mater Misericordiae. Simbolismo e Representação da Virgem da Misericórdia, exh. cat. Lisbon, 1995.

McCALL, John E. "Early Jesuit Art in the Far East." *Artibus Asiae*, vol. 10 (1947).

MECO, José. *Azulejaria Portuguesa*. Lisbon, 1985.
—. *O Azulejo em Portugal*. Lisbon, 1989.

MELO, Alexandre, and João Pinharanda. *Arte Portuguesa Contemporânea*. Lisbon, 1986.

No Tempo das Feitorias: A Arte Portuguesa na Época dos Descombrimentos, exh. cat. Lisbon, 1991.

OKAMOTO, Yoshitomo. *The Namban Art of Japan*. New York, 1971.

d'OREY, Leonor. *Five Centuries of Jewelery, National Museum of Ancient Art, Lisbon*. London and Lisbon, 1995.

PAMPLONA, Fernando de. *Dicionário de Pintores a Escultores Portugueses ou que trabalharam em Portugal*. Lisbon, 1988.

PEREIRA, José Fernandes, and Paulo Pereira, eds. *Dicionário de Arte Barroca em Portugal*. Lisbon, 1989.

PERYM, Damião Froes. *Theatro heroino, abecedario histórico e catalogo das mulheres illustres en armas, letras, accôens heroicas, e artes liberais*, vol. 1. Lisbon, 1743.

PÍMINTEL, Alberto. *História do Culto de Nossa Senhora em Portugal*. Lisbon, 1900.

Pintura Maneirista de Coimbra, exh. cat. Coimbra, 1983.

A Pintura Maneirista em Portugal: Arte no Tempo de Camões, exh. cat. Lisbon, 1995.

PORTER, Philip Wayland. *Benin to Bahia: A Chronicle of Portuguese Empire in the South Atlantic in the Fifteenth and Sixteenth Centuries. with Comments on a Chart of Jorge Reinel*. N.p., 1959.

Portugal en el Medioevo de los Monasterios a la Monarquia, exh. cat. Madrid: 1992.

PRESTON, James J., ed. *Mother Worship: Theme and Variations*. Chapel Hill, 1982.

RACZYNSKI, Atanasio. *Dictionnaire Historico-Artistique du Portugal*. Paris, 1847.

REIS, Pe. Jacinto dos. *Invocações de Nossa Senhora em Portugal de Aquém a Além-Mar e seu Padroado*. Lisbon: 1967.

REIS-SANTOS, Luís. *Josefa d'Óbidos*. Lisbon, 1955.

RIPOLL, Antonio Martínez. *Francisco de Herrera "El Viejo."* Seville, 1978.

RODRIGUES, António. *Jorge Barradas*. Lisbon: Imprensa Nacional, Casa da Moeda, 1995.

RODRIGUES, Dalila, ed. *Grão Vasco e a Pintura Europeia do Renascimento*. Lisbon, 1992.

The Sacred and the Profane: Josefa de Óbidos of Portugal, exh. cat. Washington, D.C., 1997.

SALDANHA, Nuno, ed. *Joanni V Magnífico. A Pintura em Portugal ao Tempo de D. João V. 1706-1750*. Lisbon, 1994.

SANTOS, Reynaldo dos. *A Escultura em Portugal*. Lisbon: 1948–50.

SEBASTIAN, Santiago. *Contrarreforma y Barroco. Lecturas Iconográficas y Iconológicas*. Madrid, 1981.

SERRÃO, Vitor. *O Maneirismo e o Estatuto Social dos Pintores Portugueses*. Lisbon, 1983.
—. "Pedro Nunes (1586–1637): Um notável pintor maneirista eborense." *A Cidade de Évora*, series 1, nos. 71–76.
—, ed. *Josefa de Óbidos e o Tempo Barroco*, exh. cat. Lisbon, 1991.
—, ed. *A Pintura Maneirista em Portugal. Arte no Tempo de Camões*. Lisbon, 1995.

SMITH, Robert C. *The Art of Portugal: 1500–1800*. London, 1968.

SOBRAL, Luís de Moura. *Pintura e Poesia na Época Barroca. A Homenagem da Academia dos Singulares a Bento Coelho da Silveira*. Lisbon, 1994.

—. *Do Sentido das Imagens: Ensaio Sobre pintura barroca portuguesa a outros temas ibéricos*. Lisbon, 1996.
—. "Da mentira da pintura. A Restauração, Lisboa, Madrid e alguns santos." In Pedro Cardim, ed. *A História: entre Memória e Invenção*. Lisbon, 1997 (forthcoming).
—. "*Tota pulchra est amica mea*. Simbolismo e narração num programa imaculista de António de Oliveira Bernardes." *Azulejo*, 1997 (forthcoming).
—, ed. *Bento Coelho da Silveira e a Cultura do seu Tempo*, exh. cat. Lisbon, 1998 (forthcoming).
—, and David Booth, eds. *Struggle for Synthesis*. Lisbon, 1997 (forthcoming).

SOUSA, Frei Luis de. *História de Santo Domingos*. III, XIX.

STRATTON, Suzanne. *The Immaculate Conception in Spanish Art*. New York, 1994.

SULLIVAN, Edward J. "Josefa de Ayala: A Woman Painter of the Portuguese Baroque." *Journal of the Walters Art Gallery* 37 (1978).
—. "Obras de Josefa de Ayala, pintora ibérica." *Archivo Español de Arte*, no. 213 (1981).
—. "Herod and Salomé With the Head of John the Baptist." *Source: Notes in the History of Art* 2, no. 1 (1982).

TANI, Shin'ichi, and Tadashi Sugase. *Namban Art: A Loan Exhibition from the Japanese Galleries*, exh. cat. New York, 1973.

TURNER, Victor and Edith. "Postindustrial Marian Pilgrimage." In *Mother Worship: Theme and Variations*. Chapel Hill, 1982.

VORAGINE, Jacobus de. *The Golden Legend*, trans. and adapted by Granger Ryan and Helmut Ripperger. New York, 1969.

WALSH, William Thomas. *Our Lady of Fátima*. New York, 1947.

WARNER, Marina. *Alone of All Her Sex: The Myth and the Cult of the Virgin Mary*. New York, 1983.